THE HUMAN PLANET

EARTH AT THE DAWN OF THE ANTHROPOCENE

ABRAMS, NEW YORK

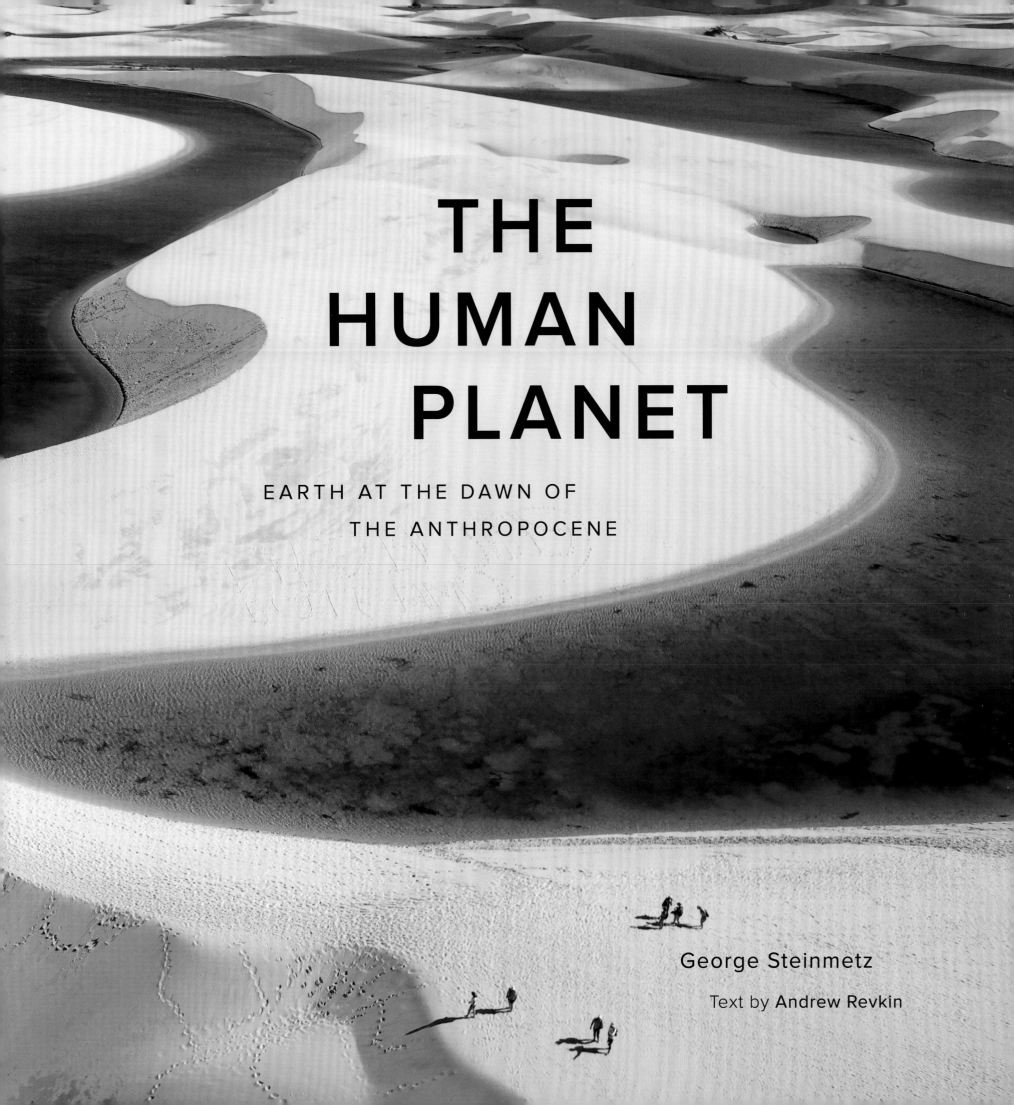

THE
HUMAN
PLANET

EARTH AT THE DAWN OF
THE ANTHROPOCENE

George Steinmetz

Text by Andrew Revkin

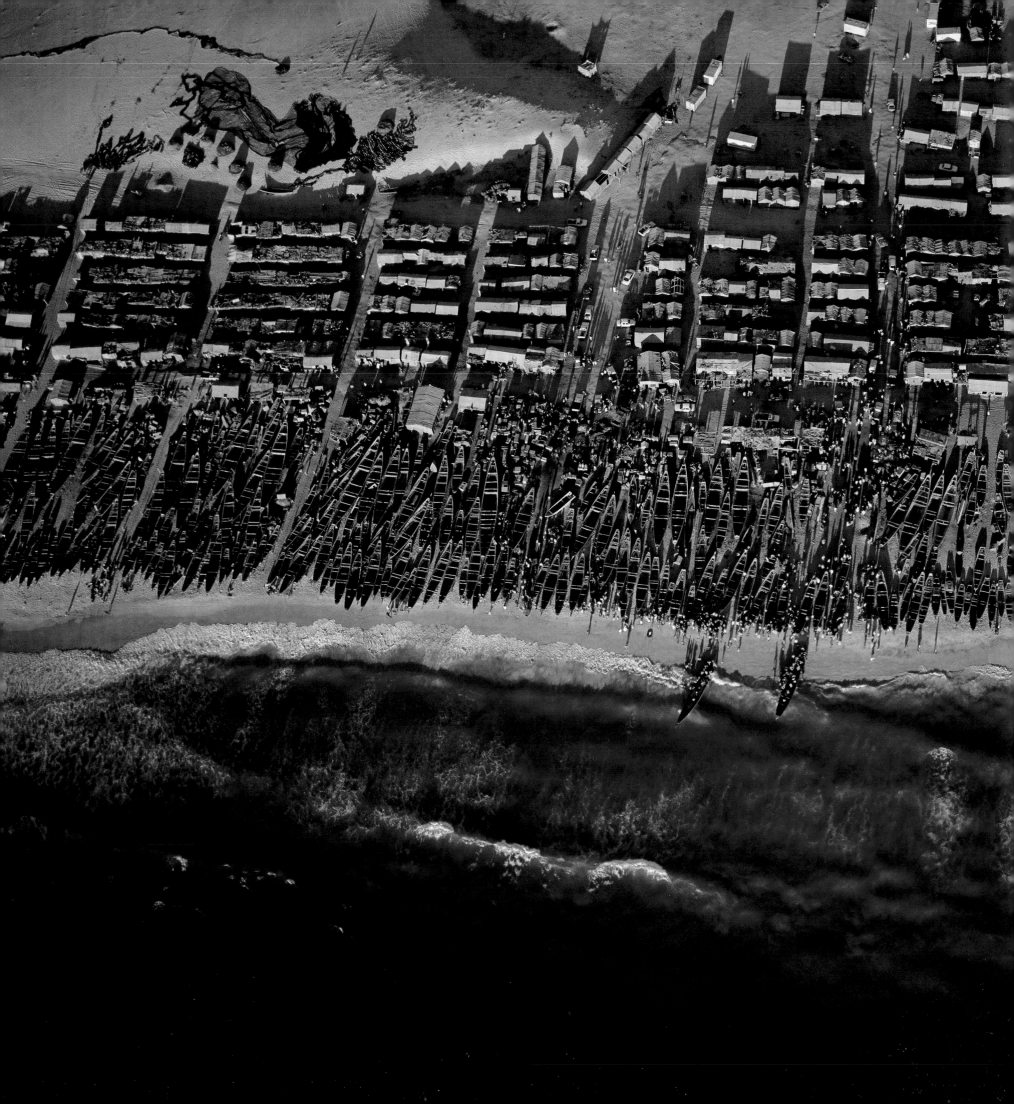

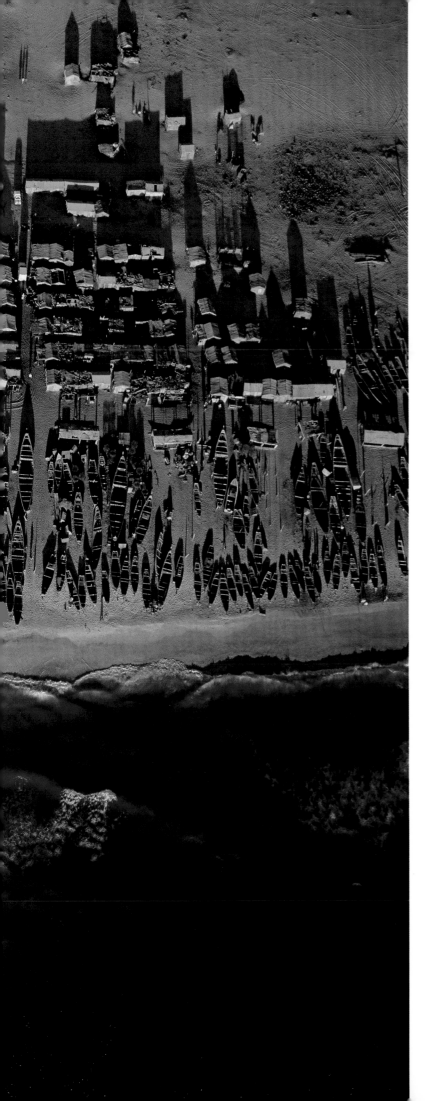

CONTENTS

THE DAWN OF THE ANTHROPOCENE

FOR MORE THAN THREE DECADES, George Steinmetz and I have been on parallel journeys exploring and chronicling the relationship between our species and our home planet. A particular focus has been the growing impact of humans on wild living landscapes and the world's climate. Now we've come together to reflect on the big picture and what lies ahead, for better or worse. In April, 1970, on the first Earth Day, environmental problems seemed relatively simple compared to the picture that presents itself today. Half a century later, with species both well-loved and unnoticed still in deep peril and global temperatures and sea levels creeping upward, headlines can make us feel that it's game over. But there's much to save and much more to restore. A sustainable relationship between people and the environment, and among people, is still ours to create.

There's been terrible damage to forests, reefs, rivers, and other treasures as the pace of industrial development, agricultural expansion, and resource extraction has surged. There's much we don't know, like the rate at which seas and temperatures will rise. Warming could still be manageable, or it could be catastrophic. Most of the current, accelerating mass loss of species, which biologists are calling the Sixth Extinction, is a statistical calculation—not directly measured. Some argue that uncertainty justifies delay in taking big steps to reduce our impacts. But that argument misses the reality that uncertainty cuts in both directions.

In the meantime, there's much that's crystal clear about how to minimize our regrets as we pursue human progress during the next half century and beyond. We know how to get more food from less land. We know how to live energy-enabled lives while cutting waste and pollution. We know that getting young women through high school reduces family size without top-down population control. We can have fine meals without mass slaughter of livestock or heaps of tossed scraps. If we build resilient, equitable, walkable cities with supply chains that limit environmental impacts, we can leave room for biological diversity to flourish. And we know, deep in our hearts, that conserving nonhuman life is vital for our own flourishing.

AN AIRBORNE WITNESS TO OUR "GREAT ACCELERATION"

George and I were both born in the late 1950s, when the human population was a mere 2.8 billion and when the rocket-like trajectory of modern civilization—which scientists now call the Great Acceleration—was just beginning. George was studying geophysics in college when, in 1979, he

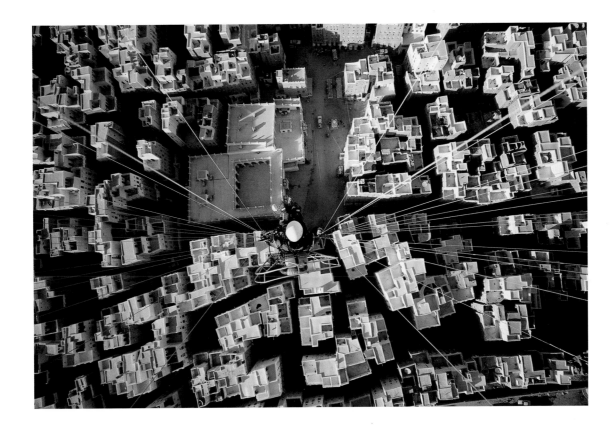

left for Africa. He spent a year hitchhiking around the continent with a camera, a camp stove, and a snake-bite kit, laying the foundation for a remarkable career that eventually saw him launching himself into the air with a paraglider wing and a gas-powered motor driving a propeller strapped to his back, to photograph mesmerizing aerial landscapes, both populated and pristine. He has flown and photographed from Antarctica to the Sahara to the Amazon to the Himalayas, crash-landing off and on, getting arrested off and on, but always coming through with the picture.

The vantage point in George's photographs is truly special. The term "overview effect" describes a special sense of awe and deep respect for our planet experienced by astronauts as they have observed Earth first from orbit and then from the moon. That feeling of reverence derives mainly from how Earth's expanse of blue, green, and white glows, in miraculous, sobering contrast, against the blackness and vacuum of space. A weaker variant of that effect was felt by those of us down on the surface when, starting in December 1968, we saw color photographs of Earth from space— particularly the iconic earthrise image captured hastily as Apollo 8 emerged from the far side of the moon for the fourth time. Each day, millions of airline passengers unremarkably crisscross continents seven miles above the surface. Those not watching seat-back screens are able to marvel at great quilts of farmland, the nocturnal electric glow of sprawling cities, the mountainous piles of cumulus storm clouds, or the sweep of great oceans. But, from that distance, it's easy to feel detached.

George's overview is different from that of an astronaut or an airline passenger. With his backpack motor and parachute-like wing, he found and perfected a way to make photographs that are both sweeping *and* intimate—capturing camel caravans and fishing fleets and rice paddies and city traffic set against broader vistas of dunes and seas and forests. The advent of the remotely piloted drone

George Steinmetz flies over the walled city of Shibam, in a photograph taken with a camera attached to his paraglider wing. Shibam, Yemen.

has extended his range and enabled him to refine his vantage point. Both George and I hope that the drone's ubiquity doesn't diminish what imagery captured this way can reveal, and the choices and actions it can inspire.

AN ANTHROPOCENE JOURNEY

After leaving college, a year earlier than George, with a degree in biology and a New Englander's love of the sea, I ended up in the South Pacific. By sheer chance, while in New Zealand to attend a science conference, I saw a Crew Wanted sign on the Auckland piers. I ended up first mate on the *Wanderlust*, a largely home-built fifty-five-foot-long sailboat halfway through a round-the-world trip from its home port in San Francisco Bay. On remote island shores, even back then, we found ourselves collecting heaps of plastic flotsam—mostly floats and net fragments and other lost fishing gear. During a stop in Djibouti before we sailed up the Red Sea, I was appalled to spot piles of leopard skins being hawked to French legionnaires. Recognizing the profound poverty of those doing the selling, I began to absorb the complexities that can impede conservation campaigns.

I was propelled into a life of environmental reporting not only by these troubling scenes, but also by experiencing the wonders of the living world, as during a heart-pounding moment when I was alone at the boat's helm late one night halfway across the western Indian Ocean. With everyone else asleep below, and just the stars and rustling sails for company, I was interrupted in my reverie by an explosive *whoosh* just astern—the great exhalation of some unseen whale surfacing for a breath before descending again into the two-mile-deep waters beneath our tiny vessel.

Once back in the "real" world, I dived into full-time journalism, writing on pesticides and the space shuttle and supercomputers and medical frontiers. My first big cover story, on the emerging threat of global warming, was published in 1988 in *Discover* magazine. That was the year the NASA climate scientist James Hansen warned the United States Senate that accumulating emissions of heat-trapping carbon dioxide from smokestacks, tailpipes, and burning forests were already measurably warming the world, with many dangers looming. It was also the year the World Conference on the Changing Atmosphere was held in Toronto, and I closed my cover story with a call to action on cutting greenhouse gases from a speech delivered there by Michael McElroy, a Harvard researcher:

> If we choose to take on this challenge, it appears that we can slow the rate of change substantially, giving us time to develop mechanisms so that the cost to society and the damage to ecosystems can be minimized. We could alternatively close our eyes, hope for the best, and pay the cost when the bill comes due.

There've been similar admonitions from a host of climate campaigners ever since. As a journalist, I experienced the climate challenge at first as a fairly simple pollution story. Invisible emissions surging from smokestacks and tailpipes were having an adverse effect. Pass a law or sign a treaty, and job done. But as the warnings piled up, and emissions continued largely unabated, I began to understand that something much more profound than an environmental problem was afoot.

Late in 1991, writing my first book on global warming, I began to absorb that what had seemed like dozens of discrete stories on burning forests, vanishing species, polluted skies and waters, urban

sprawl, and the like were all facets of one bigger story. That story was the tumultuous coming of age of a species whose potency was outracing its capacity for self-awareness and self-control.

In one chapter, I described the cycles of ice ages and warm spells during the most recent 2.6 million years of Earth's history, including the warm interval of the last 11,700 years, known to earth scientists as the Holocene epoch. It was in this span that the human journey went from dribble to flood, fueled by advances in agriculture, technology, and, most recently, the amazing energy bounty provided by coal and oil. Seeking to close with a flourish, I described the consequences of that surge and offered a bit of informal prognostication:

> Human beings and the rest of the inhabitants of planet Earth may now have to brace for a new, and much more drastic, period of change. Perhaps 2 billion years ago, the fate of the planet was forever altered by living things, as photosynthesis flooded the atmosphere with oxygen. Now, a life form is influencing Earth's fate once again, as the explosive expansion of human populations and industry dumps tens of billions of tons of carbon dioxide and other heat-trapping gases into the air. . . . Perhaps earth scientists of the future will name this new post-Holocene period for its causative element—for us. We are entering an age that might someday be referred to as, say, the Anthrocene. After all, it is a geological age of our own making.

The book came out in 1992, accompanying the first museum exhibition devoted to climate change, at the American Museum of Natural History in New York City. That was also the year the world's nations gathered at the Earth Summit in Rio de Janeiro and adopted the first international climate agreement, the United Nations Framework Convention on Climate Change.

Nearly three decades later, I don't recall much about my writing process for that book, but I do know that when I wrote "earth scientists of the future," I was envisioning some point dozens or hundreds of generations hence, as far-future excavations revealed an archaeological record of today's human growth spurt and its impacts. As it turned out, I was off by dozens of generations and a couple of letters—*p* and *o*.

My offhand prediction came true just eight years later.

At a scientific conference in Mexico in 2000, one of the world's most influential environmental scientists, Paul J. Crutzen, was growing exasperated at a protracted discussion of research on the Holocene epoch. Crutzen had worked on a host of global pollution issues and shared the 1995 Nobel Prize in Chemistry for work identifying how the planet's protective ozone layer was threatened by certain synthetic compounds. He interrupted the debate, fearing the focus on continuity with the past was obscuring the scope of contemporary environmental change. "Stop using the word 'Holocene'!" he protested, according to accounts of other participants. "We're not in the Holocene anymore."

Searching for some term that could describe post-Holocene human domination of the planet's dynamics, Crutzen hesitated, then haltingly offered the word "Anthropocene." Those attending the conference recalled an electrifying sense that this word captured this strange moment in both planetary and human history.

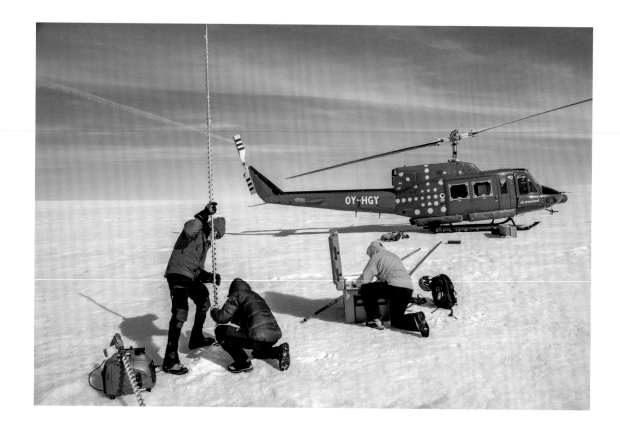

Shortly after that meeting, Crutzen learned that Eugene F. Stoermer, an admired analyst of microscopic diatom fossils, had used the word in the 1980s. The two scientists collaborated on an essay for a newsletter for sustainability-focused scientists. They laid out a scientific rationale for the term and explained why, even though there was no tradition of naming geologic intervals of time for their causative elements, in this case it was justified by the dizzying array of evidence of huge human influences on the planet's flows of energy and materials. They wrote, "It seems to us more than appropriate to emphasize the central role of mankind in geology and ecology by proposing to use the term 'anthropocene' for the current geological epoch."

In the years since, an enormous body of scholarship has emerged around the idea of the Anthropocene, in fields from geology to philosophy. The notion has inspired artwork and music—even a mournful ballad by the Australian rocker Nick Cave titled with my "Anthrocene" alternative.

At the same time, the concept has triggered two sustained and fierce debates. One is technical and turgid, as geologists battle over whether there is adequate evidence yet in sediment and ice sheets to support the proposed addition of a new Anthropocene epoch to the geologic time scale. This chart, hanging on many grade-school classroom walls, subdivides Earth's 4.56-billion-year geologic history into great acts, chapters, and subsections: eons, eras, periods, epochs, and smaller ages.

In 2008, a group of earth scientists published the first careful assessments of the intriguing Crutzen-Stoermer hypothesis. They found a durable human signature in sediment and ice sheets. Tens of bil-

lions of tons of concrete are part of that signature, along with vast amounts of smelted aluminum and more exotic alloys, distinctive spherical particles of fly ash from power plants, radioisotopes from the last atmospheric atomic bomb tests, six billion tons (and counting) of plastic, and much more.

An Anthropocene Working Group was assembled in 2009 to assess evidence and make a recommendation to the world's geologic community on whether it was justified to declare the end of the Holocene and the beginning of a new chapter in geologic history. In recognition of my quirky 1992 prediction, I was invited in 2010 to join the group as one of several nonscientist members, and served through a remarkable meeting in Oslo in 2016. A vote afterward showed a strong consensus on the validity of the Anthropocene epoch and on the mid-twentieth century as the clearest point at which the Holocene epoch ended and Earth's "age of humans" began.

The conclusions of the working group are merely recommendations to higher geologic authorities, however. Several votes are still pending that would involve a wider array of geologists, among whom there is intense division—and firm belief on either side. I don't anticipate a formal Anthropocene will be agreed on anytime soon.

The second debate set off by the concept of the Anthropocene is a nonscientific one—and, I would propose, a more important one. In its informal, lower-case usage, "anthropocene" has generated a wide discussion about responsibility and response.

Indeed, many terms besides Anthropocene have been proposed to describe the current chapter in human and planetary history. There's the Plasticene (look around you), the Capitalocene (capitalism is the real culprit), the Manthropocene (offered by those who, with some legitimacy, see mainly a male imprint on the world), and the Misanthropocene (implying we're just not up to the task). Carl Safina, the renowned marine conservationist and author of books on the intelligence and emotions of nonhuman animals, has even offered the Obscene.

I'm fine with the mash of interpretations and alternatives. After twenty years of percolation and debate, "Anthropocene"—whether capitalized or not—has become the closest thing there is to common shorthand for this turbulent, momentous, unpredictable, hopeless, hopeful time, whose duration and scope are still unknown.

There will never be a universally shared interpretation of a word like "Anthropocene," or of the signals emerging from the biogeophysical world, or of what to do about them. As I've proposed before, in essence we are all on different journeys through this consequential juncture in the intertwined histories of human beings and their home planet.

As this book's title proposes, we are at the beginning of something, not the end. This is the *dawn* of the Anthropocene. George's images provide an inspiring and sobering globe-spanning aerial snapshot of where we are right now. The text I've written provides some interpretations and provocations. It will be up to others to assess how things will have played out fifty years from now. Can there be a good Anthropocene? You'll know in fifty years, and we'll all have had a role in that outcome, either through action or the lack of it.

PART 1 OUR DYNAMIC EARTH

IN ITS 4.56 BILLION YEARS OF EXISTENCE, the planet we live on has been forged, battered, frozen, melted, eroded, and forged anew. It has been shaped by forces both external—like the early collision that made the moon when it blasted a portion of Earth's constituents into orbit—and internal—as when countless eruptions and gas releases built atmospheres and climates, both hot and icy.

Less than a billion years into Earth's journey, microbial life exploded as a new force on the planet. In another tick or two of the planetary clock, mats of early photosynthesizing organisms called cyanobacteria upended everything, flooding the atmosphere with oxygen. This sparked one of Earth's earliest-known mass biological collapses, but that oxygen shift ultimately led to the living lineages producing the myriad plants and animals around us today.

The face of the planet still holds vestiges of many early chapters, from craters formed by meteorite collisions to ancient hulks of 1.7-billion-year-old rock that rise like the rusting superstructures of time-worn battleships from South America's seas of forests and savannas.

Landmarks that we take for granted as static geographic or ecological features are newborn on planetary timescales. Their stories are also extraordinarily interconnected, with many of today's hot deserts formed of sand transported by long-vanished rivers. And that sediment is still in motion. Scientists recently found that, over millions of years, iron-rich dust blown west from the vast Sahara Desert acted as fertilizer for the marine organisms that built the white calcium carbonate Bahama Banks on which the islands of that name sit today. When that African dust is flowing west a mile or two high over the Atlantic, it can disrupt hurricanes before they grow to threaten the Caribbean; some of this dust flows on from its sere source to fertilize the humid forests of the Amazon basin thousands of miles away.

Sprawling river deltas that were the foundations on which several civilizations arose are formed by sediment scoured from young mountain ranges like the Himalayas. New York's Long Island is a bulldozed reminder of the great sheet of ice that pushed south across North America about a dozen times in the last million years and most recently retreated a mere 11,700 years ago.

Corals, as a group of organisms, have been around for at least a quarter of a billion years, but today's Great Barrier Reef and oceanic coral atolls, treasured for their biological bounty and beauty, all formed in the last ten thousand years or so—a fact easier to understand when we recall that sea levels rose nearly four hundred feet after the last ice age ended.

The world around us remains a dynamic work in progress. Great geophysical forces—from future asteroid collisions and mega-eruptions to the march of continents—will continue to reshape Earth's face and sheath of life. In a few tens of millions of years, the East African Rift, a source of keystone fossil vestiges of our species' earliest days, will be a sea, and East Africa itself a distinct continent. *Homo sapiens* won't be splitting continents anytime soon. But our species has, in an instant of planetary time, become a potent planet-scale player—at least at the scale of those world-changing mats of cyanobacteria half Earth's lifetime ago.

The difference is that, unlike blue-green algae, we have the capacity, in theory at least, to understand what we're up to. Can we move from comprehension to self-control? For the moment that's an open question.

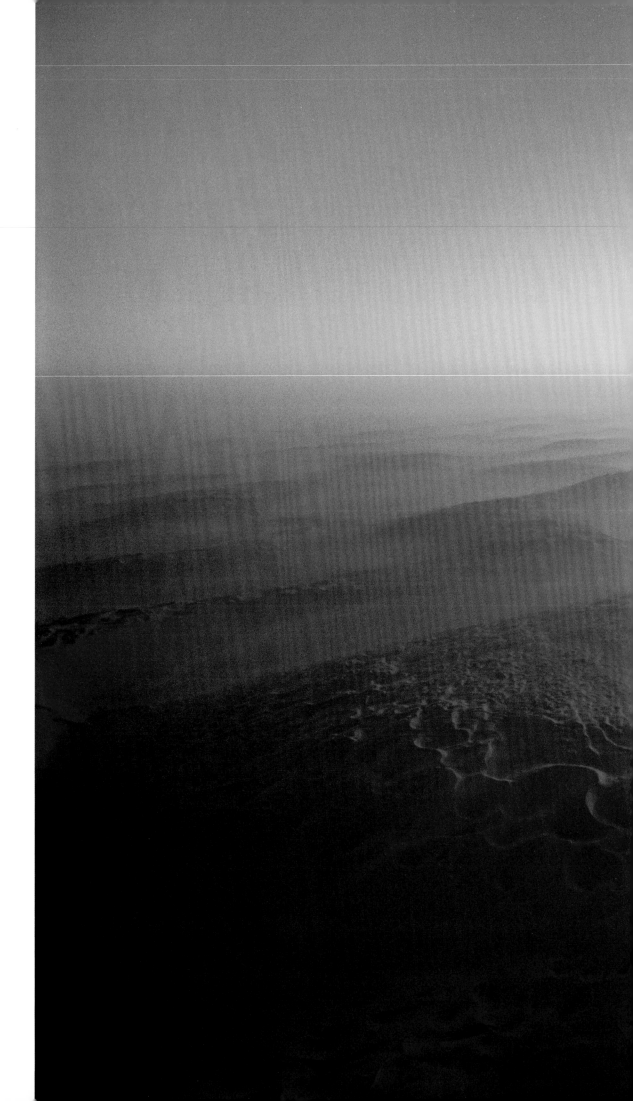

A winter mist spreads at dawn over the vast sandy undulations of the Rub' al-Khali basin, or Empty Quarter, in eastern Saudi Arabia. It would be hard to find another spot on the planet that more starkly superimposes the grandeur of an untamed landscape with the work of humans. Dunes, some rising higher than a forty-story building, dimple the largest sand sea on Earth, with the Saudi portion alone as big as the land surface of Great Britain. But just a few miles from where Steinmetz captured this image from his paraglider, one of the Saudis' biggest oil fields, Shaybah, taps a vast oil deposit nearly a mile below the surface. Both sand and oil formed and accumulated over tens of millions of years. The oil is being burned in a few ticks of geologic time. Shaybah, Saudi Arabia.

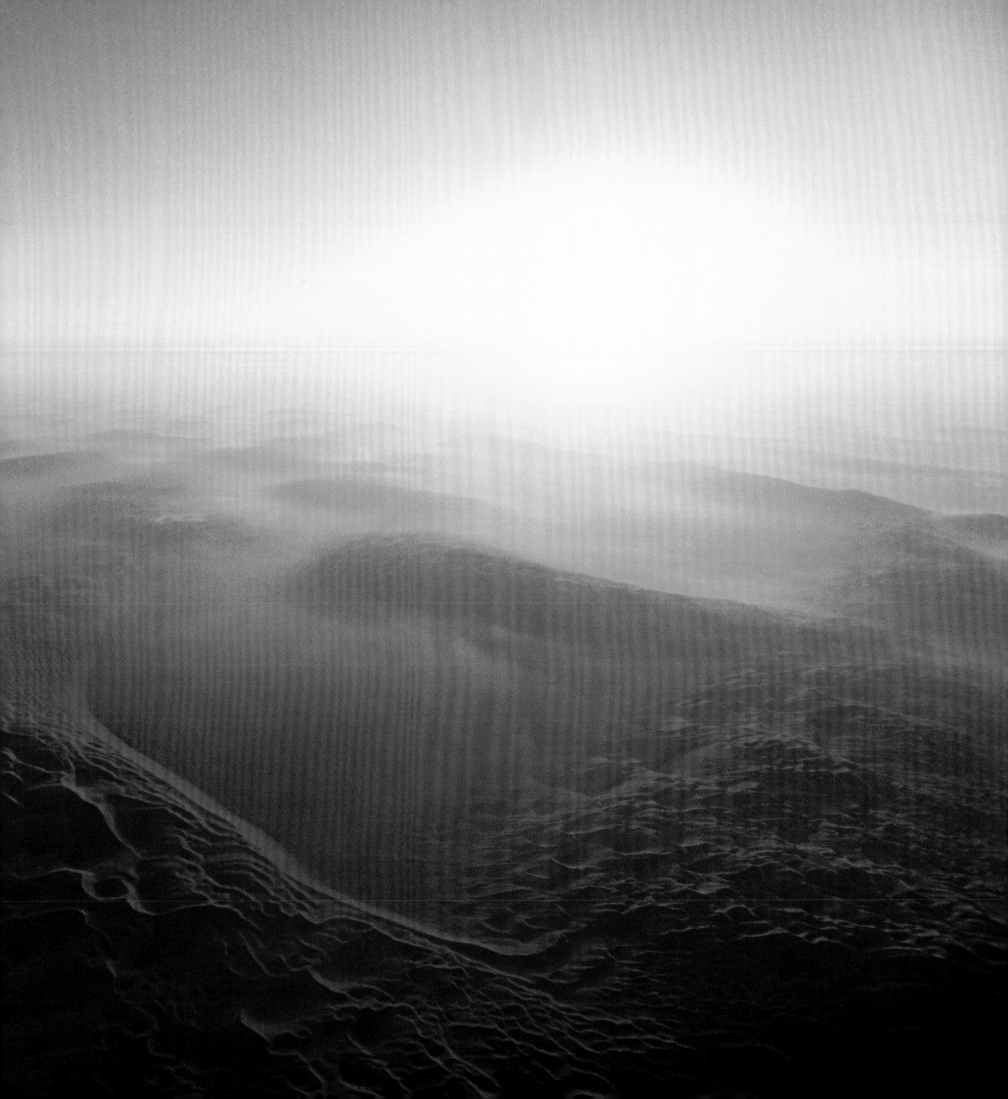

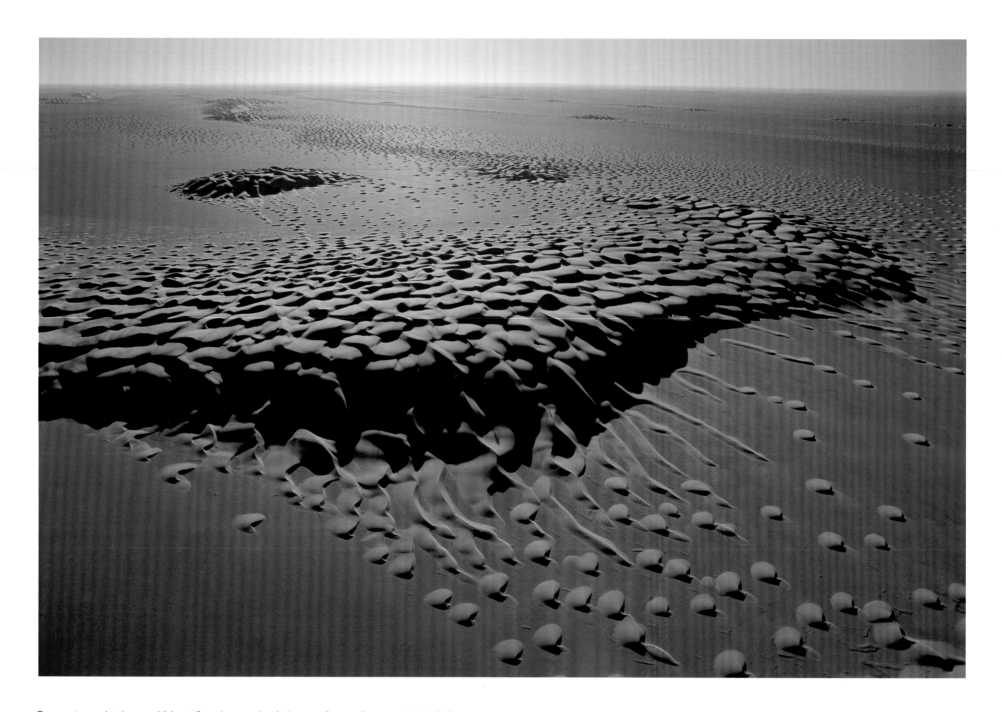

For most people, the word "desert" conjures a simple image of an endless, sandy, rippled landscape. Reality is vastly more variegated. About a third of Earth's land surface, in fact, is defined as desert through the simple calculation of a precipitation deficit. But the biggest portion of that dessicated area has no sand in sight: It's the interior of Antarctica. Only a fifth of the world's desert area is sandy. Even in sandy regions, variations in wind patterns can create an array of astonishingly strange vistas. Here is a small sample, including barchans (crescent-shaped dunes) and star dunes, which form as winds from various directions, over time, pile up mountain-shaped hills of sand—somewhat as if someone is sweeping dust from around a floor into piles.

Particularly strange dot-shaped dunes on the plain of Wādī Ḥazar in Yemen's portion of the Rubʿ al-Khali, or Empty Quarter, on the Arabian Peninsula.

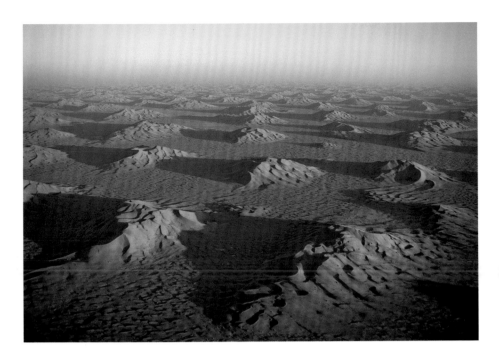

Star dunes in Ramlat Fasad in Oman's portion of the Empty Quarter.

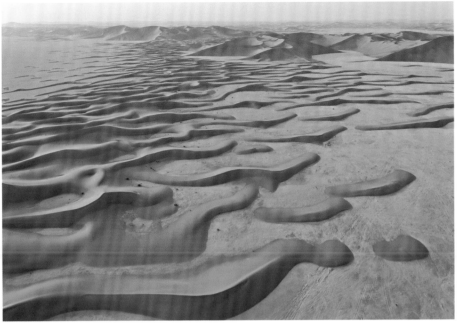

An unusual array of orange dunes spread in east-west formations over the white ancient dry lake bed of Umm az-Zamul. Abu Dhabi, United Arab Emirates.

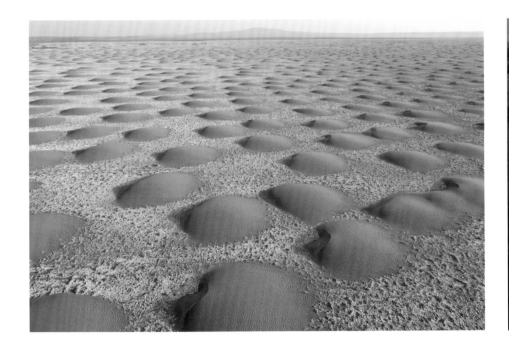

Barchans (crescent-shaped dunes) surrounded by eroded marine sediments and shells left by periodic inundations of the Danakil, or Afar, Depression. Near Lake Afrera, Afar, Ethiopia.

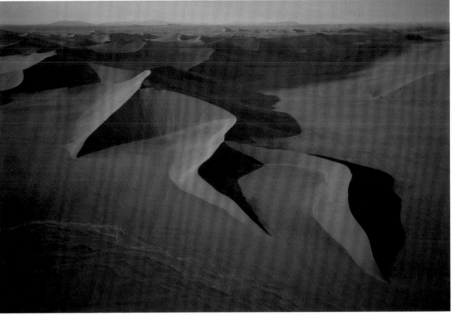

Megadunes—ancient massive sand wedges in what geologists think may be the oldest desert on Earth, the Namib. Namib-Naukluft National Park, Namibia.

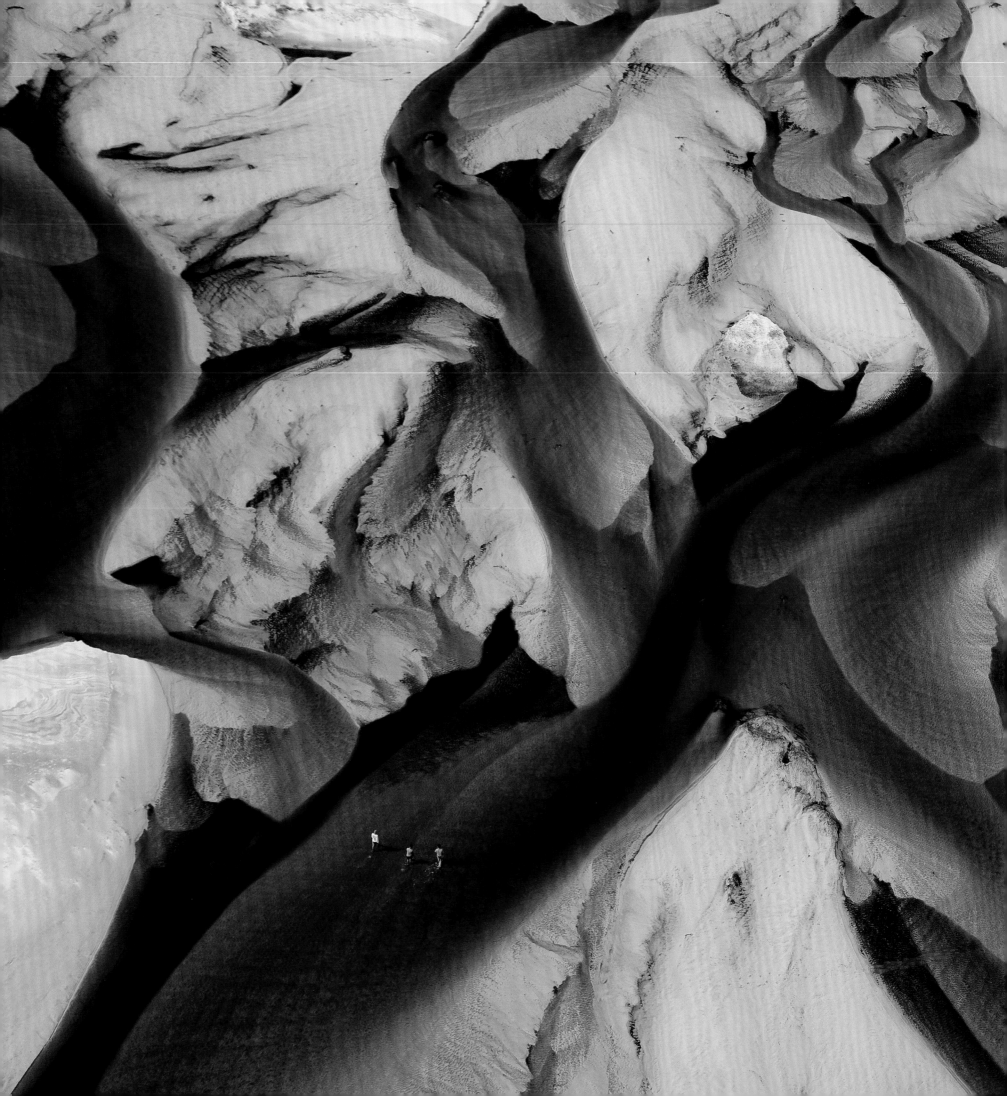

Along the coast of the state of Maranhão in northeastern Brazil, fine-grained quartz sediment carried into the sea by the Parnaíba River and by strong winds off the Atlantic has created a six-hundred-square-mile array of dunes that flood each rainy season, creating a bizarre landscape like no other on Earth. The area is protected as Lençóis Maranhenses National Park, whose literal meaning is "bedsheets of Maranhão State." Here, tannins leached from plants in adjacent forests leave a stain for hikers to explore. Maranhão State, Brazil.

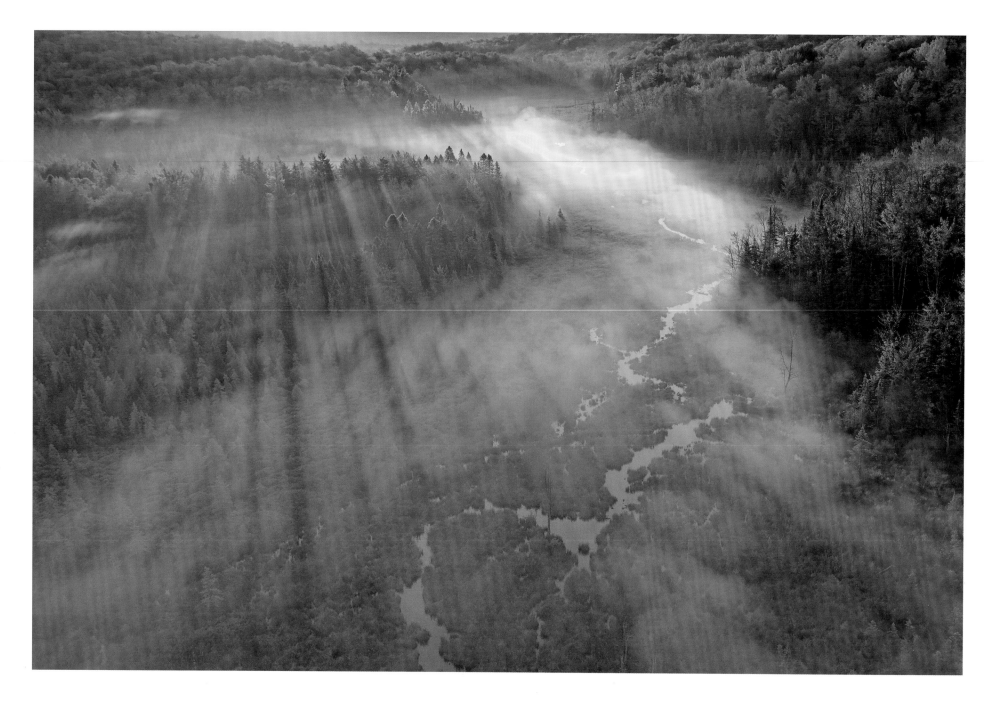

Dawn light cuts through treetops at Beaver Meadows in Green Mountain National Forest in Vermont. Most of the forests in this region were cleared for grazing more than a century ago but have regrown as agriculture shifted west, in a pattern replicated through much of the Northeast in the United States. Lincoln, Vermont, United States.

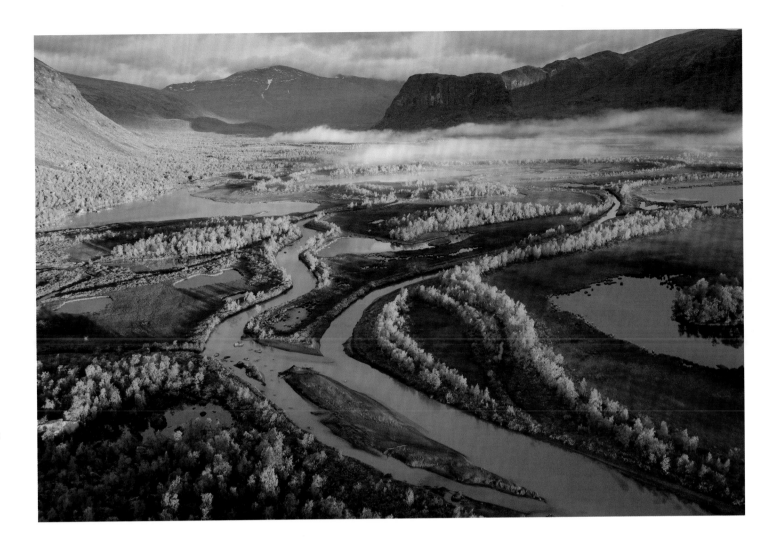

TOP AND BOTTOM:
North of the Arctic Circle, it's rare to find deciduous trees, but many grow in Sarek National Park, in Sweden's Lapland region. Here, in the low Arctic, remarkable variations in color and texture are everywhere. In the delta of the Rapa River, islets cloaked in autumn foliage are surrounded by waters tinted turquoise with "glacier flour"— fine reflective sediment scoured from rocky slopes by ancient ice at the river's distant source. Kvikkjokk, Sweden.

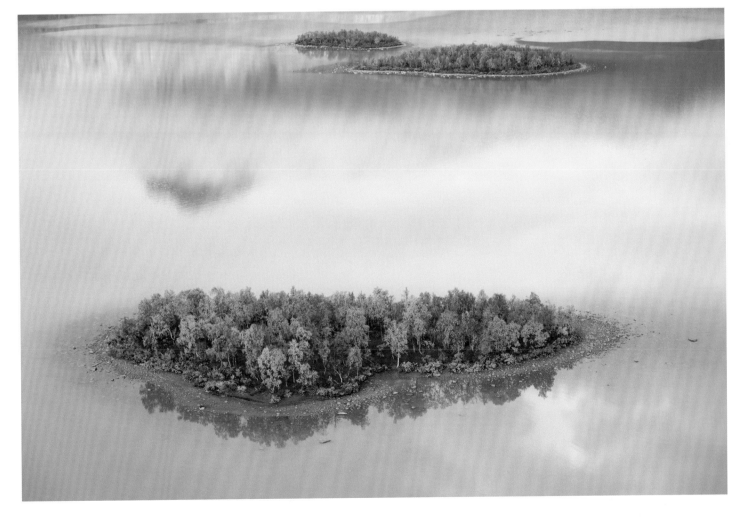

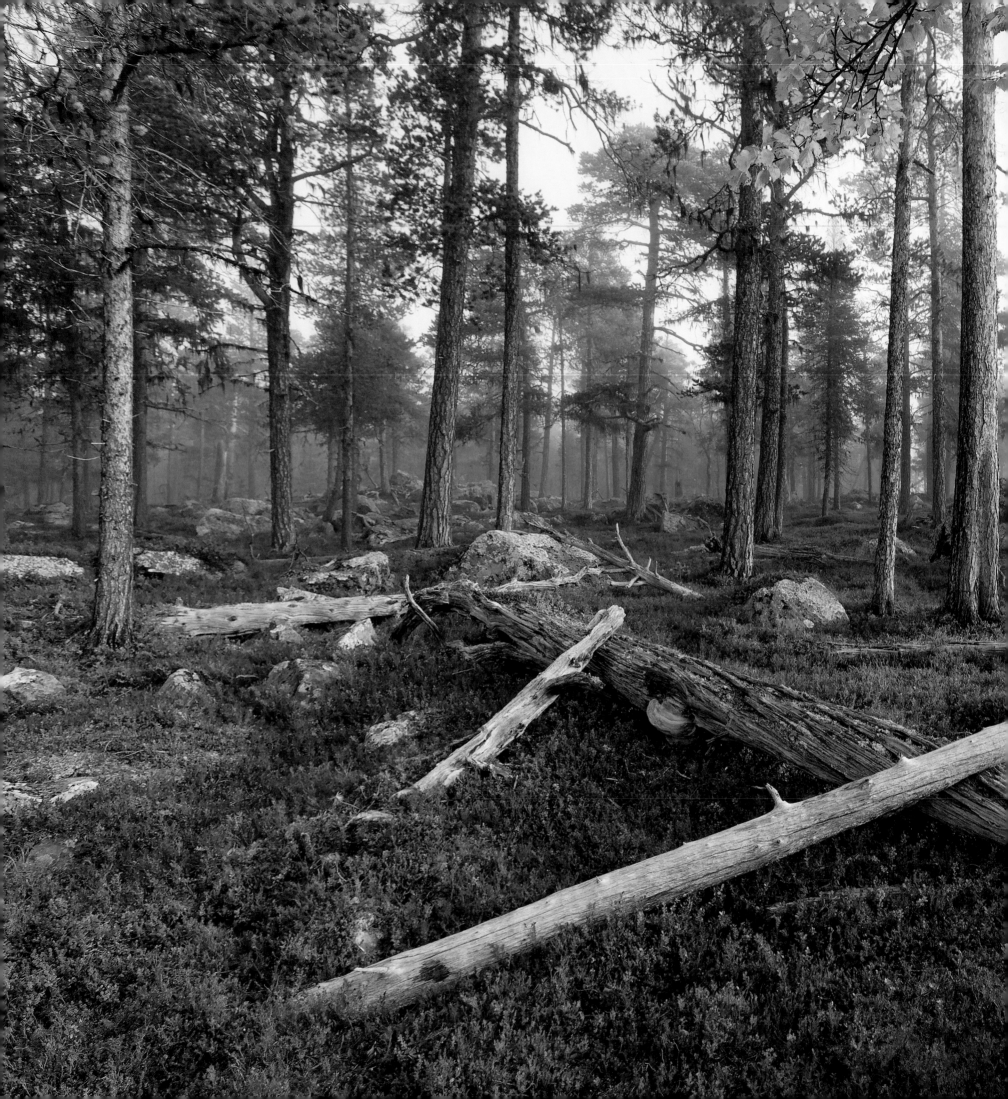

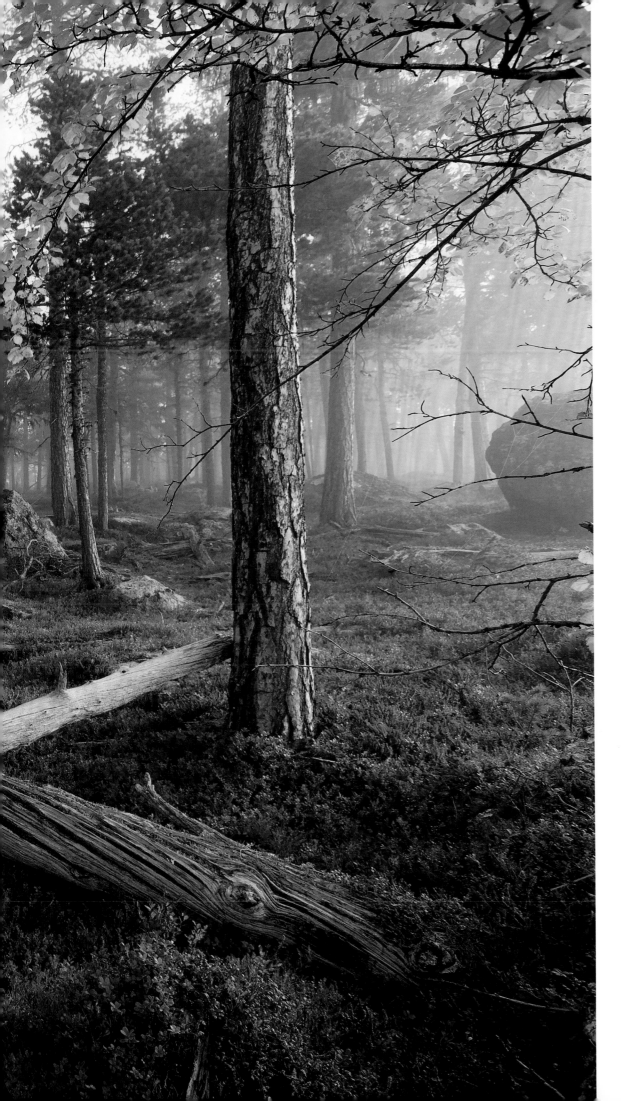

In autumn, an old-growth pine forest in Sweden's Stora Sjöfallet National Park becomes a gold-and-ruby tapestry of berry bushes and foliage on the scattered birches. Here, the standing dead pines are a reflection of antiquity, not ailments, scientists say. This is a rare sight these days. While Sweden is expanding its forests, the area covered in boreal forests more than 150 years old has decreased dramatically after generations of land clearing, charcoal production, and timber harvesting. As an indicator of what's been lost, surveys in various areas have found the volume of dead standing trees, important wildlife and bird habitat, has plunged 90 percent in a century. Stora Sjöfallet National Park, Sweden.

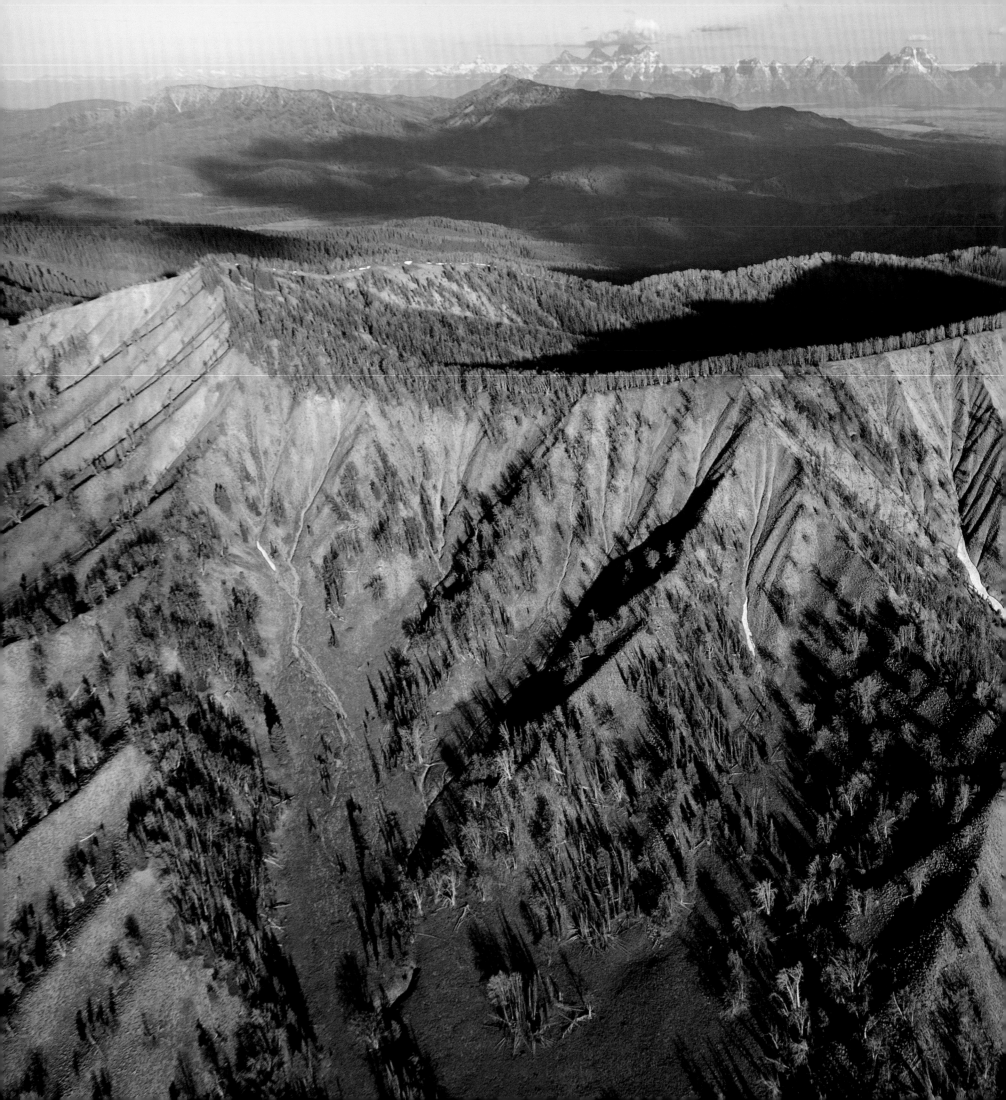

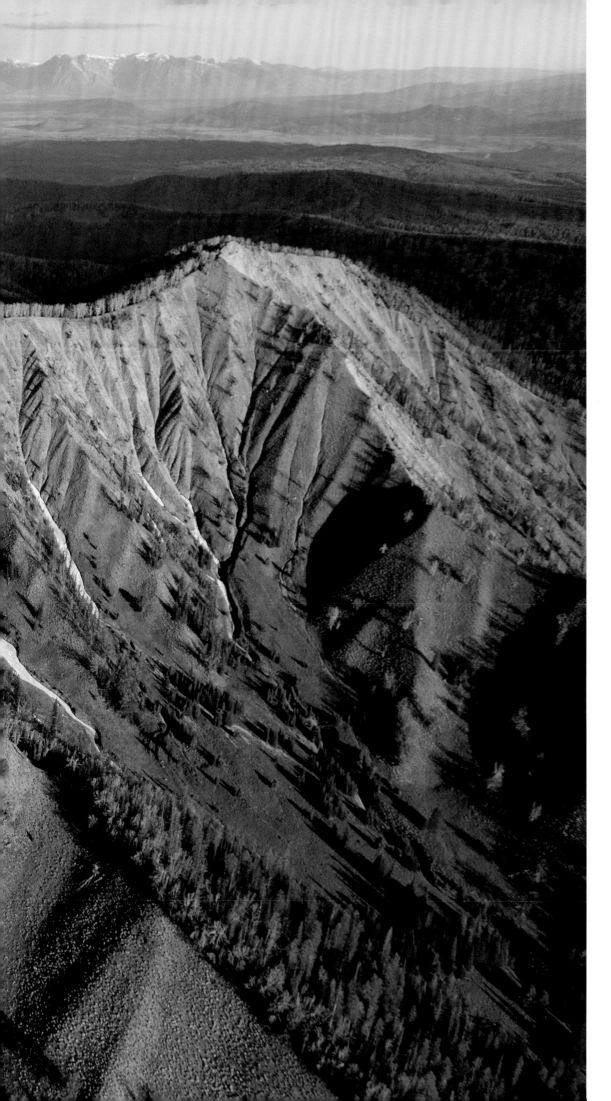

In the Greater Yellowstone Ecosystem, a mix of human influences, from introduced tree diseases to suppression of wildfire to the warming climate, is disrupting food webs and making life difficult for an iconic denizen, the grizzly, or brown, bear. The whitebark pine, seen along the ridge in this image, produces nuts that are the main food sought by bears before hibernation. Periodic outbreaks of native mountain pine beetle have resulted in the loss of about two-thirds of the pines at higher elevations. The reduced severity of winters as a result of climate change has allowed the beetles to breed more frequently.

An introduced fungus has attacked as well, producing white pine blister rust, which slowly damages and can kill infected trees. Meanwhile, long-standing efforts to extinguish wildfires have resulted in fuel loads that produce more intense fires. The US Forest Service has concluded that "climate change exacerbates each of these stressors." Restoration efforts for the pine are critical to the future of this tree species—and to prospects for grizzlies. "If no restoration activities are attempted," a Forest Service release warned, "whitebark pine forests will continue to decline and become a minor, if not missing, component on the high elevation landscapes in western North America." Pinedale, Wyoming, United States.

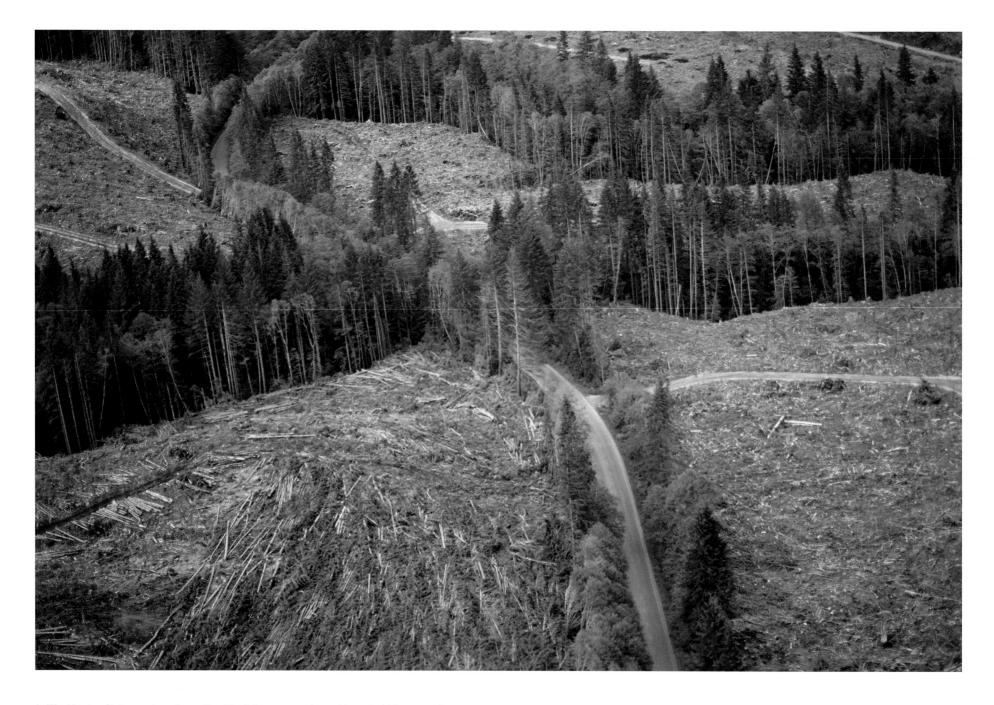

In Washington State, rural roads are lined by thin screens of uncut trees to hide scars where industrial forestry has clear-cut the landscape. The impacts of clear-cutting and replanting on local biodiversity and streams have long been clear. But the impact of such mass deforestation on climate has been debated for many years. Some forest and climate scientists side with industry, saying the replanting (typically three seedlings for each tree cut) and regrowth over time make such practices sustainable. As much, or more, climate-warming carbon dioxide ends up absorbed through photosynthesis as is lost. Indeed, both the European Union and the US government have deemed wood biomass a "renewable" fuel in the context of climate. The issue, a host of other scientists and environmental organizations say, is the decades-long delay in tree regrowth and the lack of a guarantee that such lands will remain permanently forested. Port Angeles, Washington, United States.

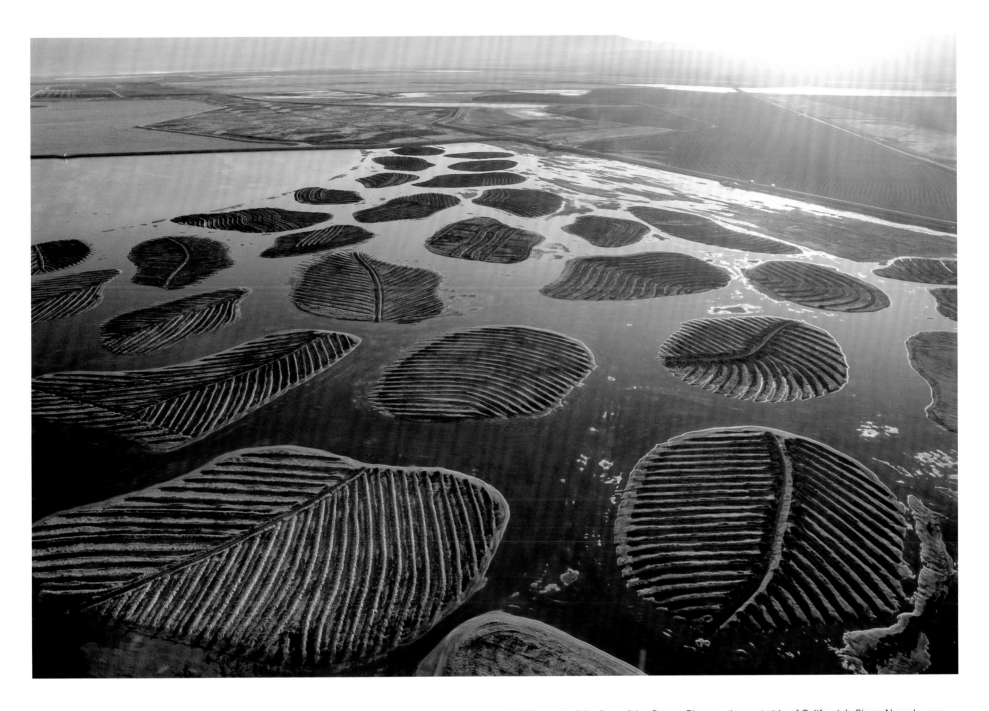

In 1913, much of the flow of the Owens River on the east side of California's Sierra Nevada was diverted into an aqueduct to supply the fast-growing city of Los Angeles on the Pacific coast. By 1926, what had been Owens Lake farther downstream had been transformed into a windswept, toxic dust bowl. Decades of restoration work have rebuilt the lake's biological vigor, but with the hand of humans glaringly on display in manufactured dust-control wetlands that double as bird habitat. In 2018, the lake was designated a "site of international importance" in the Western Hemisphere Shorebird Reserve Network. Near Cartago, California, United States.

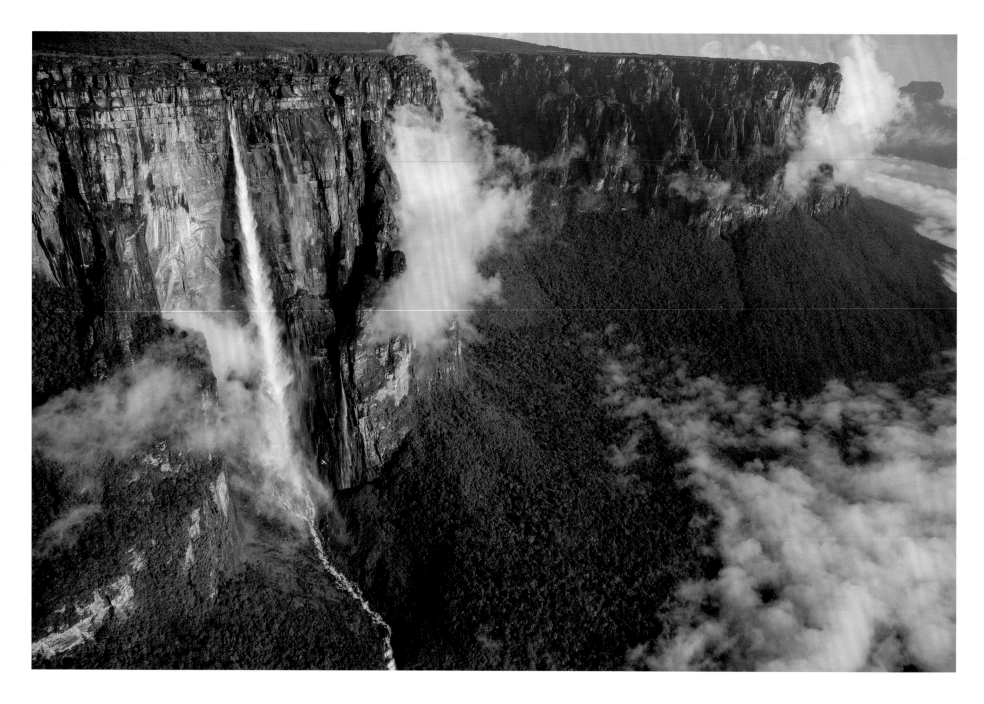

In Venezuela's Canaima National Park, Angel Falls—the highest waterfall in the world—plunges 3,230 feet. Spot the Cessna for scale.

Some places on the planet remain largely outside the direct influence of humans. One extraordinary example is a string of dozens of remote tabletop mountains rising out of the rain forests and savanna of Venezuela, western Guyana, and Brazil. The height and remoteness of these ancient mesas make them islands of unique ecology. Reflecting their grandeur, one local indigenous community's name for these mesas, *tepui*, means "house of the gods." The rock is some of the oldest on Earth—formed 1.5 billion to 1.9 billion years ago. Canaima National Park, Venezuela.

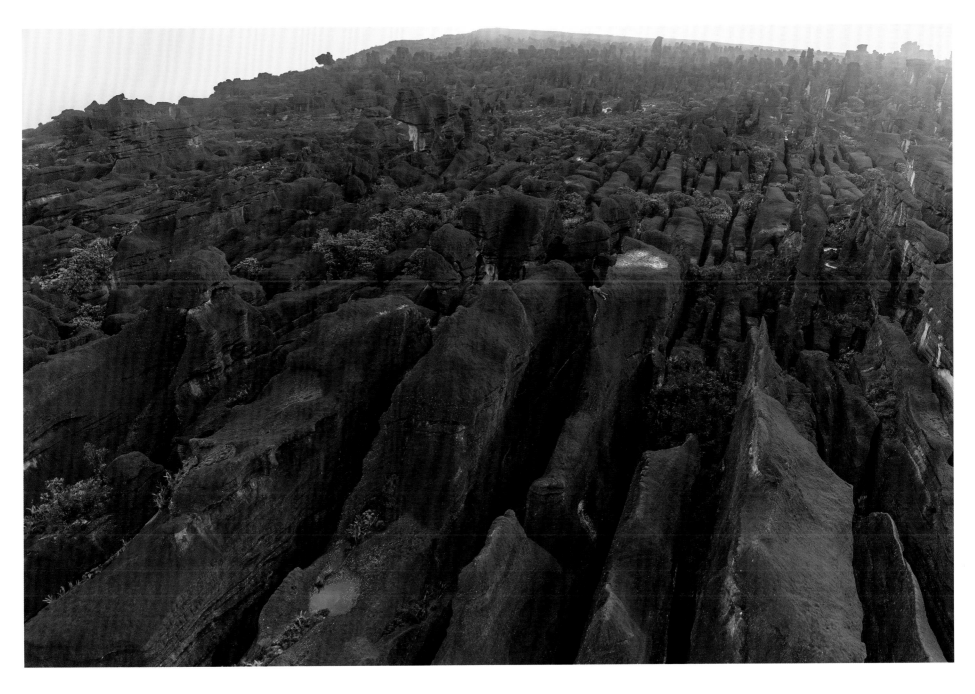

A labyrinth of eroded canyons cuts into the crystallized sandstone top of Mount Roraima, which marks the juncture of Venezuela, Guyana, and Brazil. Canaima National Park.

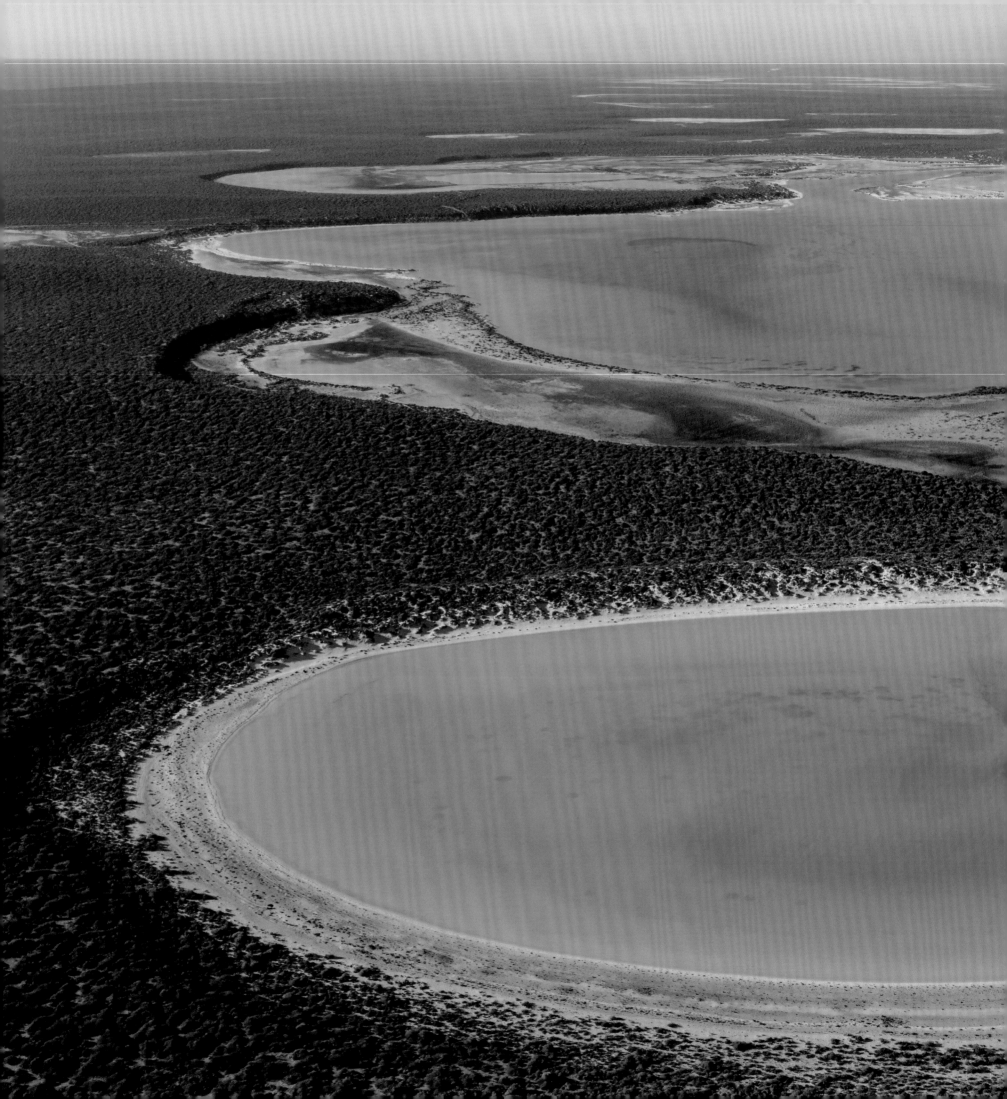

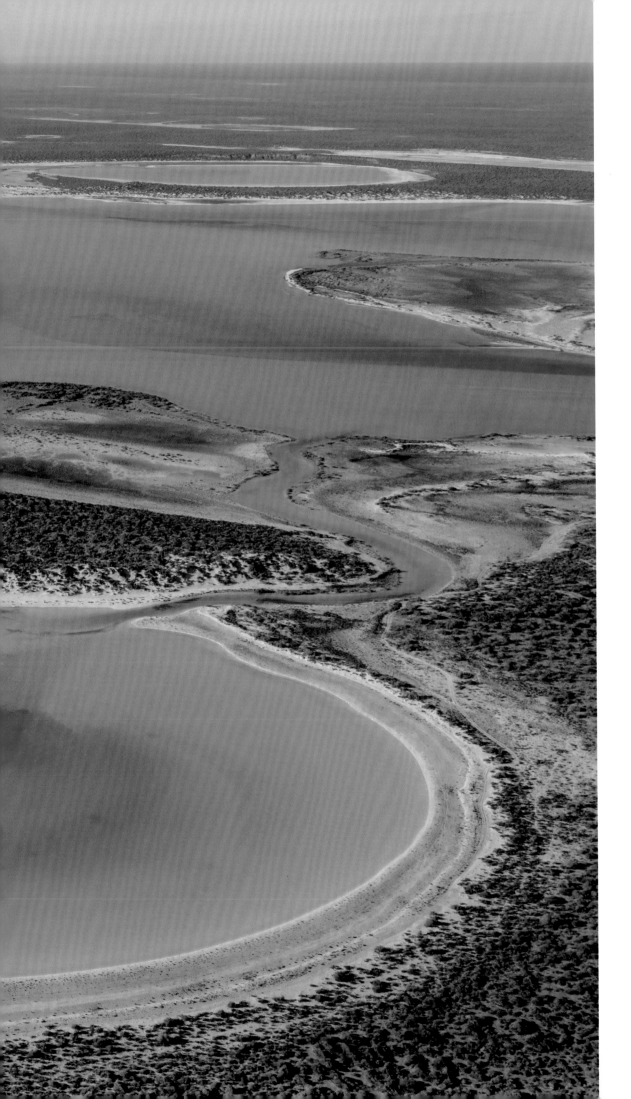

The Big Lagoon area of Shark Bay is a UNESCO World Heritage Site five hundred miles north of Perth on Australia's west coast. The shallow waters are home to some of the world's biggest and most diverse sea grass beds, which in turn are habitat and food for a host of marine species. A committee of government officials and scientists is assessing risks from climate change. One concern is repeats of a 2011 episode of extreme heat and rainfall. The combination of high temperatures and turbidity from runoff after the rains caused a substantial die-off of sea grass. Denham, Western Australia, Australia.

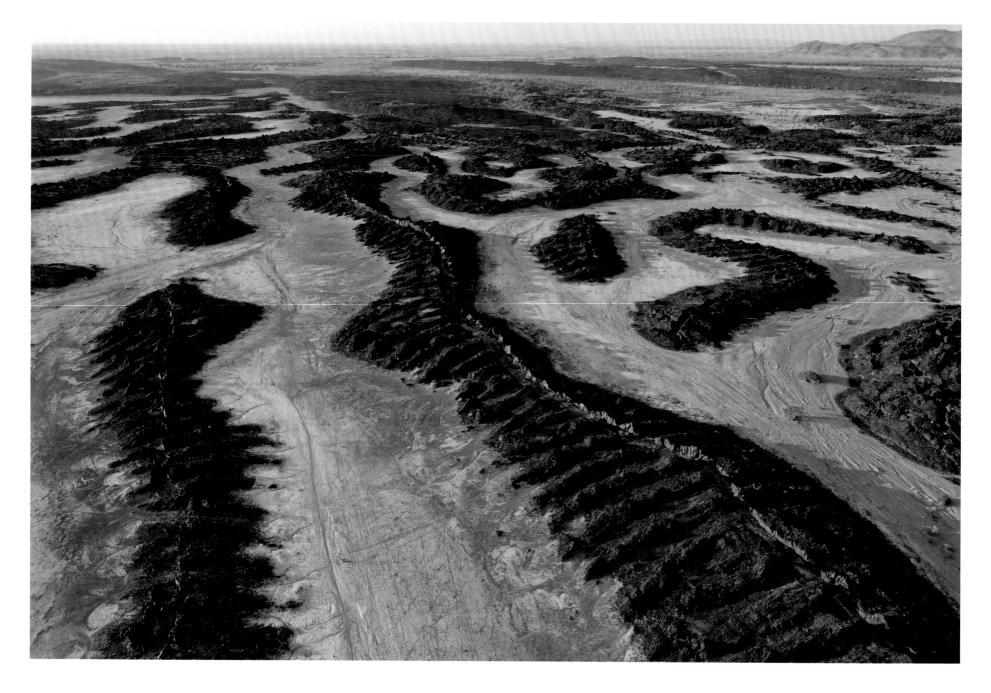

Not far from the Awash River delta in Ethiopia, ancient lava flows create a centipede-like pattern rising above the surrounding white clay, while in the distance green irrigated fields mark the adaptability of humans to just about any environment. The stark landscape is within the Ethiopian portion of the Afar Depression, a low area that will eventually be absorbed into the East African Rift. Some ten million years from now, the entire twenty-five-hundred-mile length of the rift will be flooded by the sea, splitting the Horn of Africa from the continent. Asaita, Afar, Ethiopia.

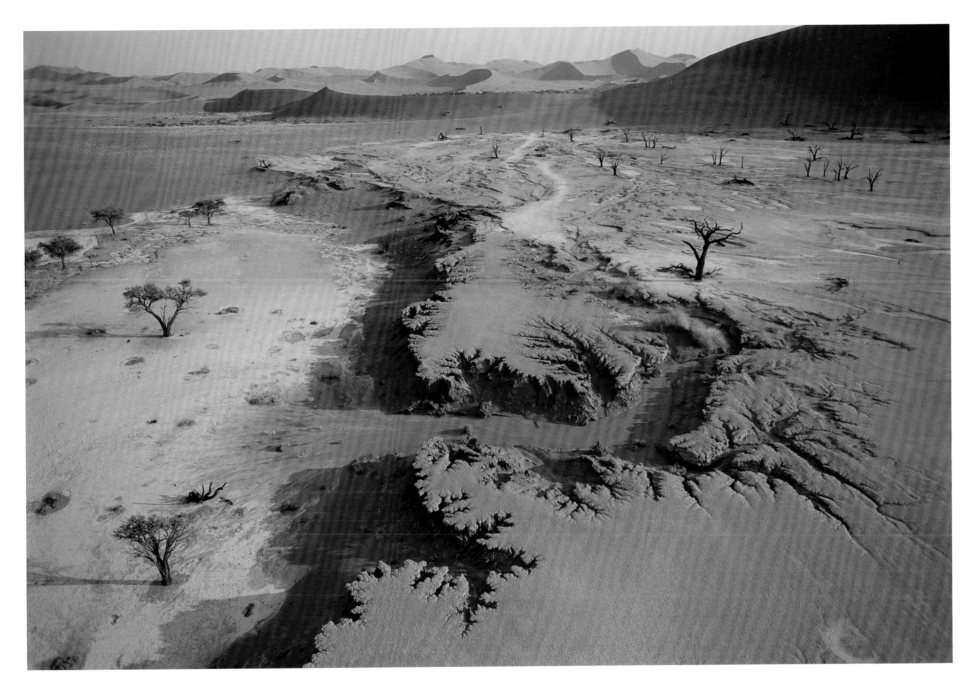

In an otherworldly stretch of desert in Namibia, dead and living trees delineate where massive, slowly moving dunes have caused an ancient lake bed to shift and the water table to drop. Some of the dead trees are six hundred to seven hundred years old, with the dry, sunny conditions inhibiting rot. The Afrikaans name for the area is Dead Vlei—"dead marsh." Namib-Naukluft National Park, Namibia.

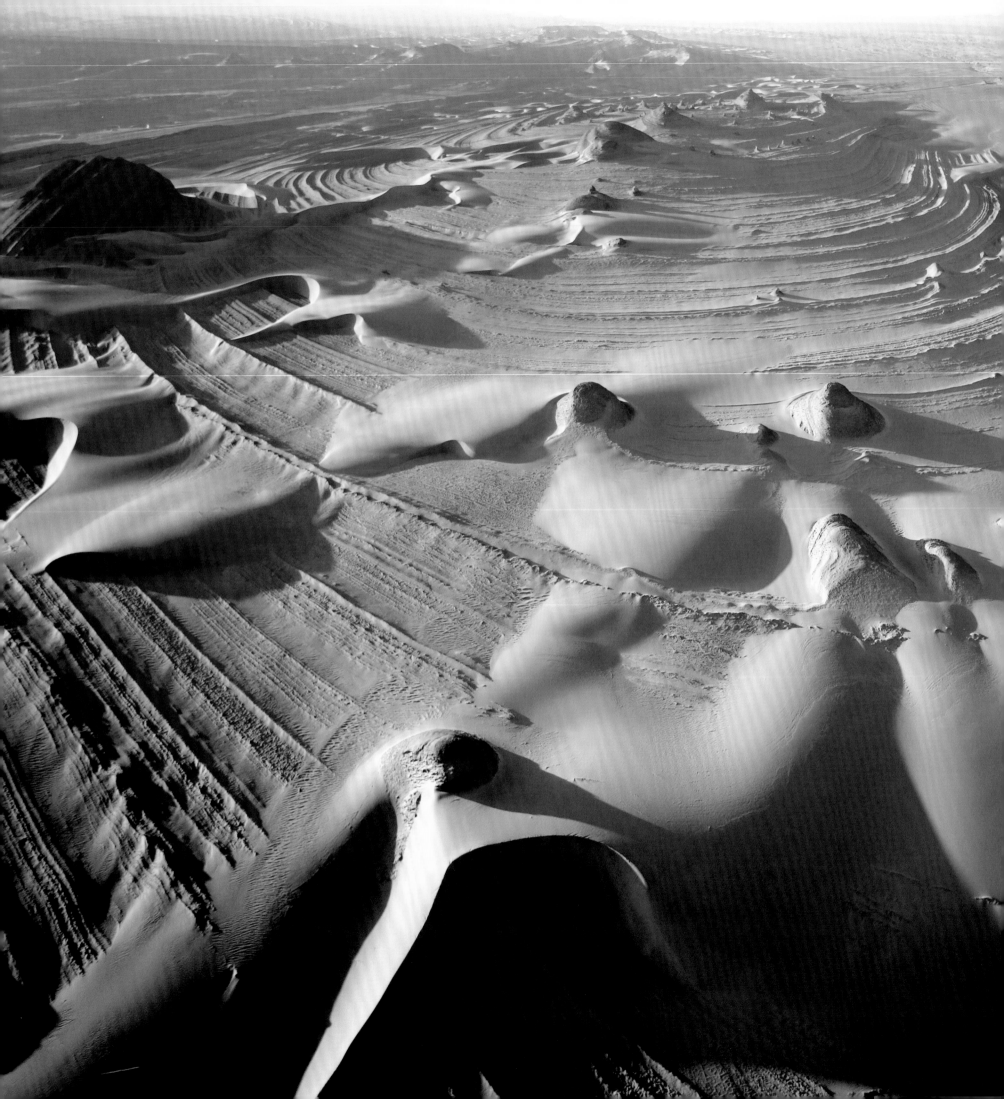

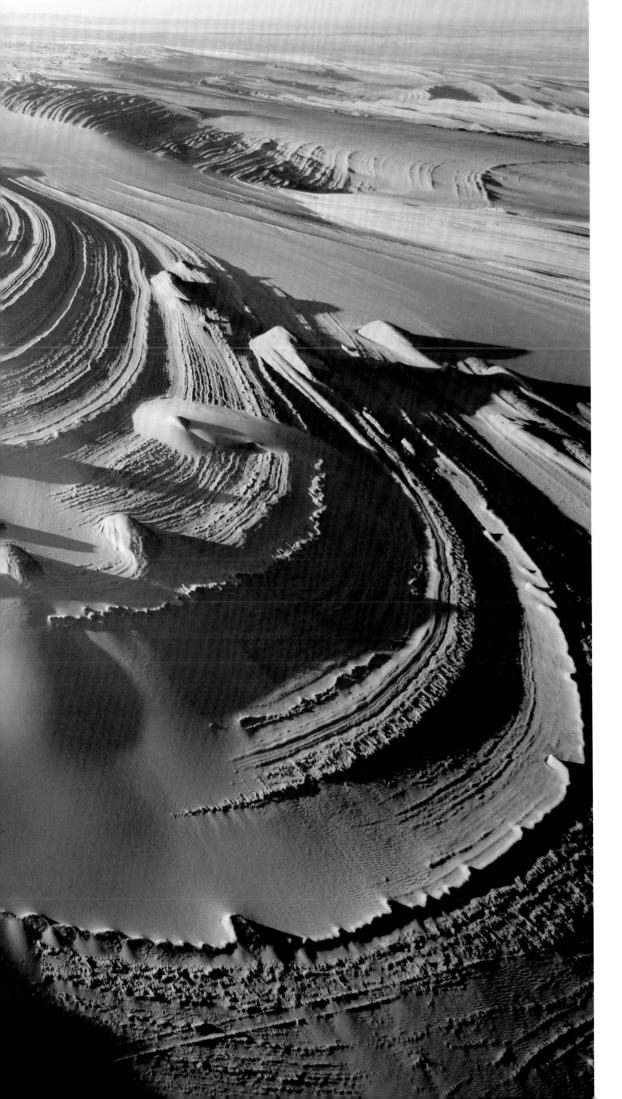

Sand dunes and distorted swirls of wind-eroded rock, called yardangs, create a mix of textures on the western edge of the Qaidam Basin in central China. The region was sparsely populated historically, but rapid development has followed rising demand for oil and minerals. Mangnai, Qinghai Province, China.

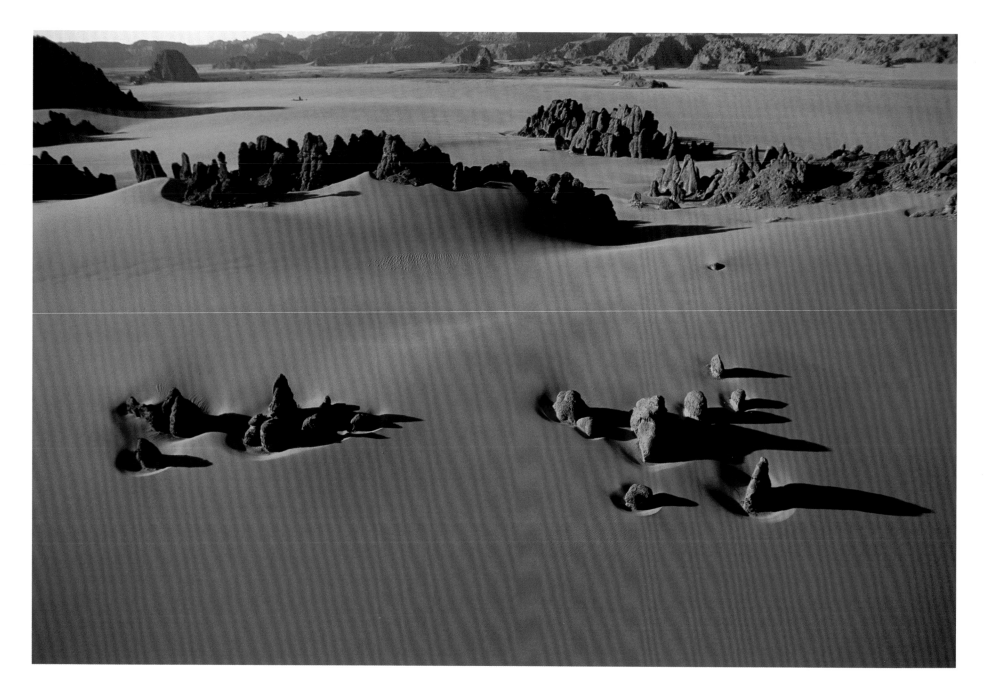

Rock is in a constant state of disintegration and reintegration. In Chad, close to the Libyan border, powerful harmattan winds loft orange sand, abrading the faces of pinnacles of sandstone—which is, of course, compacted sand from earlier eras. The sand of today was formed by the erosion of Nubian sandstone, itself formed from ancient dunes millions of years before. And thus the cycle repeats, in this region out of sight of nearly all humanity save a scattering of goat herders. Karnasai Valley, Chad.

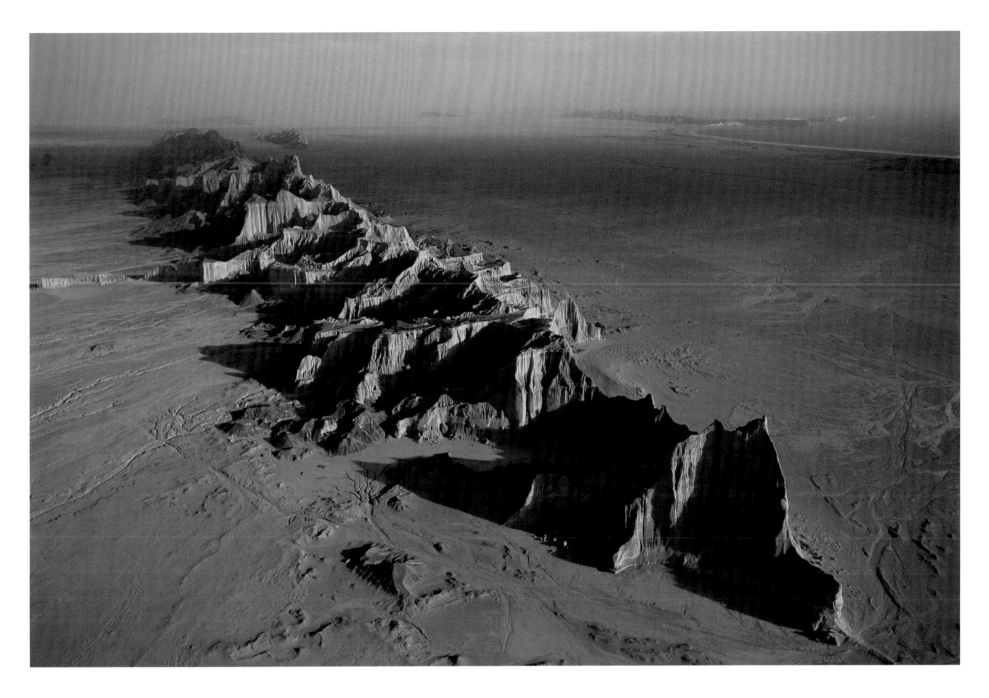

Water is nature's greatest eroding force. On the Iranian coast, stretching along the Gulf of Oman toward Pakistan, a range of sharp, steep-sided peaks of sun-hardened gypsum-rich mud rises like the battlements of some lost civilization. But their seeming strength is illusory. Monsoon rains annually rip at the sediment, giving the formation its sheer forms. Makran Coast, Iran.

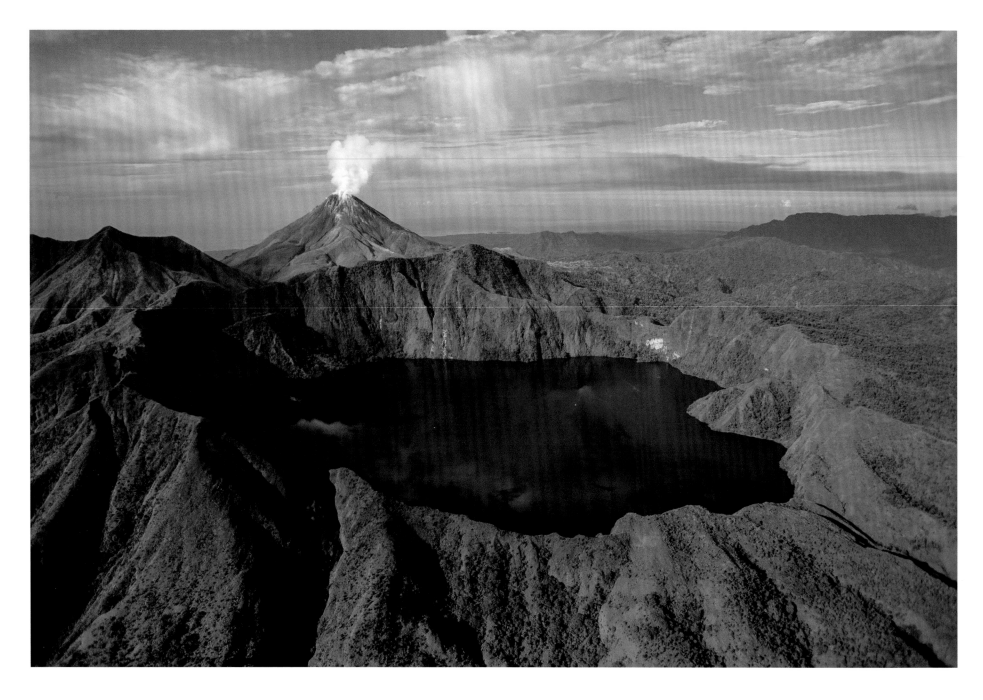

Volcanoes are one of the great forces shaping and reshaping the face and climate of Earth. That dynamism occurs from the tropics to Antarctica. Here, Mount Bagana rises a mile high in the middle of Papua New Guinea's Bougainville Island, with the crater lake of the dormant Billy Mitchell volcano in the foreground. That volcano, named for a US Army general, had two major explosive eruptions in recent geologic history—about 900 and 370 years ago—blanketing half of Bougainville Island with ash and volcanic debris. Bougainville Island, Papua New Guinea.

The southernmost visible active volcano on Earth, Mount Erebus, rises more than 12,400 feet above sea level on Ross Island, just off the coast of the Antarctic Continent. Almost daily, Strombolian eruptions occur, ejecting lava bombs from Erebus's molten lake or nearby vents. Recent science has revealed that there are more than 130 volcanoes hidden beneath the continent's great ice sheets, but little has been known about their level of activity. That changed in 2018, when researchers found evidence of volcanic heat and emissions under the Pine Island Glacier, a vast ice sheet in West Antarctica already at risk from warming seas. In press reports, the researchers described as a "wild card" the potential for that volcano to accelerate the rise in seas from global warming. Ross Island, Antarctica.

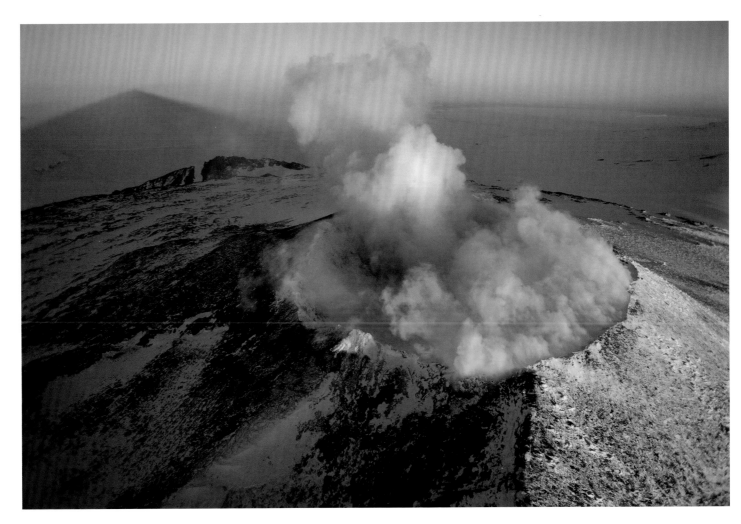

Volcanoes around the world commonly have fumaroles, vents in the slopes from which hot gases flow. But the -22°F air around Erebus produces an added feature—fumarolic ice towers, formed as water vapor flash-freezes, creating an extended chimney. The structures collapse periodically and re-form. West Antarctica.

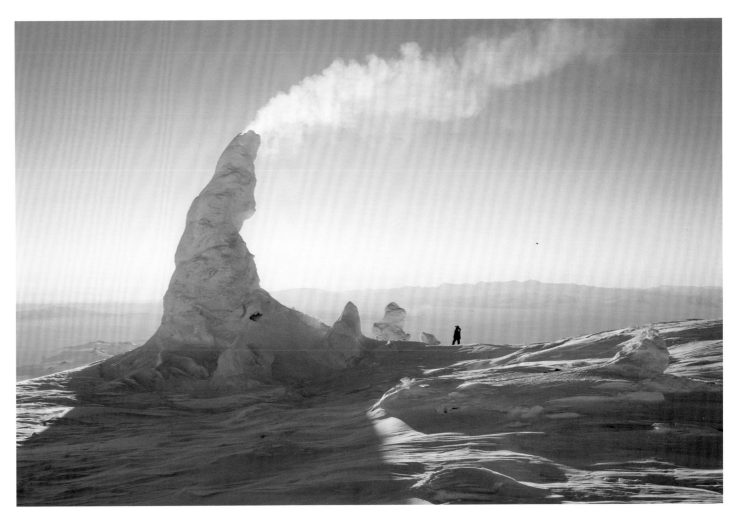

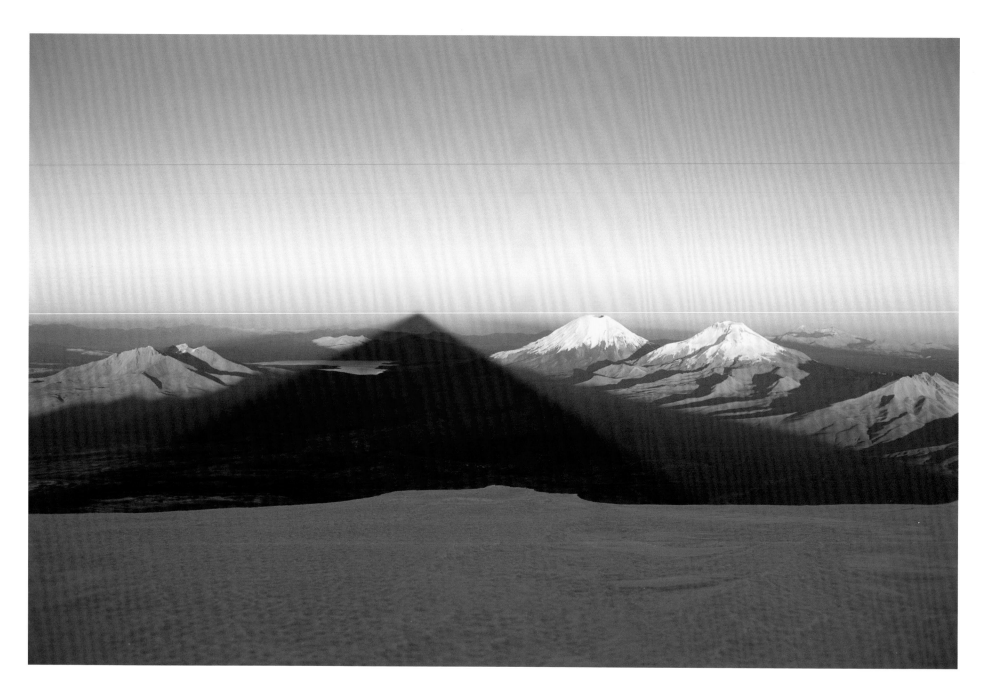

Nevado Sajama, the tallest peak in the Bolivia Andes at 21,463 feet, casts its shadow westward, toward the Pacific Ocean. The two snow-capped volcanoes in this photograph taken in 1997 are Volcán Parinacota (left) and Volcán Pomerape (right). Sajama, Oruro, Bolivia.

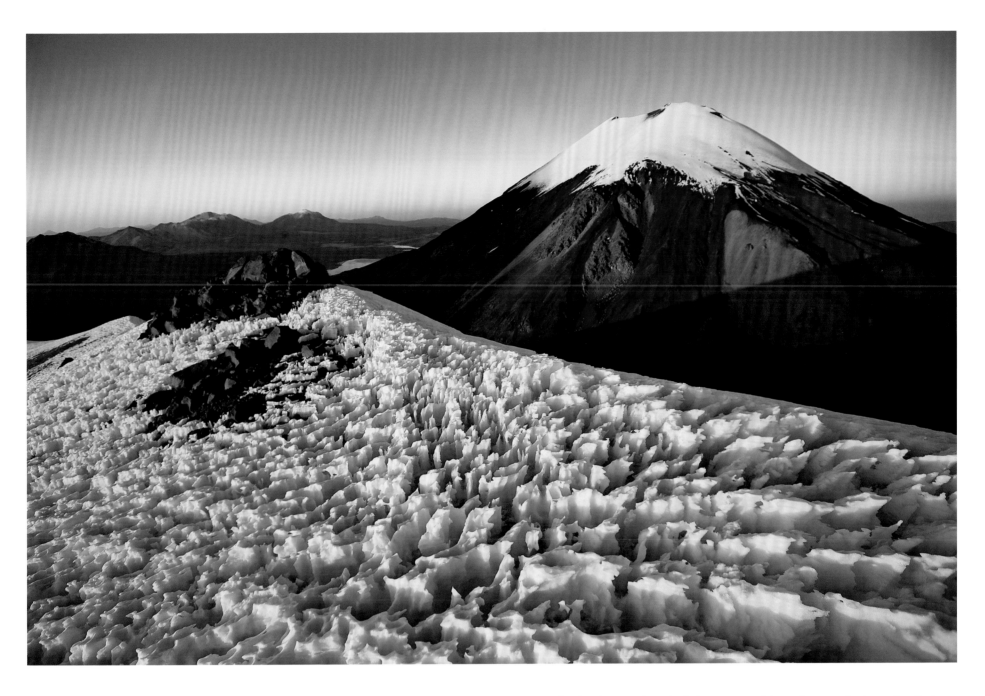

Ten years after the photograph on the facing page was taken, *nieves penitentes*, or "penitent ice," adorns the flanks of Volcán Pomerape, with its visibly diminished snow cap. This unusual ice form, created by a mix of melting and sublimation—direct conversion of ice to water vapor—is mainly found in the high-altitude deserts of the Andes and Himalayas. The name came from observers' impressions that the spiky shapes resemble hands held together in prayer. In a human-heated climate, glaciers on mountains are in retreat almost everywhere around the world. In volcanic regions, the retreat could have novel consequences. A survey of glacier extent over three decades on Pomerape and fifty-eight other South American volcanoes, published in 2019, found widespread shrinkage, and projected that continued retreat in a warming world "will generally increase the explosivity of eruptions." Sajama, Oruro, Bolivia.

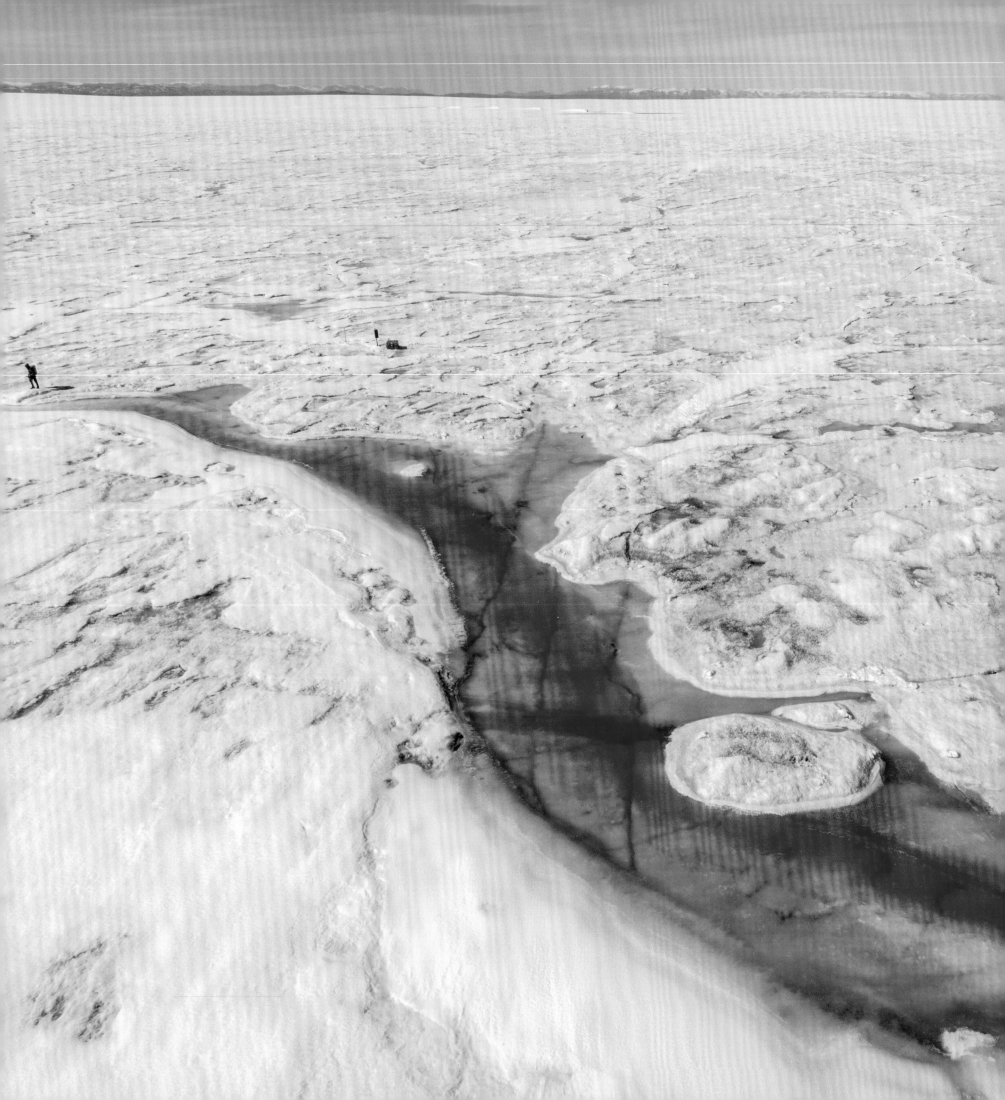

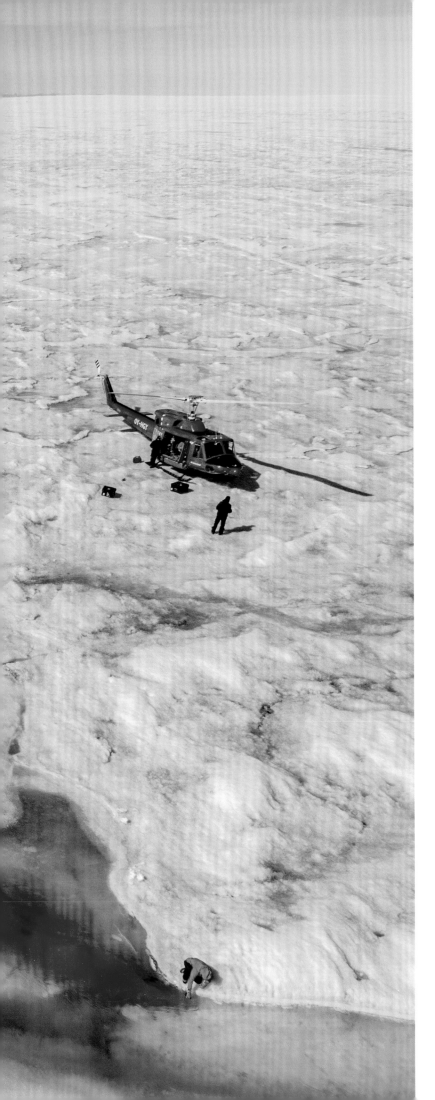

Outside Antarctica, the world's greatest storehouse of ice and potential contributor to rising sea levels is Greenland. And its ice sheets are shrinking, both as the edges collapse into the sea and as the two-mile-high surface melts in summer heat—which researchers estimate is the main driver of ice loss. In 2017, two glaciologists used bright dye to track flows of surface water as it plunges into crevasses and naturally formed drain holes called moulins. In places, this water appears to lubricate the interface between ice and bedrock far below and to increase the rate at which ice slides toward the sea. Near Ilulissat, Greenland.

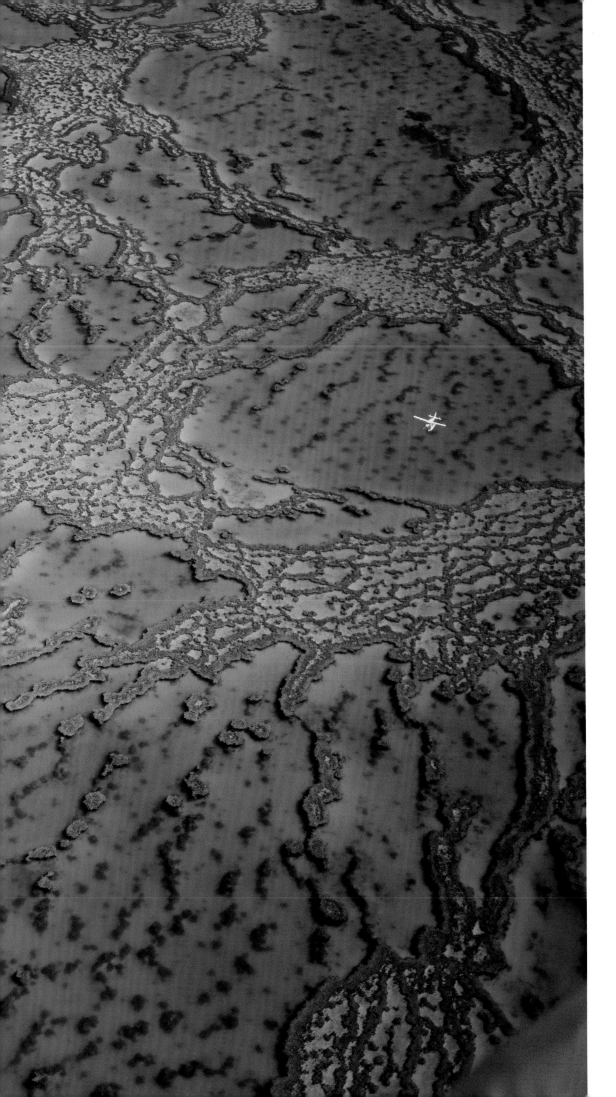

A seaplane flies over one section of Australia's fourteen-hundred-mile-long Great Barrier Reef, one of the planet's most dynamic, productive, beautiful, and imperiled storehouses of biological diversity. The reef was one of the biggest victims of the most extended and far-reaching heat-driven episode of coral bleaching on record, which ended in 2017. By some estimates, half the reef saw widespread coral death. Human-propelled climate change is considered a dominant driver of the hot spells. At the same time, though, scientists have found sources of resilience in heat-tolerant variants of the algae that live in symbiosis with corals. There is also evidence from a 2018 study that the reef was able to withstand several periods of rapid sea-level change and rising flows of choking sediment over the past thirty thousand years. That research, done by drilling in the seabed to find past reef locations, was also sobering. It took hundreds, or even thousands, of years for the reef to recover after the starkest shocks. Queensland, Australia.

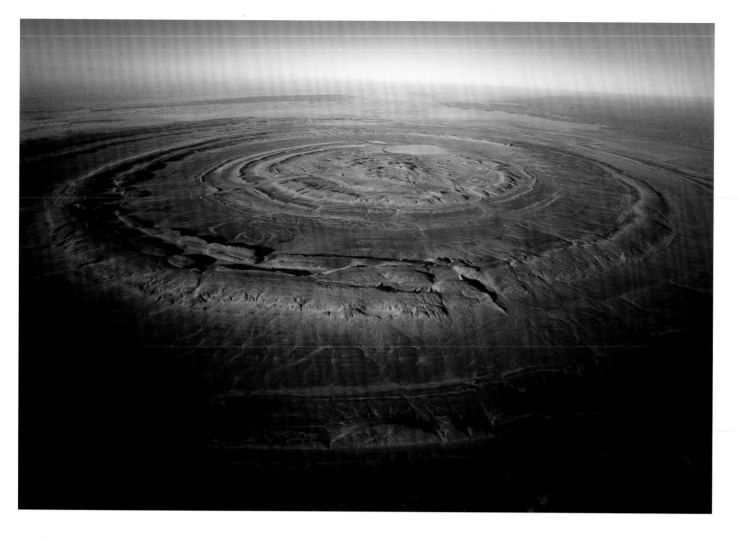

When pondering the explosive rise of humanity's planet-scale influence in recent decades, it's useful to step back and consider this surge in the context of deep Earth time. Cosmic collisions and volcanic spasms are ticks of the planetary clock but leave enduring scars. Will our surge do the same? Here are a few past scars captured from above.

The Guelb er Richât, or Richat Structure, is a familiar landmark to astronauts passing over the Sahara and remains something of an enigma for geologists. Originally thought to be a meteorite impact, it is now known to be a one-hundred-million-year-old volcanic structure that weathered away to its current form. Mauritania.

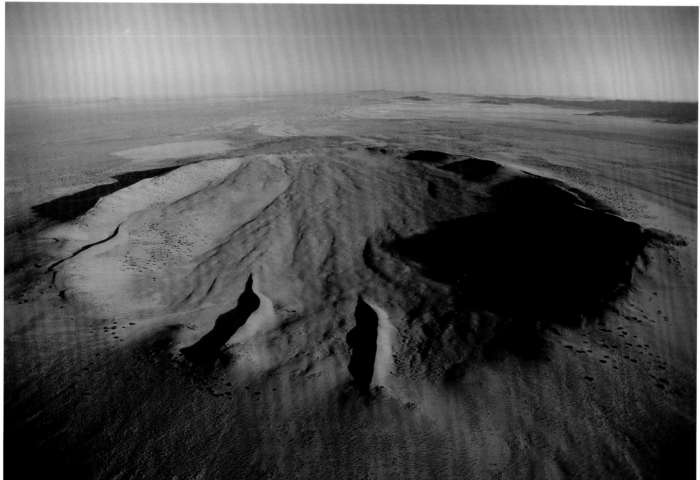

Roter Kamm, a five-million-year-old meteorite crater, is raked by wind and sand in the remote diamond mining area of southwestern Namibia. It is strictly forbidden for anyone to enter the district, and this has left the crater, one and a half miles wide and one thousand feet deep, largely pristine. Sperrgebiet region, Namibia.

Arakaou is the Tuareg name for a sunken volcano on the western edge of the Ténéré desert. It's filled with sand that has blown in through a breach in its eastern wall, with thousands of years of swirling winds producing a four-hundred-foot-tall dune in the center. Niger.

Near Libya's southern border, the vast yellow blanket of golden sand is broken by the ash around the remains of a volcano called Wāw an Nāmūs, the "oasis of mosquitoes" to locals. The inner crater is bordered by several small lakes fed by aquifers beneath. Some of the water is potable, some brackish. Libya.

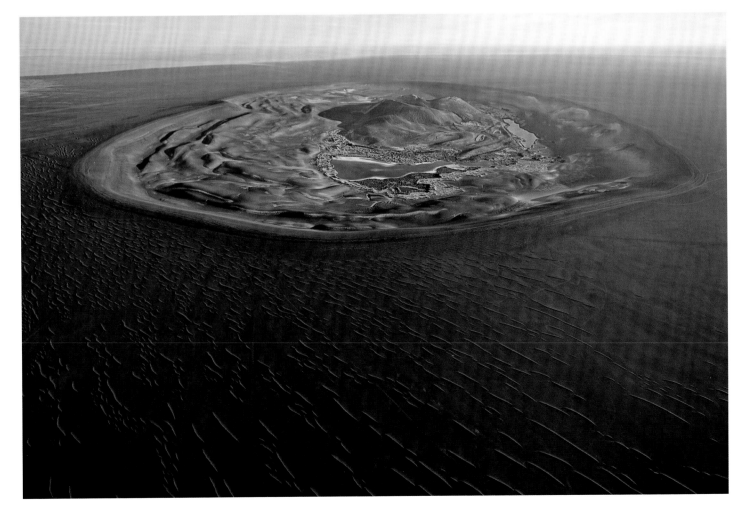

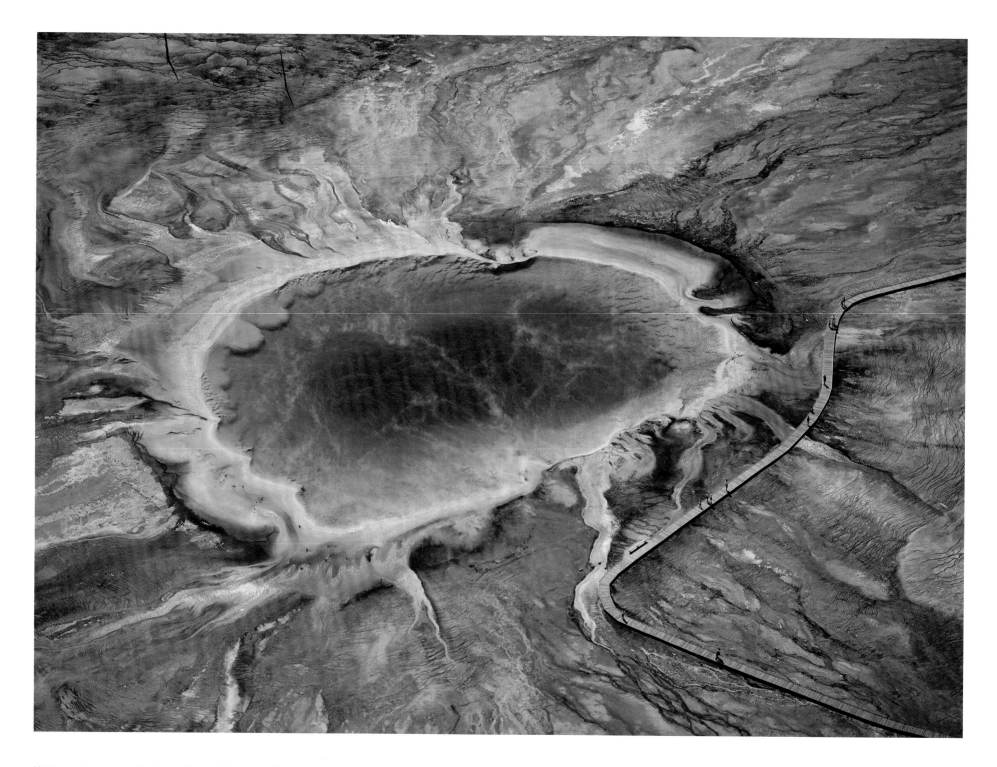

Notions of nature as a fragile entity miss the astounding capacity of living things to thrive in chemical or thermal extremes we mammals would find fatal. In Yellowstone National Park, visitors can follow a boardwalk to the edge of Grand Prismatic Spring, a natural hot spring in which water at around 189°F enters the center of the pool, creating a clear zone with no visible life. The colored bands toward the perimeter denote progressively cooler zones where different species of cyanobacteria and other microbial life thrive best. Wyoming, United States.

The conditions in the Yellowstone spring at left are mild compared to those in Ethiopia's Dallol hot springs, located in a volcanically active region at the north end of the Danakil Depression. The highly saline source springs have a pH of 0 (where 7 is neutral and car battery acid is 1) and temperatures hovering just below the boiling point. Here, the colors are mainly a function of chemical reactions, with sulfur precipitating in white and gray, then turning yellow and orange as it gets more oxidized. But in 2019, researchers studying the pools as a proxy for extreme environments on Mars found a tiny form of bacteria living in the mineral walls of the underground chimneys feeding the pools. (The green is from algae that grow in pools farther from the source.) Ahmed Ela, Ethiopia.

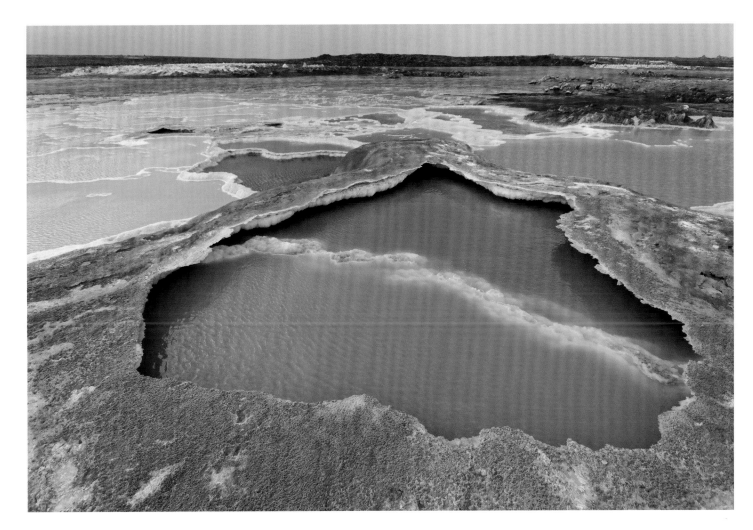

Toward the other end of the pH spectrum is Lake Natron, in the Great Rift Valley on the border between Tanzania and Kenya. Note the shadow of the airplane to absorb the scale. The super-saline water body is classified as a "soda lake" for its high levels of carbonate salts (a group of compounds including baking soda). The alkalinity can approach 12, depending on precipitation in the region—putting the lake water between ammonia and chlorine bleach. Nonetheless, some algae and invertebrates tolerate the conditions, with birds and even some fish living around the periphery. Certain salt-loving algae produce the red color. Lake Natron, Tanzania.

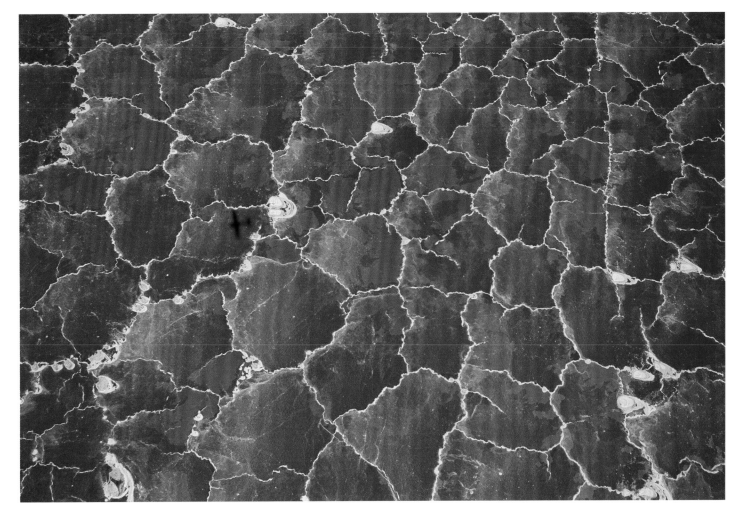

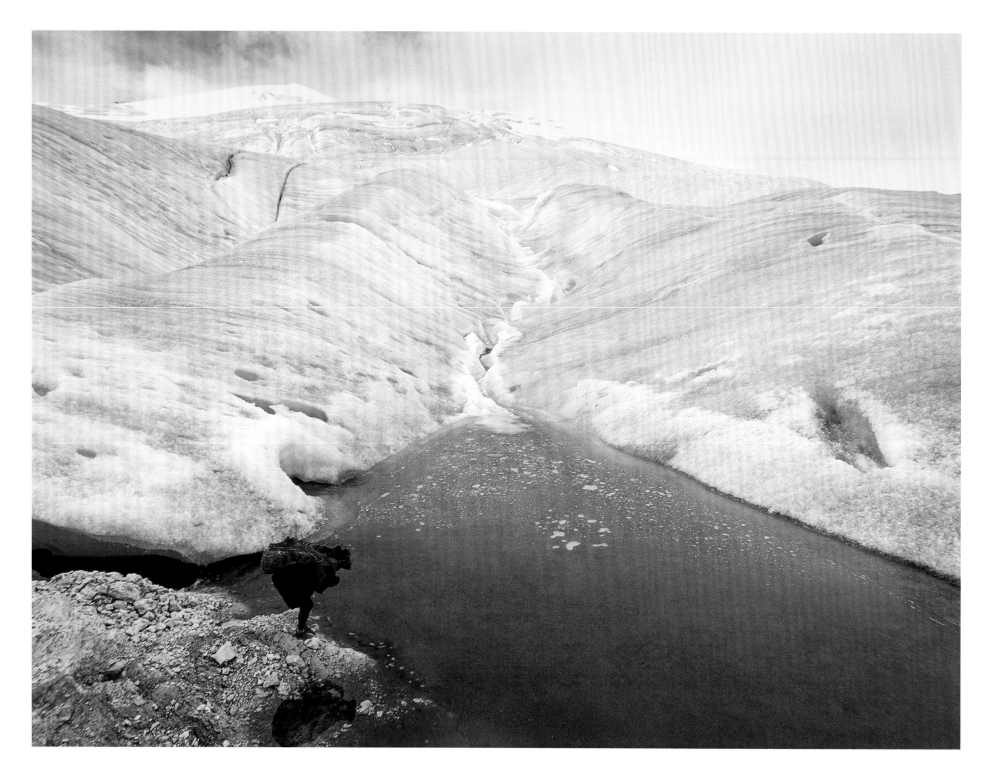

Most of the planet's stores of ice are experiencing dramatic losses in a warming climate, but mountaintop glaciers in the tropics are most at risk. Nearly all are in the Andes. A few are in Africa—on Kilimanjaro and Mount Kenya and in the Ruwenzori Mountains. And for just a little while longer, there's one last icy spot near the equator in Asia—on Indonesia's highest peak, Puncak Jaya, which rises 16,564 feet. Since the 1980s, NASA has tracked a high-speed meltdown. Here, a barefoot porter totes a load for a visiting expedition at one of those last ice fields. Papua, Indonesia.

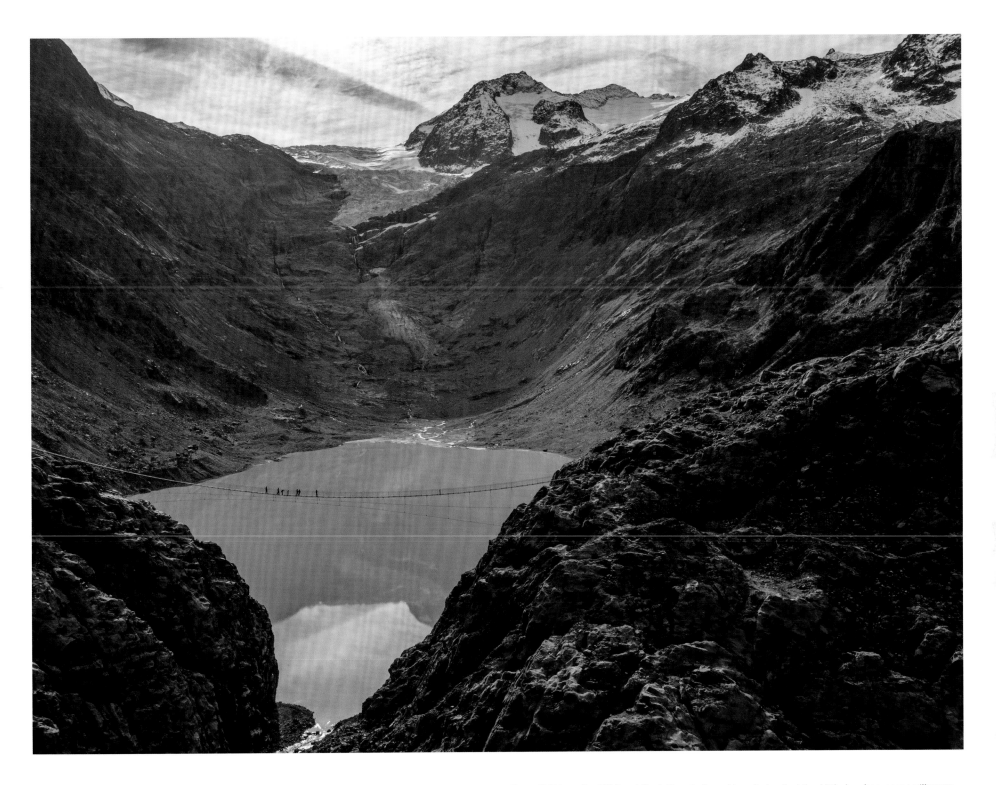

From 1818 into the 1860s, at the tail end of a cold period called the Little Ice Age, some villagers in the Swiss Alps adopted an annual rite of planting crosses at the termini of glaciers advancing toward their communities and praying to slow the ice. Now climate change is rapidly melting alpine ice, transforming landscapes and economies. Just a few decades ago, the Trift Glacier was nearly one hundred feet thick directly beneath where this pedestrian suspension bridge spans an alpine valley. Now the snout of the glacier is barely visible up the slope. Gadmen, Bern Canton, Switzerland.

March rains leave a mirror-like sheet of water across the eastern margin of Salar de Uyuni, the world's largest salt flat, twelve thousand feet up in the Bolivian Andes. The salts accumulated over tens of thousands of years of lake expansion and evaporation through changing climate conditions. The area is a seasonal haven for wildlife, with three pink flamingo species breeding there. But the salts also hold the world's biggest stores of lithium, a metal that is a key component of modern batteries. Bolivia has embarked on an audacious effort to extract the metal as part of a strategy to make the country a leading manufacturer of car batteries. Uyuni, Potosí, Bolivia.

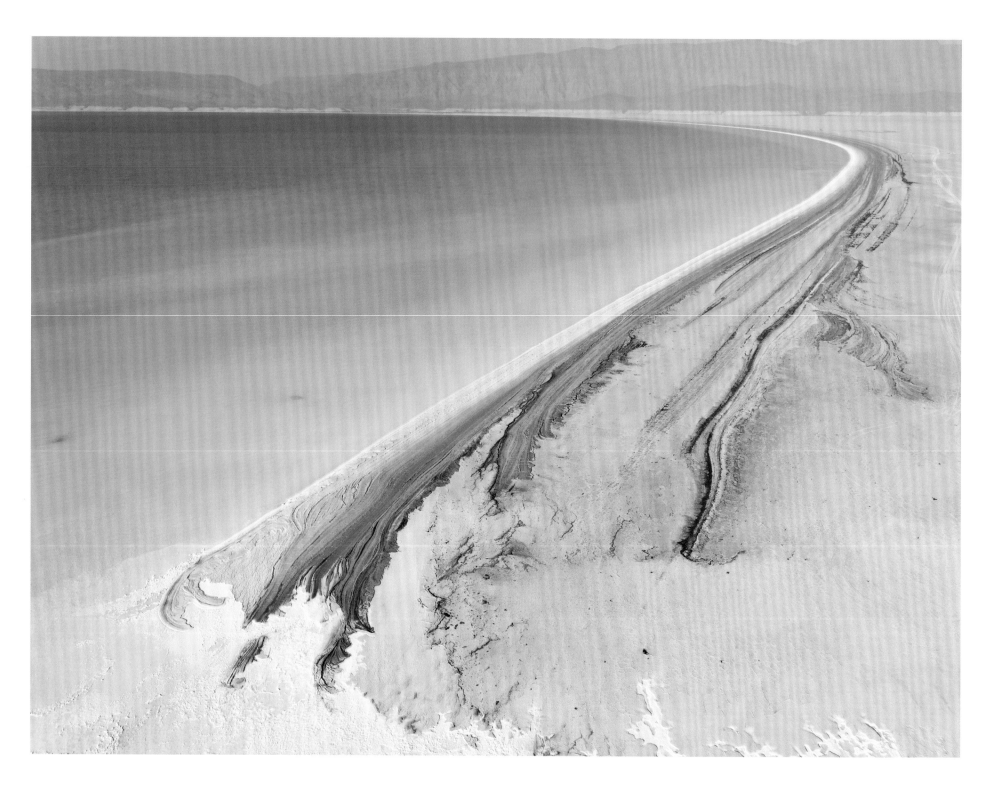

Lake Assal, located five hundred feet below sea level, is the lowest point in Africa. It is separated from the ocean waters of the Gulf of Aden by just a mile or so of barren lands. The lake is raked by strong winds every afternoon as the hot air in the sun-roasted Danakil Depression rises, drawing in cooler air from the sea, and the wind and sun combine to produce rapid evaporation. Salt is collected by local Afari communities and transported to towns by camel. The level of the lake has been dropping, with past lake shorelines visible as variations in sediment and colors as high as two hundred feet above the current shoreline. Djibouti.

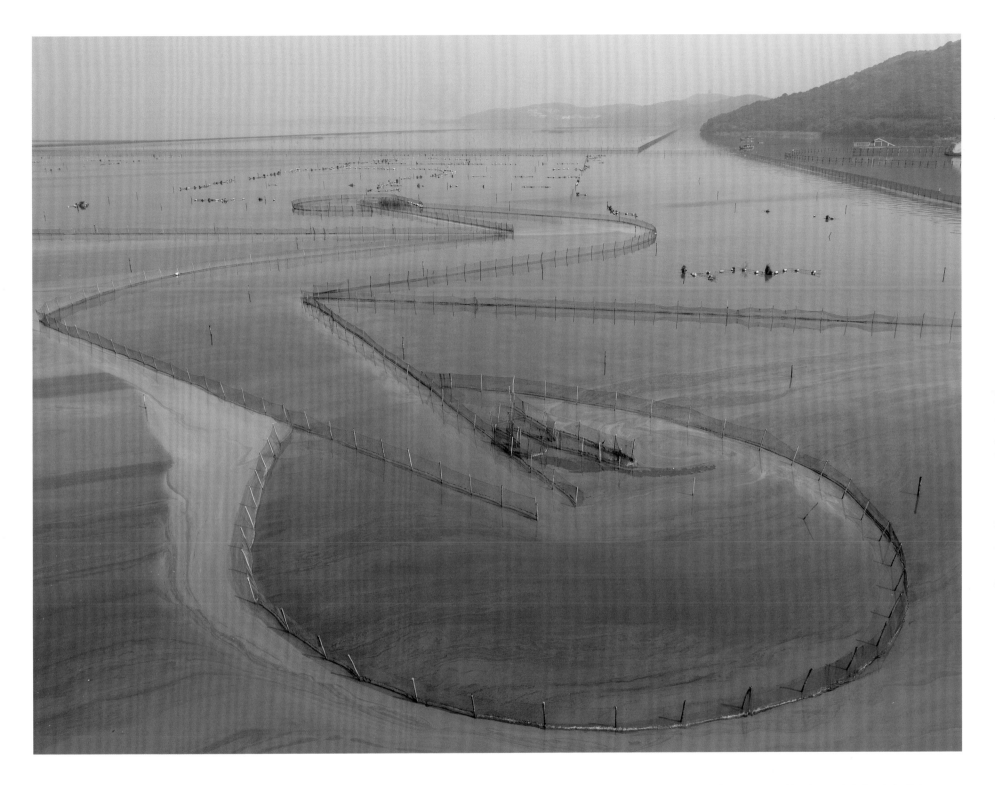

What might appear at first glance to be a verdurous pastoral landscape is in fact Lake Tai, one of the largest bodies of freshwater in China. In high summer, an artist's palette of greens swirls across the lake's surface in ribbons of juniper, moss, and emerald. Thirty years ago, the waters were clear of algae, but the lake is surrounded by high-density cities, including Wuxi, Suzhou, and Changzhou, that have grown rapidly in the past few decades. Rampant sewer dumping and livestock drainage, combined with shifting agricultural practices, allowed the algal blooms to flourish, and now human mismanagement and global warming have entrenched them. This blue-green algae, *Microcystis aeruginosa*, produces toxins that can damage human organs and nerves. It is reported that China's efforts to prevent these toxic algal blooms is meeting with success in some parts of the country, but in northeastern China, where Lake Tai is located, the problem remains endemic. Wuxi, Jiangsu Province, China.

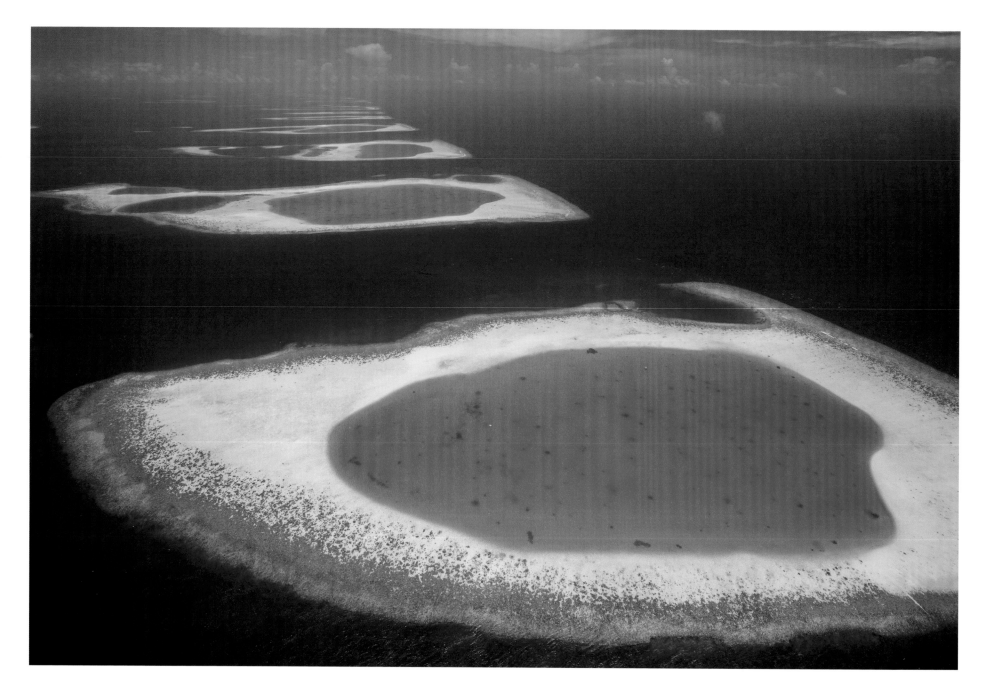

The projected rise in sea levels as climate change plays out in coming decades will have enormous consequences for all coastal communities. But few nations on Earth are as exposed as the Republic of Maldives, in the Indian Ocean. There, 420,000 citizens live on 1,192 low coral islands and islets grouped with innumerable smaller reefs in twenty-six atolls, circular clusters of land surrounding great lagoons. Some geographers have measured a remarkable capacity for many coral islands and reefs of the sort seen in this aerial view to shift and essentially keep up with rising waters. But if sea-level rise is at the higher end of what's projected, the risk of inundation of inhabited areas, particularly in cyclones, could become existential. Ari Atoll, Maldives.

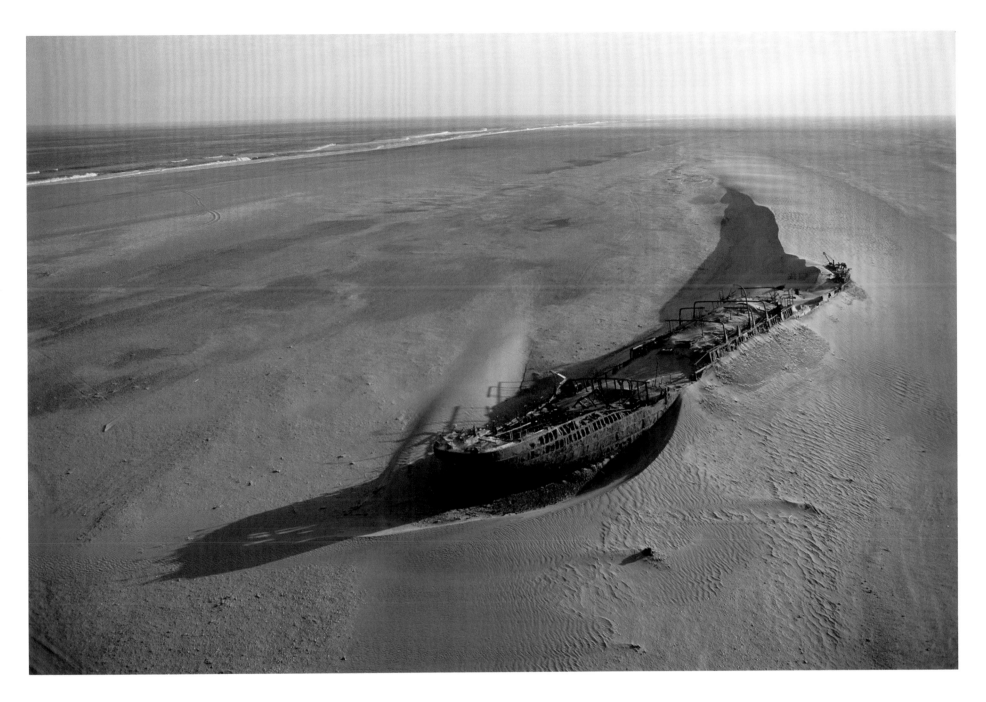

One of the world's most unforgiving shorelines is the 976-mile-long Skeleton Coast of Namibia. This fog-swept, largely unpopulated sandscape is strewn with whale bones and shipwrecks, most visibly the remains of the *Eduard Bohlen*, a cargo vessel that foundered in 1909 and now lies cloaked in windblown sands more than one thousand feet from the waves. Namibia.

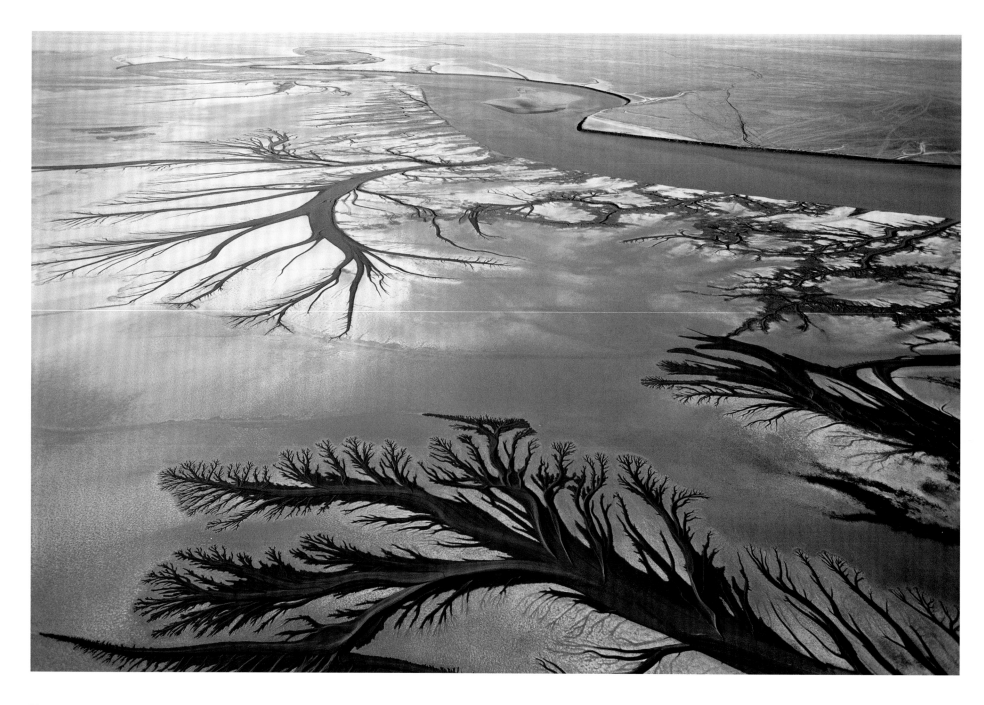

The delta that spreads where the Colorado River meets the sea in the Gulf of California once supported unique and bountiful ecosystems rich in fish, mollusks, and seasonal greenery nourished by a mix of freshwater, brackish water, and saltwater. As dams and irrigation projects upstream diverted ever more river water to American cities and Mexican farms through the twentieth century, much of that biological bounty vanished. Starting in 2014, carefully timed releases of river water and ecological restoration projects have produced the beginnings of an ecological revival, scientists say. Tides in the ranges of thirty feet around the time of the full moon create a twice-daily lacework of channels. San Luis Río Colorado, Sonora, Mexico.

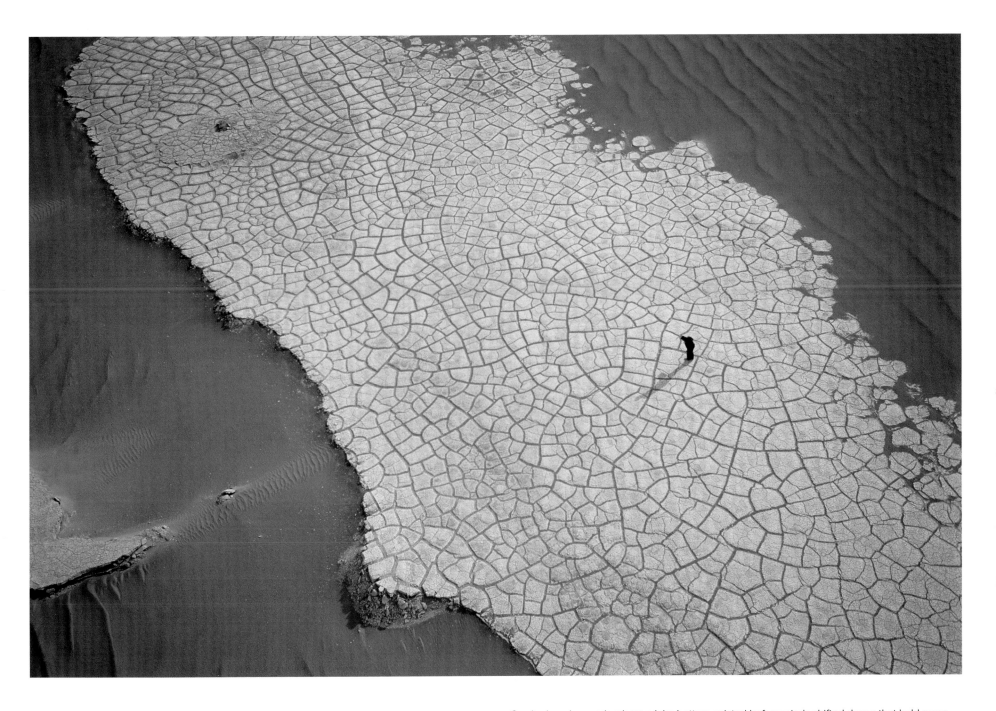

Cracked mud spreads where a lake bottom existed before winds shifted dunes that held some water in this spot in Iran's Dasht-e-Lūt—Farsi for "plain of emptiness." NASA satellite readings between 2003 and 2010 indicated that this region had the hottest surface temperatures on Earth, topping 159°F. Dasht-e-Lūt basin, eastern Iran.

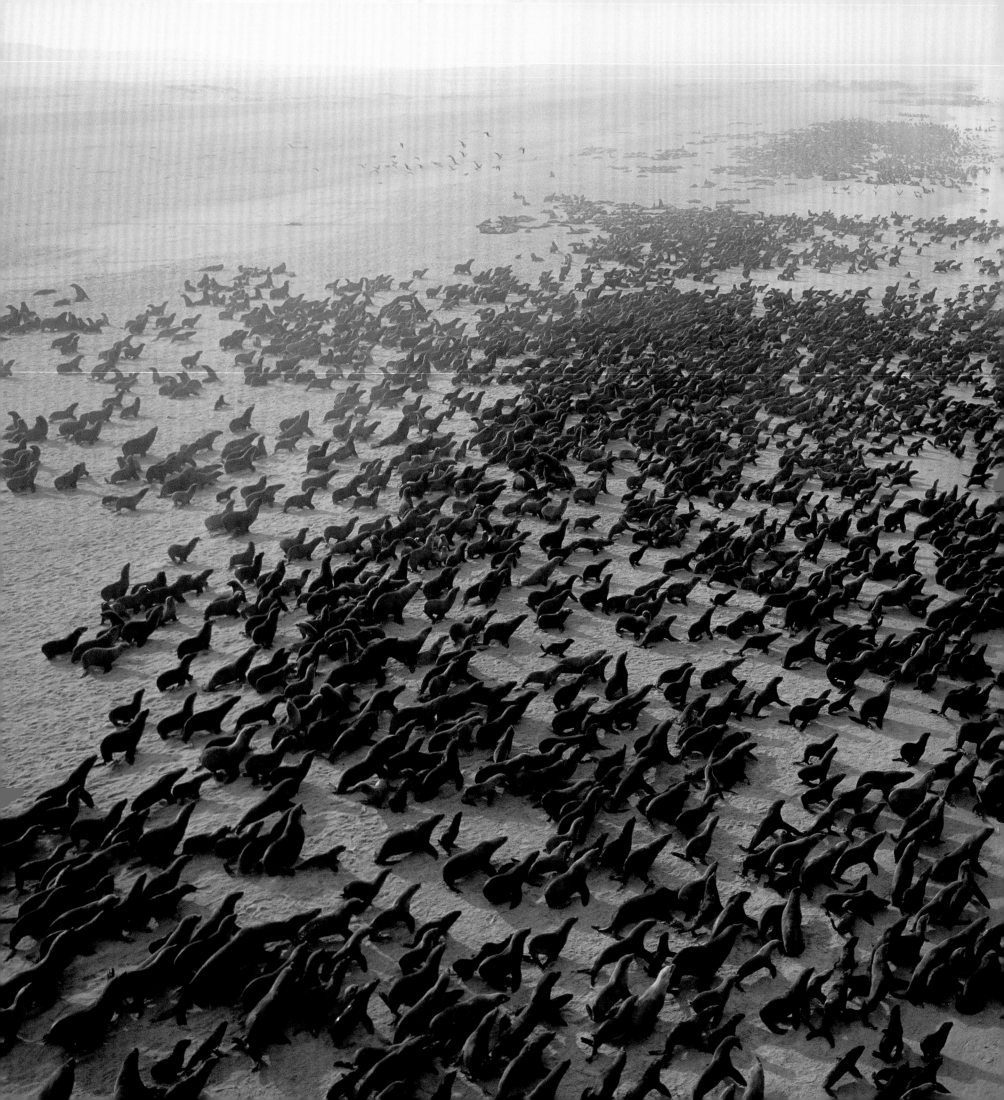

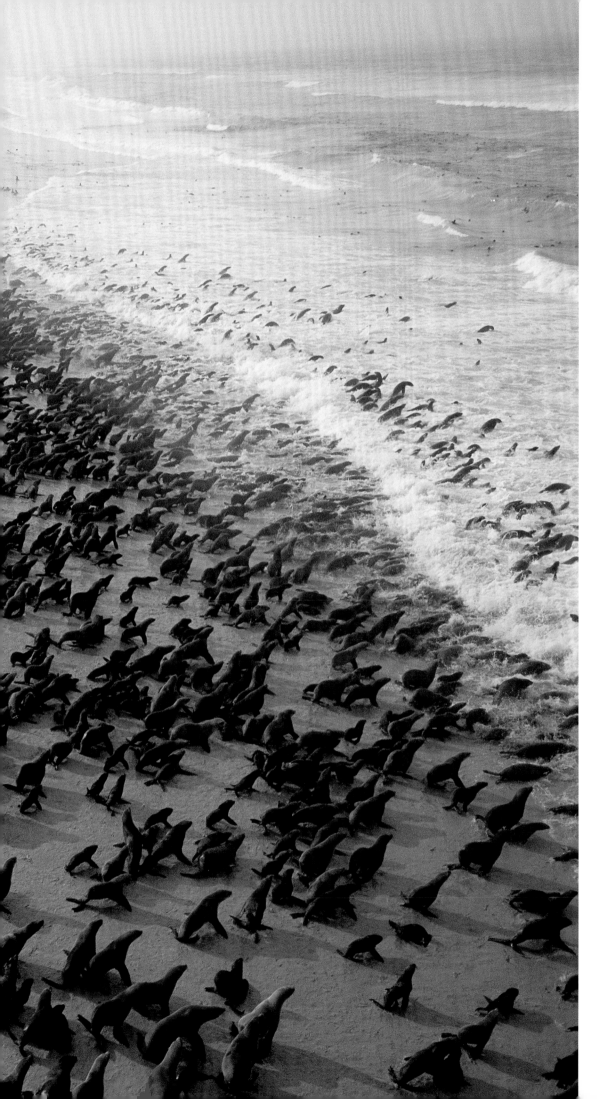

Along the coast of Namibia, cape seals (also called brown fur seals) live a bifurcated life, breeding on a harsh desert shore while feeding amid offshore biological abundance nourished by upwellings of nutrient-rich deep ocean water. The species was hunted intensively by Dutch mariners as early as the 1600s. Here, the northernmost breeding colony of some thirty thousand individuals roams near Cape Fria on the Skeleton Coast. This area is protected, but Namibia allows an annual hunt of up to eighty thousand fur seal pups and six thousand bulls. Cape Fria, Namibia.

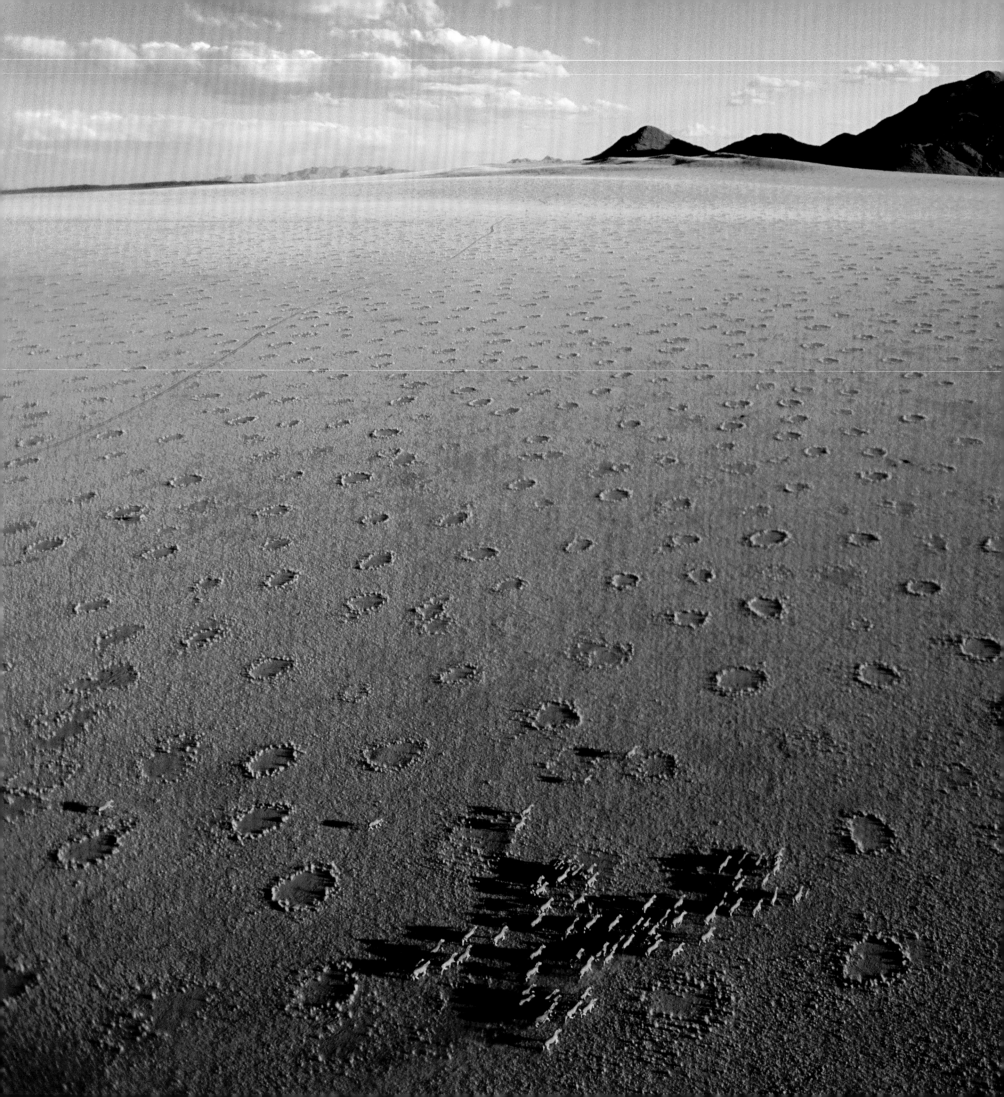

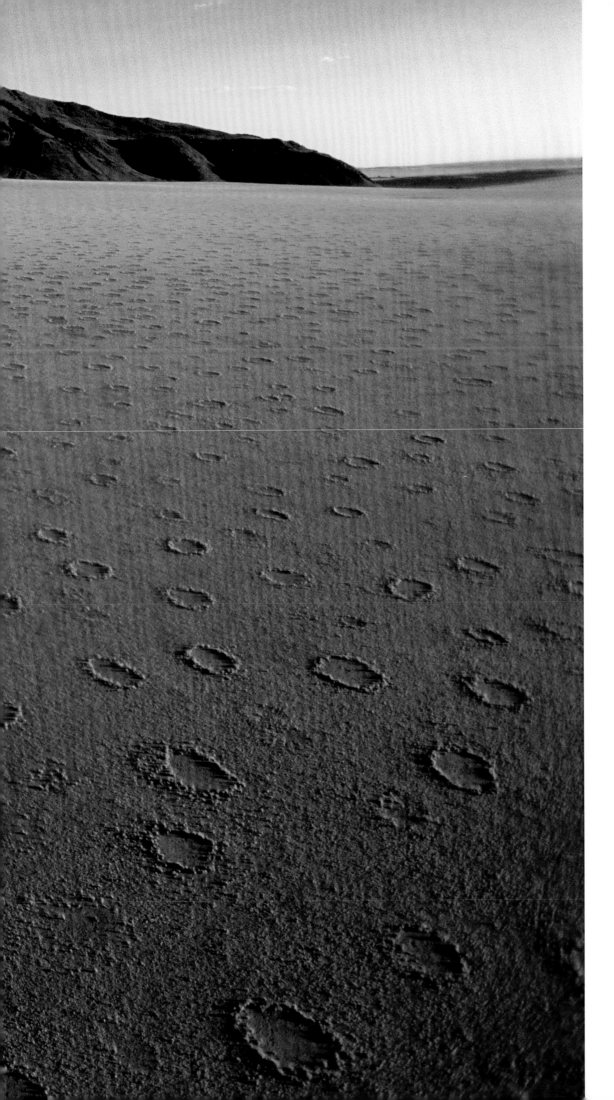

Zebras thrive among the "fairy circles" of grass on the edge of the Namib Desert. The cause of these grassy circles is still debated, but recent research suggests that the seemingly orderly arrays are actually the result of territorial tensions between adjacent colonies of termites and complicated relationships between grass species. The grasses benefit to some extent from shade thrown by neighboring plants but, in dry conditions, also compete for scant water. Comparable patterns are found in parched landscapes in Australia, Brazil, Kenya, Mozambique, and the US state of Arizona. NamibRand Nature Reserve, Namibia.

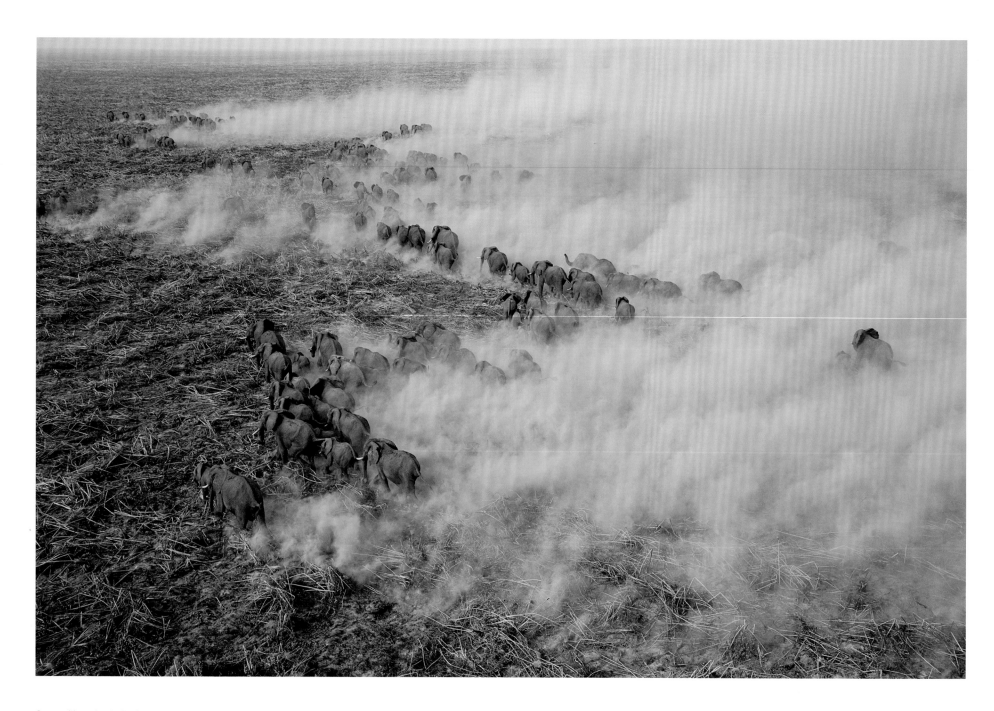

Several hundred elephants thunder across a burned-out section of the Al-Sudd swamp between Kongor and the main channel of the Nile. Much of the Al-Sudd burns during the dry season, but the papyrus quickly grows back. The dust being kicked up by the elephants is ash from a bushfire. Elephants are normally found in small, family-size herds of no more than twenty individuals. The large size of this herd implied the animals felt threatened by hunters. The region endured twenty-five years of civil war before Sudan and South Sudan split in 2011, a year after this photograph was taken. Jonglei State, South Sudan.

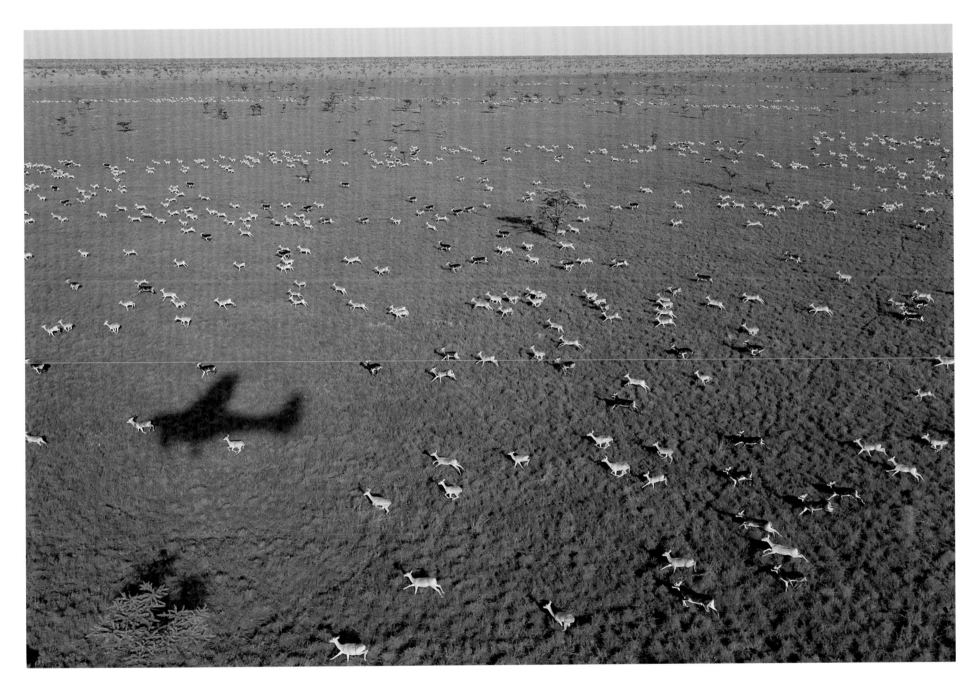

A small portion of an extraordinary herd of nearly one million white-eared kob take flight, startled by a small plane surveying the region for the Wildlife Conservation Society (WCS) before South Sudan gained independence. The largely uninhabited South Sudanese savanna is home to one of the world's largest annual animal migrations. The civil war that has killed an estimated four hundred thousand people in South Sudan since 2013 largely spared much of that troubled young nation's wildlife. But recent surveys by the WCS and others have found that poaching and wildlife trafficking are increasing, along with illegal mining, timber harvests, and charcoal production that are eating into important habitat. Jonglei State, South Sudan.

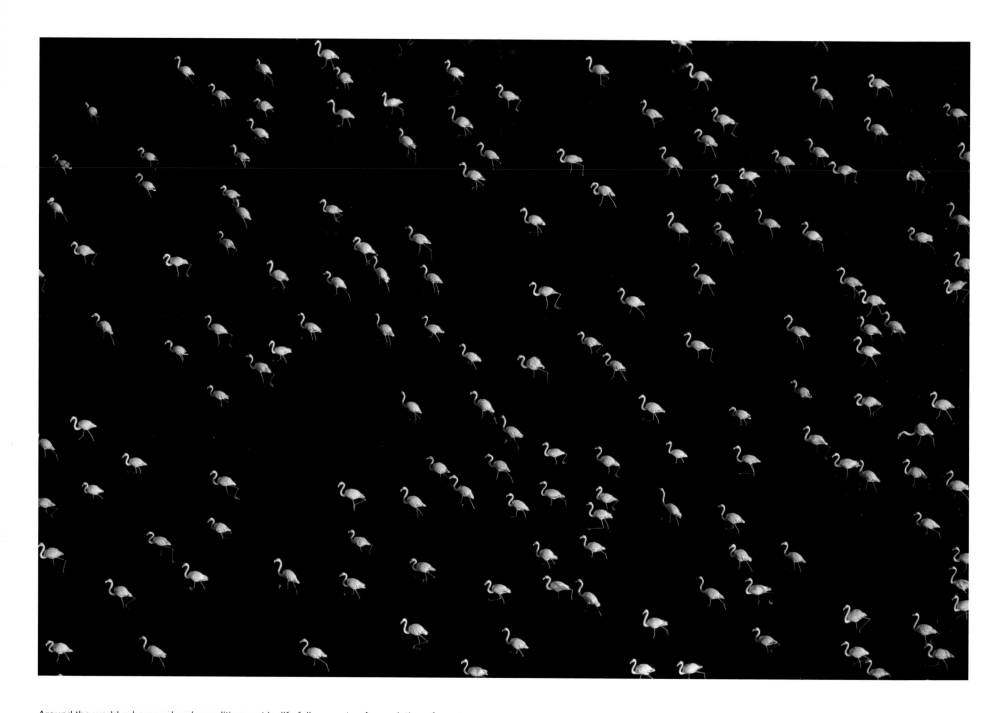

Around the world, wherever harsh conditions set in, life follows water. A population of greater flamingos gathers on salty Tashk Lake in southern Iran on a chilly morning with the temperature several degrees below freezing. This lake is fed by springs and, when there is sufficient rainfall, by outflow from a marsh on its western fringe. But many such saline lakes in Iran have shriveled, posing a threat to birds and other wildlife, as the country has diverted ever more water with dams and irrigation projects. In 2017, Iran's second-biggest lake, Bakhtegān, which nearly adjoins Tashk Lake, dried completely. Iran.

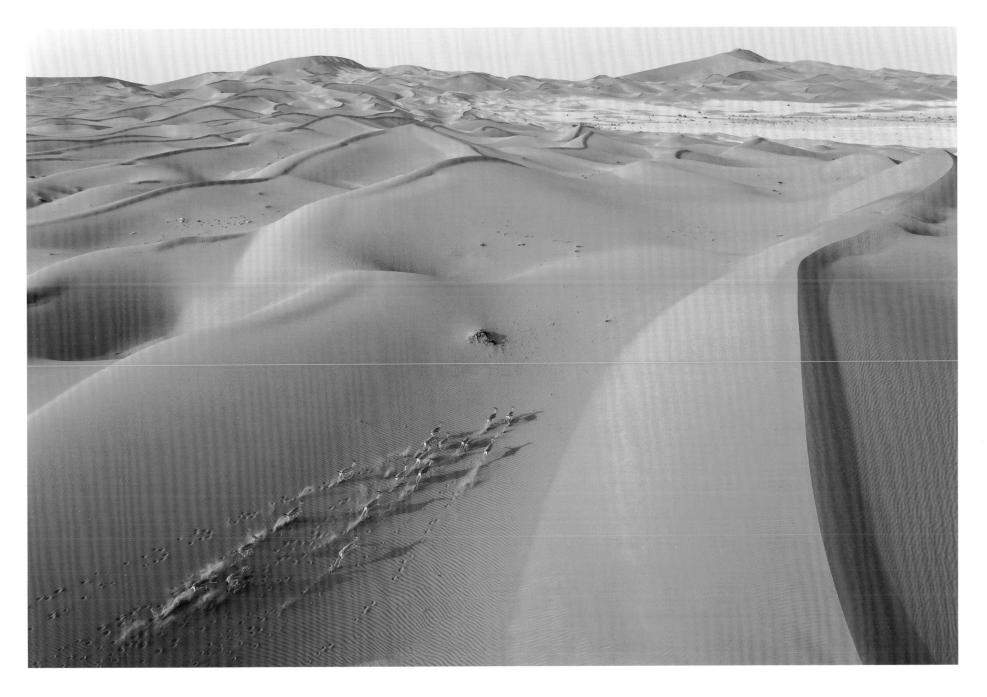

On the eastern hook of the Arabian Peninsula in the United Arab Emirates, a herd of Arabian sand gazelle races across orange dunes toward a white dry lake bed in the distance. Along with the oryx, this gazelle species, also known as reem, was nearly wiped out by hunting in the twentieth century, but it has been reintroduced to this area from abundant captive populations. In recent years, the wild population has been sustained with watering and feeding stations set up by the Abu Dhabi Environment Agency. Umm az-Zamul, Abu Dhabi, United Arab Emirates.

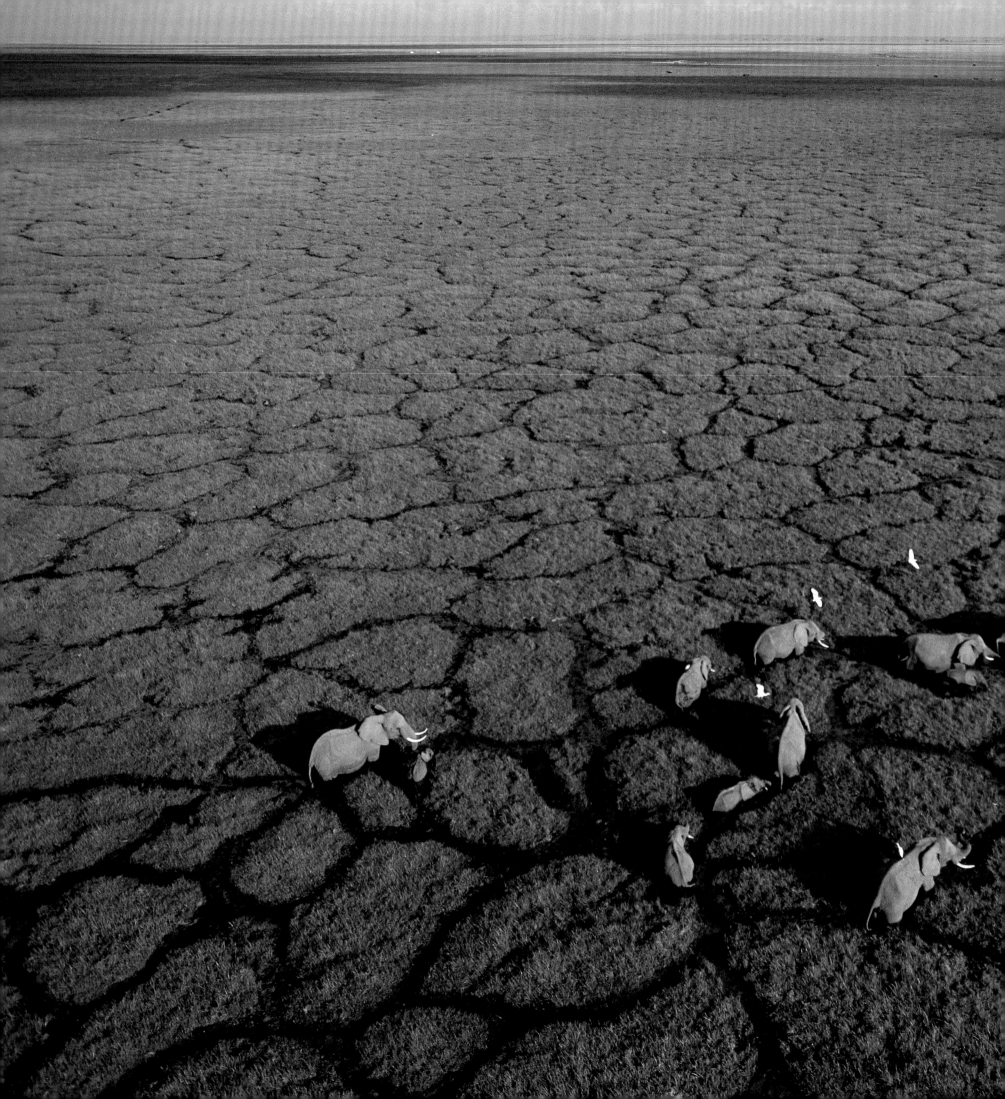

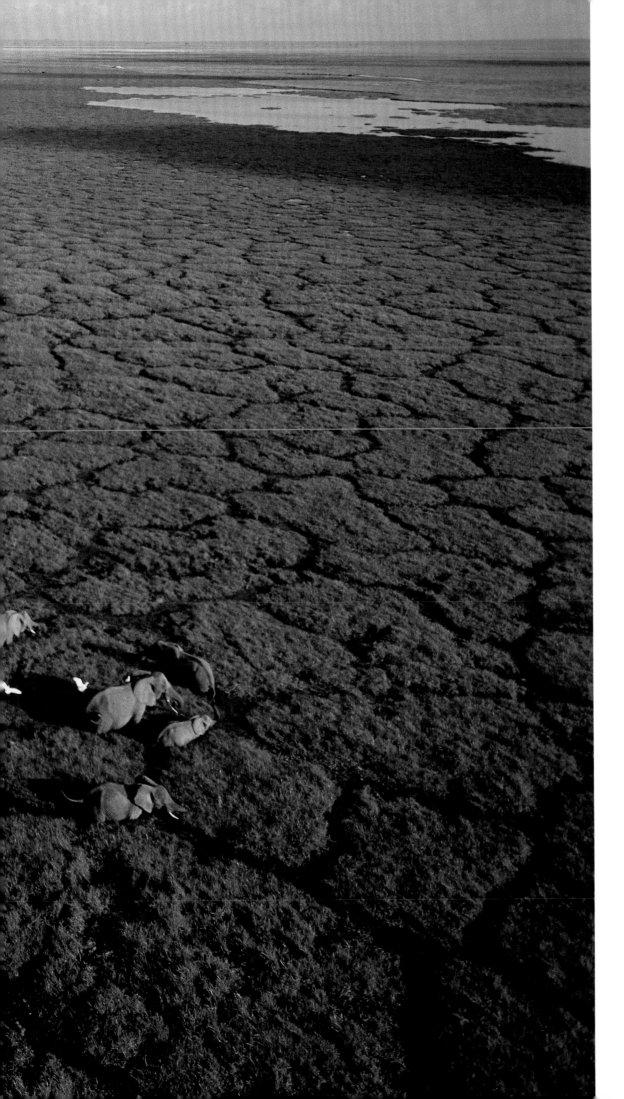

A network of elephant trails cuts through the tall grass in the mostly dry bed of Lake Amboseli, at the center of Amboseli National Park. The lake is fed from beneath by aquifers charged with waters from the flanks of Kilimanjaro. The elephants migrate from the surrounding plains almost daily in dry seasons to drink and graze. A worldwide ban on the ivory trade has allowed Kenya's elephant population to rebound. The human population in the region is rising rapidly and the impact of climate change on local conditions remains unclear. Amboseli National Park, Kenya.

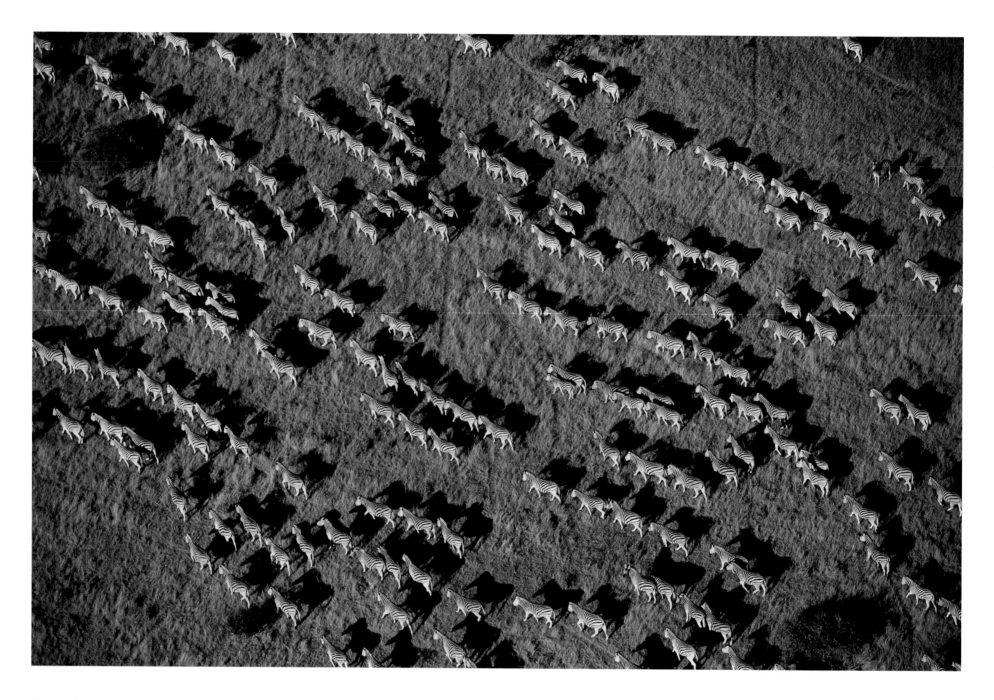

Thousands of zebra congregate near a last watering hole before they begin their annual migration from Botswana's Makgadikgadi Pans, a vast salt flat in the northeast, to the Boteti River. Botswana.

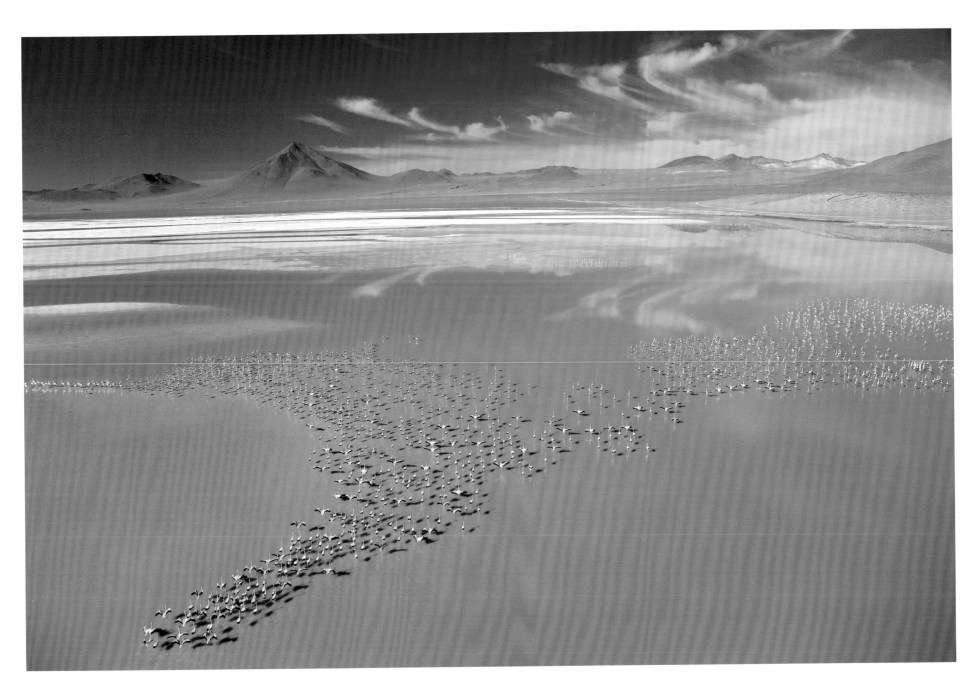

High in the Bolivian Andes, a colony of James's flamingos moves across the shallow algae-tinted waters that give Laguna Colorada its name—"red lagoon"—and provide the large filter-feeding bird its food source. The algae are sustained in the shallow lake by natural hot springs. There are only fifty thousand James's flamingos in the world, and thirty thousand of them nest here each summer. Potosí, Bolivia.

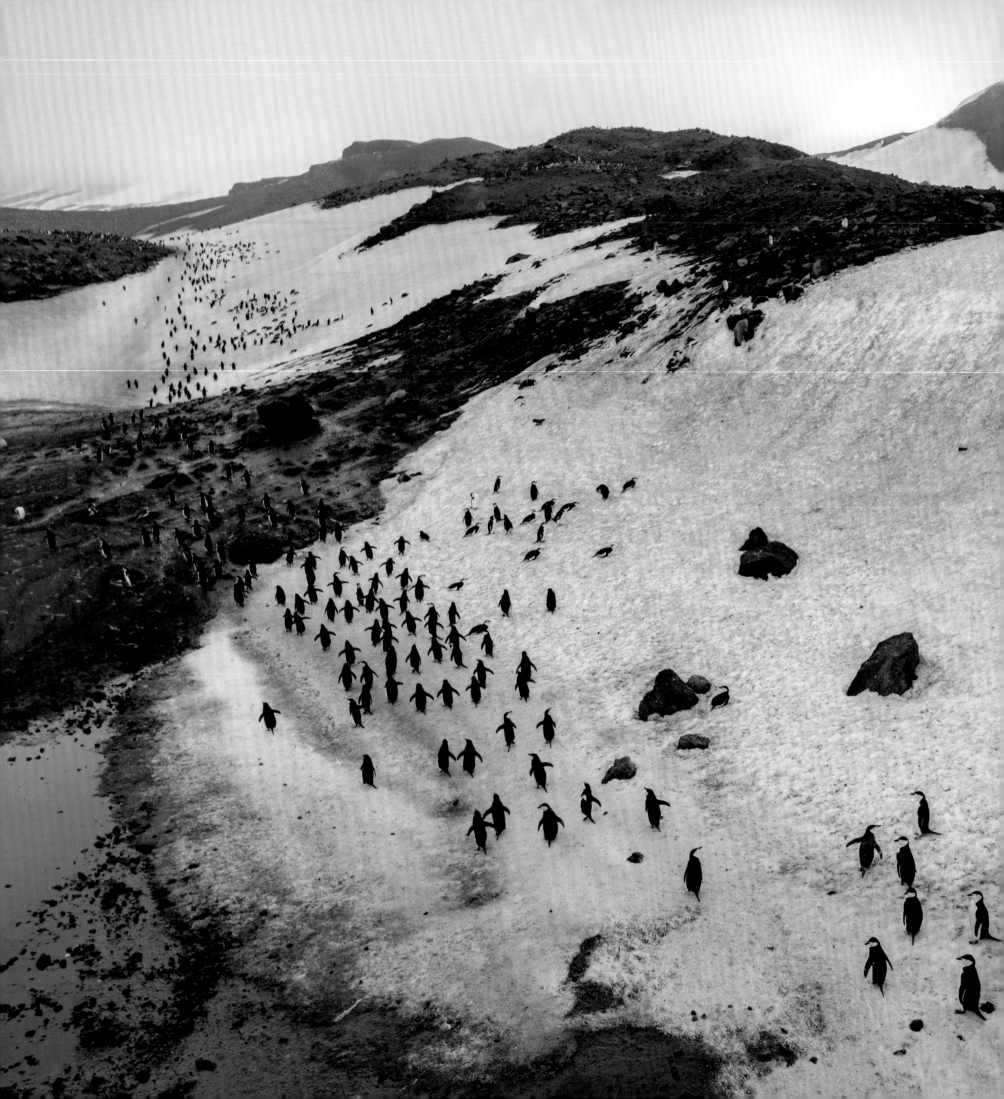

Chinstrap penguins waddle toward their nesting sites at Baily Head on Deception Island, the caldera of an active volcano situated off the north coast of the Antarctic Peninsula. These penguins nest on rocky ice-free areas adjacent to water, and at this point in the late Antarctic spring they were just laying their eggs on the island's high ground. When nesting, the birds make a daily commute down to the sea to feed. Their snowy pathway back to the colony is stained pink with excrement from recently digested krill. The colony, tracked carefully in recent decades, has seen a sharp drop in population, in parallel with a significant southward shift of krill populations. Deception Island, South Shetland Islands.

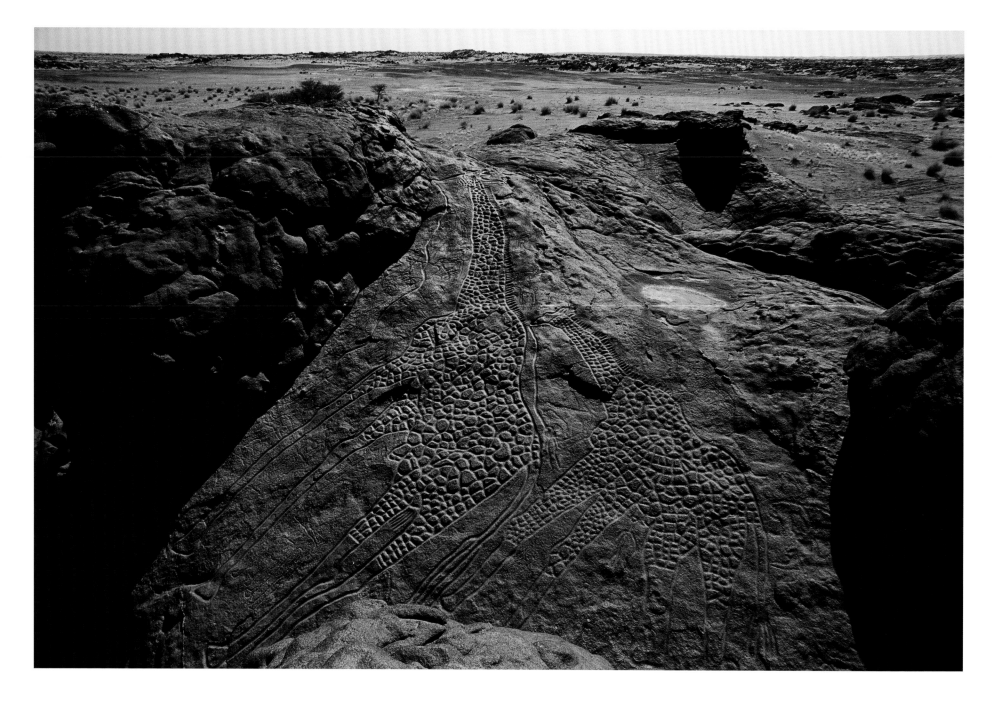

Life-size rock carving of a male and a female giraffe in the heart of the Sahara Desert, where there are no giraffes today. The animals were carved by hunter-fisher-gatherers some six thousand to ten thousand years ago in the peak of climate warmth after the last ice age, when the Sahara was a land of lakes, rivers, and fertile grasslands. Many cycles between desert and fertile land tracked the natural glacial-interglacial cycles throughout the last three million years, punctuating our ancestors' migration out of Africa. Dabous, near Arlit, northern Niger.

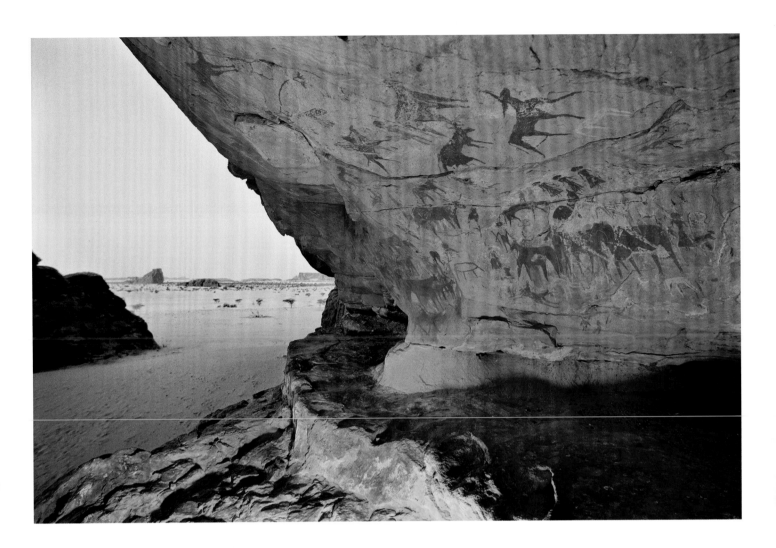

Cave paintings depicting camels and other animals in the Sahara. Guelta d'Archeï, Chad.

Fighting cats engraved by inhabitants of the Sahara more than five thousand years ago. After the carvings were damaged by oil prospectors, a project to conserve them and many others in the area was halted by civil war in 2011. Wadi Mathendous, Libya.

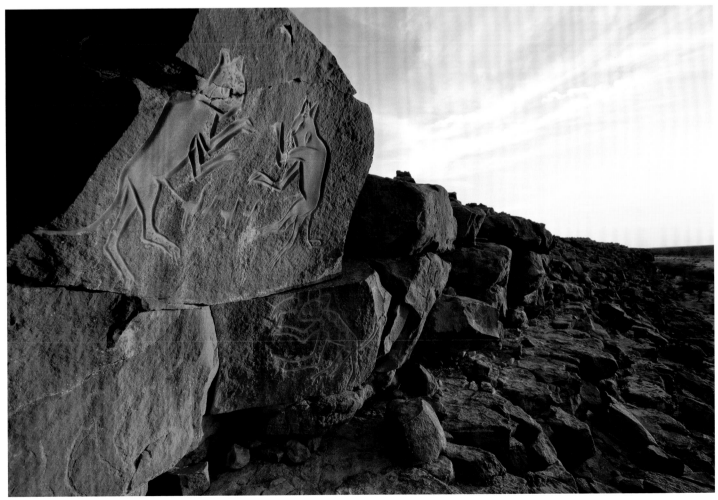

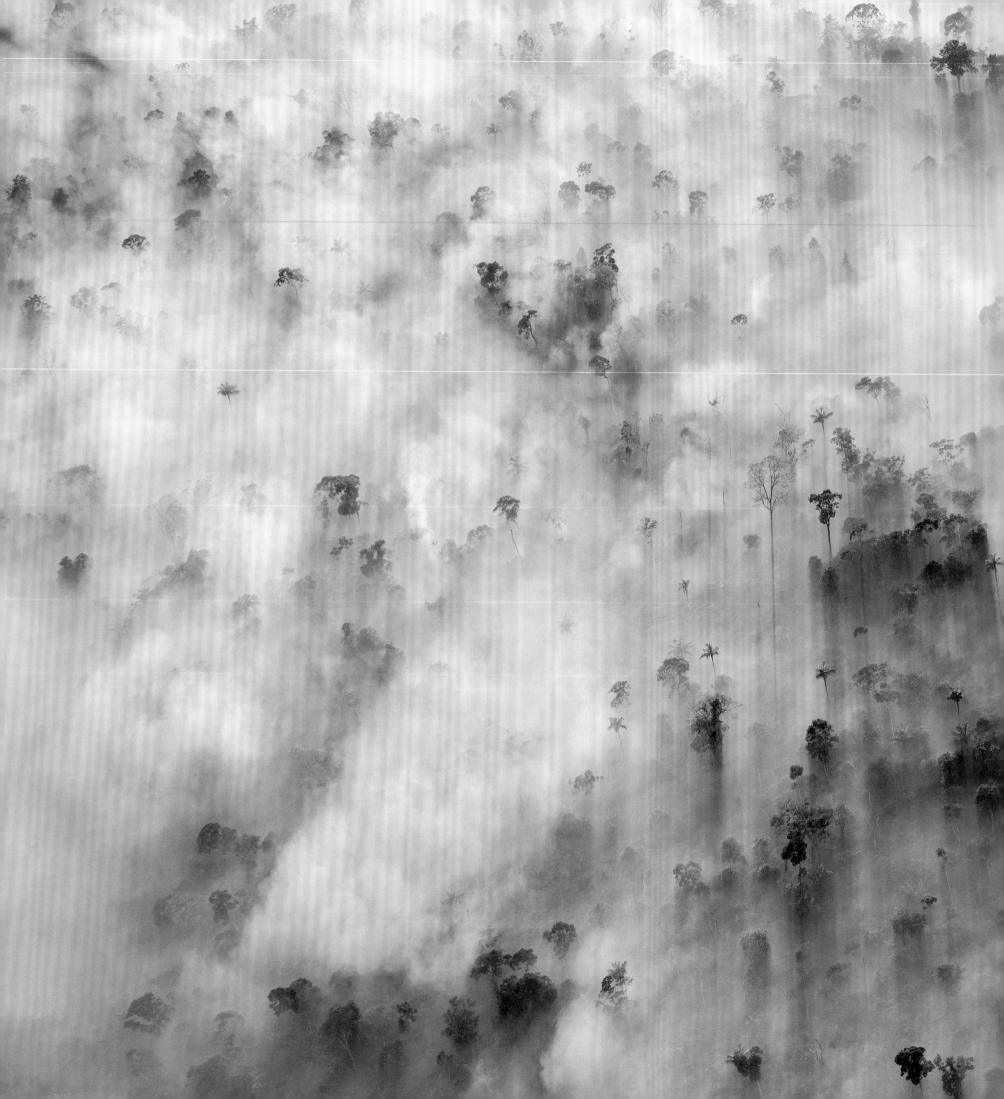

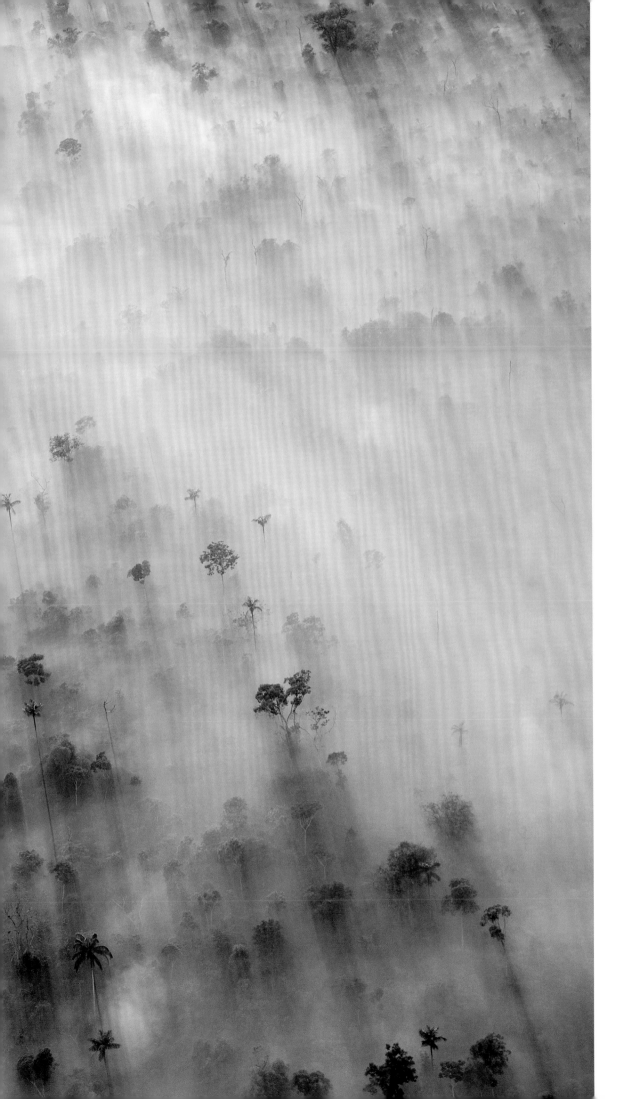

Smoke clings to trees in the morning sunlight near the dead center of Brazil, on the boundary between the vast Amazon River basin and more developed regions to the south. This region was still largely intact forest until the 1990s, when an average of 3,110 square miles of forest were cleared yearly for cattle ranches and soy farms. Government efforts in the mid-2000s significantly reduced deforestation, but illegal logging and agriculture have driven the trend upward again since 2013. Deforestation generates the same volume of greenhouse gases as the global transportation sector. East of Sinop, Mato Grosso State, Brazil.

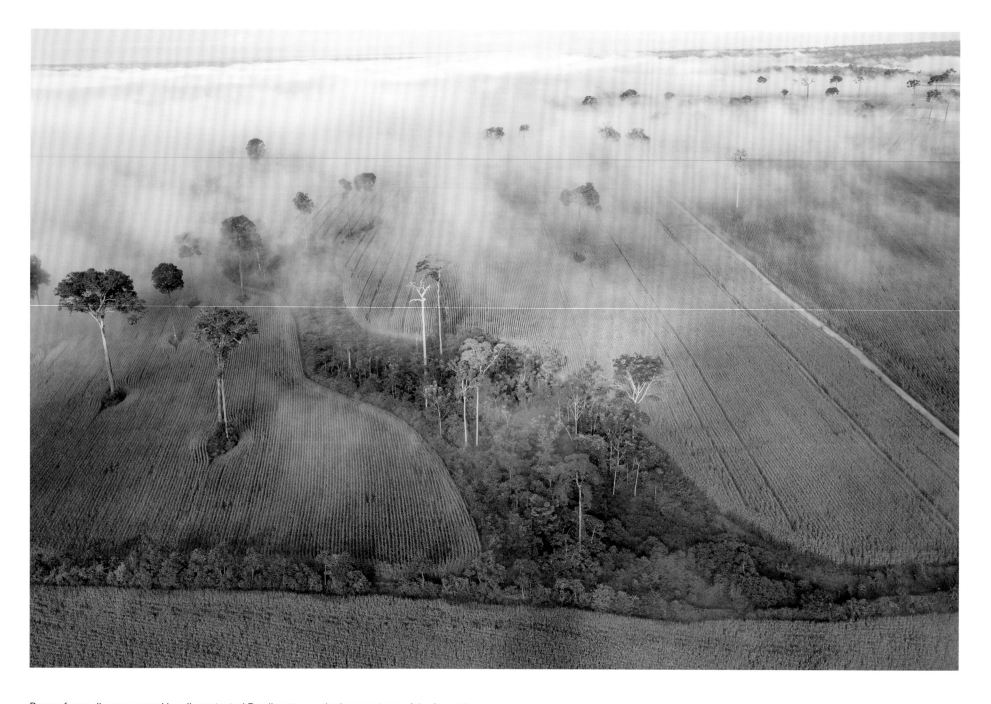

Rows of corn diverge around legally protected Brazil nut trees, the last survivors of the forest that once stood here. Known as "Brazil nut cemeteries," these isolated trees hardly bear fruit owing to lack of pollination. They often die either from fire damage when the forest around them is cleared or from the transformation of their habitat. Southeast of Santarém, Pará State, Brazil.

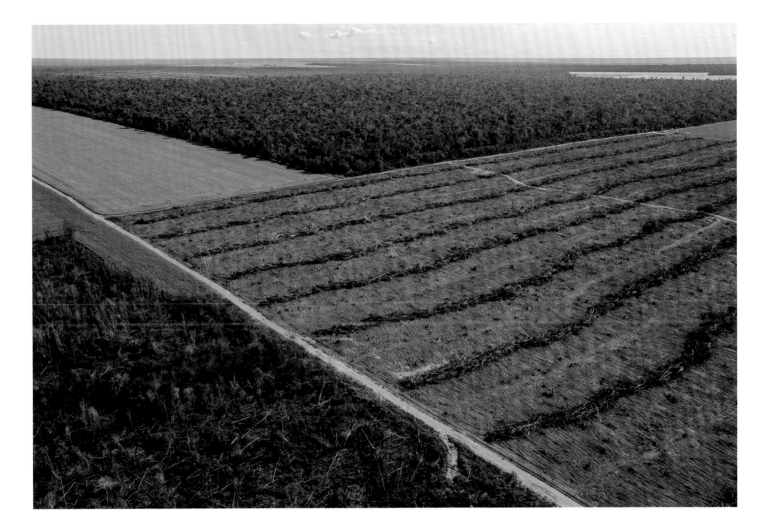

Four stages of deforestation can be seen in this view of Brazil's Cerrado, a vast region of savanna, forest, and farms that straddle the southern edge of the Amazon River basin in Brazil. The land is first cleared of valuable hardwoods, then burned, scraped clean by pairs of bulldozers connected by chains, and smoothed for planting. Feliz Natal, Mato Grosso State, Brazil.

Smoldering tree trunks seen from a helicopter carrying armed agents of IBAMA, Brazil's federal environmental agency, who were based in a frontier town on a mission to stop illegal logging in the Amazon. With poor soil, once the land is denuded of valuable timber, it will be converted to pasture for cattle. Novo Progresso, Pará State, Brazil.

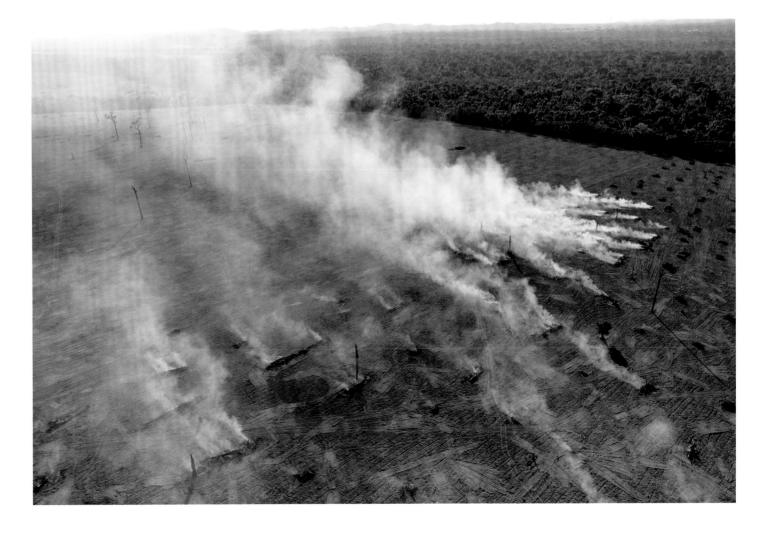

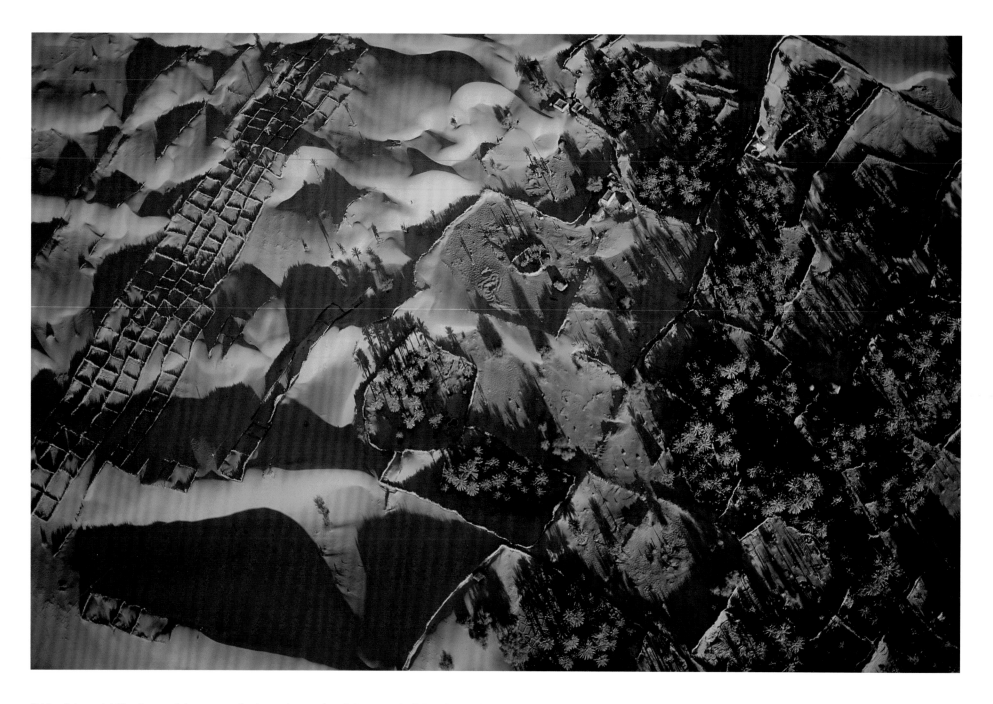

Grids of straw stabilize the sand dunes creeping toward an ancient Saharan oasis. Driven by wind and gravity, the dunes are constantly in motion and can advance at the rate of twenty meters per year. No simple solution exists to counteract the motion of granular flow, in which sand particles behave sometimes like liquids and sometimes like solids. Tekenket, Mauritania.

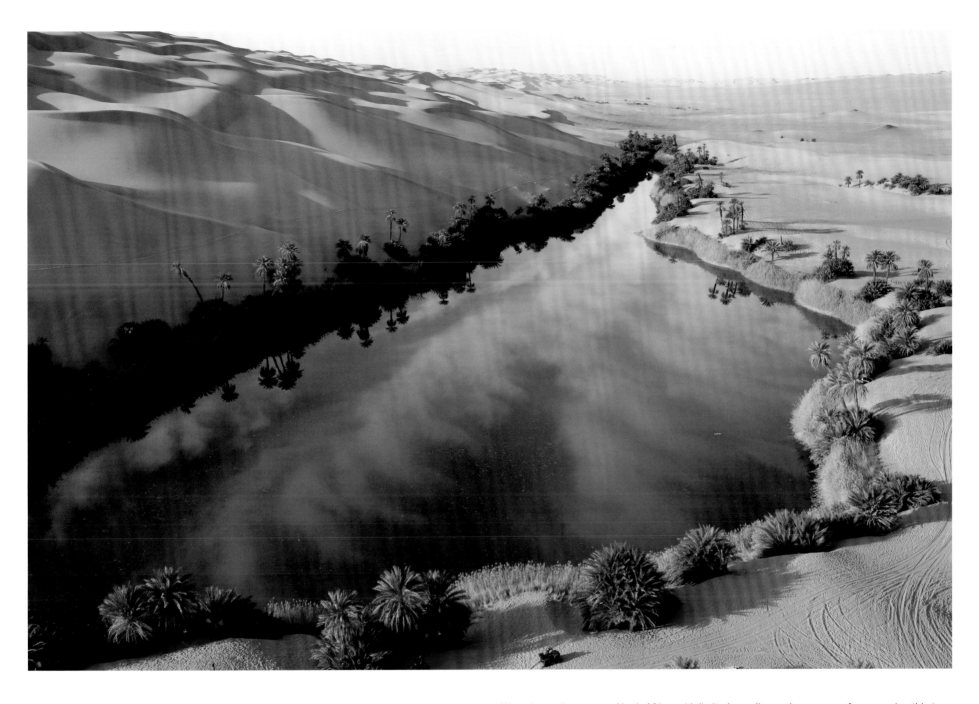

Water is precious across North Africa, with limited supplies under pressure from growing thirsty populations. Here, the lake Umm al-Maa (mother of water) beckons in the Ubari Sand Sea. This salty lake and others nearby are fed by freshwater springs that have slowly been drying up as the water table has dropped, presumably owing to increasing aridity and groundwater pumping for agriculture in nearby communities. Wadi al Hayaa District, Libya.

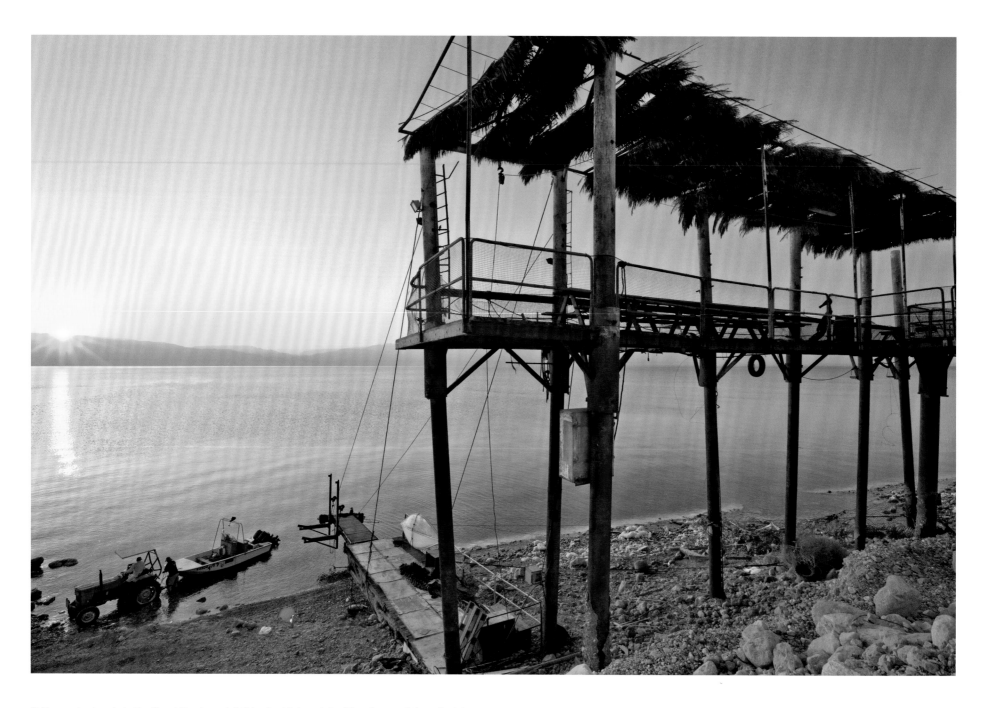

Falling water levels in the Dead Sea have left this pier high and dry. The shores of the salty lake mark the lowest point on Earth's land surface, 1,410 feet below sea level. And that low point has been falling about 3 feet per year, as more water is diverted from the river that enters this basin for irrigation, thirsty cities, and industry. Ein Gedi, Israel.

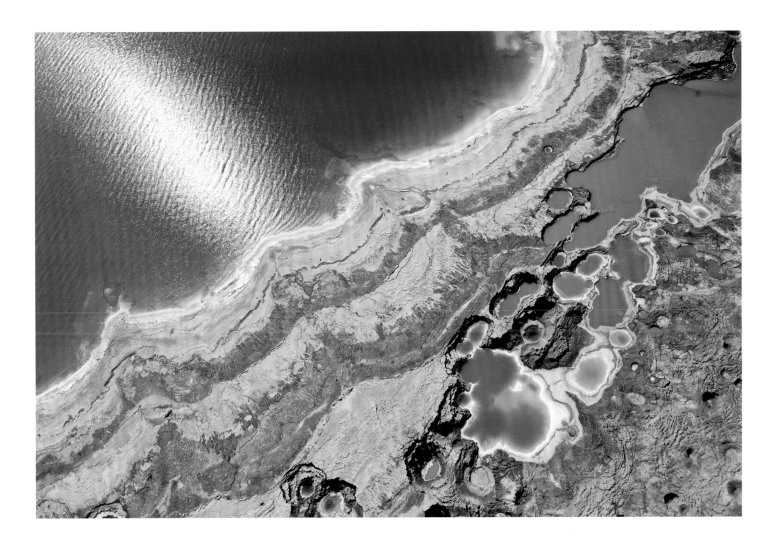

As the saline Dead Sea shrinks, underground salt layers are invaded by fresh groundwater, dissolving them away to leave thousands of sinkholes that have consumed roads, bridges, buildings, and date groves. Ein Gedi, Israel.

The water of the Dead Sea is nine times saltier than seawater. Splashing waves evaporating in the oppressive heat have left a thick layer of salt crystals and stalactites in this cave on the Jordanian shore. Zara Spring, Jordan.

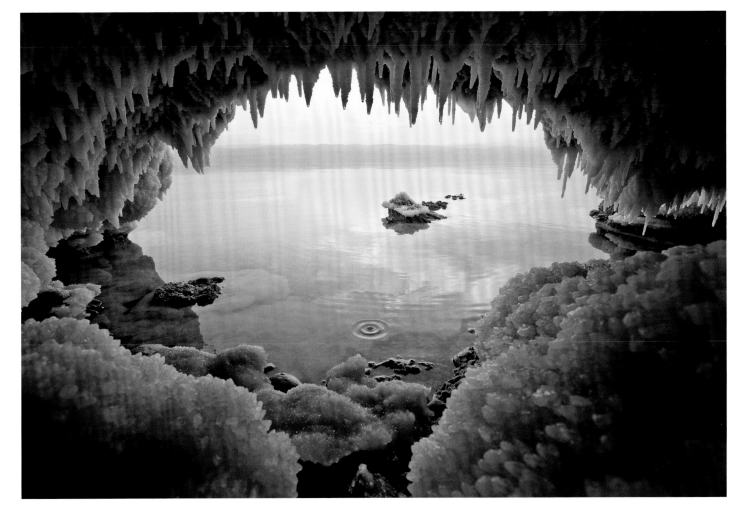

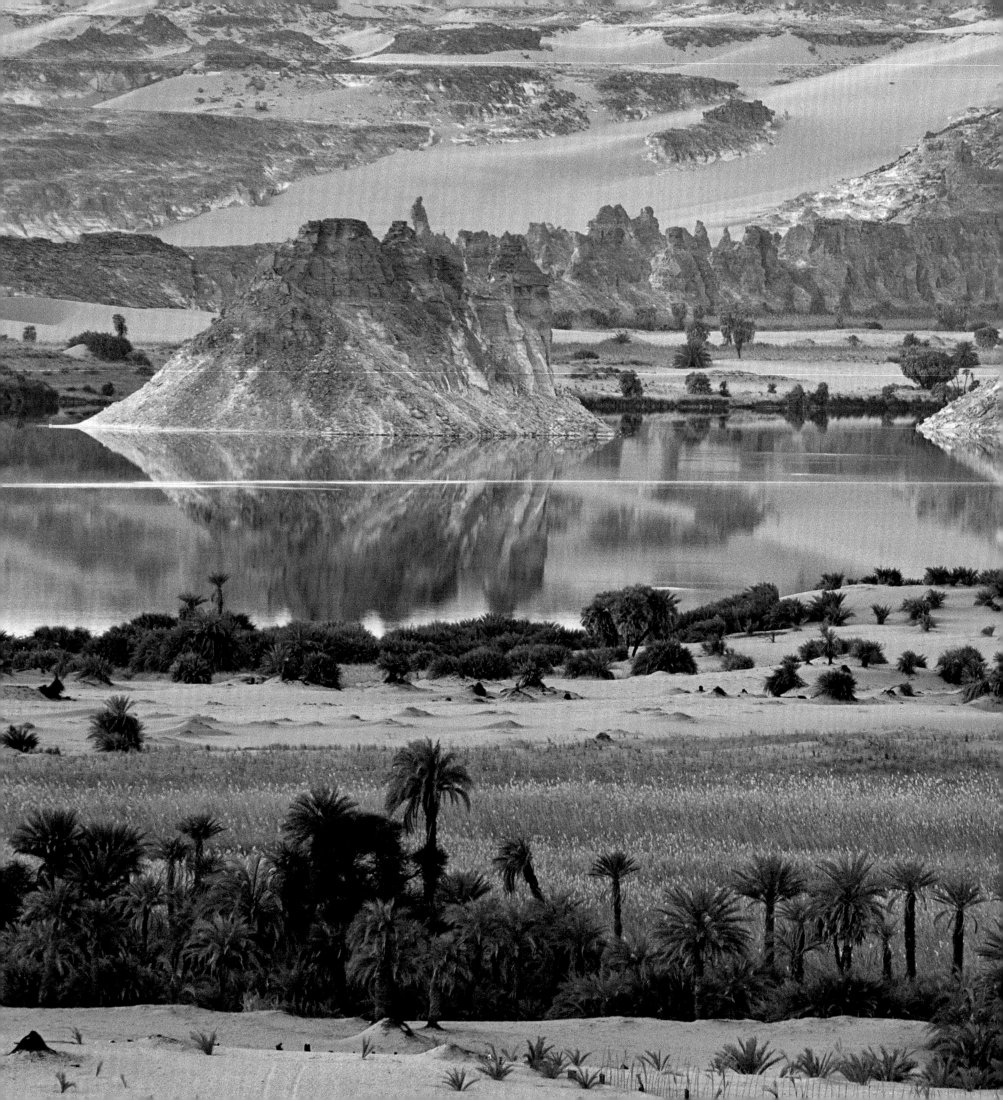

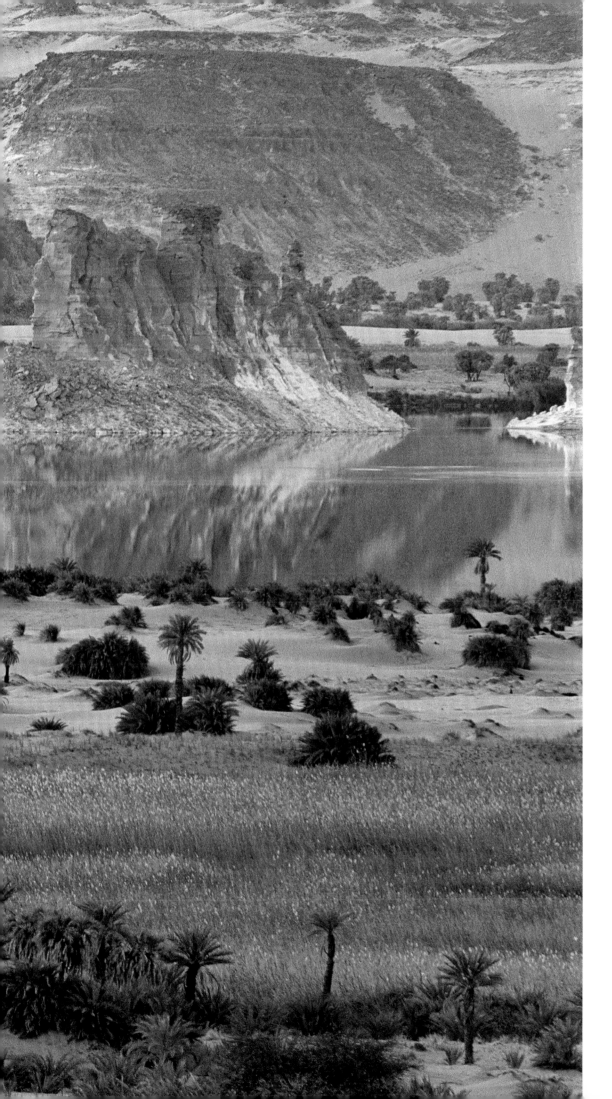

Salt left by evaporating groundwater frosts outcrops of sandstone at Ounianga Serir in Chad. This lake and a handful of others are all that remains of an enormous body of water that stretched seven hundred miles across the Sahara eleven thousand years ago. Sand dunes now divide this vestige of a wetter era into fourteen parts.

of years of banked solar energy compressed into potent, portable, abundant supplies of dense black rock, oil, and, most recently, gas. Advances in chemistry and engineering and medicine and agriculture followed in quick succession. The result has been an astonishing burst of human flourishing

(albeit not universally shared)—and a simultaneous surge of global and local environmental impacts. It is instructive to consider that in 1800 the human population totaled one billion, while today there are more than one billion *teenagers*, and another billion children below that age. It is the reproductive potential in that young pulse of humanity that almost surely guarantees a path to at least nine billion people by mid-century. Predictions beyond that point are far tougher, demographers have long noted, because just a small change in the average number of children per woman can bend population curves up or down remarkably quickly.

Early warnings of an impending population bomb driving global famine missed how agricultural innovations, education, urbanization, family planning, and better health care could sustain human progress while slowing growth in numbers. But debates over population might have distracted us somewhat from the main driver of our impact on the planet and the multitudes of species and ecosystems around us—how much and how we consume and waste.

The grand challenge now is finding ways to expand human well-being while shrinking our planetary footprint.

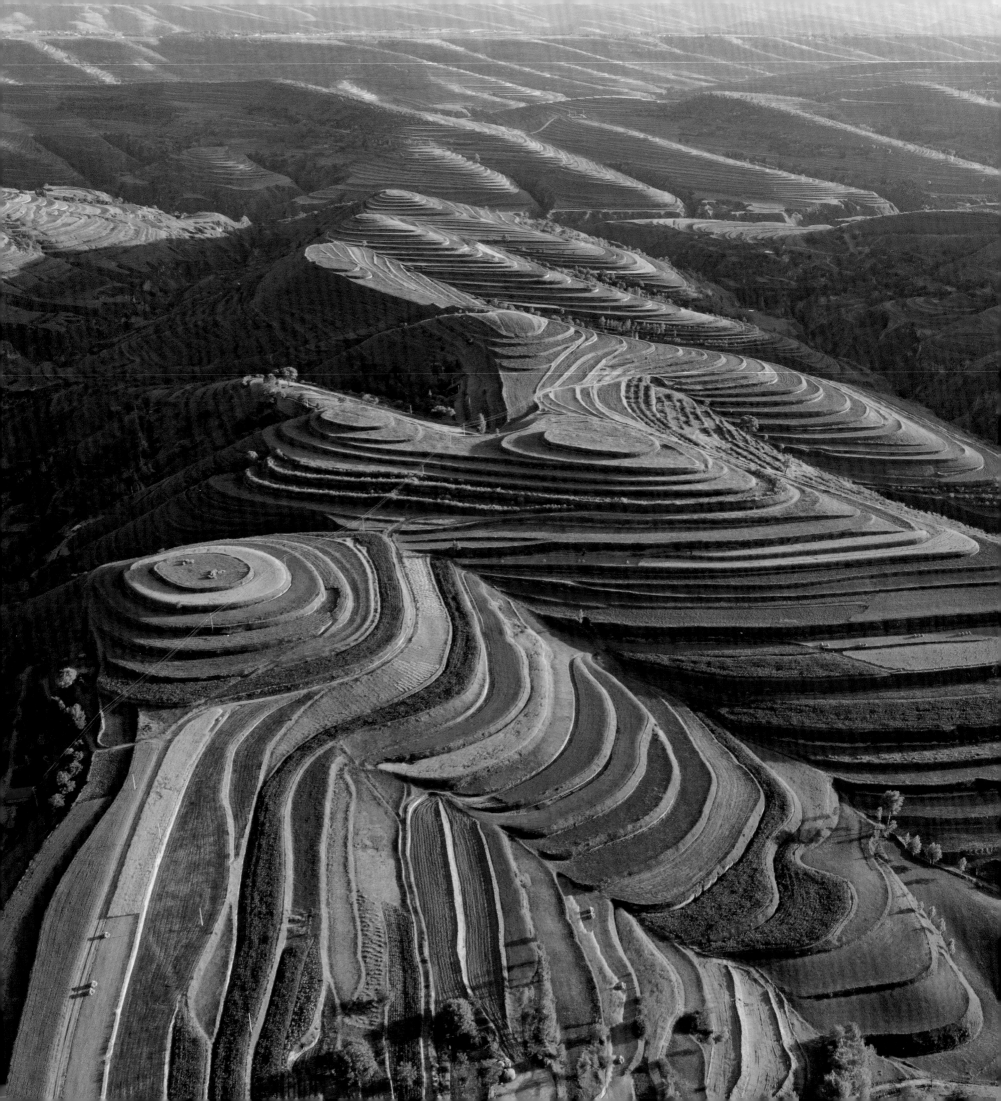

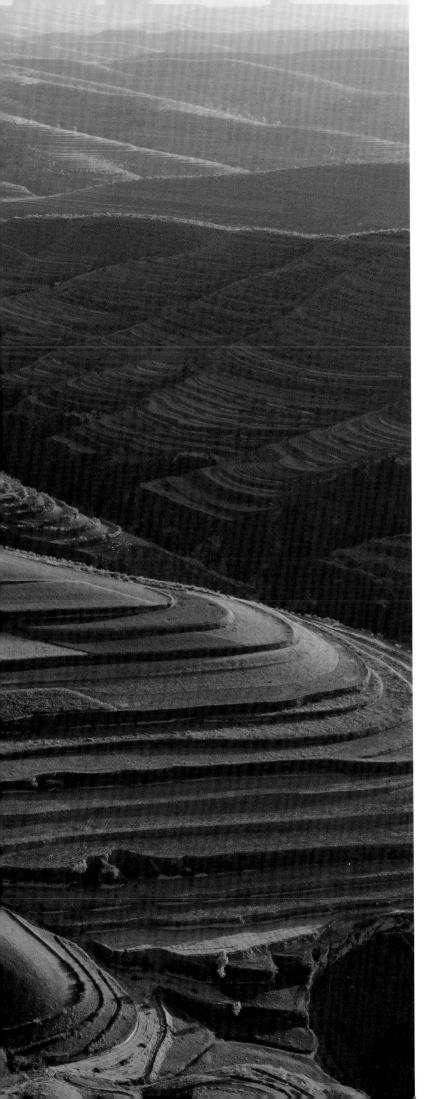

Delicate whorls spiral the hills and gullies of a Loess Plateau village in China's Pengyang County. Mimicking the contours of natural formations, these concentric steps have been shaped by farmers to better accommodate terraces of wheat. Drought and water shortages continue to be obstacles to farmers struggling to maintain the labor-intensive terraces, even as their children migrate to cities seeking better-paying jobs. Pengyang County, Ningxia, China.

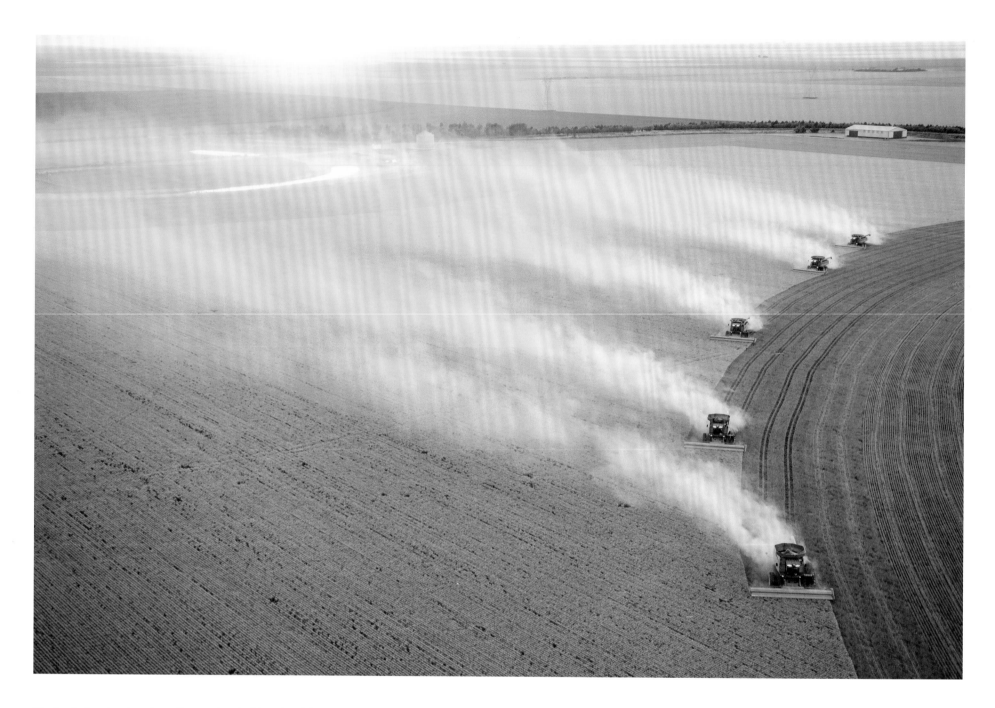

The family farm has long been the very heart of American identity, and the real-life realm of the much-vaunted amber waves of grain. Every crop is a gamble, every harvest is the product of blood, sweat, tears, and luck, and the number of family farms being consolidated or going through Chapter 12 bankruptcy is on the rise. Nonetheless, there remain many multigenerational farms in the Midwest. Here, a combine harvests dryland wheat on the Vulgamore Family Farms. During the two-week harvest, the Vulgamores will work around the clock. Five generations of Vulgamores have weathered the annual wheat harvest on what is now one of the largest farms in the county. Scott City, Kansas, United States.

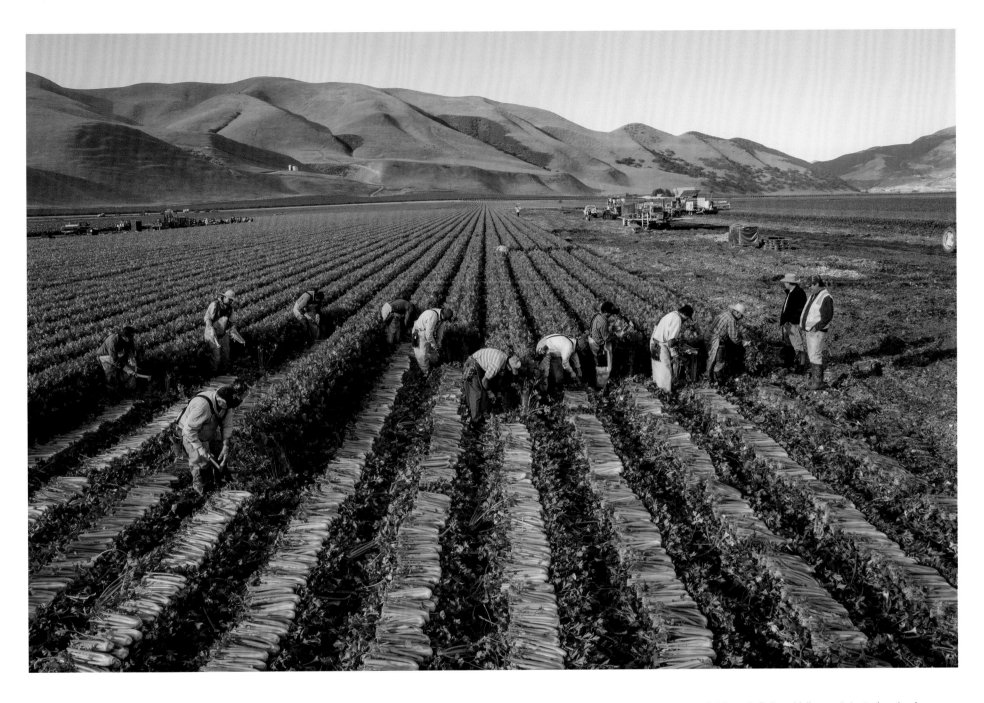

Harvesting celery on the Bassetti Farms in California's Salinas Valley, an irrigated region long known as "America's Salad Bowl." The harvest will be boxed in the field for direct shipment to retail outlets in the United States and China. Greenfield, California, United States.

Ancient Naxi farming village at the base of Jade Dragon Snow Mountain. Mountainous Yunnan Province has been spared some of the modernization encroaching on much of northern China. Yunnan's range of climatic conditions allows the cultivation of a variety of crops. Here, the stalks of recently harvested corn have been set against a farmyard wall to dry. Lijiang, Yunnan Province, China.

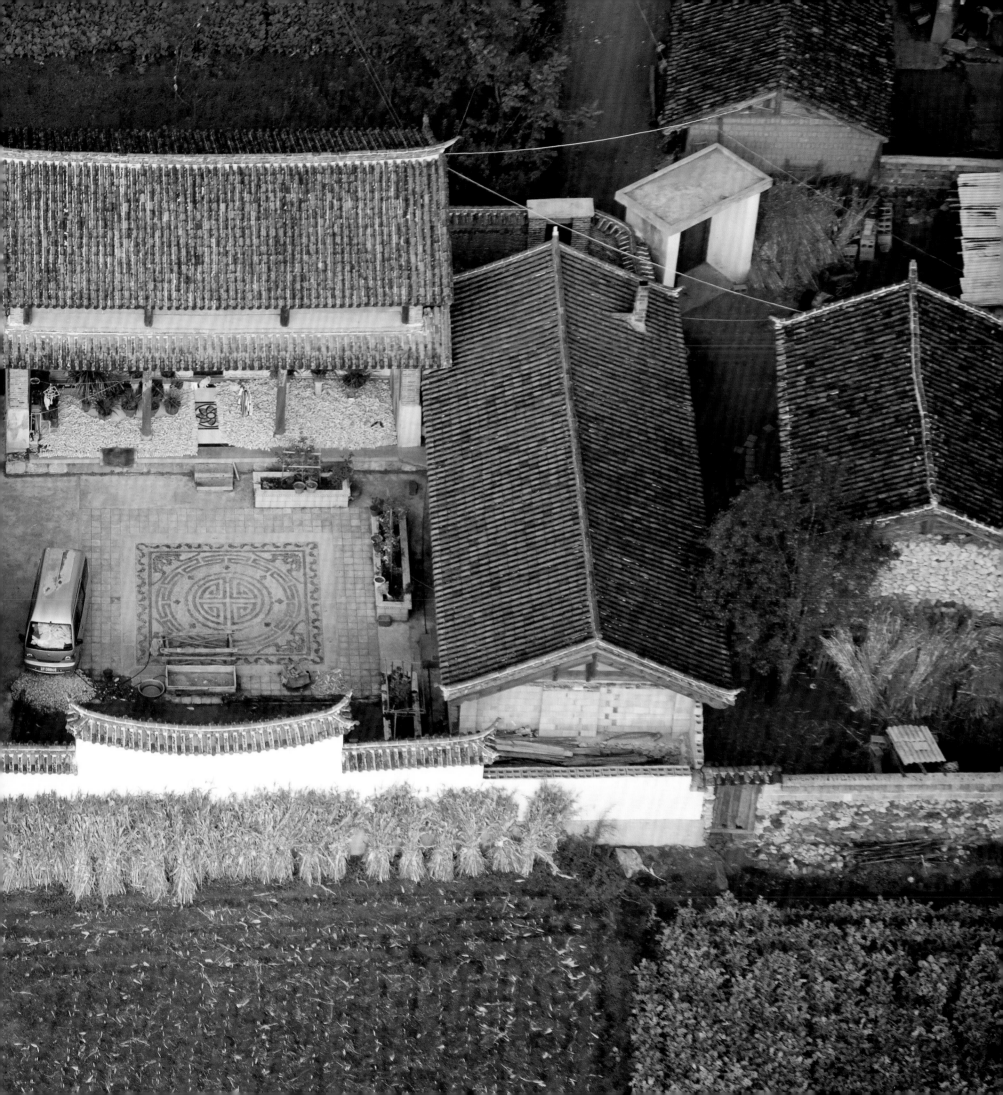

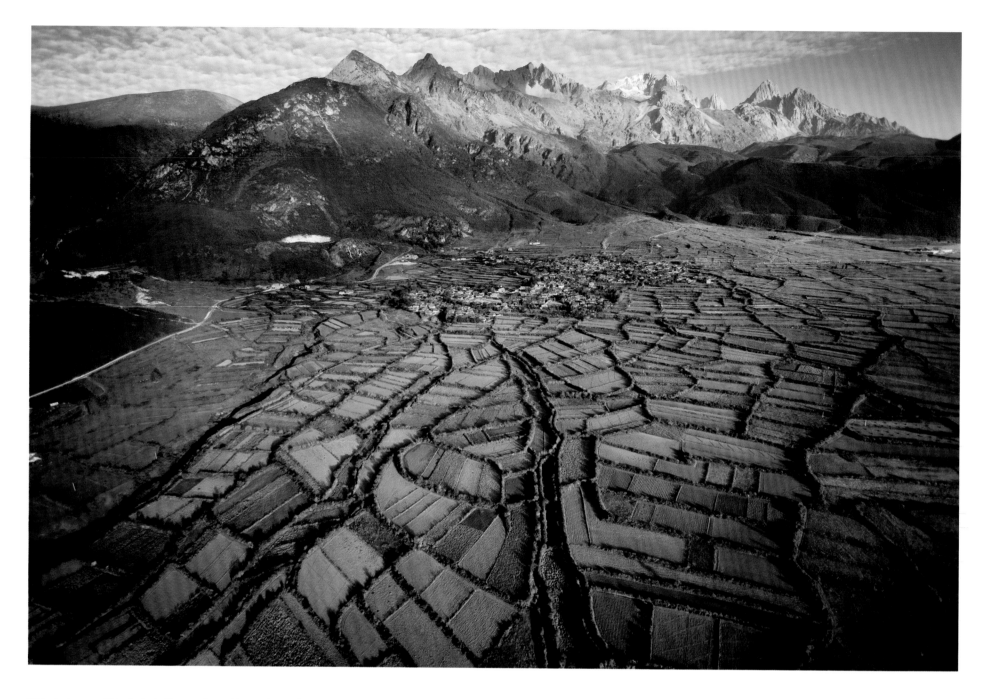

The glaciers on China's Jade Dragon Snow Mountain are the southern-most in the Himalayas, the third pole of global fresh-water storage after Antarctica and Greenland. The mountains' glaciers have lost 60 percent of their mass since 1982, creating problems for the region's farmers who depend on the ice for a stable water supply for their crops. Because so much of the terrain is steep, less than 7 percent of Yunnan's land area can be farmed. Lijiang, Yunnan Province, China.

The stepped fields of Naxi farms blanket the landscape of Judian in an undulating mosaic. Subsistence crops of millet, cabbage, corn, and wheat are cultivated side by side. The region is also home to a vast array of animal life, plants, and herbs used in traditional medicine. Of the thirty thousand species of plants growing in China, more than half can be found in this province. Judian, Yunnan Province, China.

An area of Malaysian oil-palm plantation is being replanted. Palm oil is a high-yield crop with low production costs and consistent global demand that is used in everything from car fuel to cosmetics and candy. The clearing of rain forests to make way for oil-palm plantations has devastated important ecosystems and displaced indigenous peoples; the practice is spreading from Southeast Asia around the tropics. Sapi, Sabah, Malaysia.

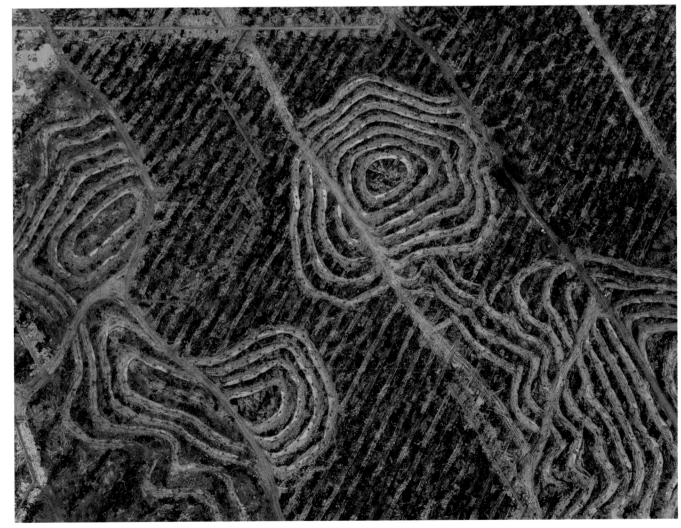

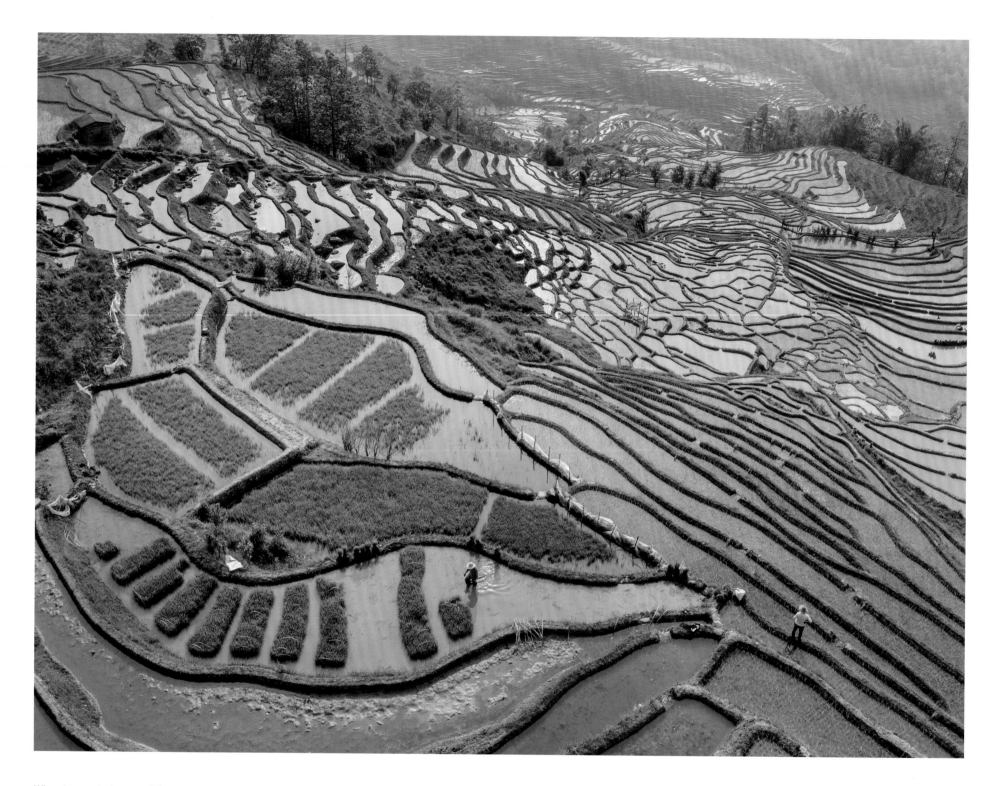

When human beings work in concert with their environment rather than against it, the earth becomes a living canvas of resilience. The Hani rice terraces of Yuanyang County wind down the slopes of the Ailao Mountains in colorful, living ribbons. The paddies in Laohuzui, descending through more than three thousand feet of elevation, are the world's largest. April is the beginning of the rice-planting season, when seedlings are transplanted by hand from greenhouses to the freshly plowed terraces. Dating back more than twelve centuries, more than 10 percent of these terraces are now uncultivated, as younger generations turn to less labor-intensive ways to farm. Yuanyang County, Yunnan Province, China.

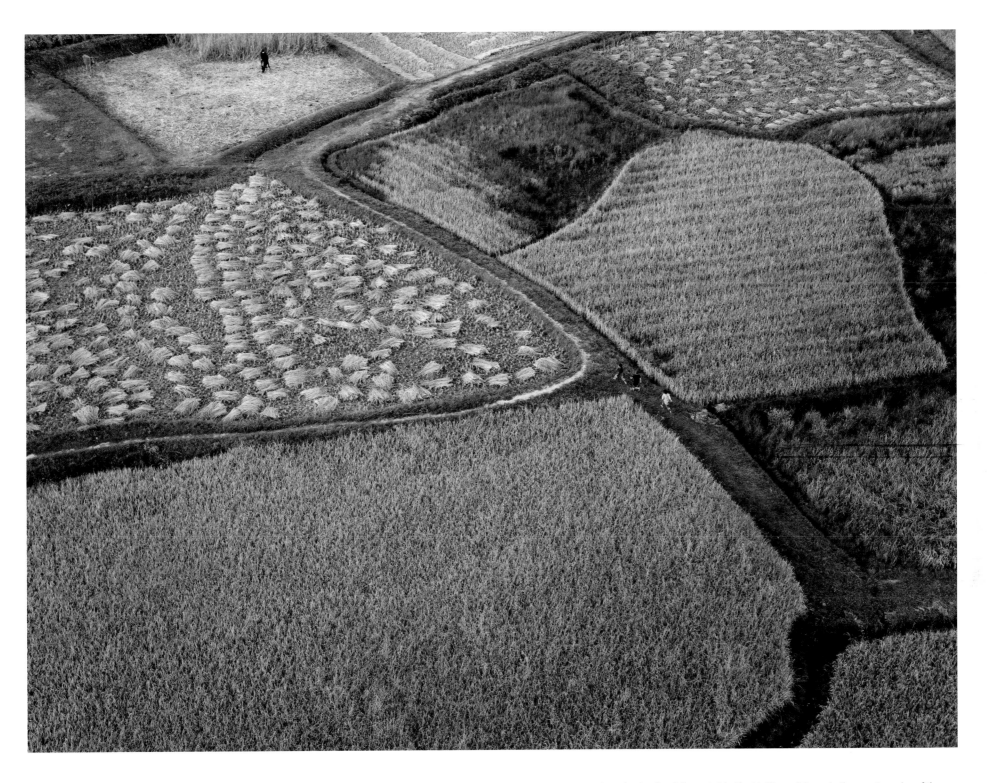

Rice being harvested on the fertile plains outside Kashi. The soil here in the western rim of the Tarim basin is rich with loess and alluvial deposits from the Kashgar River. With a view to the future, new irrigation technologies are now bringing rice farming to regions of Xinjiang that were not arable in the past. Kashi, Xinjiang, China.

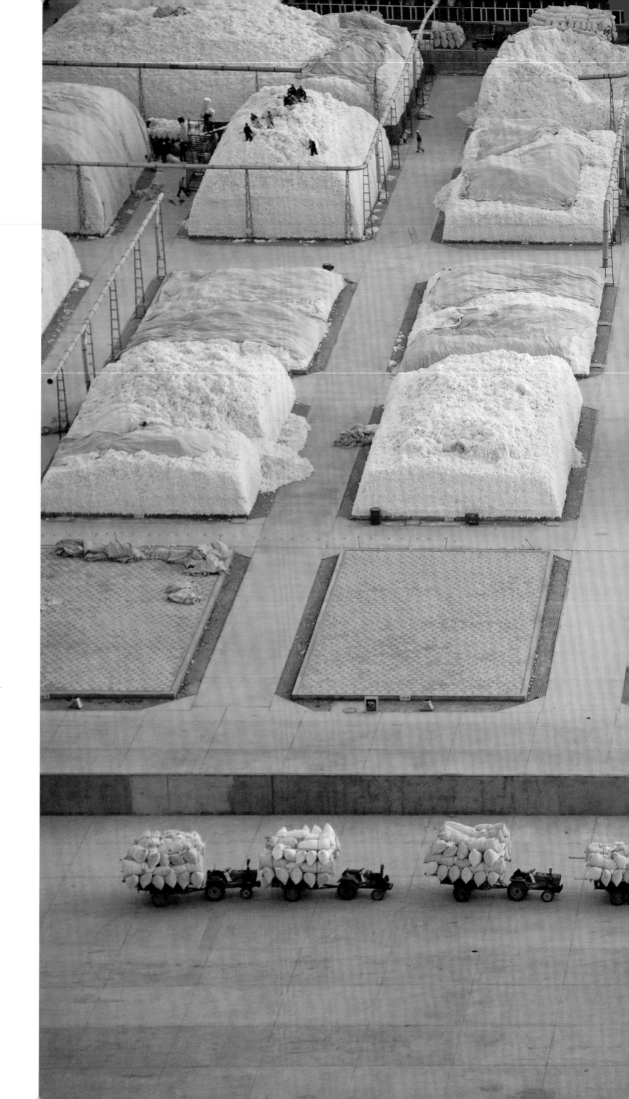

Cotton-processing factory outside Yuli in China's Xinjiang region. Raw cotton from private farms is loaded into piles to be deseeded and baled. Cotton crops require high levels of irrigation, and water scarcity in this arid region has led to resource competition. A number of Yuli smallholder farmers have joined a cotton cooperative that gives them access to water-efficient drip irrigation technology and high-quality pesticides. Young farmers are increasingly open to pursuing more environmentally friendly and sustainable farming approaches. Yuli, Xinjiang, China.

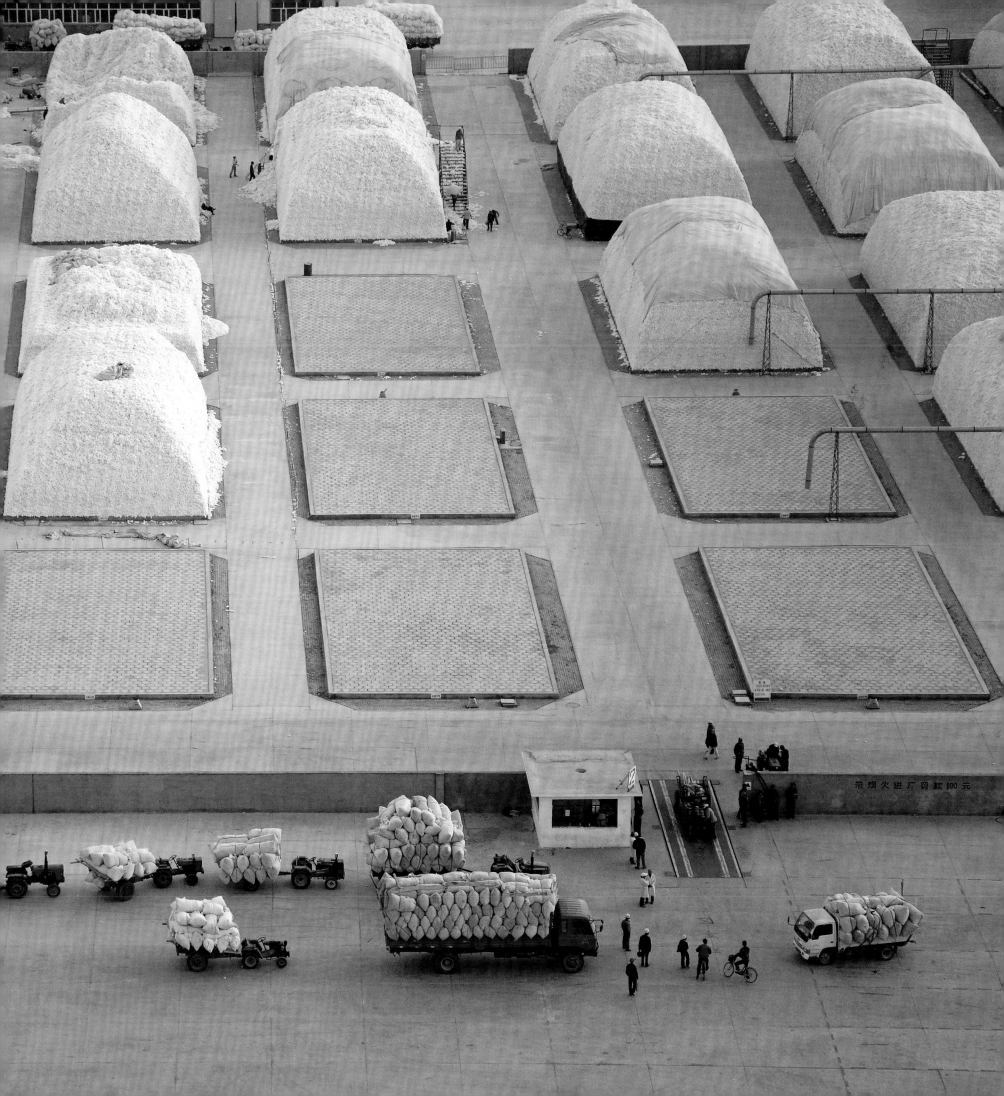

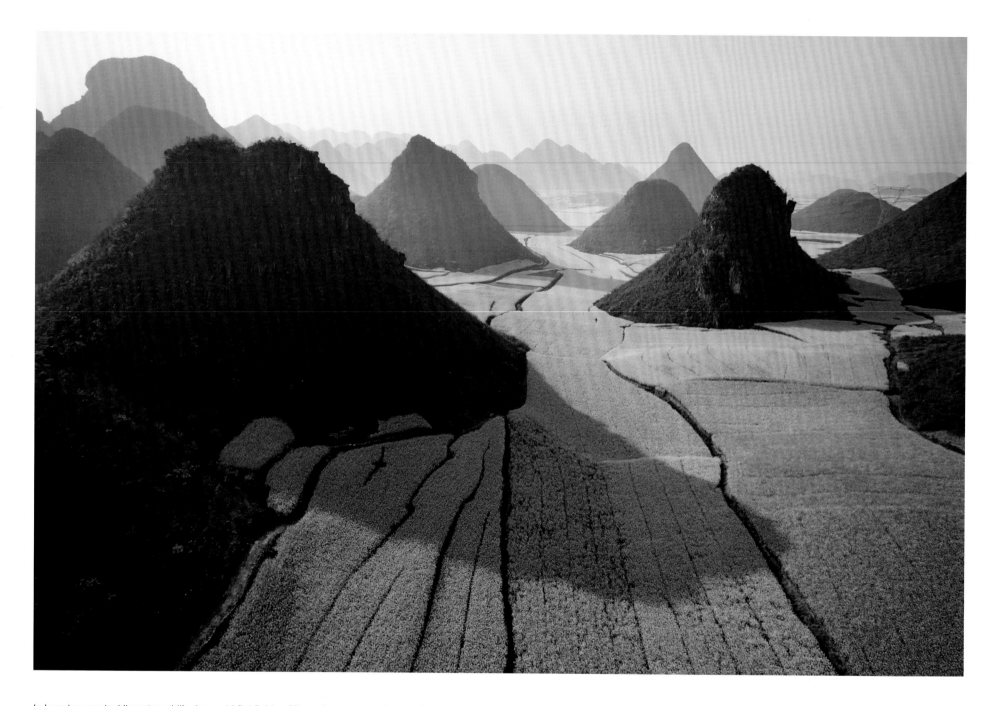

In Luoping, conical limestone hills rise amid flat fields of flowering rape plants, creating an arresting landscape of contrasting shapes and textures. Rape seed is China's largest oilseed crop, and the plants' stalks are used for architectural insulation. The plants blossom in early spring, and for a few brief weeks the countryside is illuminated by the brilliant yellow blossoms, in fields covering twenty contiguous acres. Along with tourists, traveling beekeepers flock to the Luoping fields with their hives. The honey that they harvest from rape flowers, sometimes called canola flowers, is greatly prized. Luoping, Yunnan Province, China.

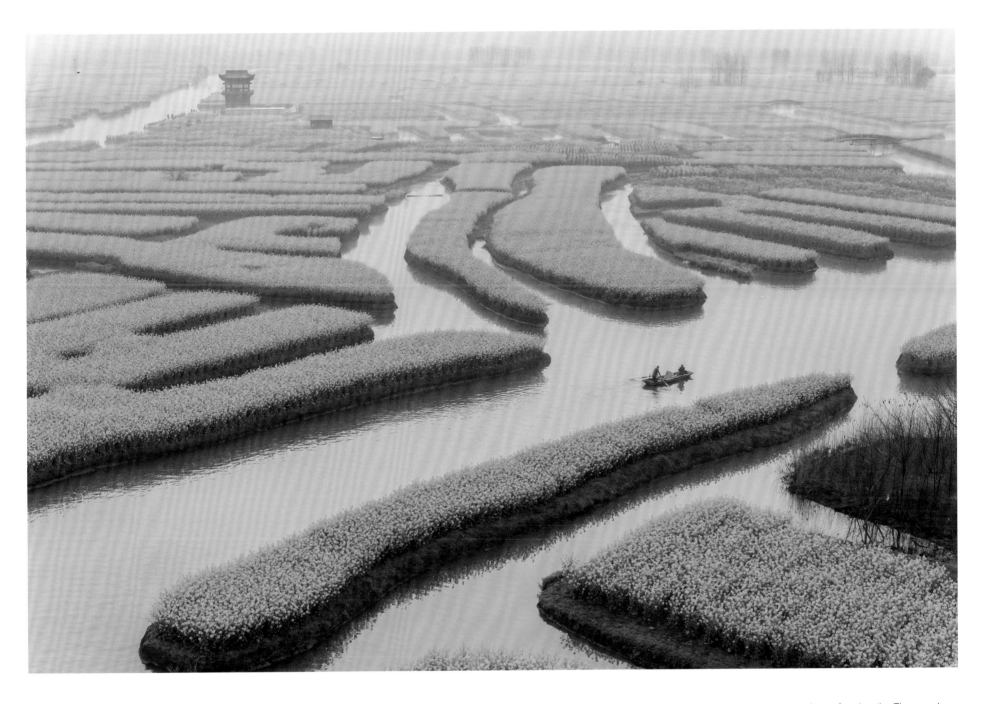

In Xinghua, waterways wind through islands of blossoming rape plants, forming the Thousand Islet canola flower fields. Sightseers can take a languid journey through the fields by boat, savoring the heady fragrance and the green-and-golden vista from the tranquility of the water. Xinghua, Jiangsu Province, China.

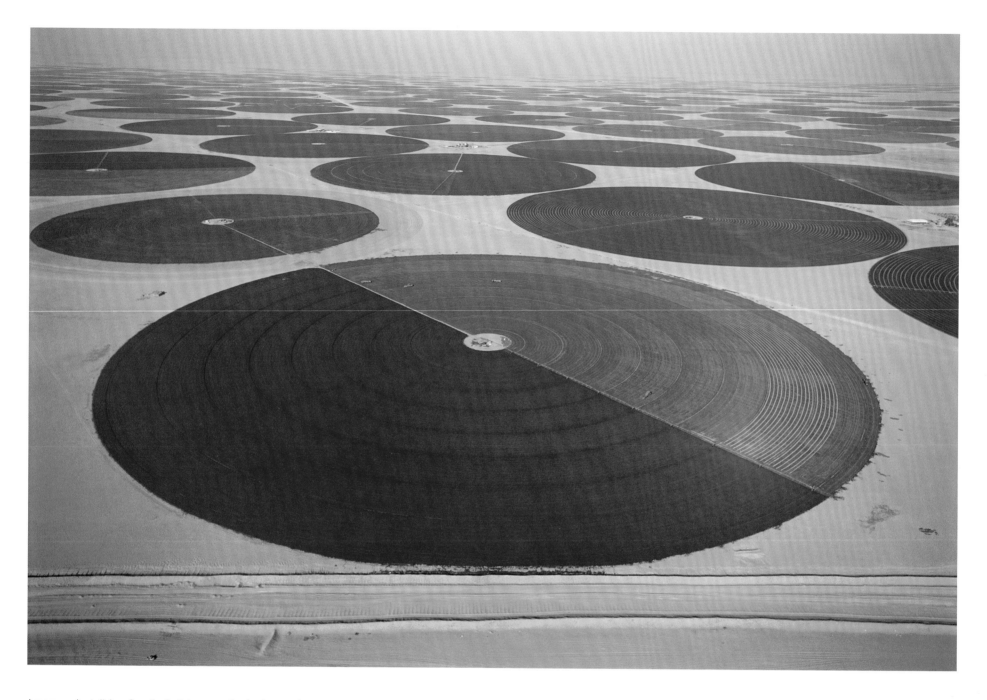

Large verdant disks of earth stretch across the horizon at the edge of the expanse of desert known as the Empty Quarter. Farmers employ center-pivot irrigation to cultivate crop circles measuring one kilometer in diameter. The wells irrigating these circles range from 100 to 200 meters in depth and extract "fossil water" that rained onto the earth thousands of years ago. The fields must be irrigated year-round to sustain a four-month crop. Nourished with fertilizers and water, the once-barren land comes to life, but its time is limited. Technology and persistence can master this arid terrain, but not permanently. After some twenty years, the wells will be diminished and the fields abandoned, to be reclaimed by the desert sands. Saudi Arabia.

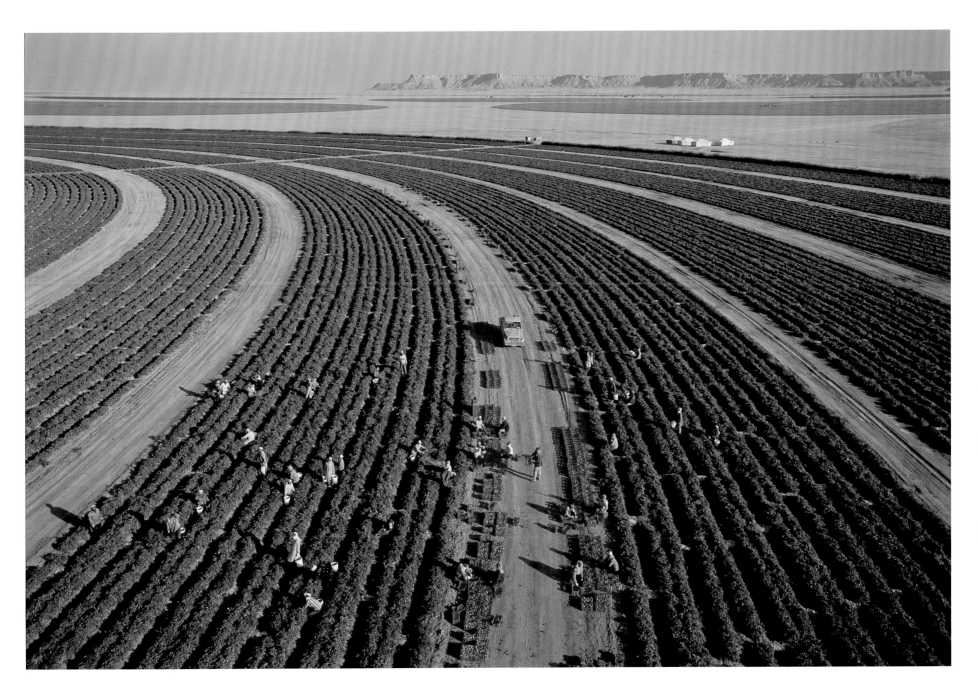

Here, laborers near Al Faw work their way through the rings of a crop circle, picking tomatoes and packing them to be shipped. Saudi Arabia.

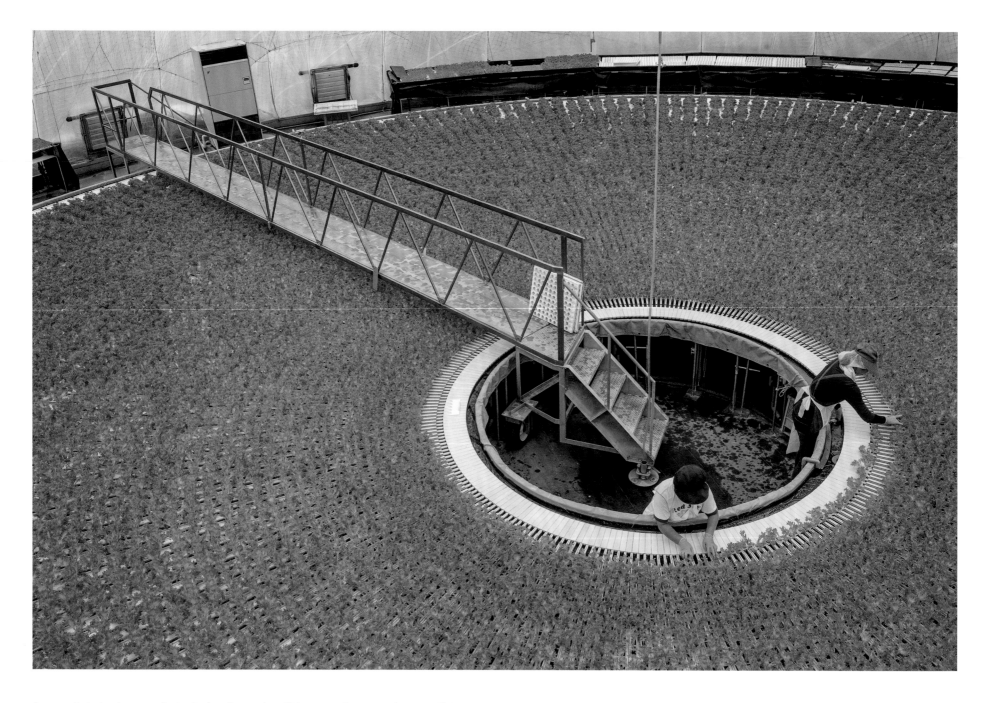

Agronomic technology predicates its function on the efficient use of space and energy. This rotating hydroponic farm (called "Granpa Dome") was designed by an entrepreneur hoping to rehabilitate Japanese agriculture through an indoor growing system with minimal reliance on pesticides and chemicals. The seedlings, nourished by a liquid diet of phosphate and other minerals, begin at the center of a water tank and gradually move outward as the mechanism rotates. Sheltered beneath a pressure dome, crops can be harvested year-round. Hadano, Kanagawa Prefecture, Japan.

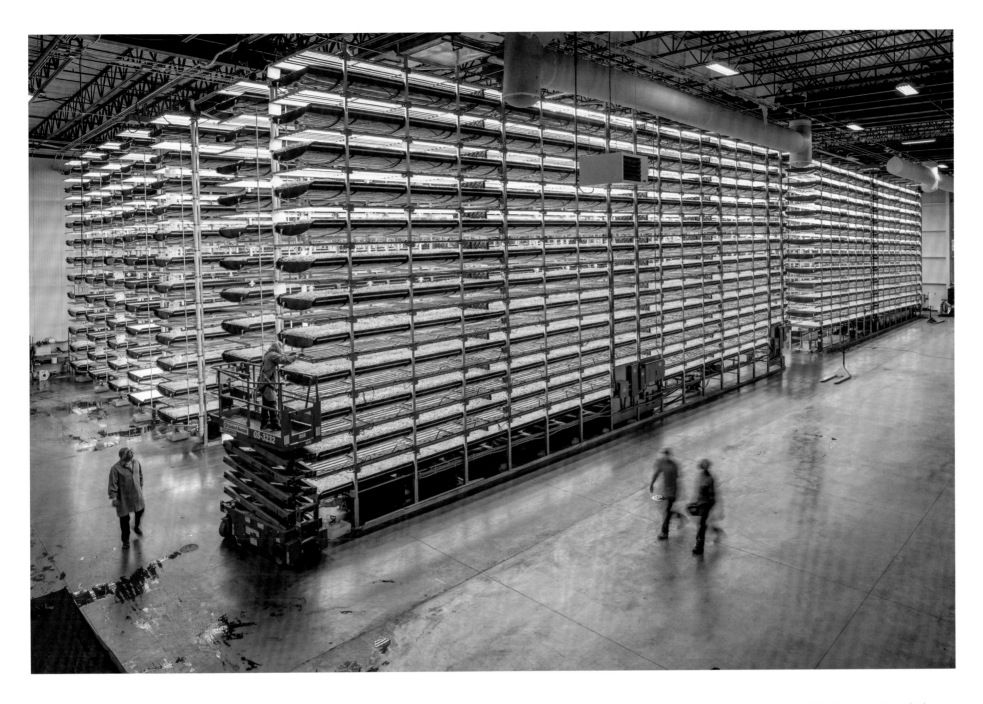

Vertical farming is one of the latest innovations in agriculture, in which plants receive only the water and nutrients they require—often just a third of the water used in traditional farming. This recent start-up, AeroFarms, uses aeroponic technology to spray the growing plants with a nutrient-rich solution, starting from seeds on mats. Vertical aeroponic farming is a promising technique where soil, water, and space are at a premium. AeroFarms, Newark, New Jersey,

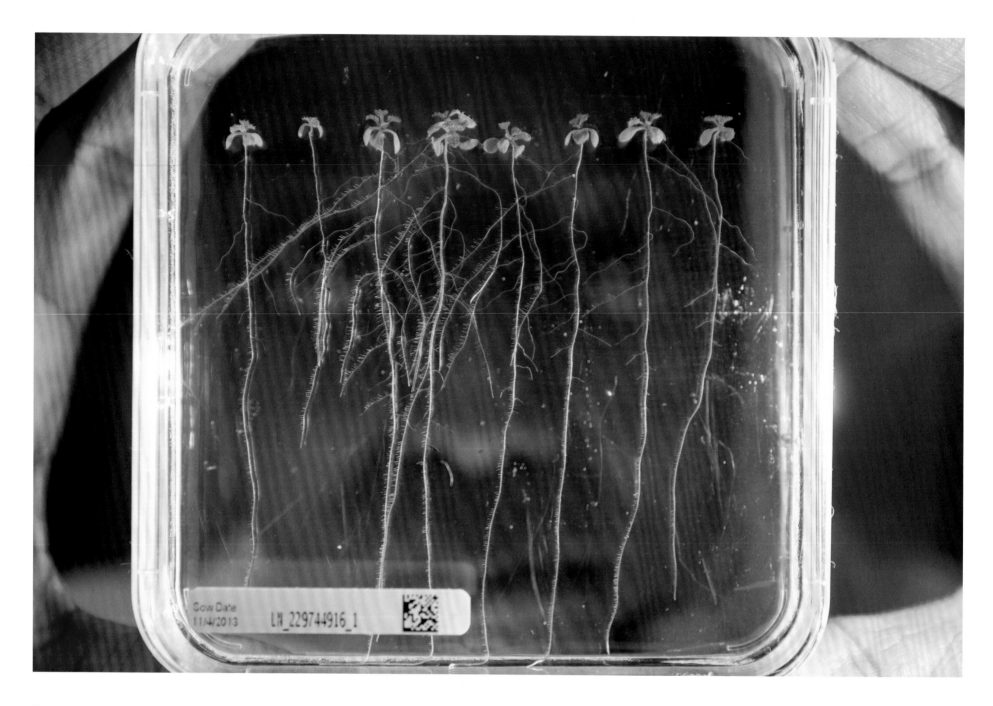

Tanyja Liles, a research associate at a Monsanto lab, examines root development in varieties of the cress genus *Arabidopsis* growing in nutrient gel. *Arabidopsis* is the lab-mouse equivalent in plant genetics research around the world, and traits developed in this genus can be transferred to other plants. Intensive agriculture, aiming to get the most food production from the least land, is one path to saving space for wildlife and ecosystems on a planet predicted to have nine billion people toward mid-century. Industrial-scale agriculture comes with a focus on breeding the most productive strains of food crops and, in some cases, transferring traits from one plant species to another, a process known as genetic modification. Research Triangle Park, North Carolina, United States.

At Germany's Leibniz Institute of Plant Genetics and Crop Plant Research, southwest of Berlin, gardeners work carefully to remove weeds and prevent plants from spreading between plots containing thousands of genetically distinct varieties of herbs and other perennial plants that don't propagate well by seed. Most of the varieties maintained here don't have the high yield or nutritional qualities of modern hybrids, but they hold genetic traits that are valuable for developing future crop strains. Gatersleben, Germany.

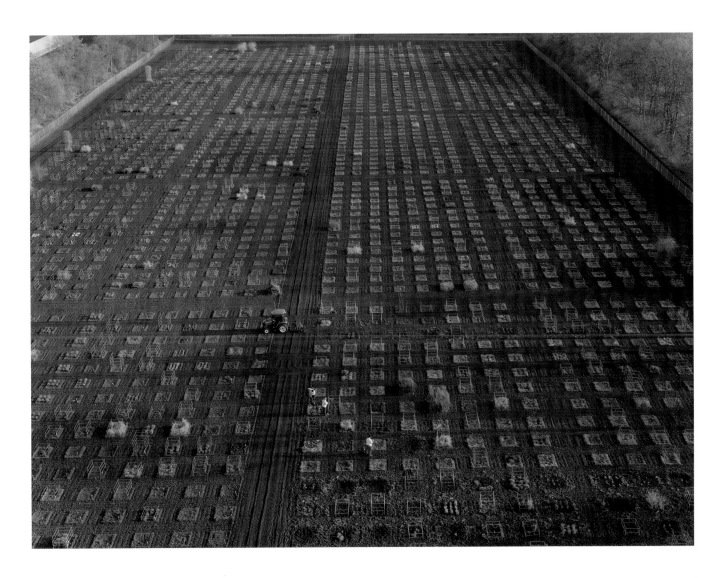

In eastern Washington State, the most productive wheat-growing region in the United States, John Kuehner, a research assistant, checks the dryness of experimental plots of this keystone grain the morning before harvest at the Spillman Agronomy Farm of Washington State University. These varieties have been developed for resistance to disease, drought, and other traits through traditional crossbreeding, not genetic engineering techniques, and are licensed to seed growers. The climate and soils of the Palouse region of Washington and Idaho produce the most bountiful rain-fed wheat yields in the United States. Pullman, Washington, United States.

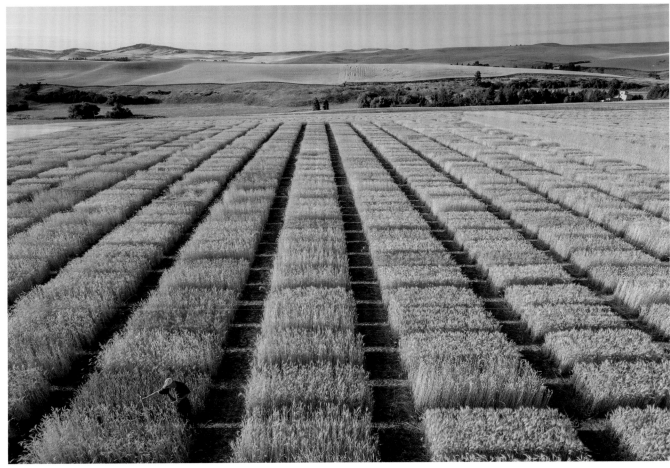

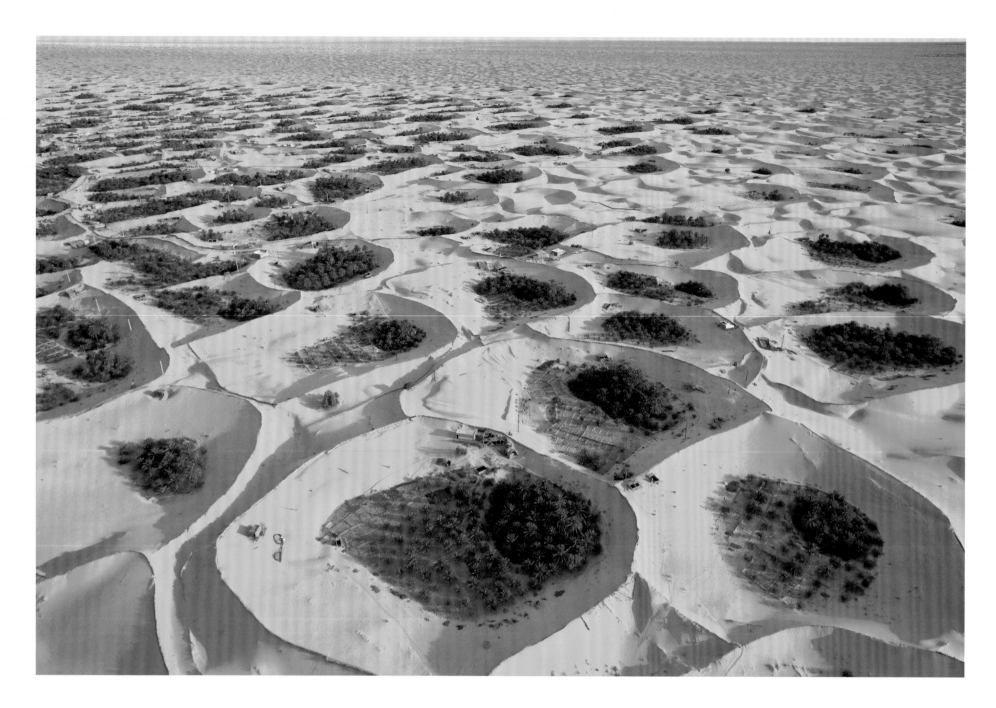

Desert gardens flourish between the dunes of the Algerian desert, a moonscape springing to life. The gardens are encircled by barriers of palm fronds that protect vulnerable plants from the wind and sandblast. Land in this hyperarid region has been irrigated for centuries by hand-dug wells that tap into shallow groundwater, an ancient *ghout* system that is rapidly disappearing due to overuse and electric pumping. Timimoun, Adrar, Algeria.

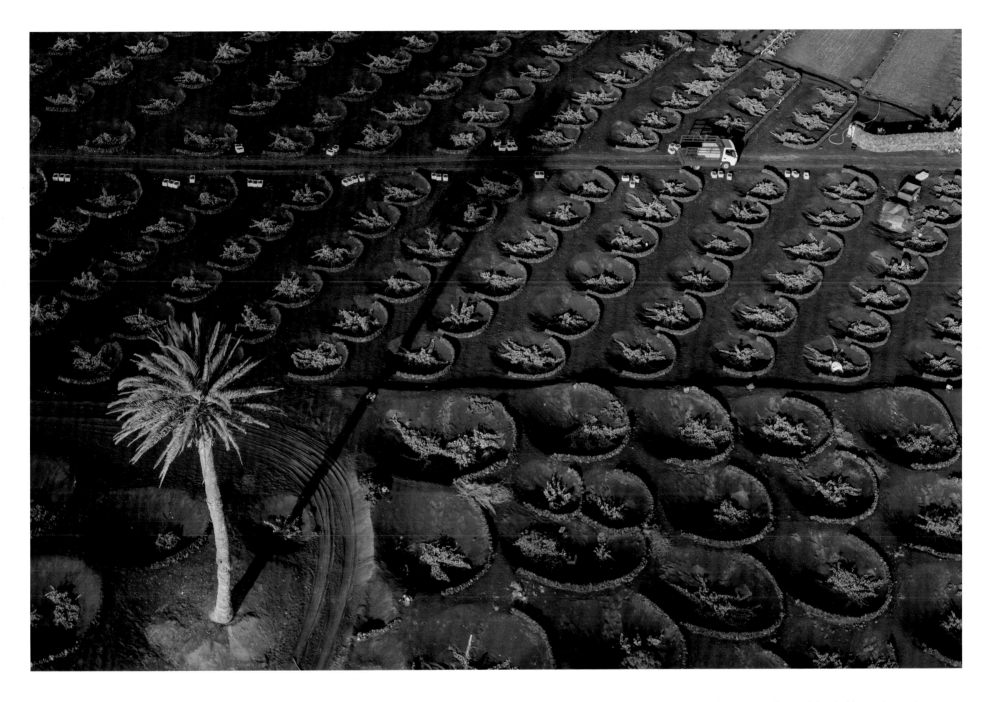

Life blooms in the ashes on the slopes of La Geria, in the Canary Islands. Human ingenuity has triumphed in the face of destruction visited on the land after the massive eruption of the Timanfaya volcano in 1730. Forced after the eruption to abandon their staple crop of cereals, farmers focused their endeavors on grapes. Grapevines are seeded in small craters that are dug into the soil and capped with half-moon stone barriers on the wind-facing edges, which protect the plants from gusts blowing in from the Atlantic. The black soil absorbs and retains the heat of the sun, providing the vines with nourishing warmth. The local white wine of this region is known as Malvasía Volcánica. Uga, Lanzarote, Canary Islands, Spain.

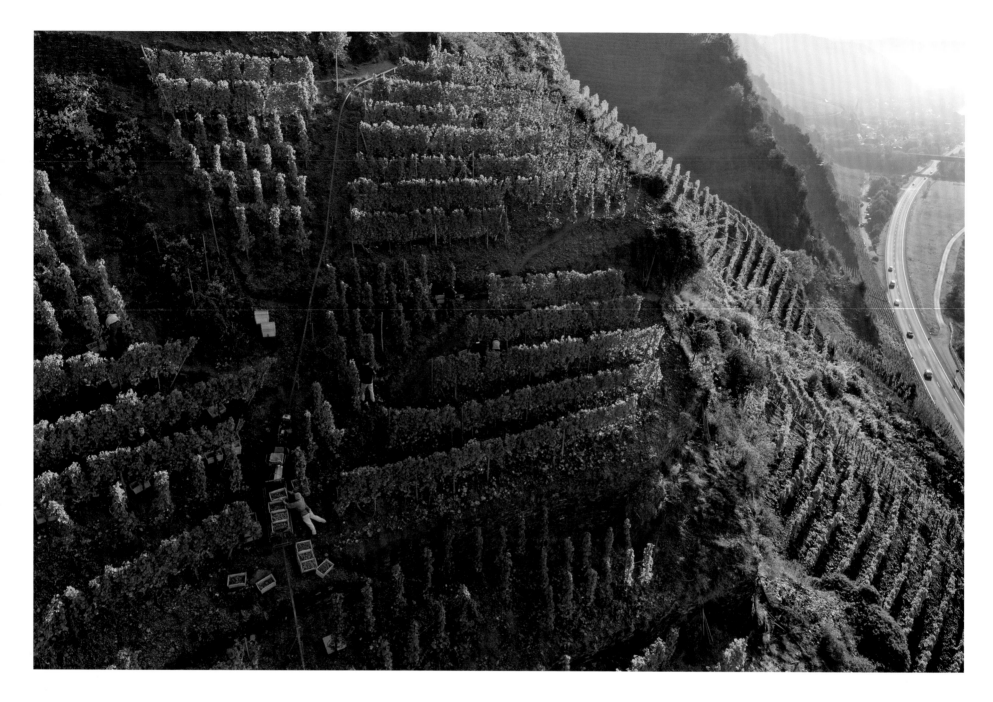

The hills of the Calmont vineyard rise dramatically some 290 meters above the Mosel River, with inclines of up to sixty-five degrees, making it the steepest vineyard in all of Europe. This wild and mountainous terrain is ideally suited to viticulture. The inclination of the land angles the plants toward the sun, optimizing the amount of light and warmth that they receive. The slate walls that cross the hill in horizontal steps absorb heat during the day, keeping the grapes warm for much of the night. The harvest is labor-intensive, with workers carefully treading the precipitous slopes to gather the grapes by hand. This particular vineyard within the site is owned by Günter Leitzgen and has been in his family for four generations. Grapevines have been cultivated in these hills continuously since Roman times. Bremm, North Rhine–Westphalia, Germany.

A patchwork of water and the raised green beds of a banana plantation emerge from the Nyabarongo wetlands, a series of marshes in the Nyabarongo River's floodplain. The ecosystem of Rwanda's longest river is under siege from the country's high-density population and its heavy dependence on agriculture. The government is offering farmers incentives to conserve natural resources and to reforest. Deforestation and poor agricultural practices are the primary causes of the soil erosion that has muddied the Nyabarongo's water. Rwanda.

Cabbage cultivators etch their trails into the soil of John de Boer's family farm. Cabbages are farmed mainly in the province of Noord-Holland, owing to its chalky mineral-rich soil. The cabbages are planted in May, and once harvested they will be sold throughout Europe and the Middle East. 't Veld, Noord-Holland, Netherlands.

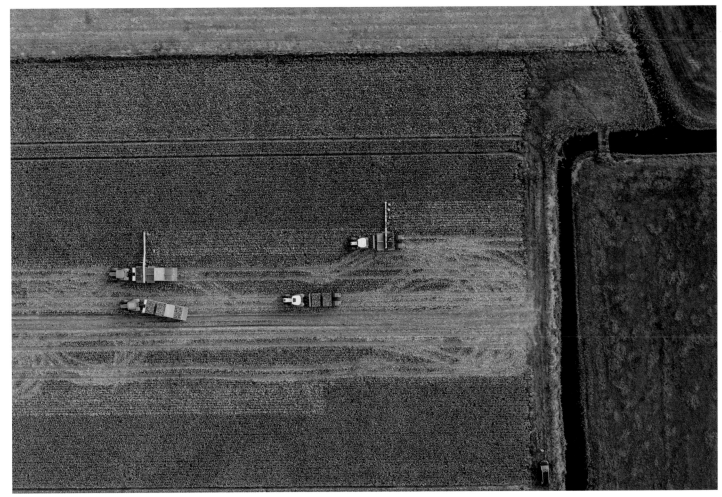

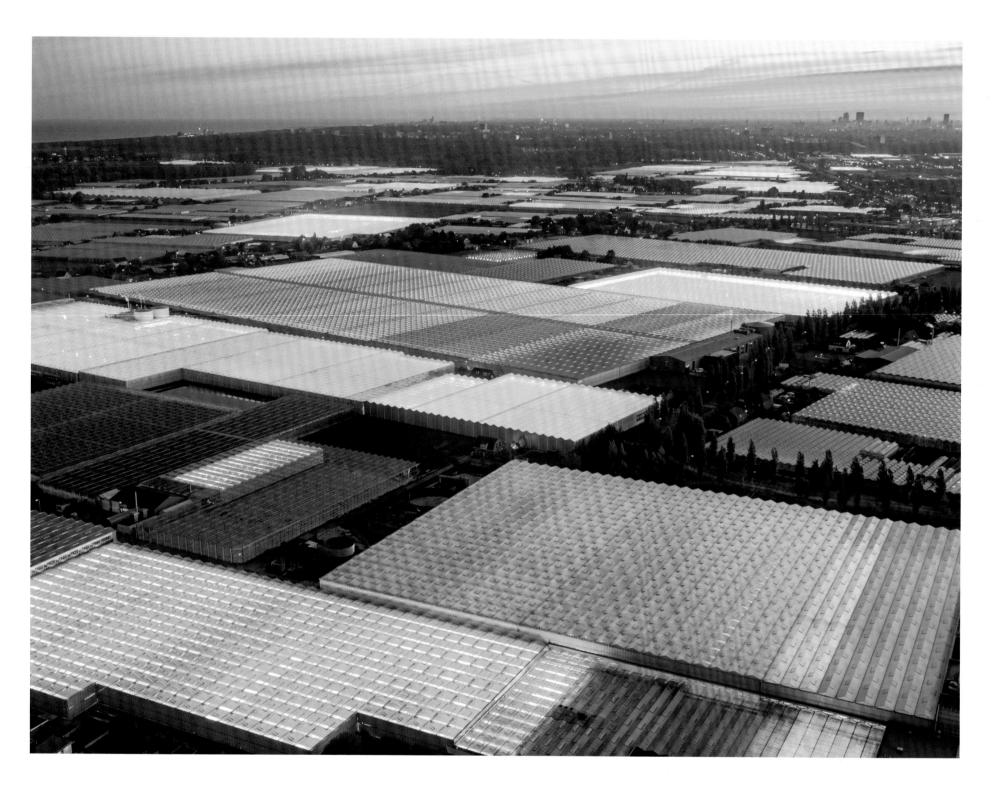

The richly hued amber and fuschia lights of the Koppert Cress greenhouses have a festive appearance but have been designed to maximize growth efficiency and minimize light pollution. The Netherlands micro-vegetable nursery uses pink spectrum LED lighting and constructs its greenhouses with hammered glass designed to deflect light back to the plants. Koppert has enjoyed international success with environmentalists and gastronomes alike, producing greens that are in demand from Michelin-star chefs throughout the world. Monster, Zuid-Holland, Netherlands.

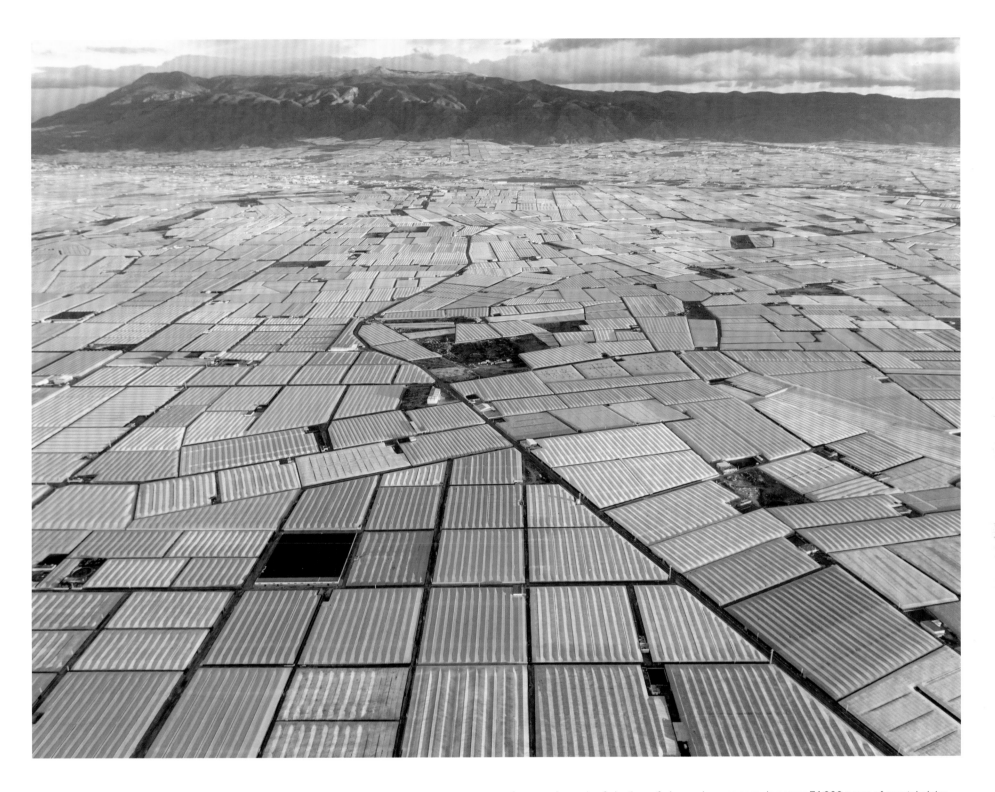

A grooved mosaic of plastic-roofed greenhouses sprawls across 74,000 acres of coastal plains in southern Spain. Huge amounts of produce are inexpensively grown here and sold throughout Europe. The primary crops are tomatoes, sweet peppers, cucumbers, and eggplants. Many of the plants are grown hydroponically with recycled water. The intensive agricultural system has resurrected the economy of the Almería region, but it has many detractors who cite its depletion of aquifers and contribution to nitrate pollution in the soil, as well as exploitation of migrant laborers. San Augustín, Andalucía, Spain.

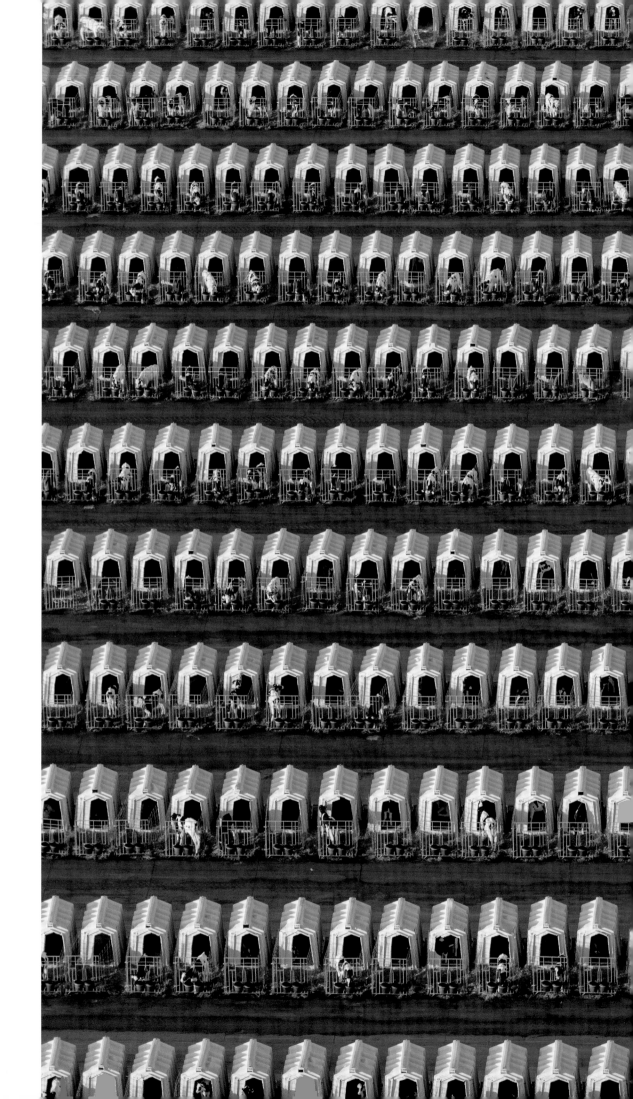

At a Wisconsin mega-dairy's calf farm, thirty-three hundred calf shelters line the landscape. Long known as America's "Dairy State," Wisconsin has seen a shift in farming fortunes. Small dairy farms are closing at a record rate, replaced by larger factory-style operations like Milk Source, which operates dairies throughout the Midwest. Calves, all conceived via artificial insemination, shelter in these Calf Source hutches from birth until they are six months old, then transfer to one of Milk Source's heifer farms. Greenleaf, Wisconsin, United States.

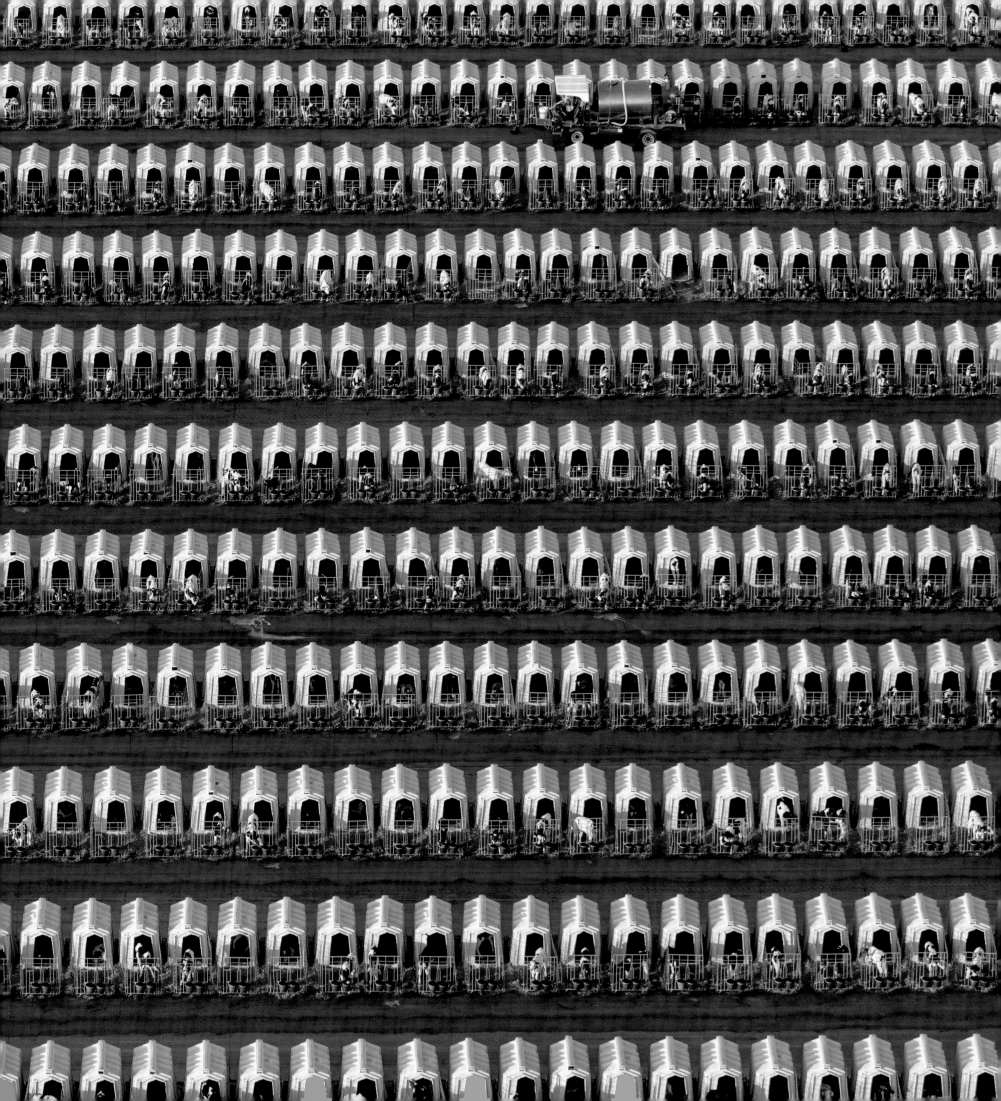

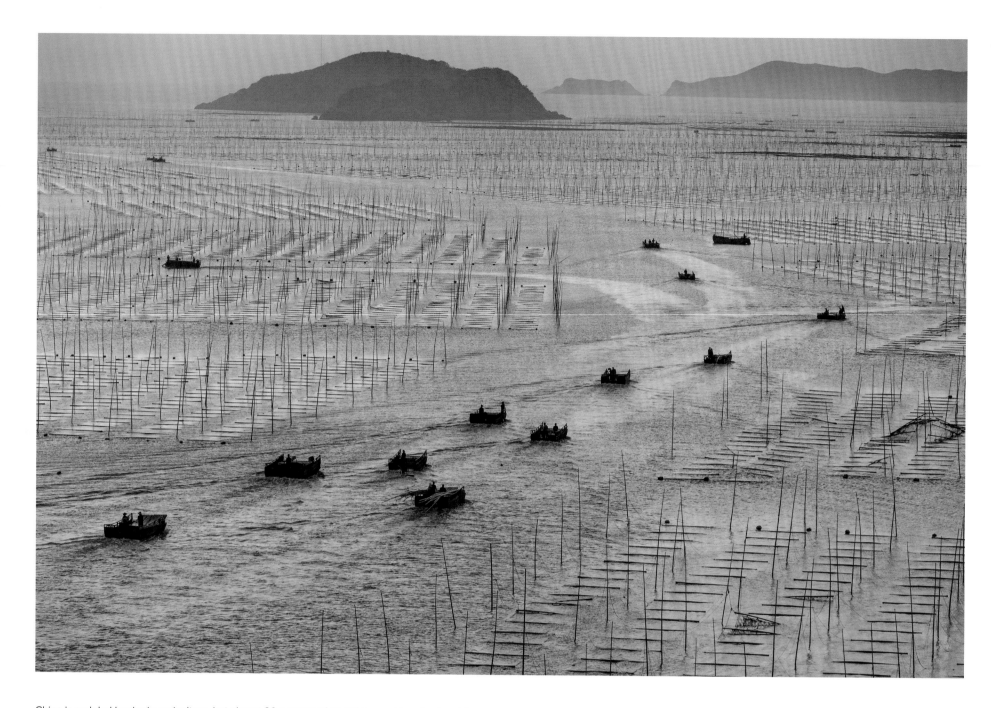

China is a global leader in agriculture, but almost 90 percent of its soil is considered not arable. To accommodate continued growth, China makes intensive use of the sea through a mix of aquaculture methods, often farming fish, seaweed, and shellfish side by side, as here along the shallow muddy coastline of Fujian Province. The small boats are heading out to the north end of the bay to harvest farmed *tsai* seaweed, a staple in soup. Xiapu, Fujian Province, China.

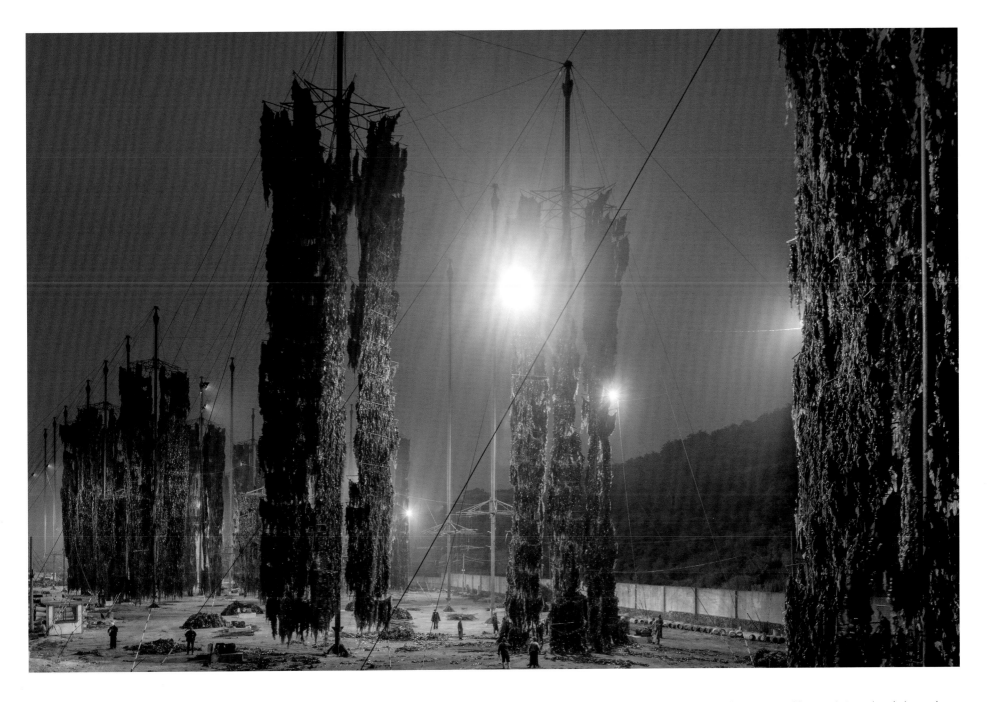

Hundreds of miles north, one sign of the scale of the seaweed harvest is towering drying racks that spin in the wind. Air-dried seaweed can get a higher price, although Steinmetz noticed that workers hauling seaweed to and from these racks often dragged it across the barren ground. Ningjin, Shandong Province, China.

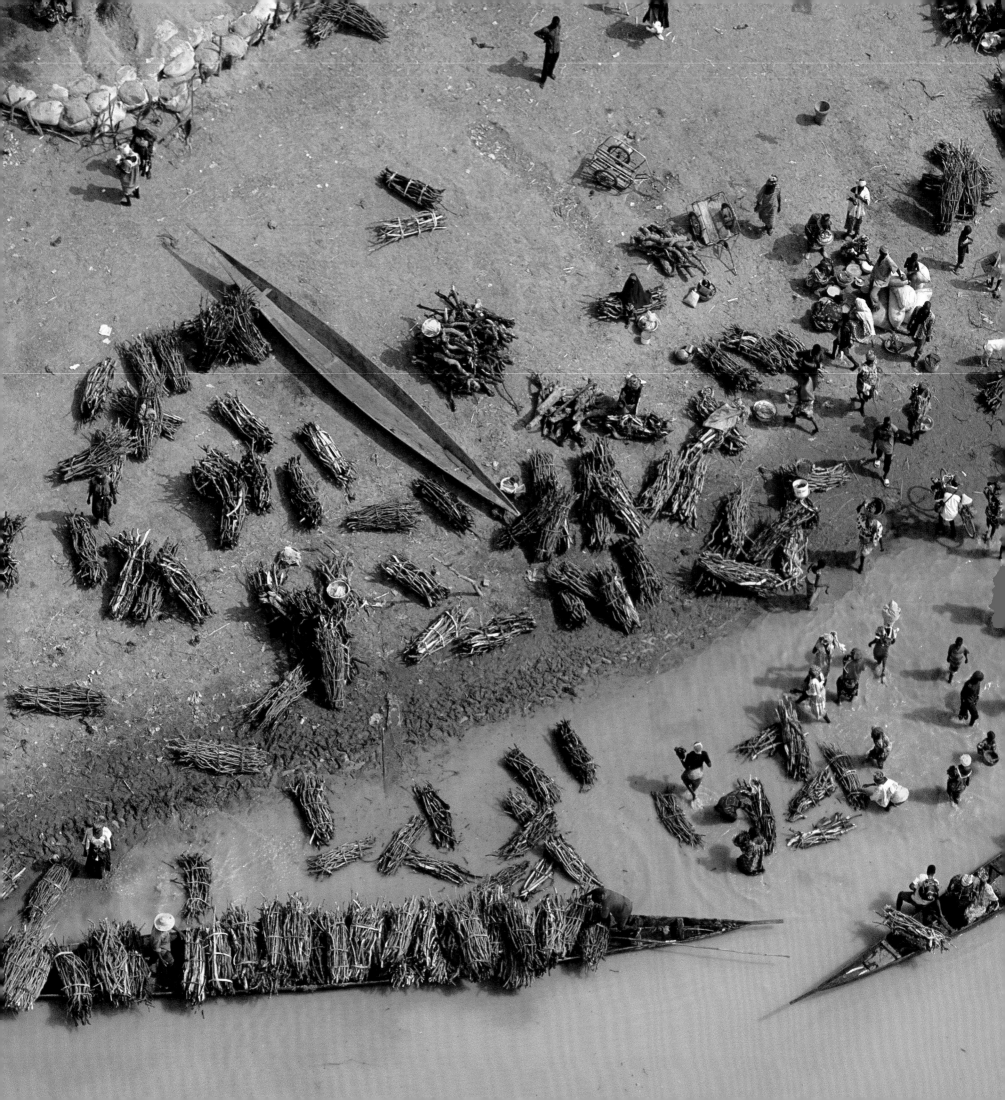

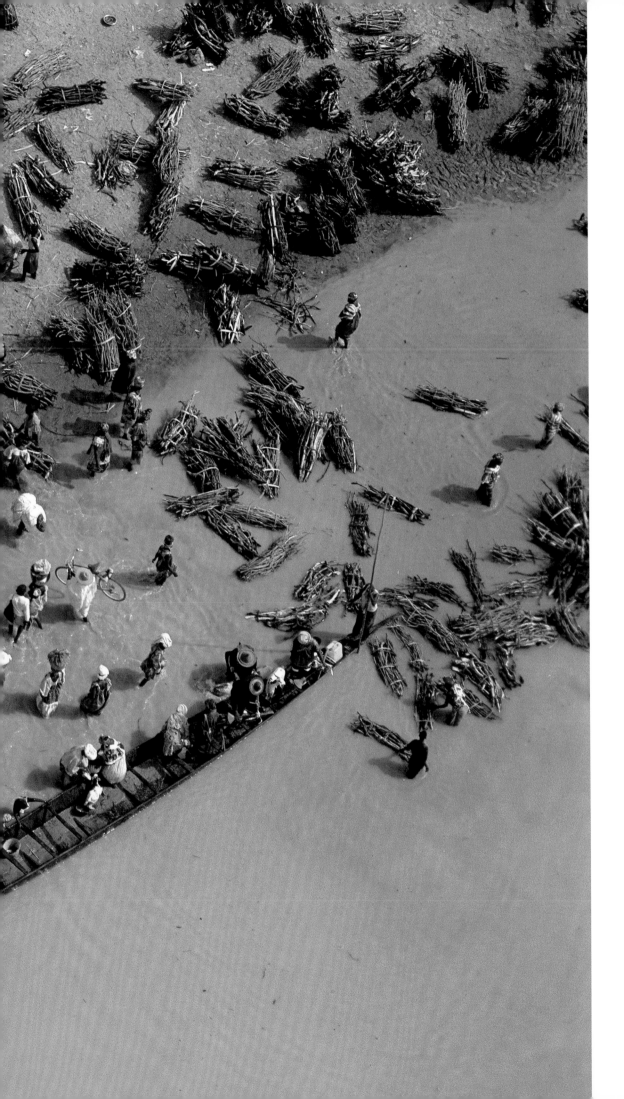

Men and women along the Bani River unload bundles of firewood to sell at Djenné's market. Located in the Niger floodplain, Djenné grew into a central merchant city in the ninth century and flourished as a meeting place for traders. Once a week, thousands of traders descend on the Monday market at the great square in the shadow of Djenné's ancient mosque. Demand for wood used in cooking fires is leading to deforestation of the surrounding plains. Djenné, Mali.

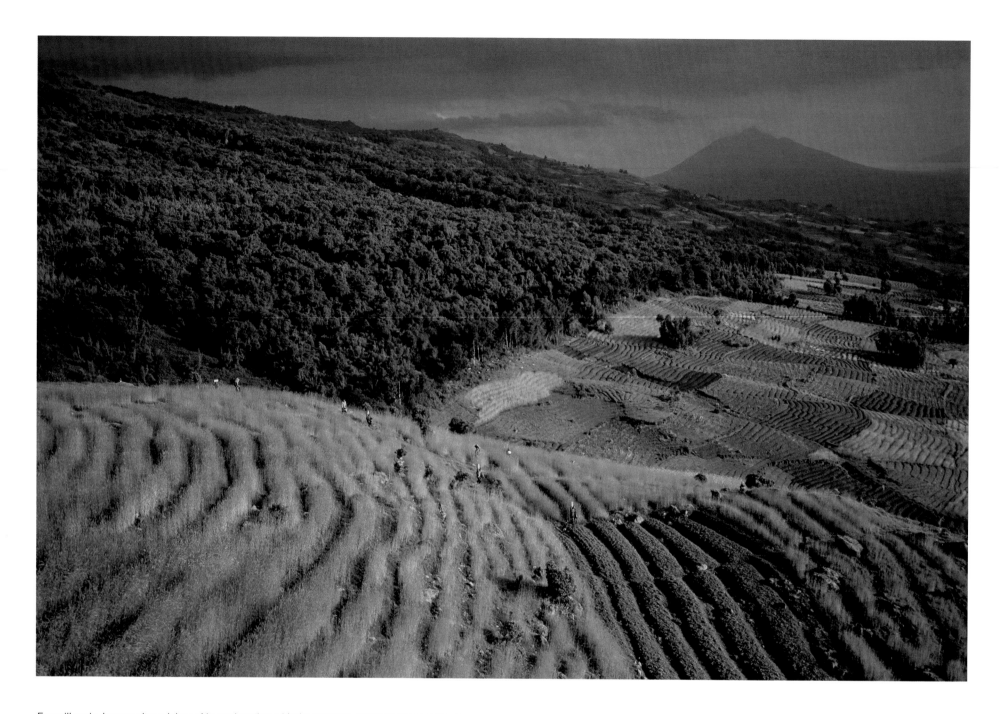

For millennia, humans have labored in conjunction with the seasons and with one another to coax crops from whatever land is at hand. When the environment is unyielding, humans must adapt. In densely populated Rwanda, there are close to eight hundred people per square mile. Many farms are under an acre in size and competition for land is intense. Here, villagers walk through terraced fields that push up the mountainside all the way to the protected Parc National des Volcans, sanctuary for the endangered mountain gorilla. Rwanda.

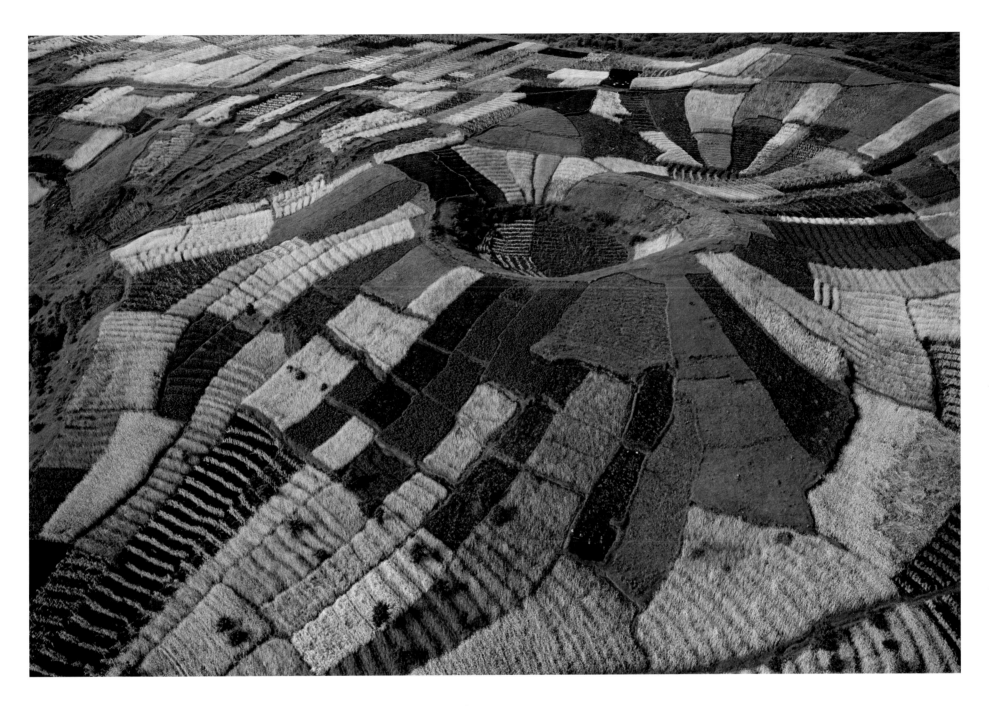

Tightly patched fields of wheat carpet the cone of a small volcano near the Virunga Mountains. With a growing population comes an ever-increasing need for arable land. Seven out of every ten Rwandans work in the agricultural sector, and some of the main challenges farmers face are land degradation and soil erosion. With its dependence on rainwater and seasonal consistency, Rwanda is increasingly vulnerable to the effects of climate change. Rwanda.

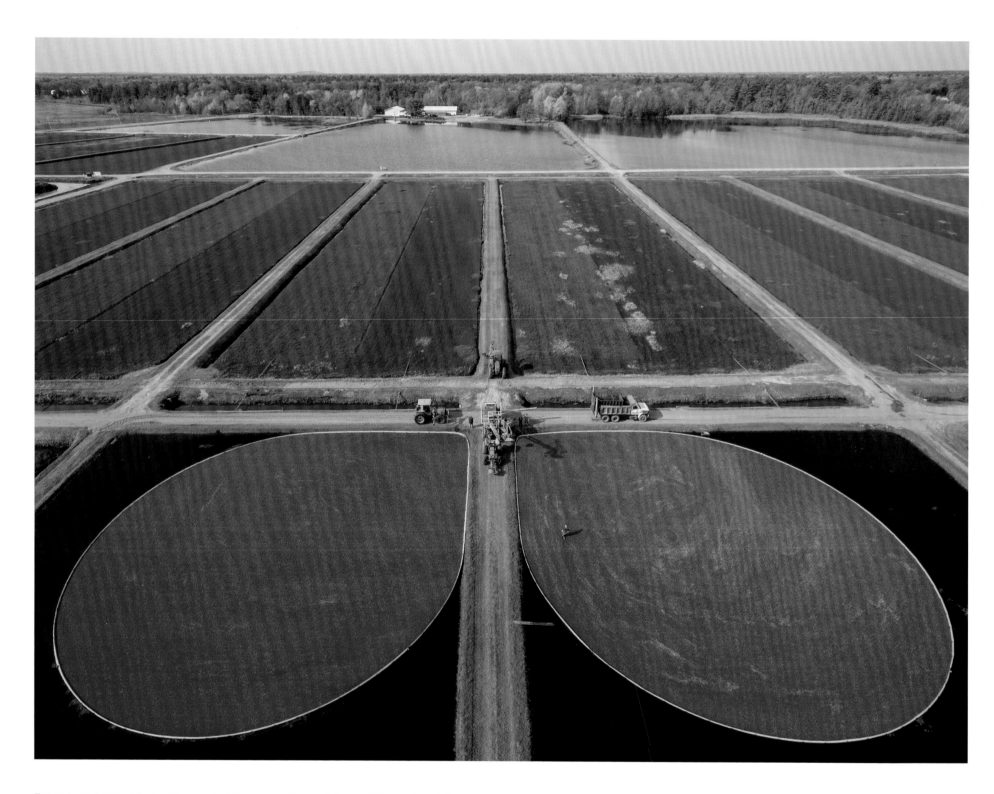

Twin ruby-red drops of color blaze against the surrounding earth tones of Ocean Spray's Bennett family cranberry farm. The cooperative's members are the company's only shareholders, and each member receives a prorated share of profit dividends. Every cranberry contains a tiny pocket of air; near harvest time the bogs are flooded with water and the berries float to the surface, making it easier to collect them. Though cranberry cultivation began in Massachusetts, more than 60 percent of the national crop is now grown in Wisconsin. These flat and rectangular bogs are easier to irrigate and harvest than their New England counterparts. Cranberry consumption in the United States peaks each year at Thanksgiving, and the berry is one of only a handful of fruits that are native to North America. Cranmoor, Wisconsin, United States.

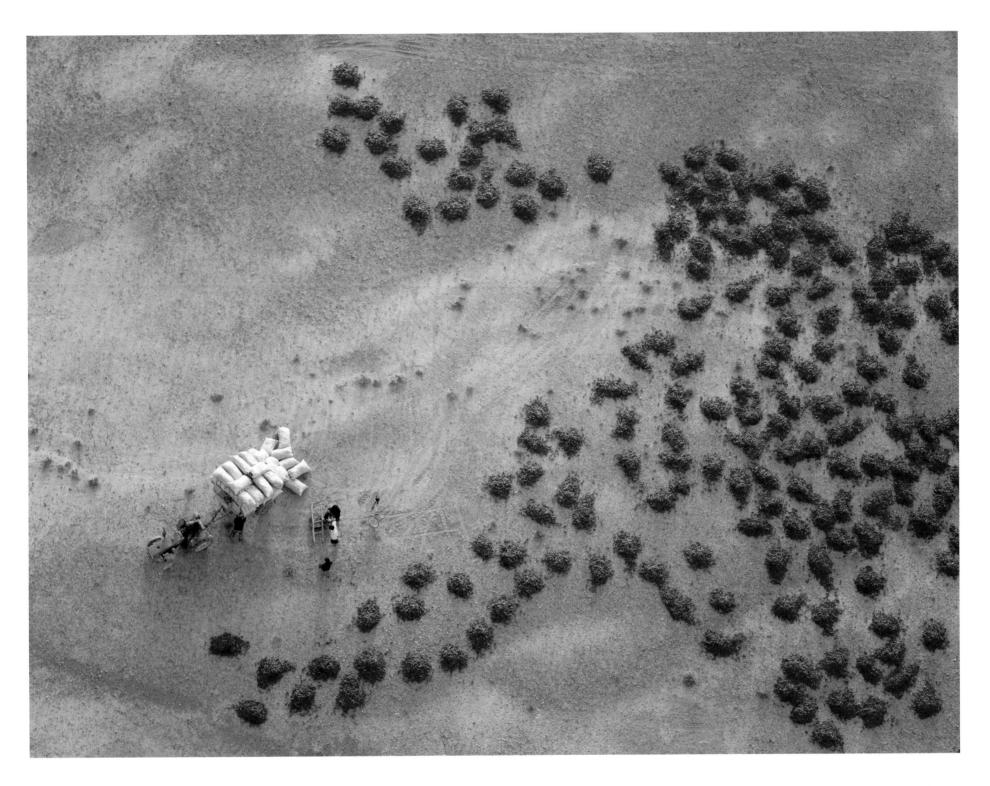

Chinese red peppers, also known as Tien Tsin chile peppers, laid out to dry in the desert after harvest. The peppers retain much of their bright red color after being cooked, and their fiery hue serves as a warning that they should be consumed with caution. Baicheng, Xinjiang, China.

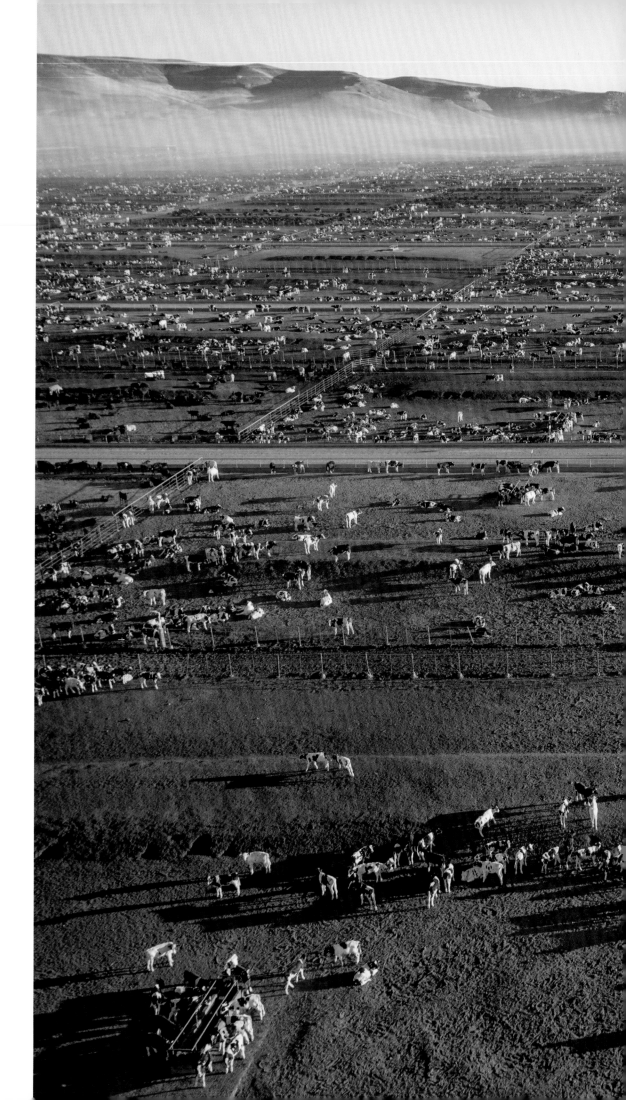

The Simplot cattle feedlot in Idaho covers some 750 acres. The Simplot Company started out in the potato business and grew into an empire, eventually becoming the largest national shipper of fresh potatoes and a primary source for McDonald's french fries. This massive feedlot, which can support 150,000 cows, is the result of founder J. R. Simplot's realization that by-products from his potato machines could be used to feed cattle. Grand View, Idaho, United States.

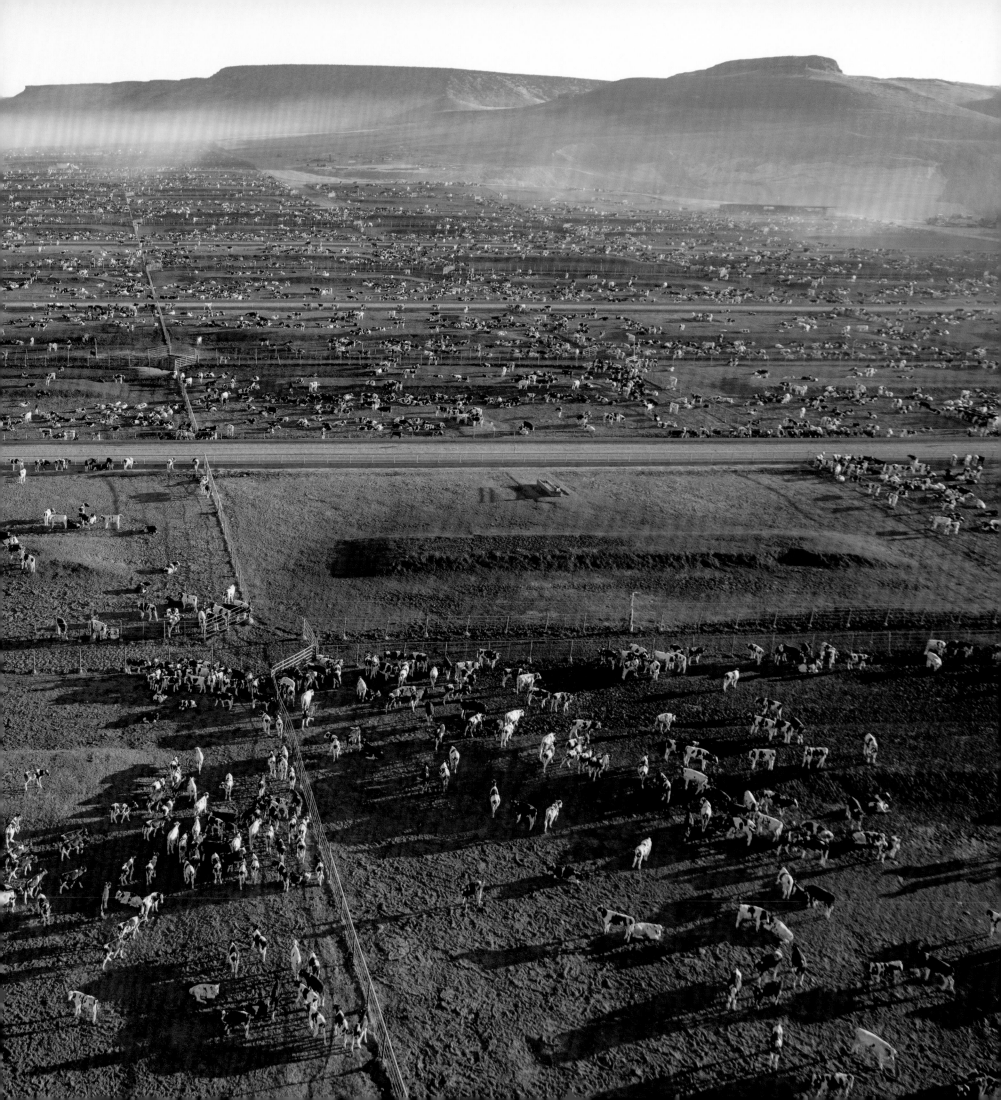

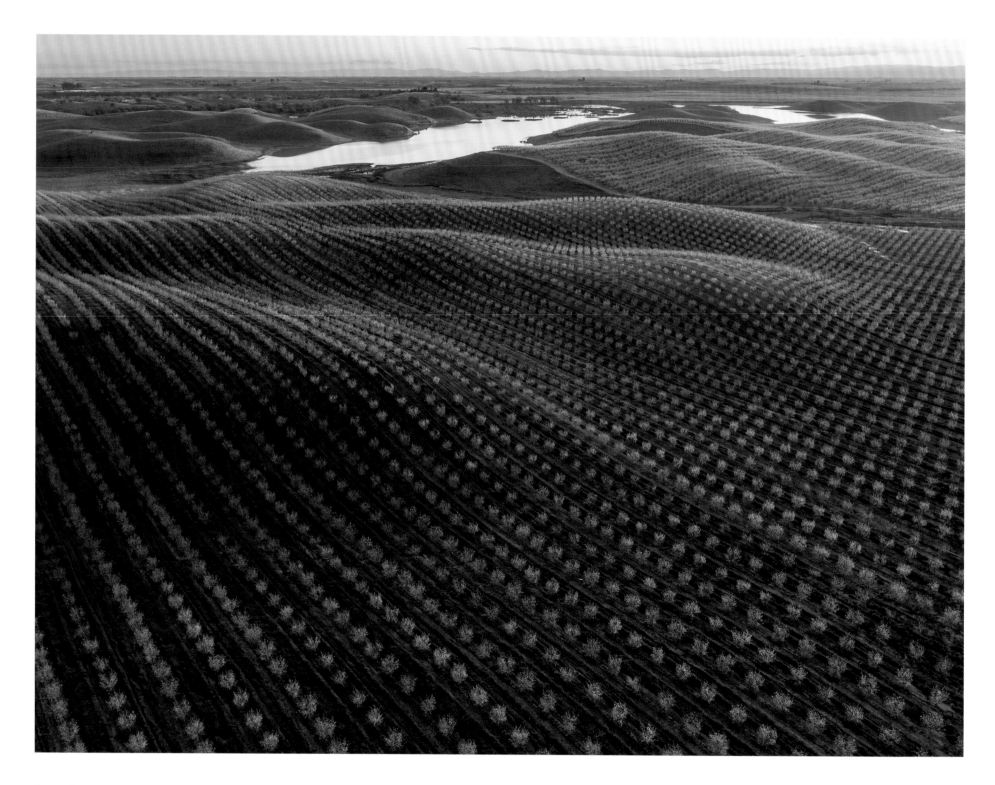

Rows of almond trees extend to the horizon, imposing an impressionistic precision on the landscape. Eight out of ten almonds consumed worldwide are grown in California. The demand for pollinators of almond flowers vastly exceeds the capacity of California's hives, so each February during blooming season bees are trucked in from apiaries all over the country. It has been estimated that 85 percent of all commercial bee colonies in the United States will visit California's almond orchards. Colony collapse disorder has created a honeybee shortage, and as a result an interdependence has arisen between the almond and commercial beekeeping industries. American apiarism is on the rise as pollination income increases, but there is concern among apiculturists about the long-term impact on bee health of the shipping and year-round pollination. Waterford, California, United States.

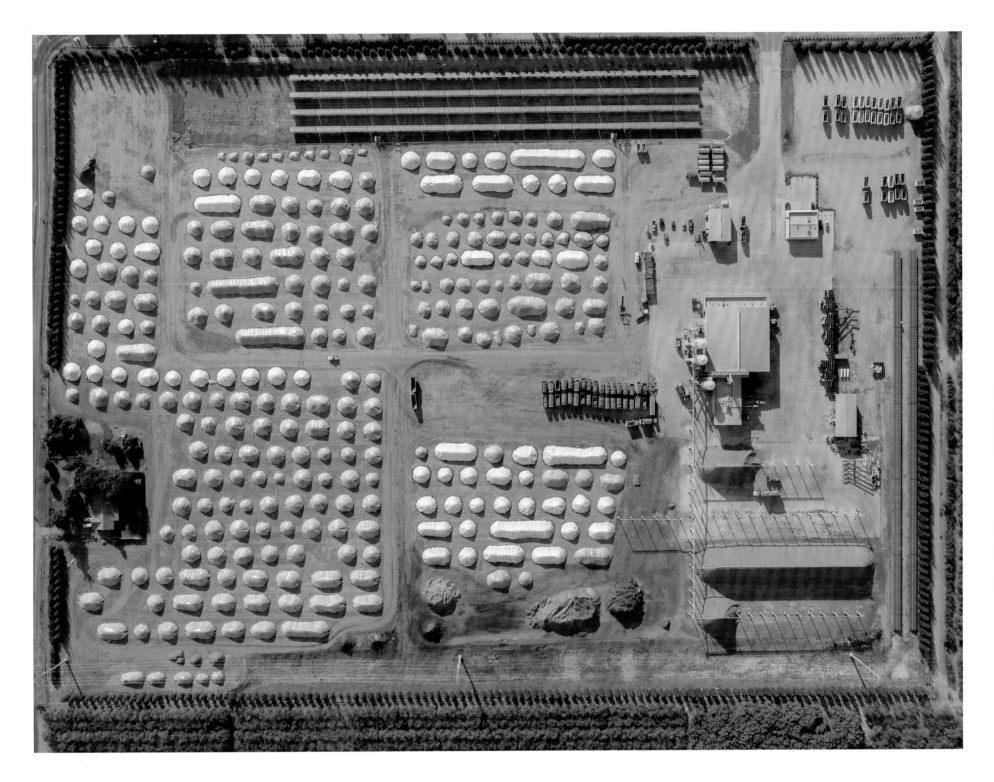

Almond storage yard of the Salida Hulling Association, where twenty-eight million pounds of recently harvested almonds lie covered by tarps until they can be shelled and hulled. Salida, California, United States.

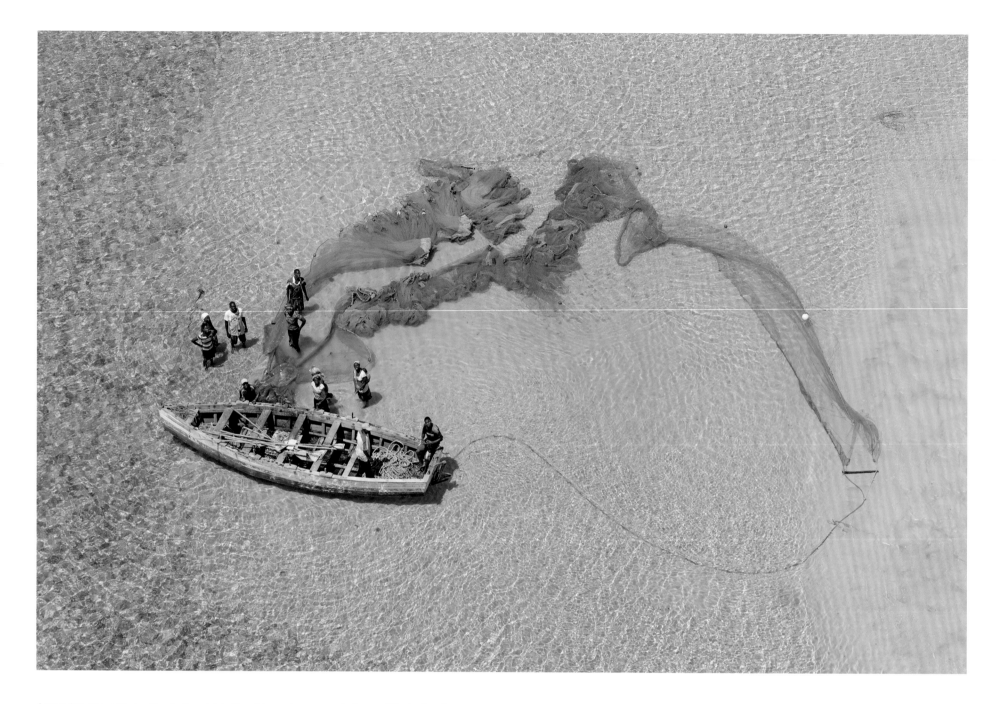

A wooden dhow carries the day's catch in the shimmering azure shallows of the Indian Ocean at low tide. Islanders from Benguerra fish the low spring tides, working in teams to haul in long, narrow nets. Benguerra is one of five islands that make up Mozambique's celebrated Bazaruto Archipelago, home to some two thousand species of marine life, from humpback whales to the endangered, manatee-like dugong. Declared a national park in 1971, Bazaruto is one of the largest marine parks in the Indian Ocean, and efforts continue to coax the region toward a conservation-led economy. Illegal fishing and the collateral damage caused by gill nets pose the most immediate danger to the ecosystem. In 2017, the National Administration of Conservation Areas of Mozambique joined with the NGO African Parks in an organized move to encourage sustainable tourism while protecting the reefs from overfishing, anchor damage, and sea grass destruction. Inhassoro District, Inhambane Province, Mozambique.

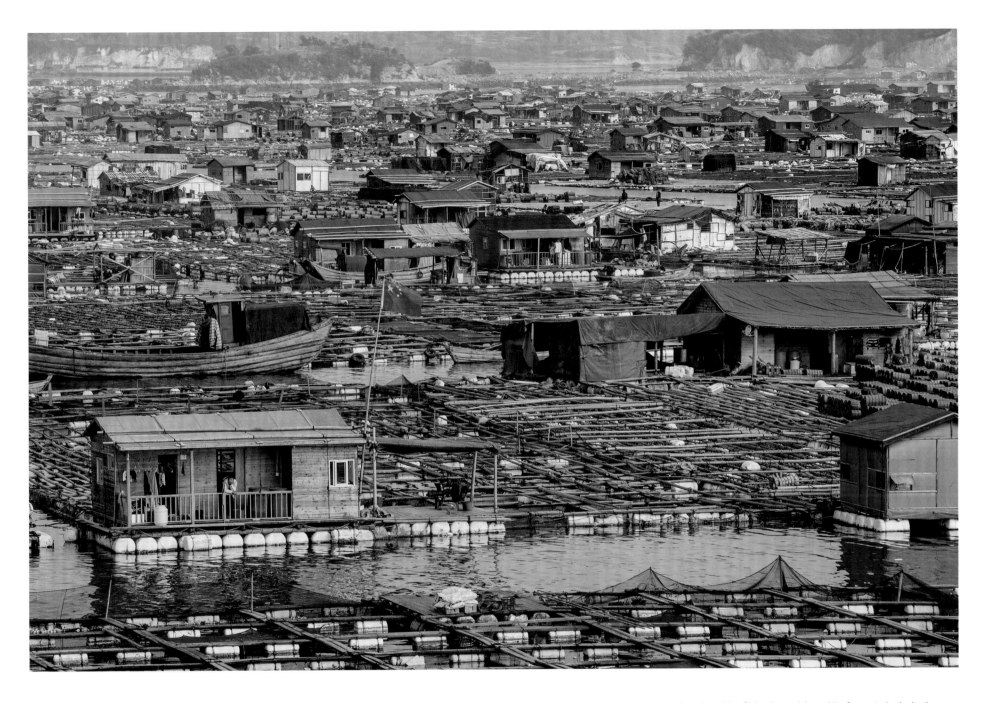

With only 10 percent of its land considered arable, China has widened its focus to include the sea as an area of agricultural expansion, and the Chinese now produce almost 70 percent of the aquacultural output worldwide. This floating village near Dong An serves as a seasonal home for families raising abalone and sea cucumber in cages that hang beneath a maze-like grid of floating walkways. This community has been aquafarming for more than fifty years, and China's history of aquaculture dates back millennia. It is believed the Chinese began farming freshwater carp before 1000 BCE. Xiapu, Fujian Province, China.

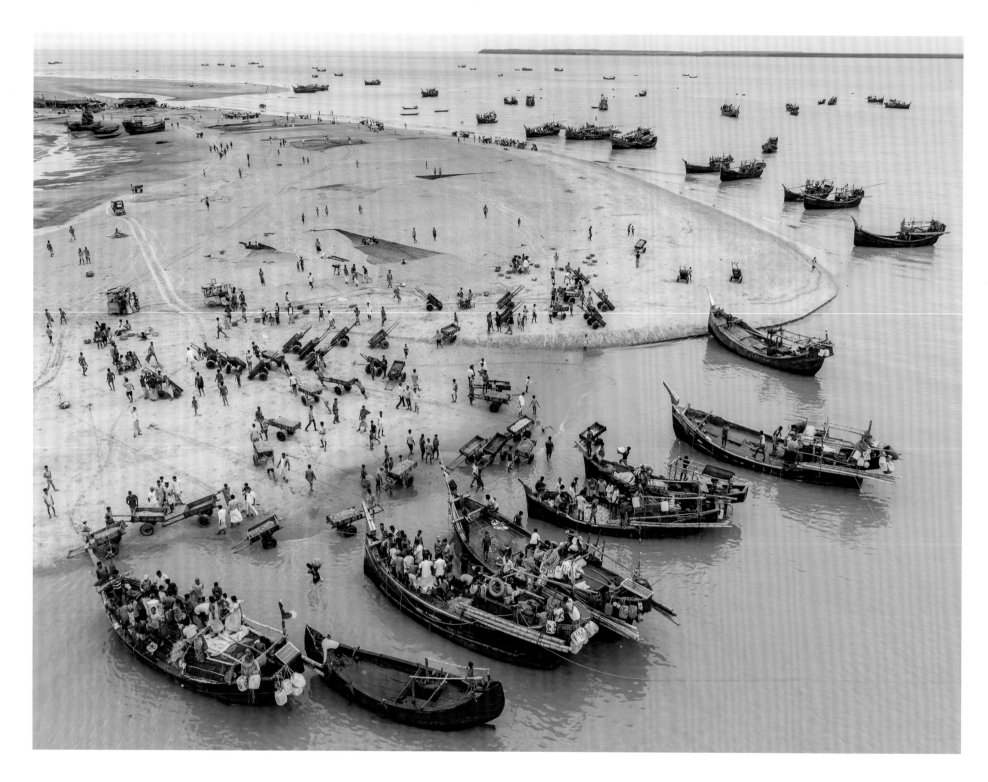

Fishing boats bring in their catch of mostly small knifefish to the beach of Cox's Bazar, celebrated as the longest contiguous natural sea beach in the world. This Bangladeshi seaside town has been dramatically affected by the arrival of some nine hundred thousand Rohingya refugees from neighboring Myanmar. A thriving fishing port and tourist destination, Cox's Bazar is now home to the planet's largest refugee camp and a host of smaller temporary settlements. The influx of humanity has severely strained the local ecosystem, with deforestation and water scarcity reaching critical levels, setting the stage for environmental disaster. It has been estimated that the effects of climate change will hit Cox's Bazar harder than any other region in South Asia. Cox's Bazar, Chattogram, Bangladesh.

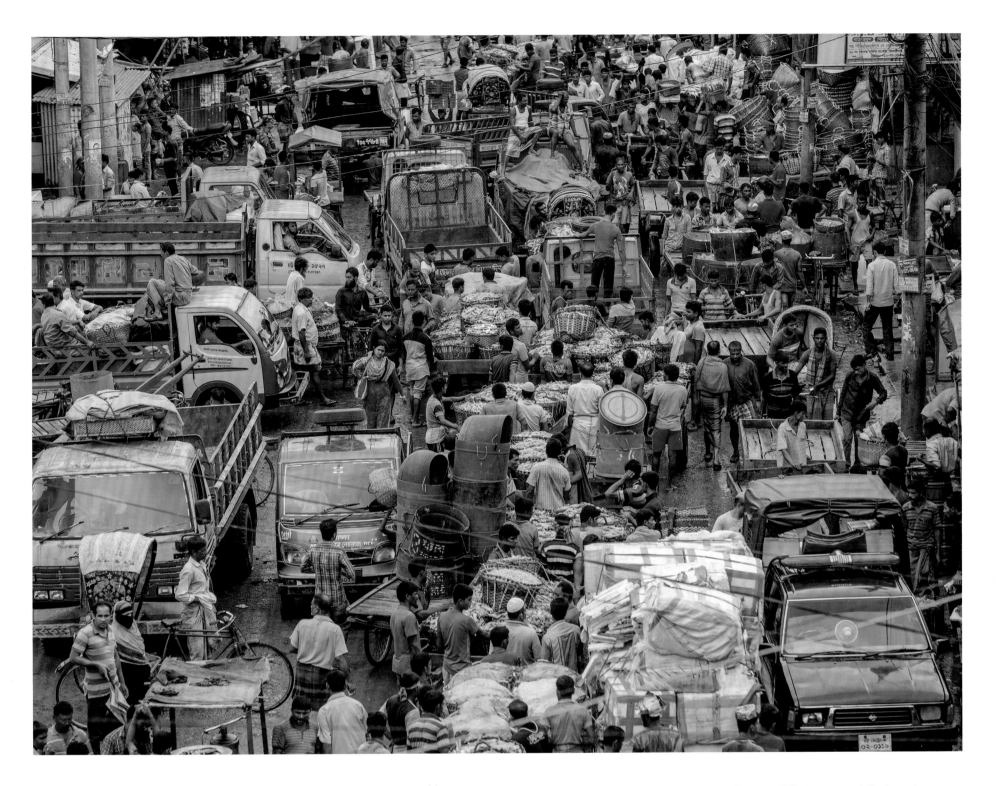

Fish being unloaded in the heavily congested streets of Chattogram port, the largest seaport in Bangladesh, on the north bank of the Karnaphuli River. Baskets of fish are carried ashore in headloads, then brought to the crowded fish market on handcarts. Bangladesh is heavily dependent on mariculture, and more than 80 percent of its dietary protein is derived from fish. The city of Chattogram is particularly vulnerable to storm-surge flooding and tropical cyclones, such as the one that struck in 1991, killing 138,000 people. The city was called Chittagong until late 2018, when the Bangladeshi government announced that the name would be changed to Chattogram, in keeping with local pronunciation of the word. Chattogram port, Chattogram, Bangladesh.

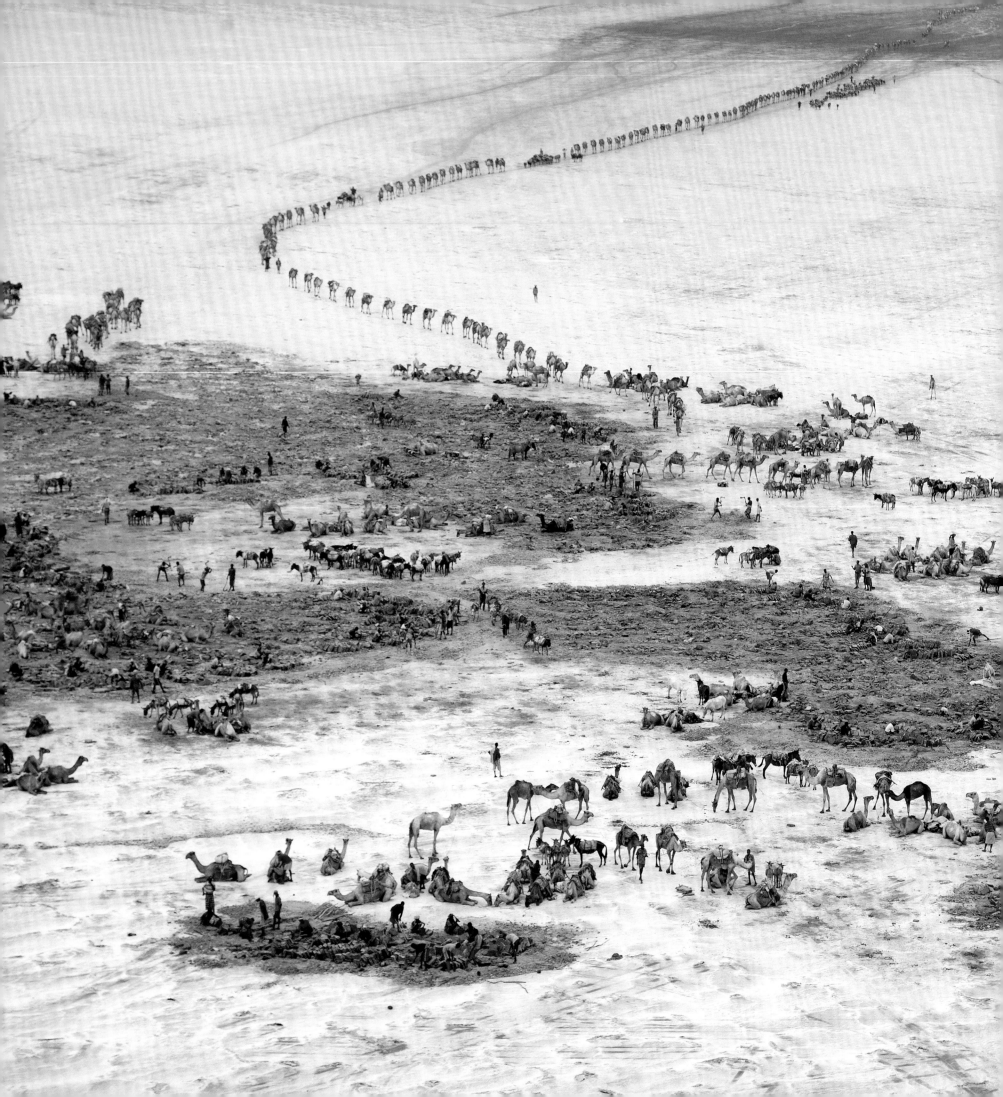

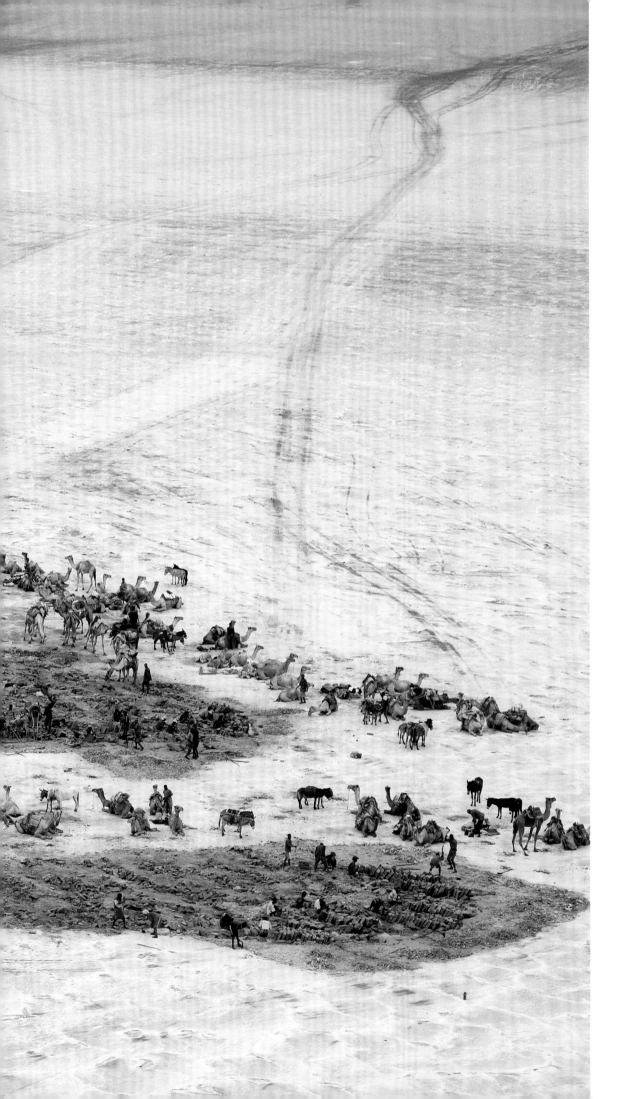

For the equivalent of five to seven dollars per day, men pry slabs of salt out of Lake Assale, at the northern end of the Danakil Depression in Ethiopia. Camels and donkeys are laden with about three hundred pounds of salt each for the strenuous twenty-five-hundred-foot elevation climb and thirty-mile trek to Berhale, where the salt is sold for human and animal consumption. This tradition has lasted centuries, but mechanized extraction, a new road, and a railway threaten to render the camel caravan obsolete. Lake Assale (Lake Karum), Afar, Ethiopia.

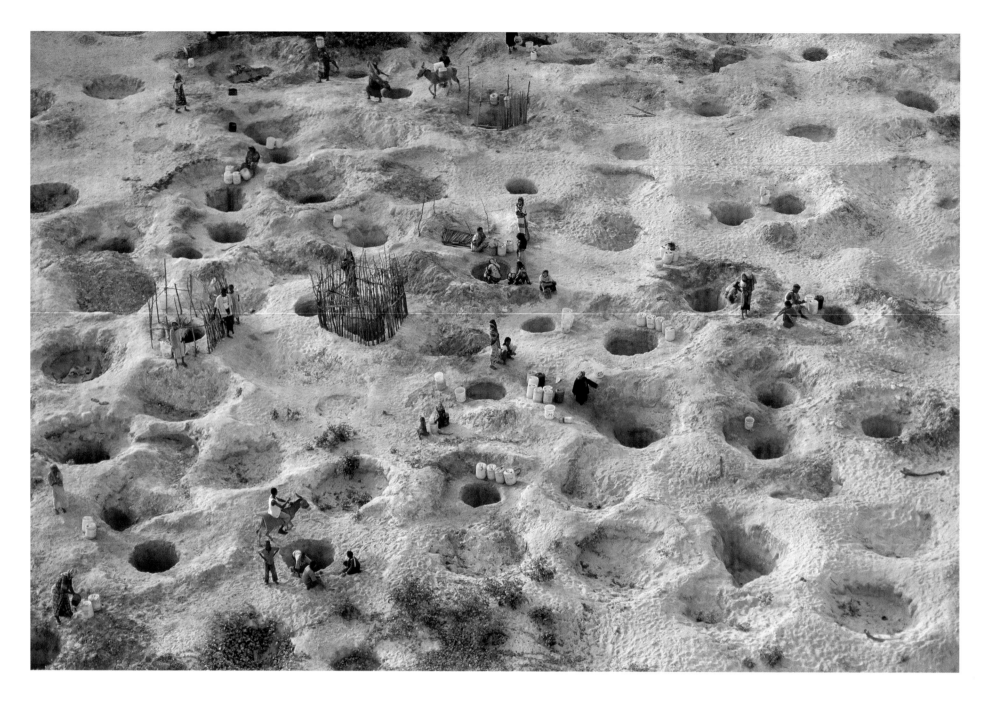

Villagers gather brackish drinking water from shallow wells within a hundred yards of the ocean in the Lamu archipelago, Kenya. Freshwater is a limited resource for the rapidly growing population. A desalination plant, which began operation in 2018, has brought welcome, if pricey, relief. Pate Island, Lamu, Kenya.

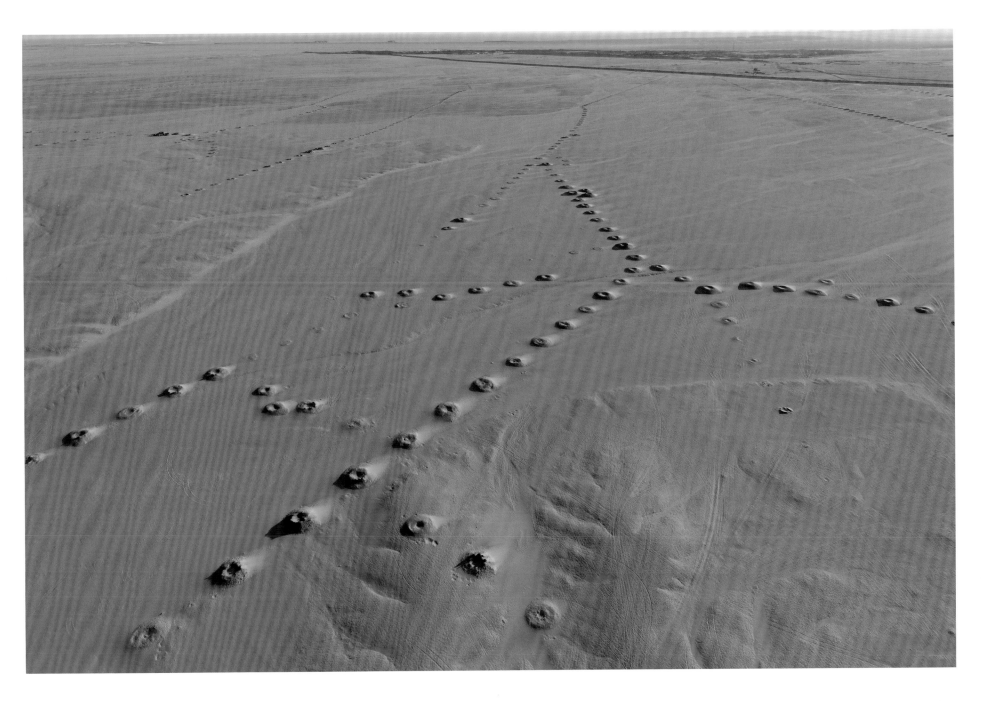

The Algerian desert is dotted by shafts to underground aqueducts, called foggaras. This irrigation technology, borrowed from the ancient Persians, dates back a thousand years in the Sahara. The tunnels provide water to gardens and families in small desert settlements, but they are gradually silting up or falling into disrepair from collapses. Akabli, Adrar, Algeria.

A road in the Taklimakan Desert in western China is a transportation lifeline to the oil and gas fields of the Tarim basin. It's protected from drifting sand by a belt of salt-tolerant plants that are watered with brackish well water by a drip irrigation system. Blue buildings every few miles along the road house workers who maintain sections of the green belt. Taklimakan Desert, Xinjiang, China.

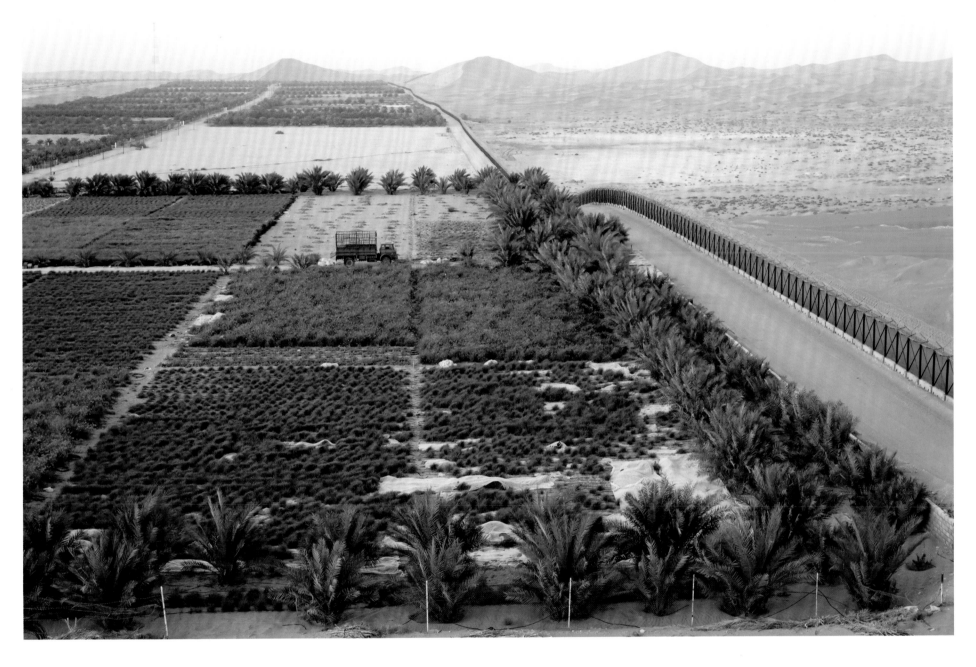

In the desert landscape along the border between Oman and the United Arab Emirates, groundwater flowing from the mountains in Oman is pumped to support agriculture along the Emirates' side. Al Qaw, Abu Dhabi, United Arab Emirates.

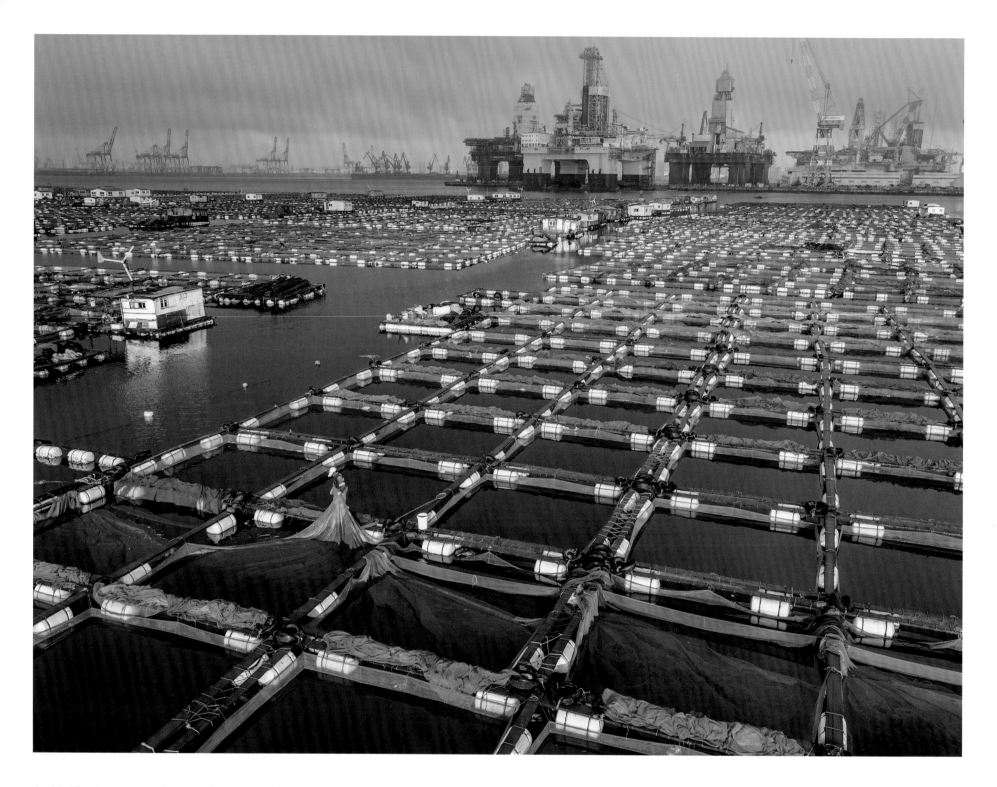

A grid of floating sea cucumber pens shares Yantai Harbor with the industrial shipyard of CIMC Raffles, where deep-water oil rigs are constructed. Contrary to what the name might suggest, the sea cucumber is not a vegetable but an invertebrate animal of the echinoderm family, like the sea urchin and the starfish. It feeds on algae and various small matter on the seafloor, breaking the particles down in its digestive system and recycling them into the marine ecosystem. China has been improving food safety, but keeping pollution out of the food supply is still a problem. Yantai, Shandong Province, China.

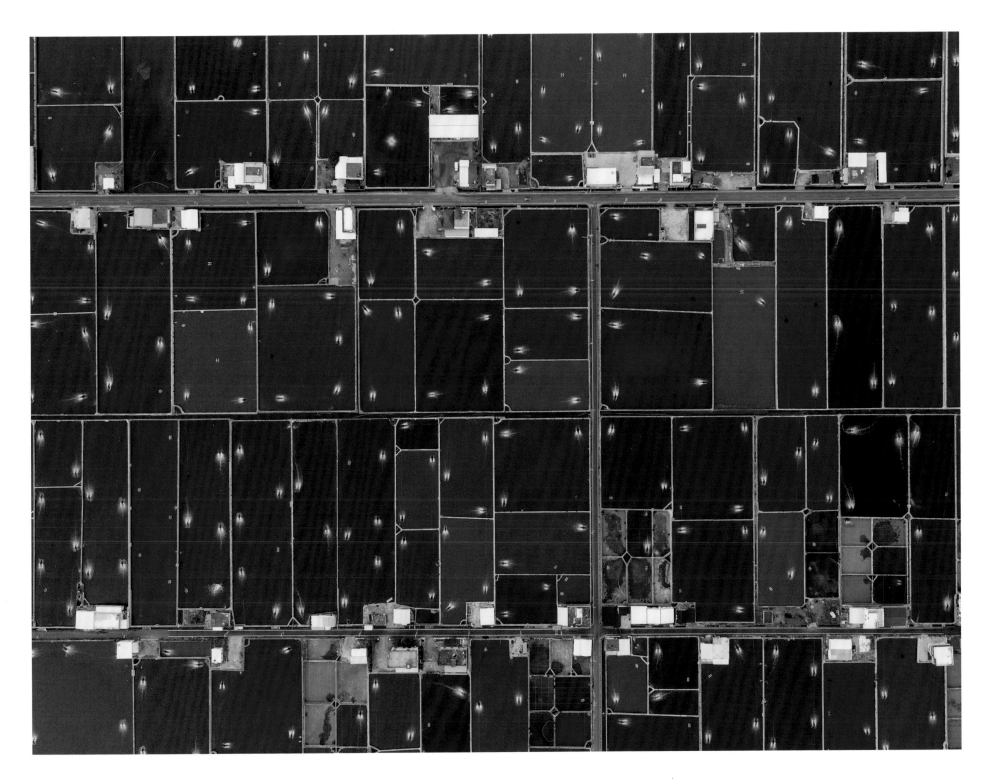

In Taiwan's Jiadong township, concrete-lined fish farms occupy every available square foot between the houses and narrow roadways. Much of Taiwan is too mountainous for agriculture, so the people have come to depend on mariculture, or fish farming. These ponds are designed to raise high-value fish such as grouper, which fetch almost double the prices paid for fish from the mainland. In 2009, Typhoon Morakot devastated the fish farms in this region, hitting just as many farmers were preparing to ship and sell their goods. It has been estimated that grouper aquaculture alone sustained some $64 million in losses as a result of the typhoon. Jiadong, Pingtung County, Taiwan, China.

Thousands converge on Xuyi County for the annual crayfish-eating festival. Crayfish, often referred to as "little lobsters," provide a significant source of revenue to residents of Xuyi, accounting for about one-fifth of their average income. Chinese demand for the high-protein crustaceans is on the rise, and more than 32,000 acres in Xuyi have been cultivated as crayfish pond farms. Owing in part to the naturally robust constitution of the crayfish, no pesticides are used on these farms, and farmers are creating a system that will enable consumers to easily determine the source of the crayfish they are purchasing, as part of an environmental monitoring system currently being developed in Jiangsu Province. Though crayfish are caught wild from local rivers and lakes, their farming is a relatively recent phenomenon in China, beginning in the 1990s. Xuyi County, Jiangsu Province, China.

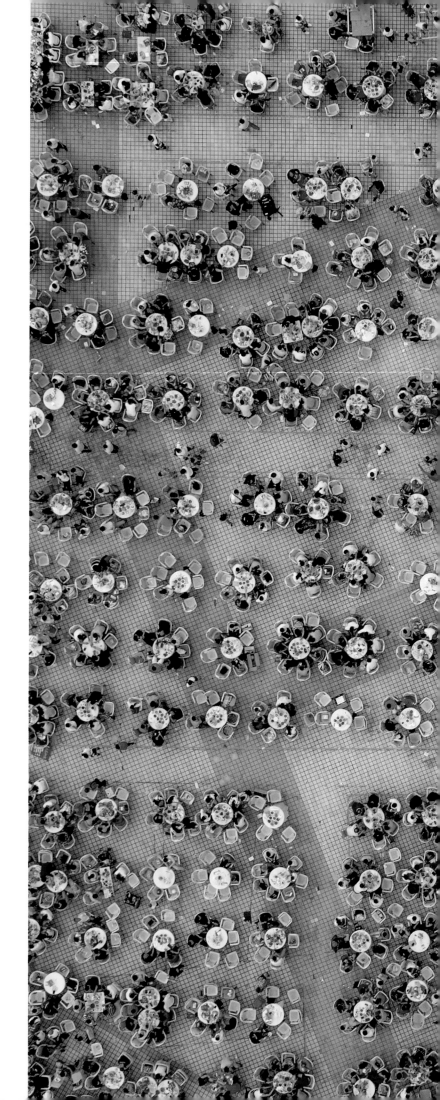

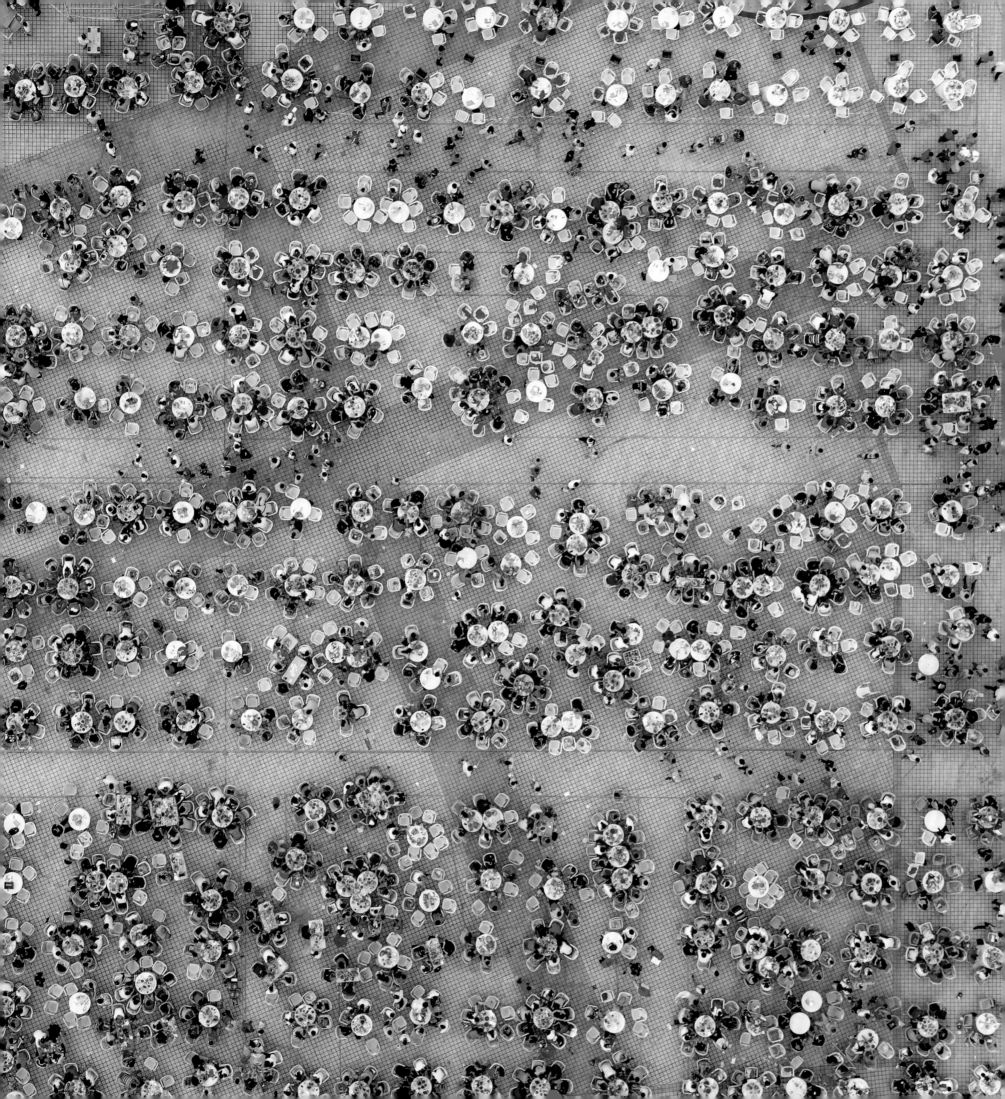

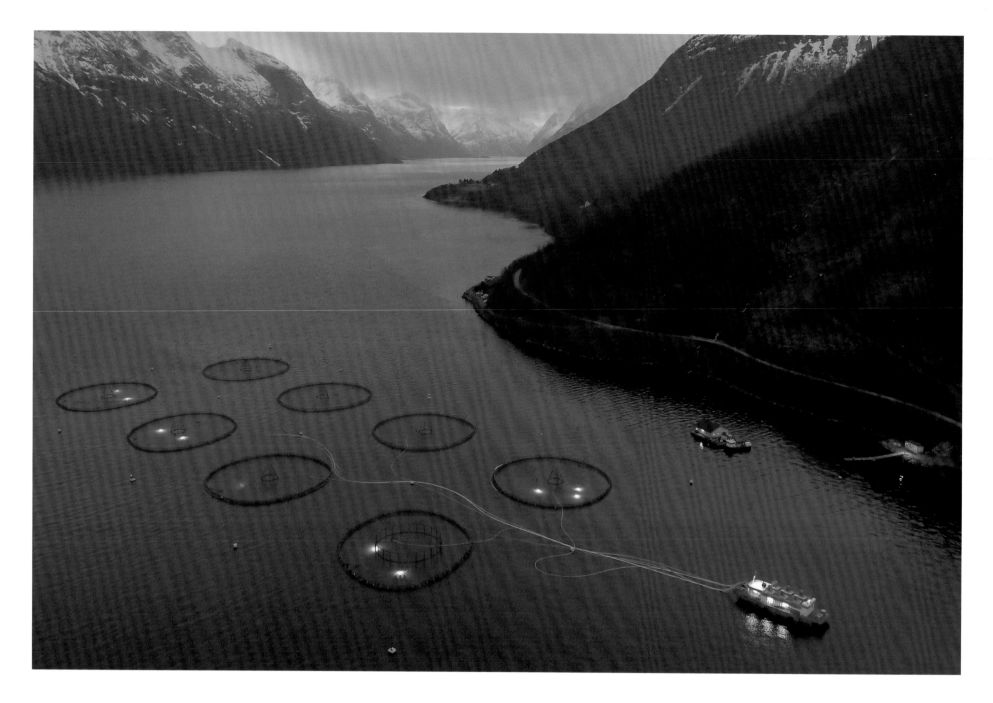

Salmon pens float atop the tranquil waters of a Norwegian fjord. This farm is owned and managed by Marine Harvest, recently renamed Mowi ASA, the world's largest farmer and distributor of salmon. Each pen contains approximately two hundred thousand salmon, all descended from fish captured in the Vosso River in 1960. The narrow and deep fjord affords the pens protection from wind and wave damage, while tidal action beneath and between the enclosures is sufficient to dissipate excrement. After each eighteen-month generation, the pens are cleaned and left empty. On average, Mowi has close to 30 percent of the global salmon market, but in 2019 an algae surge fueled by warm temperatures killed some eight million salmon in Norwegian farms, and algae is continuing to spread. The algae adheres to the gills of fish; wild salmon can dislodge it as they swim, but farmed salmon cannot and suffocate. Hjørundfjord, Norway.

A Mowi (Marine Harvest) processing facility in Norway. This plant in Fosnavåg is Mowi's largest, where on average workers will handle one hundred thousand salmon each day. Fish arrive live from up to twenty-eight Norwegian aquafarm sites and are kept in holding pens until they are slaughtered, filleted, and processed. Demand for salmon has increased consistently for a number of years, and global production of farmed salmon is currently projected to increase fivefold by the year 2050. Challenges continue to arise, however. Disease and parasites such as sea lice are continually of concern, and it is not known if the deadly algae bloom of 2019 will become a recurring event. Fosnavåg, Norway.

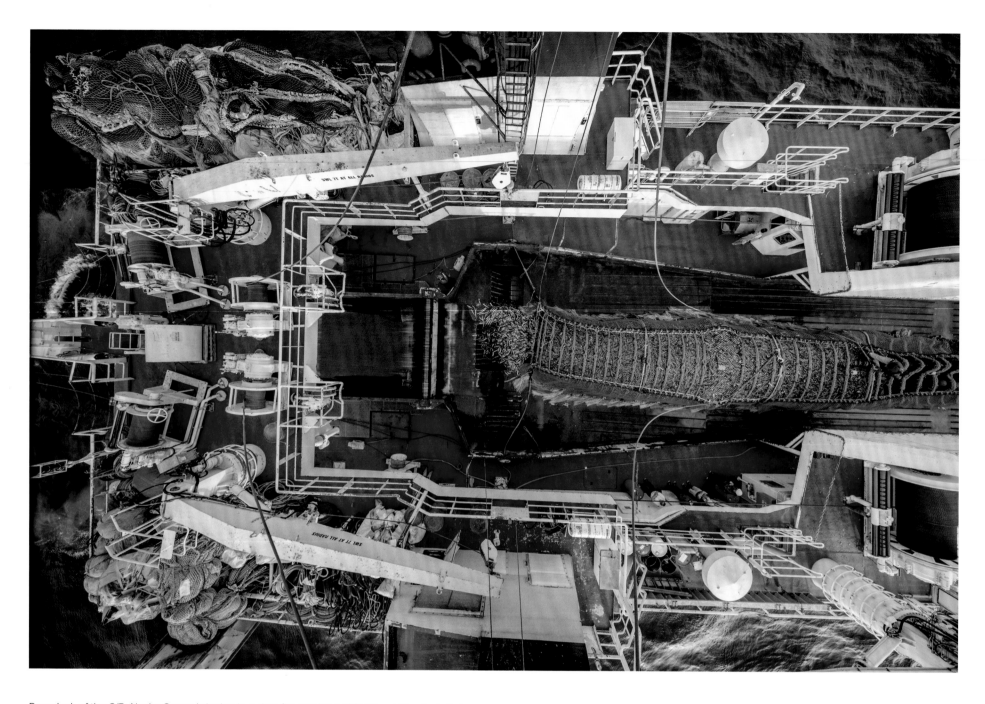

Rear deck of the C/P *Alaska Ocean* bringing in a sixty-five-ton load of Pacific whiting (or hake) thirty miles off Oregon's coast. The *Alaska Ocean*, which fishes primarily for Alaska pollock and Pacific whiting, is a catcher/processor or factory trawler, meaning a vessel whose catch can be processed on board. The 376-foot-long ship is some six stories high and accommodates a crew of 150. The largest catcher/processor in the US fleet, *Alaska Ocean* can haul in two hundred tons of product for human consumption a day (in addition to thirty tons of fish meal), ranging from the Oregon coast north to the US exclusive economic zone in the Bering Sea, one of the most tempestuous oceans in the world. Coos Bay, Oregon, United States.

In 2015, the *Alaska Ocean* hauled in sixty-five hundred tons of Pacific whiting, but the majority of its take is pollock, amounting to some sixty-three thousand tons annually. Most of the catch is consumed as fillets or breaded fish sticks, and McDonalds is one of the ship's biggest customers. Sonar and tracking equipment allow the captain to locate large schools of fish. As the ship approaches a school, it deploys a seventeen-hundred-foot-long net that spreads into a giant cone and can pull in one hundred tons of fish at a time.

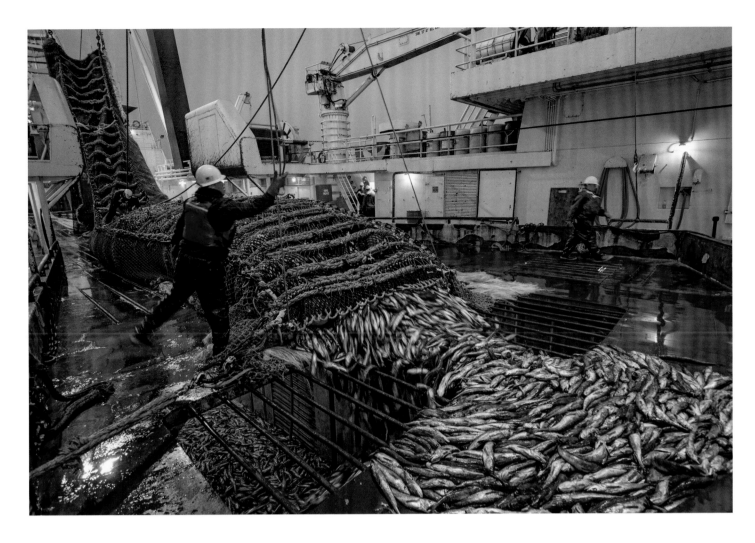

Below deck, fish are filleted, flash-frozen, and packaged around the clock at the rate of 750 per minute. Processing on board allows the ship to fish continuously, rather than returning to port to unload each catch.

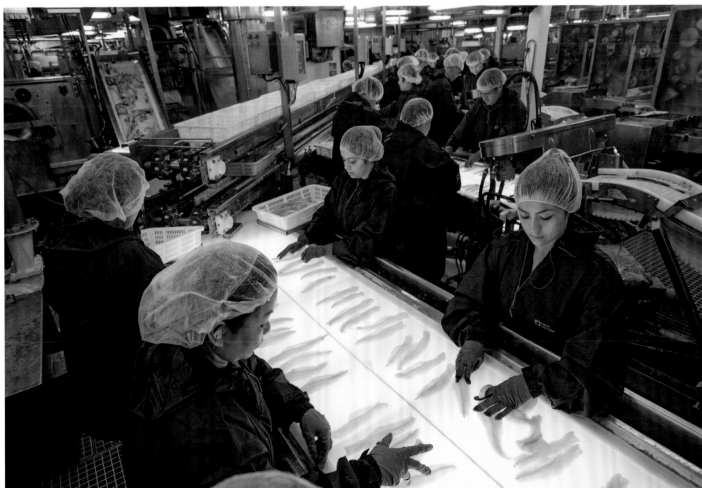

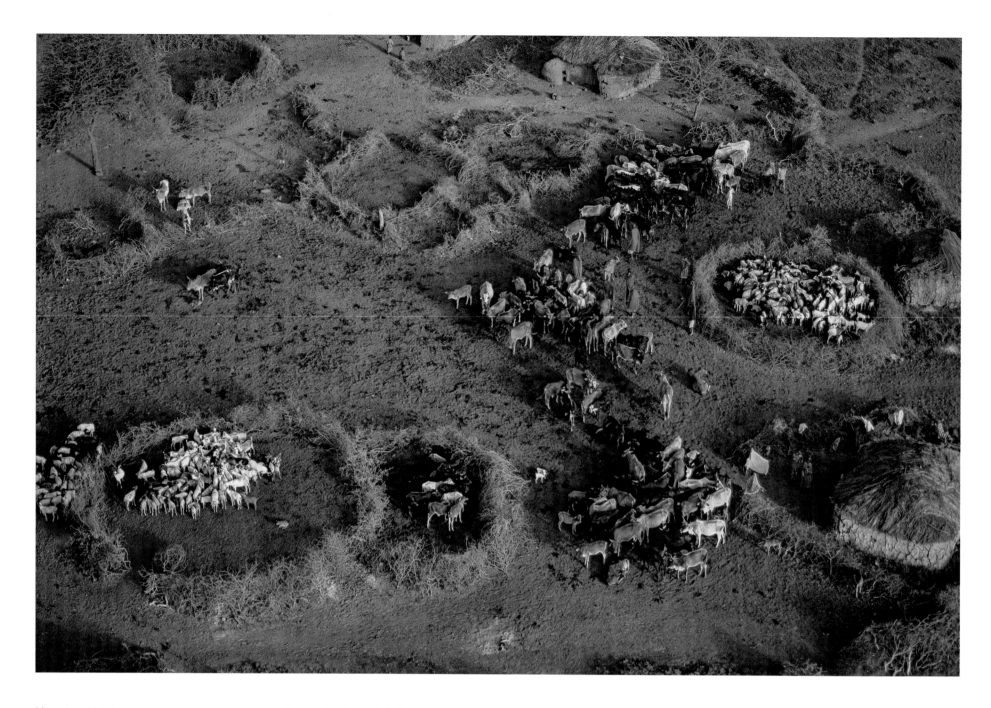

Maasai cattle and goat camp in the Orbili region near Amboseli National Park, Kenya. The Maasai are a seminomadic pastoral people, and cattle are a central part of their lives, not just as an economy but as a basis for their social structure and religion, and as the source of their physical sustenance. To protect themselves and their livestock, the Maasai build circular bomas, sometimes called "living walls," around their encampments, and may create a reinforced inner wall of thorny acacia branches to enclose their livestock. Kenya.

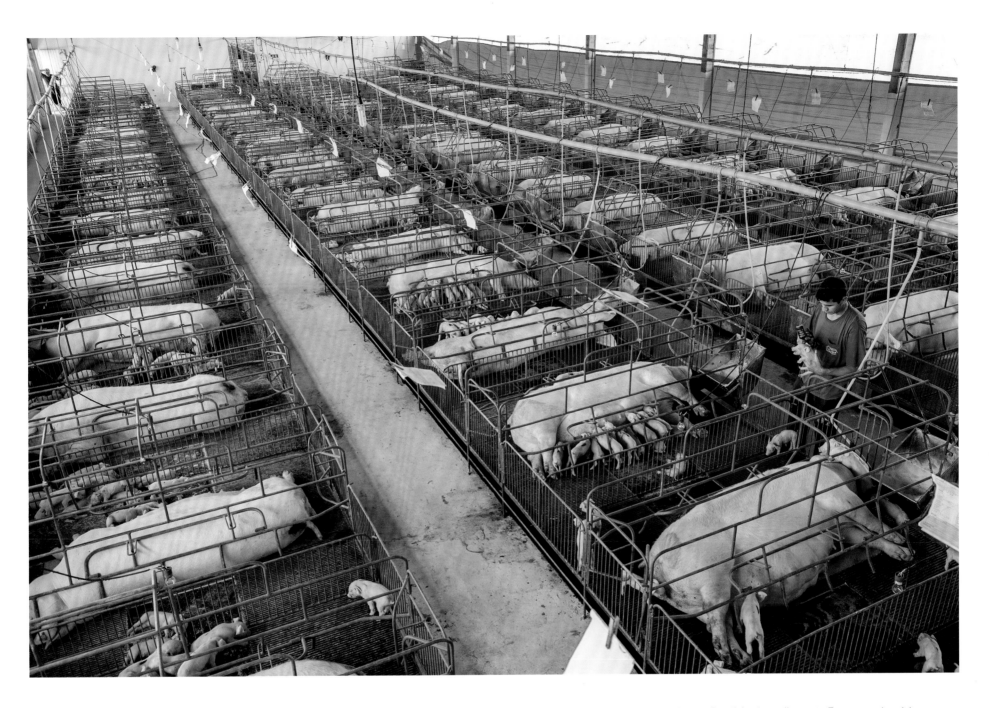

Sows feed their young at Lucion pig farm in Brazil. Lucion adheres to European pig raising standards, which require that female pigs have a thirty-day period during their maternal cycle to walk about freely. Pig excrement is collected and distributed as fertilizer on the corn and soybean fields that provide most of the animals' food, and methane gas is harvested from the excrement and used to power much of the farm's machinery. The pens on this farm are designed to provide steady access to food and water while preventing the sows from accidentally crushing their young. On average, almost one thousand pigs from this farm are slaughtered each day. Sorriso, Mato Grosso State, Brazil.

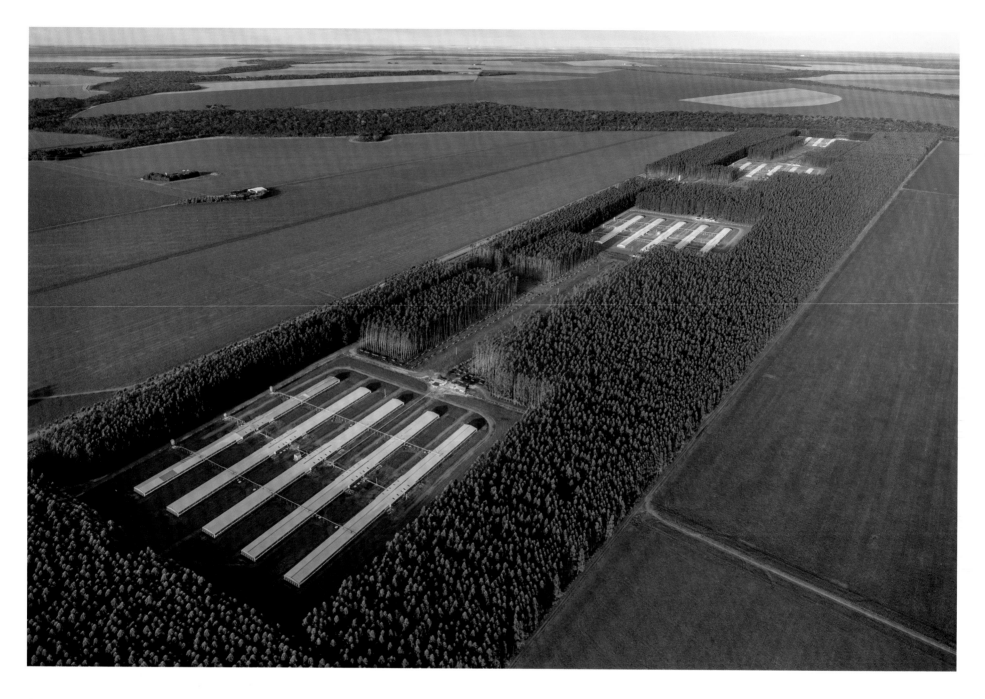

An egg farm in the region of Brazil known as the Cerrado, surrounded by trees planted to protect the monogenetic hens from wind-borne disease. This tropical savanna has traditionally been quite biodiverse, but the Cerrado biome has suffered significant destruction at the hands of soy farmers clearing the terrain for cultivation. A number of large food retailers have agreed to stop using soy-fed chickens from Amazonian land that has been cleared for soy cultivation, but the Cerrado region has not gained the same protection, and the effects of destroying the native plant cover may exacerbate global warming. Lucas do Rio Verde, northern Mato Grosso State, Brazil.

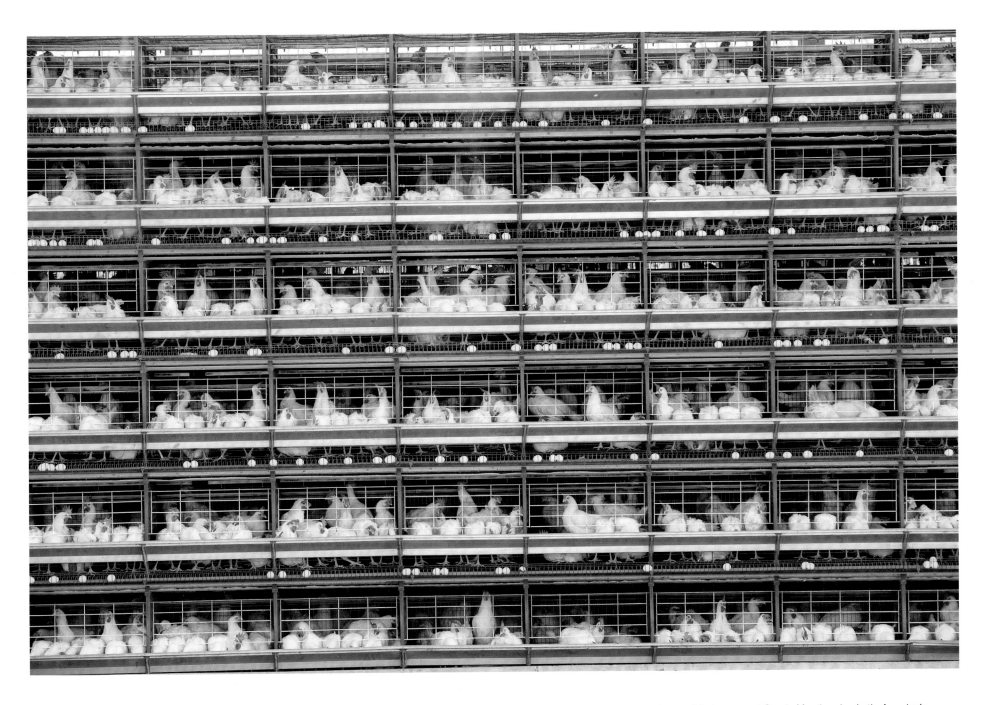

Hens peer out through the wire fronts of their cages at Granja Mantiqueira, Latin America's largest egg farm. Each hen has about ninety-five weeks of productivity, during which she will lay 1 egg on most but not all days, averaging 300 per year. Twenty-six hens share a single cage, enjoying less space than their counterparts in Europe, where battery cages were banned in 2012. The floors of these cages are slightly inclined to allow each newly laid egg to roll through a small opening to a conveyor system that takes it to the building where eggs are sorted, cleaned, and packed. The facility is highly automated, delivering sustenance and clearing excrement automatically. Modern hens are considerably more productive than their World War II–era ancestors, who on average laid just 150 eggs each year. When these hens have passed their productive years, they will make their final journey to a slaughterhouse in São Paulo. Primavera do Leste, Mato Grosso State, Brazil.

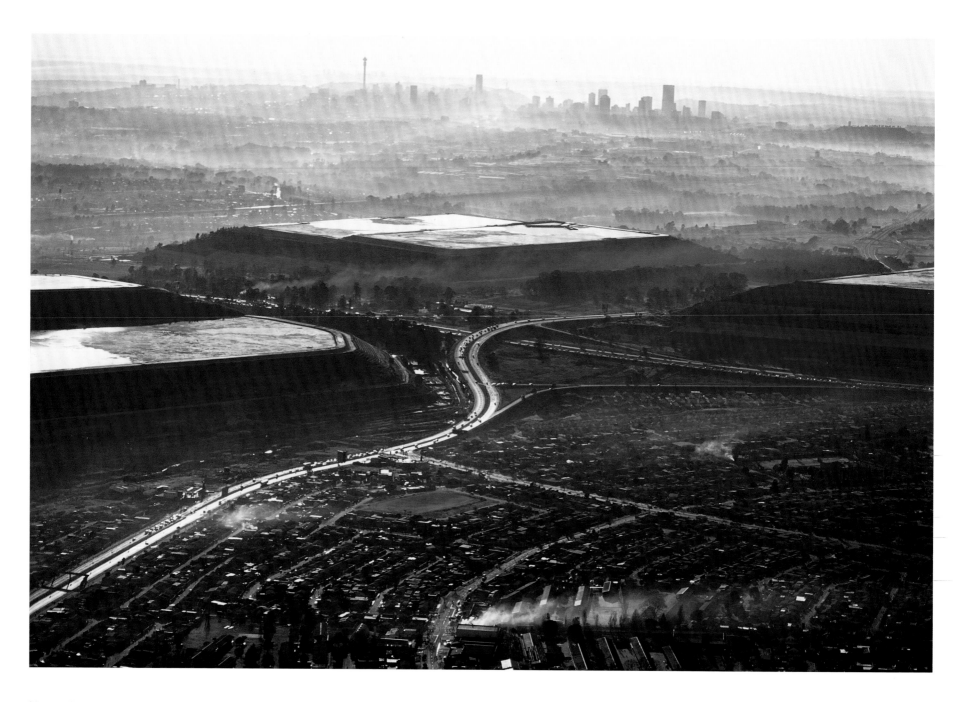

Man-made mountains of mining waste dominate Soweto, a mainly poor suburb of Johannesburg. These piles of unwanted minerals from a century of deep gold mining are rich in toxic uranium, lead, arsenic, and heavy metals, which blow in the wind and leach into rainwater runoff. Soweto, Johannesburg, South Africa.

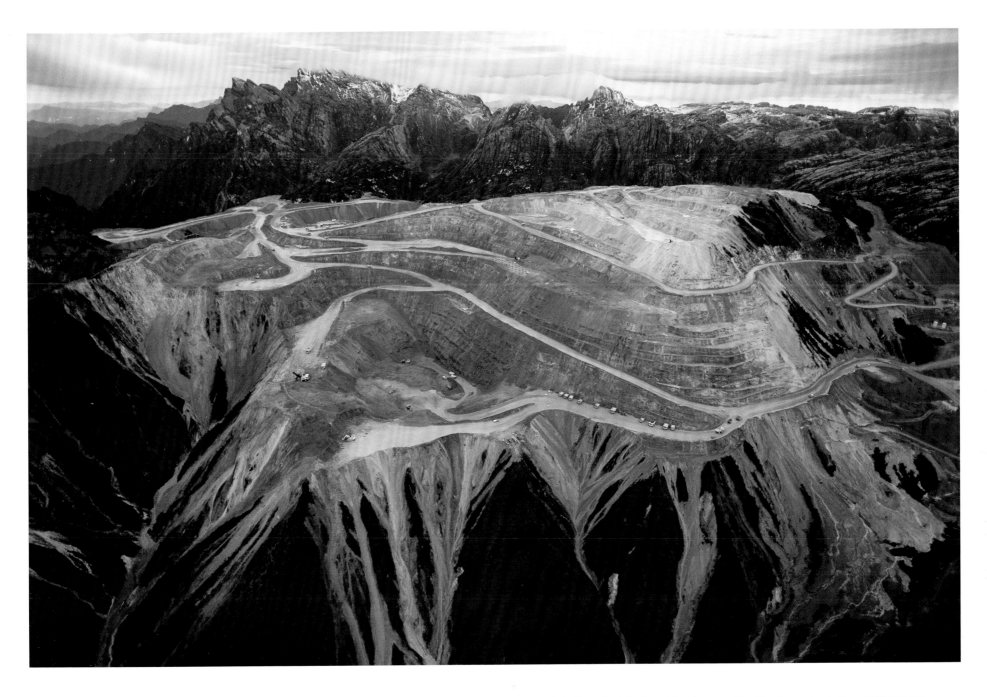

A mountain hollowed out for its gold and copper. The Grasberg mine is the world's largest mine, and the largest producer of gold and second-largest of copper. The ore formed about three million years ago, relatively recent in geologic time, in the collision between the Pacific and Australian tectonic plates, which squeezed the deposit to its altitude of fourteen thousand feet. While a boon to the national economy, the mine has been a source of tension between the Indonesian state and many West Papuan citizens who blame it for flooding their lands. Owned in a joint venture among Freeport-McMoRan, Rio Tinto, and the Indonesian state-owned mining company PT Indonesia Asahan Aluminium, it still has about $14 billion of reserves left to mine. Timika, Indonesia.

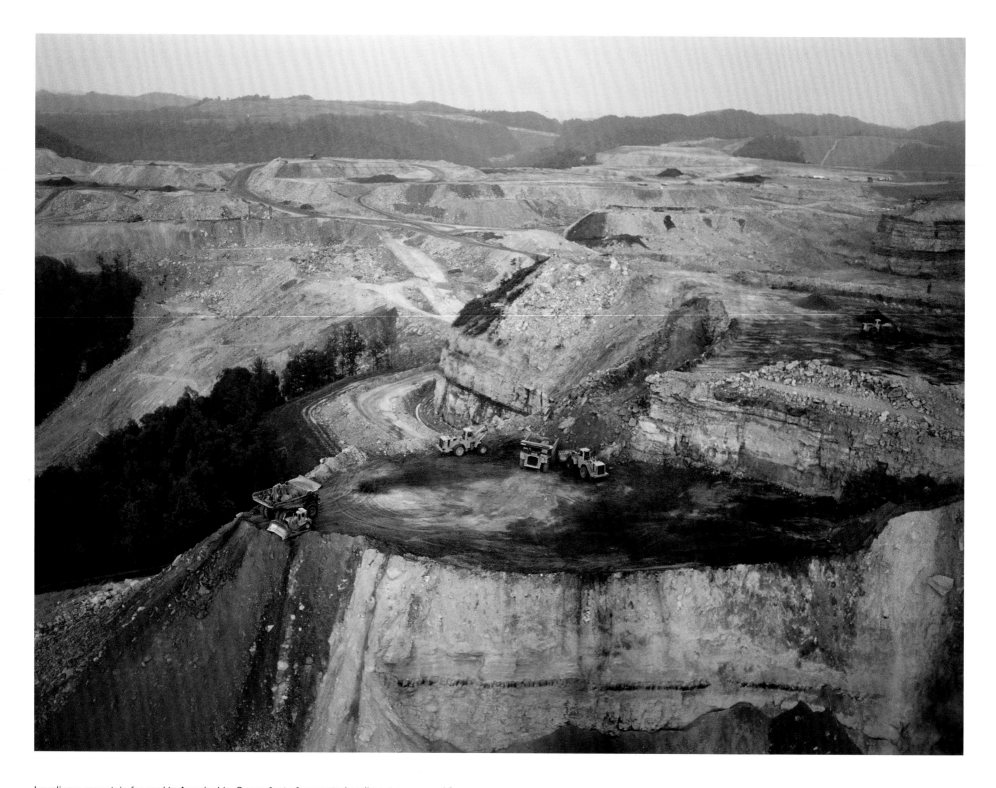

Leveling a mountain for coal in Appalachia. Seven feet of unwanted sediment are moved for every foot of coal extracted, so mountain tops end up dumped into valleys, leaving sprawling infertile mesas in place of diverse temperate forests. While recent rollbacks of regulations have allowed the dumping of mine waste in streams, coal mines in the region continue to close, mainly owing to competition from expanded supplies of natural gas. In 2008, the region produced 17 million tons of coal annually, but that haul dropped to about 4.1 million tons in 2017. In one of the poorest regions in the United States, mining is still seen as a source of much-needed jobs. Kentucky, United States.

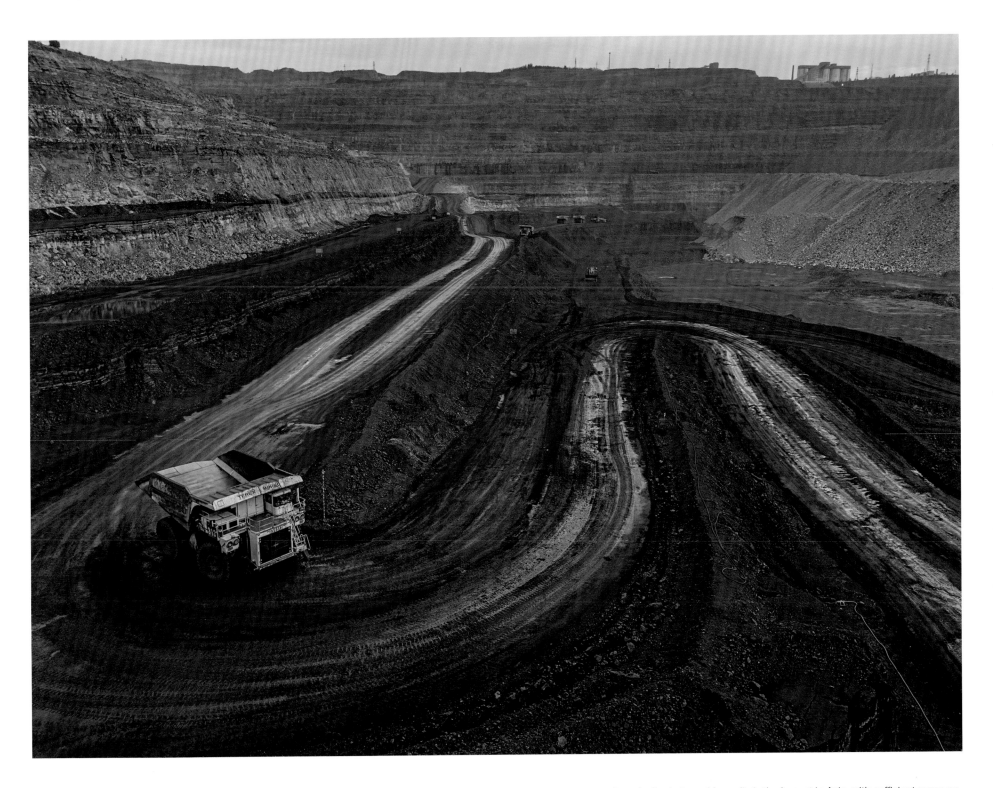

The Haerwusu open pit coal mine in Inner Mongolia is the largest in Asia, with sufficient reserves to last the next seventy-five years. Despite gains in renewable energy, China still generates more electricity from coal than any other nation, and its coal production and consumption are both still rising. The truck in this photograph is almost as tall as a three-story building and can carry 325 tons of coal in one load. Junggar, Inner Mongolia, China.

Sorting coal in a 1.8-mile-long open-air yard near the Tuoketuo power plant in Inner Mongolia. Tuoketuo is the biggest coal-fired power plant in the world and receives most of its coal from the Haerwusu open pit coal mine. Satellite images show a black smudge all around this yard, despite fences intended to stop the spread of coal dust. Tuoketuo, Inner Mongolia, China.

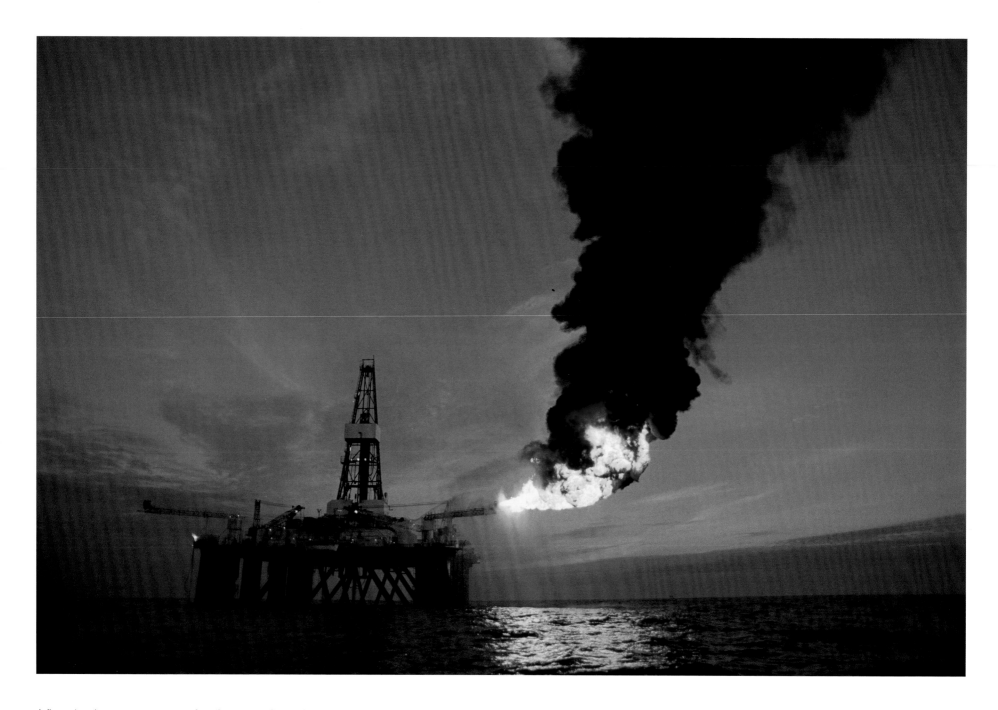

A flare signals enormous success for oil company Amerada Hess in the Scottish North Sea. This exploration rig drilled an oil well capable of producing ten thousand barrels of oil a day—the biggest find in that area in more than a decade. Exploration rigs are not hooked up to pipelines, so produced oil and gas are shot out into the atmosphere and ignited. A test burn like this will last several hours to be sure the rate of flow is sustainable before a company will invest millions to lay an underwater pipeline and bring in a production platform. Scotland, United Kingdom.

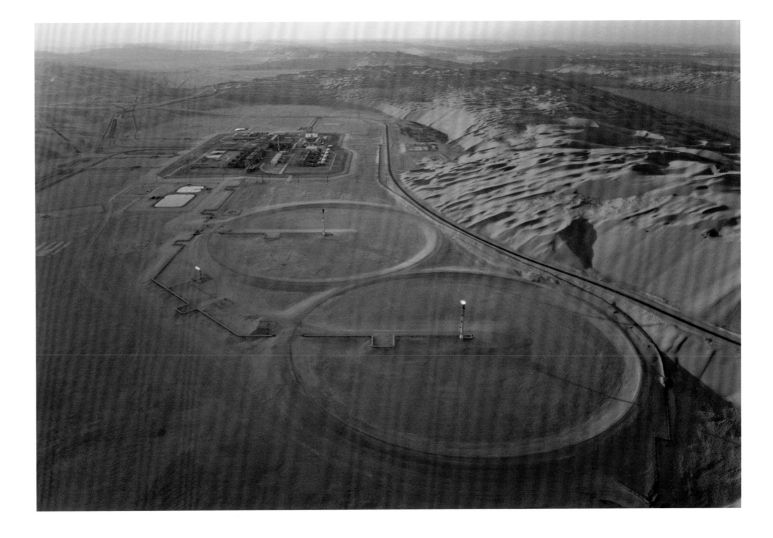

After drilling an exploration well on the frozen tundra forty miles south of Prudhoe Bay on Alaska's North Slope, an exploration drilling rig was pulled at a walking pace back across the Arctic plains. Such activities have become more challenging in recent decades as the warming climate has reduced the "tundra travel" season when the ground is hard enough to endure such activity without ecological harm. Dead Horse, Alaska, United States.

A plant separating oil and gas nestles between dunes in Saudi Arabia's Rub' al-Khali, or Empty Quarter. A million barrels of oil are produced here per day, as well as 2.4 billion cubic feet per day of natural gas liquids, all piped four hundred miles to a processing facility at Abqaiq and then on to ports in the Persian Gulf, the Red Sea, and a refinery in Bahrain. Shaybah, Saudi Arabia.

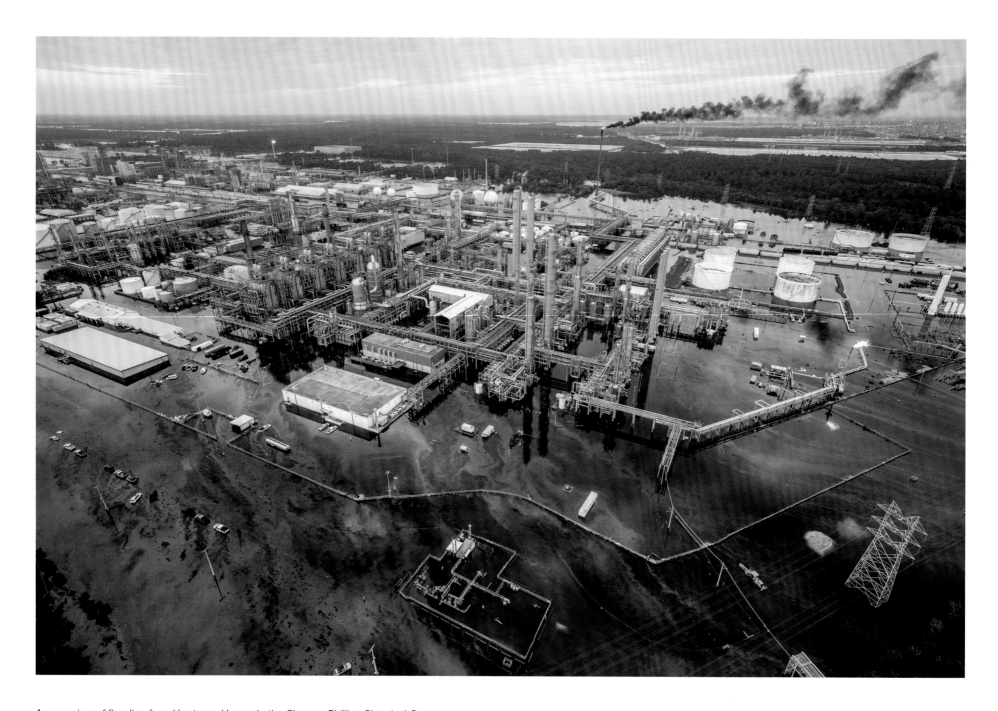

An overview of flooding from Hurricane Harvey in the Chevron Phillips Chemical Company refinery in Baytown, Texas, the day after the storm dumped more than fifty inches of rain on parts of Texas in August 2017. Several independent scientific studies linked Harvey's record rainfall and behavior to man-made climate change, while heavy industrial and residential development in flood-prone areas added tremendously to the impacts. Baytown, Texas, United States.

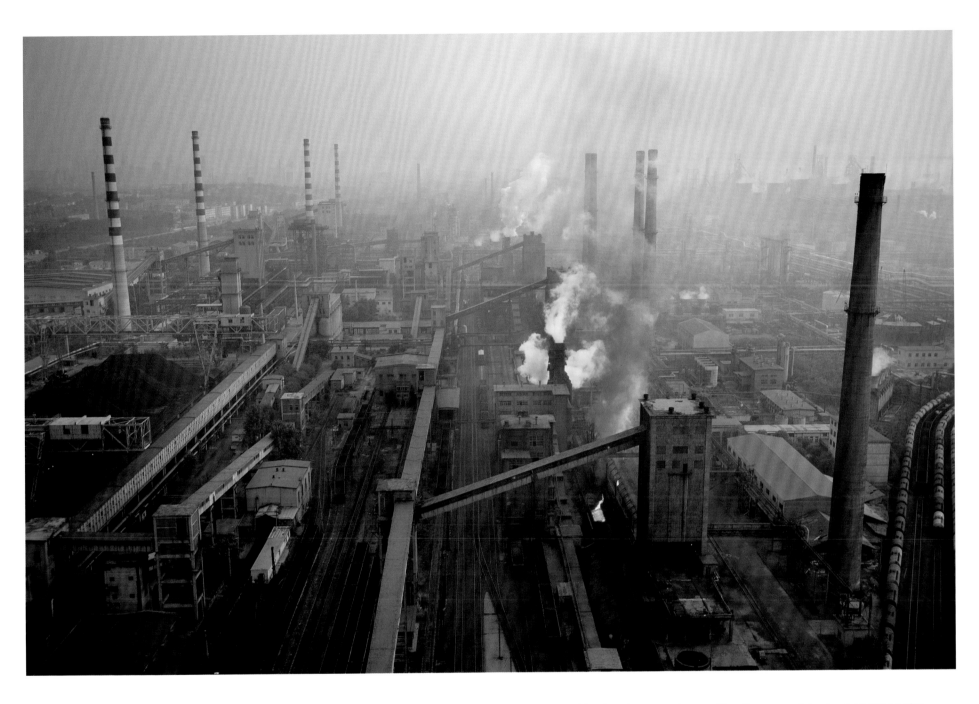

Anshan Iron and Steel works, a steaming, smoking, fiery array of structures covering a nine-square-mile site, is said to be the largest such complex in China. Under pressure from the government, the giant parent company has committed to recycling more of the millions of tons of slag left by the steelmaking process. Air pollution here is so severe that even cloudless days produce almost shadowless light. Anshan, Liaoning Province, China.

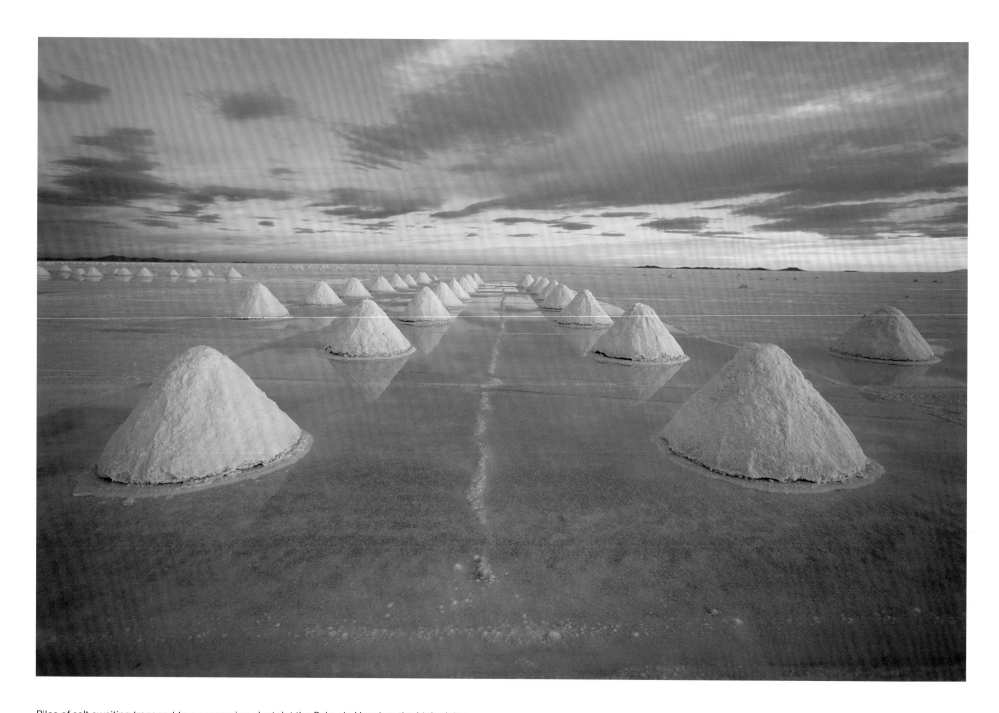

Piles of salt awaiting transport to a processing plant dot the Salar de Uyuni on the high plains twelve thousand feet up in the Bolivian Andes. At thirty-eight hundred square miles, this is the largest salt flat in the world, located at the edge of the Atacama Desert. The salt flat holds more than table salt; it is the world's second-largest deposit of lithium, a metal essential to the modern economy, mainly through its use in batteries. Colchani, Potosí, Bolivia.

Salt production in the Gobi Desert of Inner Mongolia. The region is also a source of mirabilite (sodium sulfate), which in Chinese traditional medicine is an intestinal purgative. Bayinwusu, Hangjin, Inner Mongolia, China.

The Arab Potash Company, at the southern end of the Dead Sea, produces table salt, potash, and a range of other chemicals. Gawr as-Safi, Jordan.

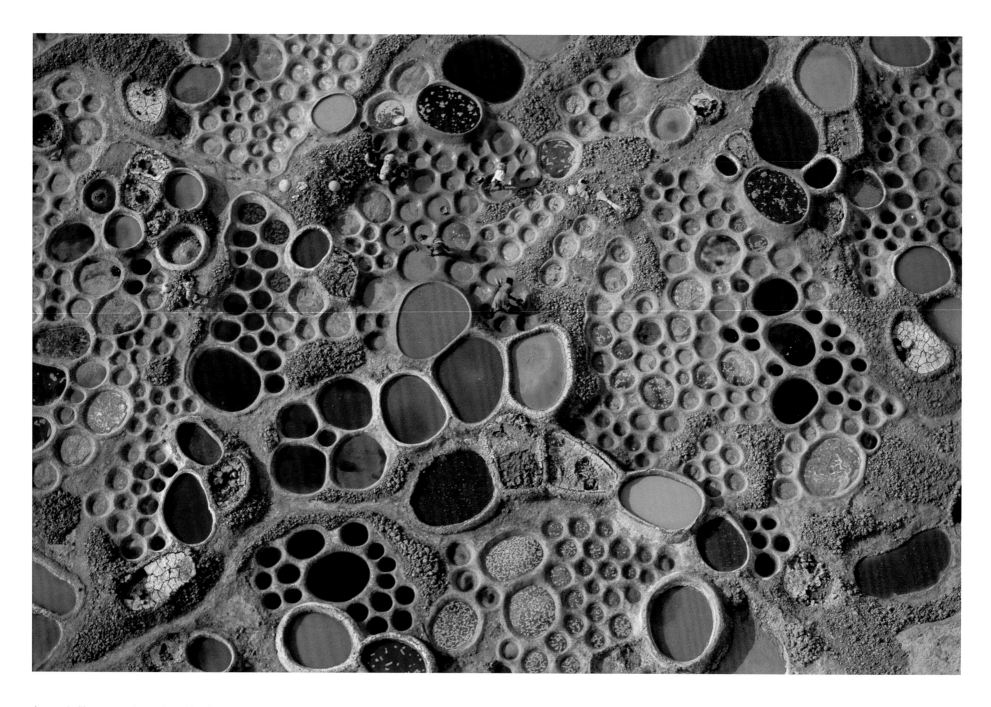

A mosaic-like pattern is produced by dozens of salt-production pools tended by villagers for livestock in the Sahara Desert in Niger. Brine from shallow wells is mixed with salty clay to produce slurries that end up different colors, depending on the mix of mud, algae, and salt. Teguidda-n-Tessoumt, Niger.

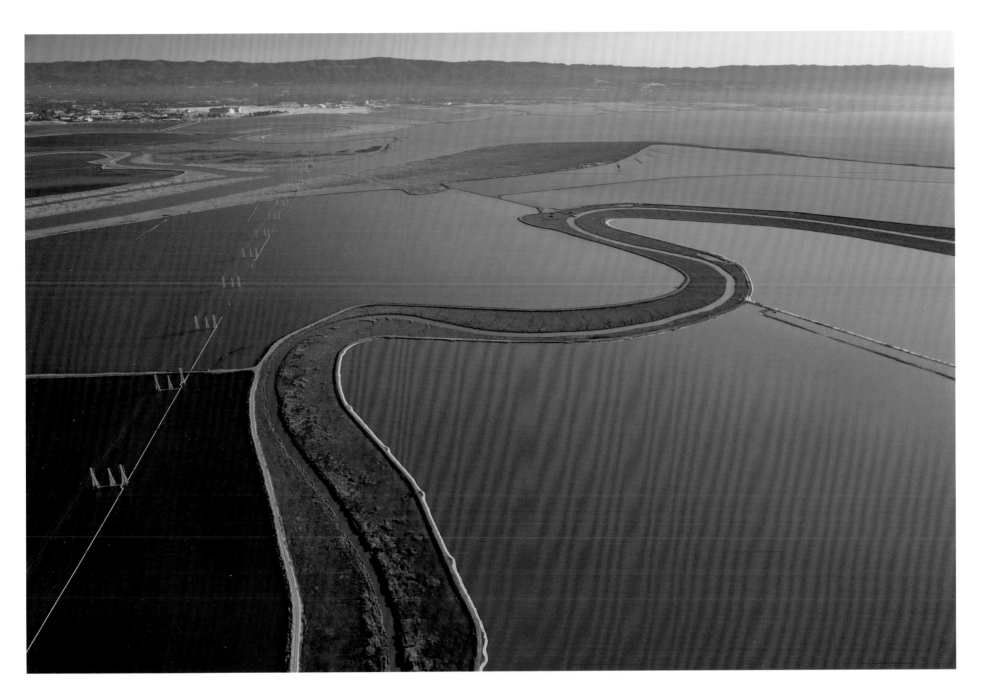

Starting in the mid-1800s, wide areas of wetlands in the southern end of San Francisco Bay were converted to evaporation areas for salt production. In recent decades, some five hundred thousand tons of salt have been harvested annually for use in industry, water softeners, ice control on roads, and edible sea salt. The red color is caused by concentrations of salt-adapted algae known as *Dunaliella salina* and of haloarchaea, a domain of life that resembles bacteria but is genetically distinct. A restoration project is transforming one area of fifteen thousand acres back into wetlands. Newark, California, United States.

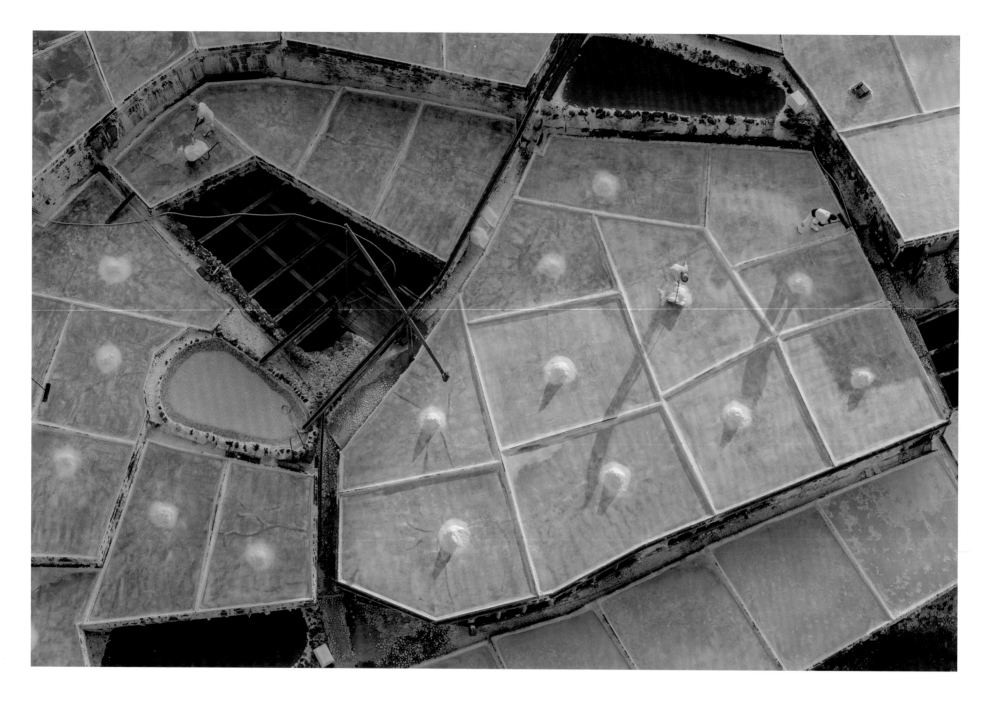

Just ten full-time *salineros* now tend the 7,000-year-old Valle Salado de Añana salt works in the Basque region of Spain. The brine originates from salt deposited by an ancient sea 220 million years ago, brought to the surface today by saline springs. Originally the brine was evaporated using fire, but Roman engineering transformed the site into the natural evaporation system still in use today. In the 1950s, there were three hundred workers; competition from large-scale salt works across the world collapsed the market. From the 1960s to 2000, there was almost no production, but now a nonprofit foundation supports artisanal salt production and upkeep of the site. Salinas de Añana-Gesaltza Añana, Álava, Spain.

Salt production at Lake Afrera in the Danakil Depression, a tectonic rift at the southern end of the Red Sea. The lake level is 367 feet below sea level—it has fallen by about 33 feet in the last fifty years owing to the drying climate. About 290 million tons of table salt per year were produced here until 2011, when sulfuric acid from the nearby Nabro volcano, in Eritrea, made it inedible, not long after this photograph was taken. Lake Afrera, Afar, Ethiopia.

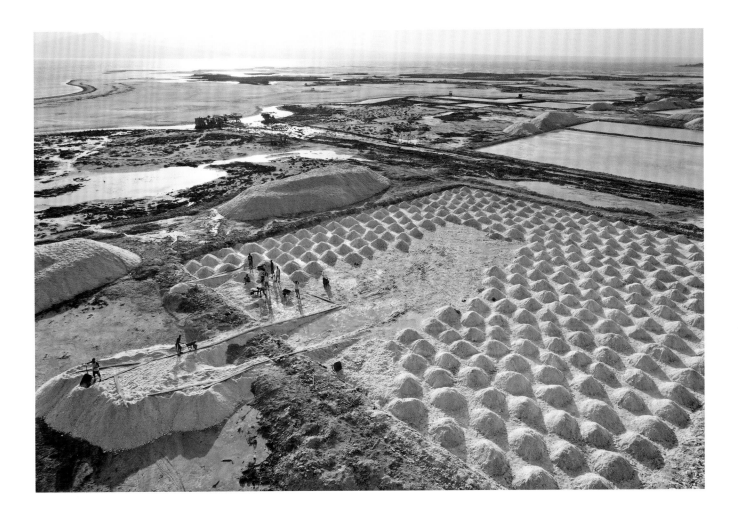

Small boats carry salt harvested from the bottom of Lac Rose, near the coast of Senegal. Lac Rose is named for its pink color, due to salt-adapted algae and haloarchaea. Lac Retba (Lac Rose), Senegal.

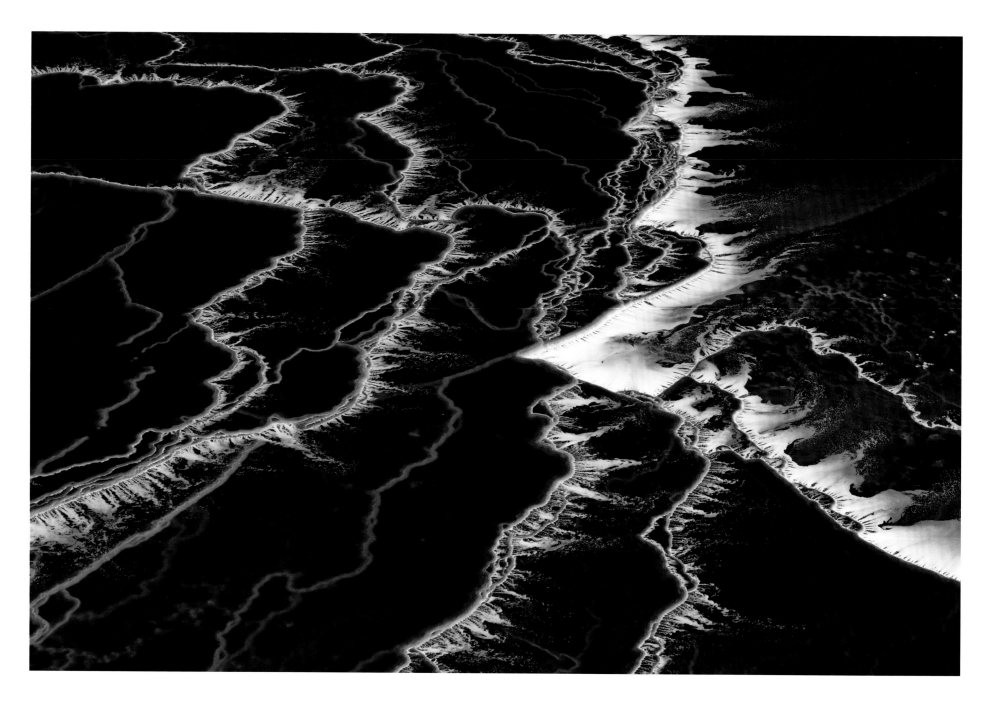

The southernmost eighteen miles of the Dead Sea are divided into evaporation ponds. Coffee-colored brine cascades from pond to pond, depositing table salt and carrying more valuable magnesium, potassium, chlorine, and bromine salts that remain dissolved until they can be collected and processed by the Dead Sea Works industrial plants. These salts end up in products ranging from potash for fertilizer to flame retardants to batteries. Ne'ot HaKikar, Israel.

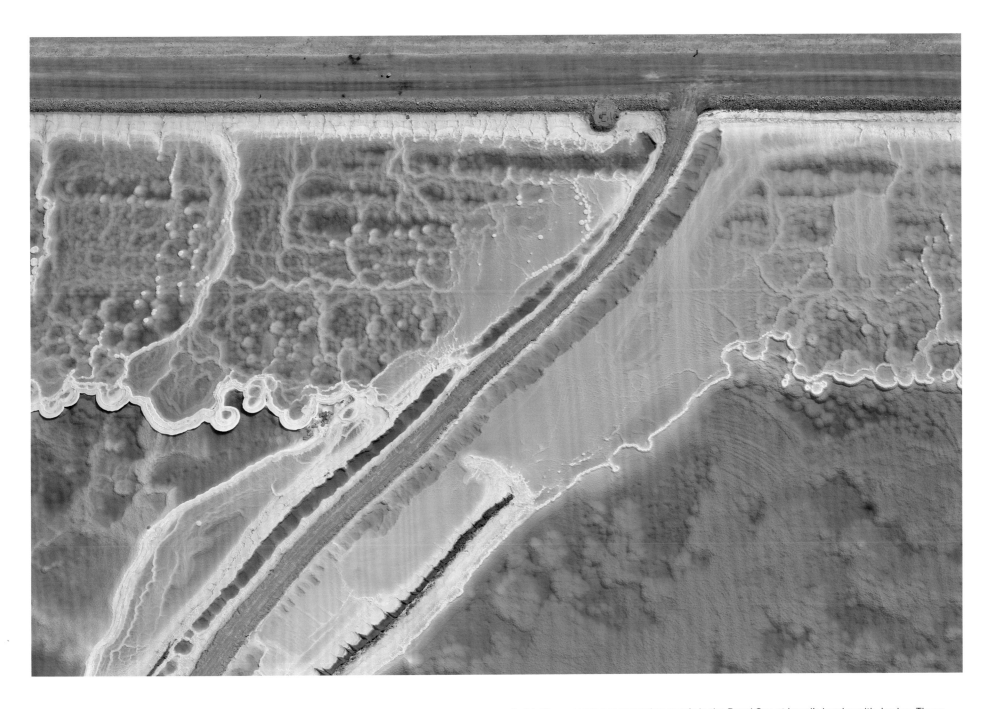

A dirt dike separates evaporation ponds in the Dead Sea at Israel's border with Jordan. These greenish ponds are the early stages of the evaporation process, where about twenty million tons of table salt precipitates from the brine each year, raising the floor of the ponds by about eight inches in the process. The Dead Sea Works must harvest these hard deposits to keep the evaporation ponds working and to protect nearby hotels. Ne'ot HaKikar, Israel.

PART 3 THE HUMAN FOOTPRINT

WHATEVER TERM WE USE TO DESCRIBE THIS MOMENT ON EARTH, the scale of change we have wrought in landscapes and ecosystems is astounding. Back in 2004, researchers had already calculated that humans had become the greatest earth mover on the planet, eroding soil and rock ten times faster than winds or precipitation and rivers. In 2016, an international assessment concluded that, in total, the materials and objects created by humankind weighed thirty trillion tons— one hundred thousand times more than the weight of the human population.

In a heartbeat of human history, our species has burned hundreds of billions of tons of fossil fuels, raising atmospheric levels of long-lived carbon dioxide more than 45 percent, from 280 parts per million when the Industrial Revolution was getting into gear in the mid-nineteenth century, to more than 415 parts per million in 2020—the highest concentration in 3 million years. While, even at this concentration, this gas is still only a trace constituent of air, the heat-trapping properties of carbon dioxide are leveraged as warming causes seawater to evaporate, adding water vapor, which is another greenhouse gas, to the air.

And, once liberated from a long-stashed lump of coal or gallon of fuel, carbon dioxide stays in circulation for centuries. The ideal way to stabilize the concentration of this gas in the atmosphere, let alone to reduce it, would be to remove more of the carbon dioxide from the atmosphere than is being released, and to do so even as the human population heads toward more than nine billion by mid-century—with every person on the planet eager for at least a decent life, and with access to energy for heating, cooling, mobility, manufacturing, and more a prerequisite.

A portion of that gas removal can be done, according to some recent studies, through massive efforts to plant hundreds of billions of carbon-storing trees. Another approach being pursued is

testing and refining technologies that can capture carbon dioxide and put the carbon to use in materials or fuels replacing fossil fuels, or compress it into a liquid and pump it into the ground from which it came.

The scale at which such efforts would need to take place is barely imaginable, let alone doable. And that means the main task remains cutting emissions in the first place. Rapid advancements in generating electricity with wind and sunshine, and replacing fossil fuels with electricity in transportation and other sectors, are beginning to dent fossil fuel use. Nuclear power, which for decades was the dominant source of carbon-free electricity, could still play a big role in the years ahead. Expansion in the United States and most of Europe is stalled because of costs and public fear. But China, Russia, South Korea, and other countries are working on new generations of reactors.

As the energy challenge plays out, human demand for food and water is also surging, although there are signs in developed countries of what might be called "peak meat"—a drop in meat consumption even as wealth rises. Recent assessments also see strong signs of "peak farmland," as ever more places around the world find ways to grow more food on less land.

Humanity is rapidly becoming an urban species. If cities, throughout human history a distinguishing mark of the human footprint on Earth, are designed well, ongoing urbanization can be a powerful driver of sustainable development. If urban influxes result in the kind of suburban sprawl that was typical in the mid-twentieth century, cities will remain part of the problem, not a path to a balanced relationship between people and the planet.

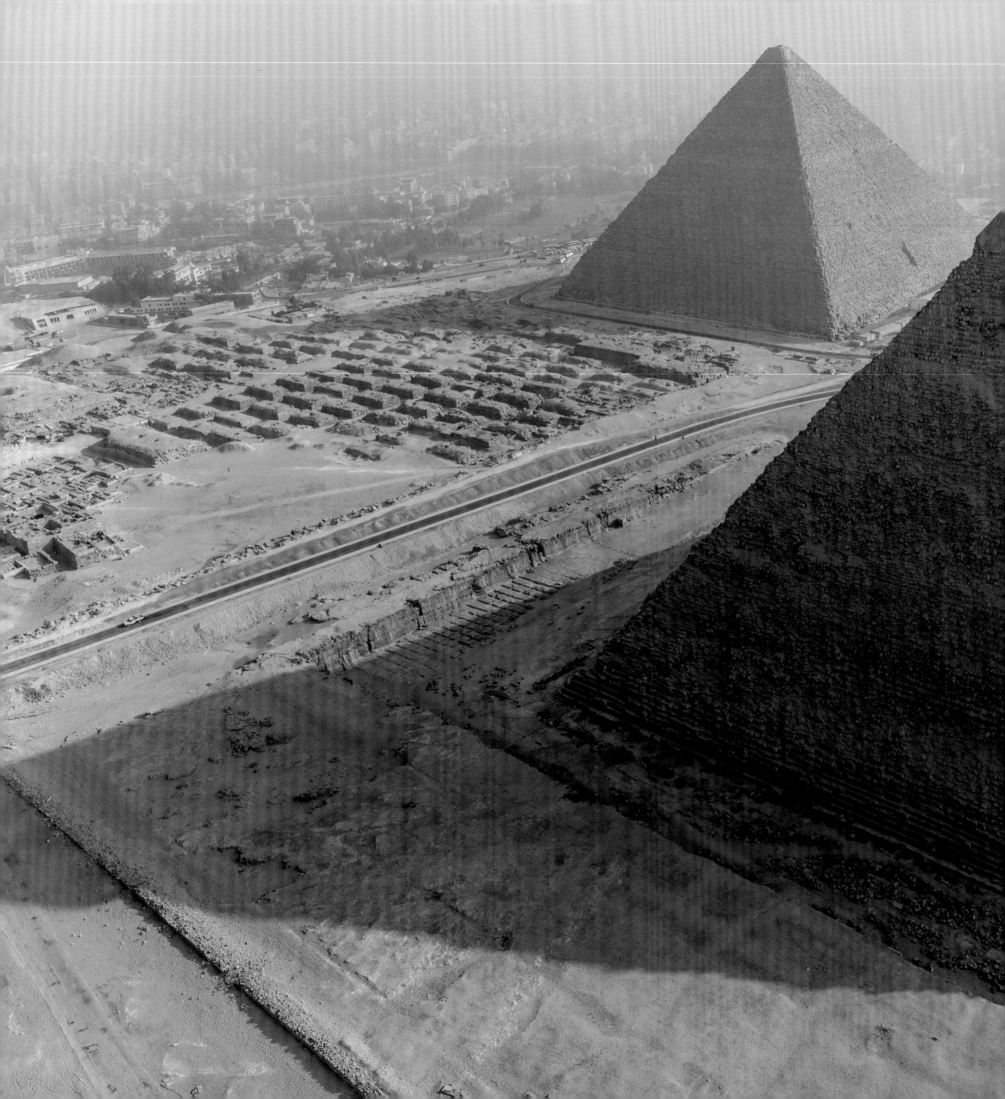

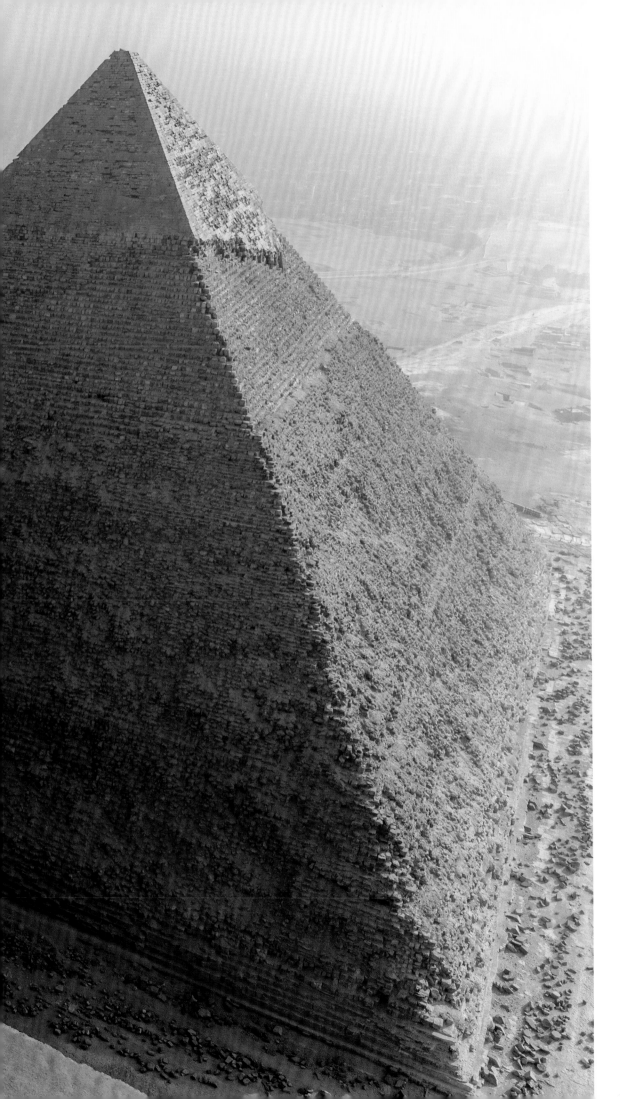

Rare close aerial view of the pyramids of Giza, with the pyramid of Khufu, often called the Great Pyramid, in the background. The Giza pyramids, which are more than four thousand years old, have been the subject of awe and wonder for centuries. To build a structure of this scale and durability today would entail enormous mechanized effort and would leave a significant environmental footprint. Exactly how the ancient Egyptians were able to do what they did remains a subject of mystery and widespread hypothesis. Giza, Egypt.

Molded by the hands of young boys, a village of clay toys forms a circle on a rainy afternoon during South Sudan's wet season. During the rainy months, adult men of Burgilo Payam village take livestock to a cattle camp seven miles away, while the children remain at home with the women and elderly. Several years before this photograph was taken, in 2009, these people had been forced to relocate their village by the second Sudanese civil war (1983–2005). Lafon, Imatong State, South Sudan.

Spheres and circular forms rise like sculptures from the dusky red soil of northern Kenya. The seminomadic Rendille people live in round villages, building their own huts around the circumference and placing thornscrub-fortified livestock pens in the protected inner ring. This village in Kargi is situated near a missionary post that offers a dispensary, school, and water wells, services that have drawn the Rendille to the area in spite of the lack of vegetation. The people's goats and camels are largely absent from the pens pictured here, as the men have had to take them elsewhere to find terrain suitable for grazing. Kenya.

A large, five-pointed Buddhist stupa, or domed shrine, is surrounded by four groups of smaller stupas. The earthen-bricked stupas are part of the ruins of the ancient city of Jiaohe, believed to date from the seventh century CE and built on the site of much older structures. Over the centuries, this garrison city, located within the natural fortification of a raised terrace, has been occupied by multiple peoples, including the Han, the Tibetans, and the Uighurs. Turpan, Xinjiang, China.

Bronze Age raised burial mounds create striking depressions and projections on the English landscape. These ancient graves are also known as barrows or tumuli. A circular or bowl-shaped mound generally marks the burial place of a single important or wealthy individual. These mounds, known as the Normanton Down barrow group, are located within sight of Stonehenge, among hundreds of other earthen monuments and ancient cemeteries that ring the famous standing stones over several miles of countryside. Stonehenge, Wiltshire, United Kingdom.

On the rugged plains near Ethiopia's Awash River delta, clusters of circular and rectangular graves piled with stones create a village-like cemetery. The rectangular ones follow the custom of burying the dead with the head pointing toward Mecca and appear to be Islamic. This is a cemetery of the Afar, a tribe of nomads and herdsman occupying parts of eastern Ethiopia, Eritrea, and Djibouti. The graves lie partially buried in clay amid lava flows emanating from Rift Valley volcanoes. Asaita, Afar, Ethiopia.

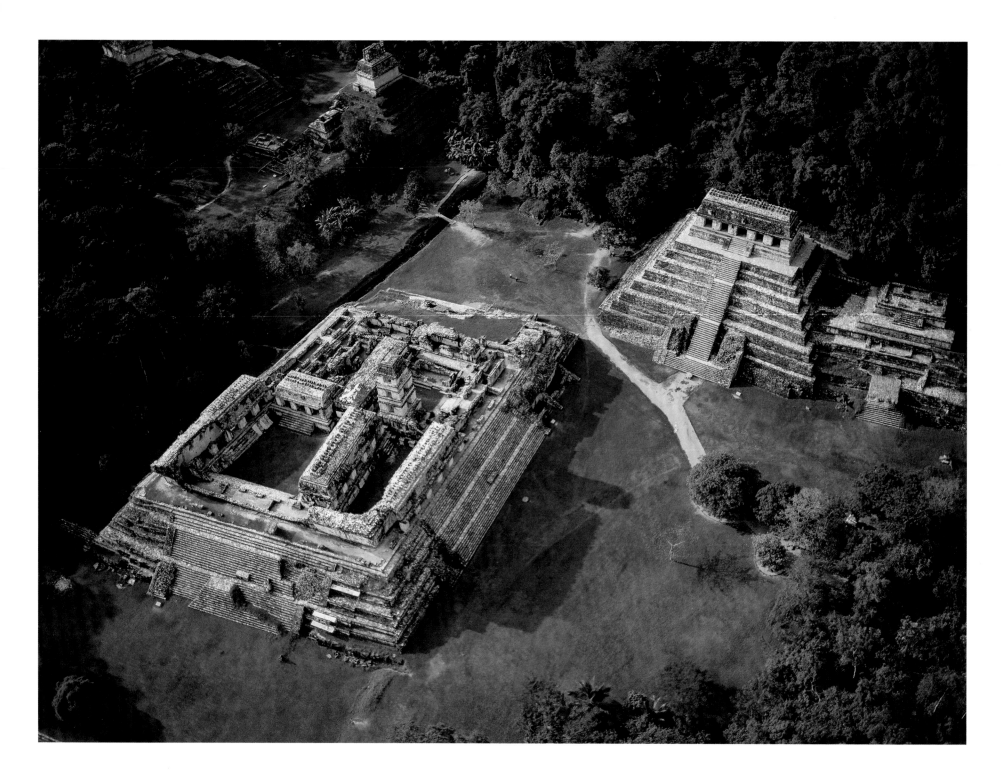

Much of what we know about the Mayan civilization has been communicated through the language of stone—in Mayan architecture, carvings, and hieroglyphs. The ruined city of Palenque gives a picture of the great wealth, sophisticated culture, and religious devotion of the Mayan people. Palenque came to power in the seventh century CE, and was one of about forty Mayan cities composing the predominant society of the region. Pictured on the left is the Royal Palace, the residence of Pakal the Great, which also served as the administrative heart of the city. On the right is the Temple of Inscriptions, the largest known Mesoamerican step pyramid. Palenque, Chiapas, Mexico.

The largest of the two Abu Simbel temples was originally carved directly into a mountain face on the Nile's west bank. Both temples were commissioned by Pharaoh Ramses II some three thousand years ago. Completion of the Aswan High Dam in 1960 meant that the monuments would become submerged, and probably irreparably damaged. UNESCO organized a plan to move the temples to higher ground. The porous sandstone structure had to be cut into twenty-ton blocks with handsaws and hauled 650 feet uphill of the original location, then carefully reassembled. Much of the work was done by hand, and the relocation is a remarkable accomplishment of modern engineering that rivals the temple's original construction. Abu Simbel, Egypt.

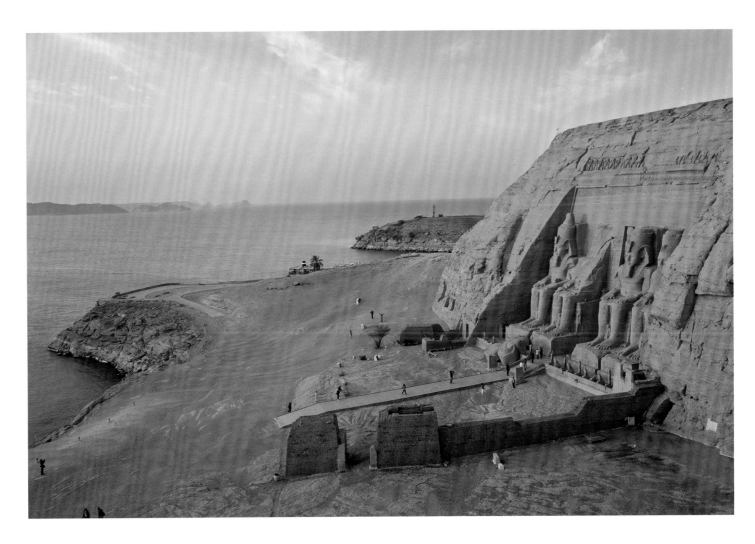

The spectacular facade of Al-Khazneh, hewn into the pink-hued sandstone at the edge of a narrow canyon in the ancient city of Petra. Here, Al-Khazneh is illuminated by candlelight during a biweekly musical performance. Though its name translates as "the treasury," Al-Khazneh is in fact a royal tomb built in the first century BCE. In the surrounding gorges and rocky channels, the coral- and peach-colored rock is carved into multiple structures and ornate facades, a magnificent triumph of the architecture of permanence. Petra, Jordan.

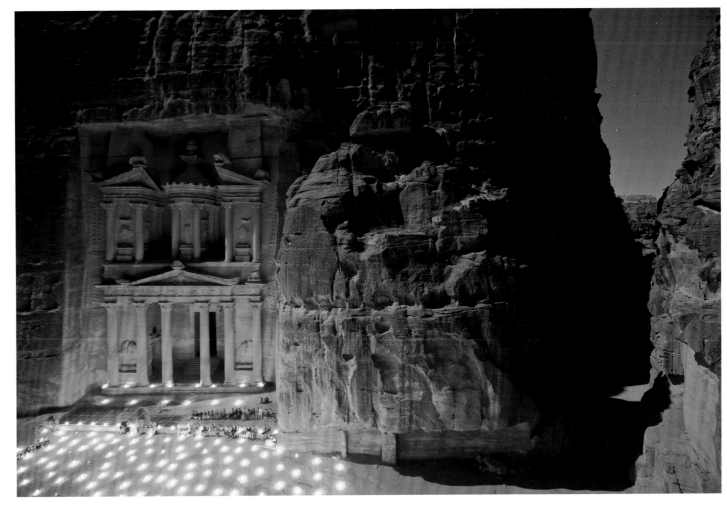

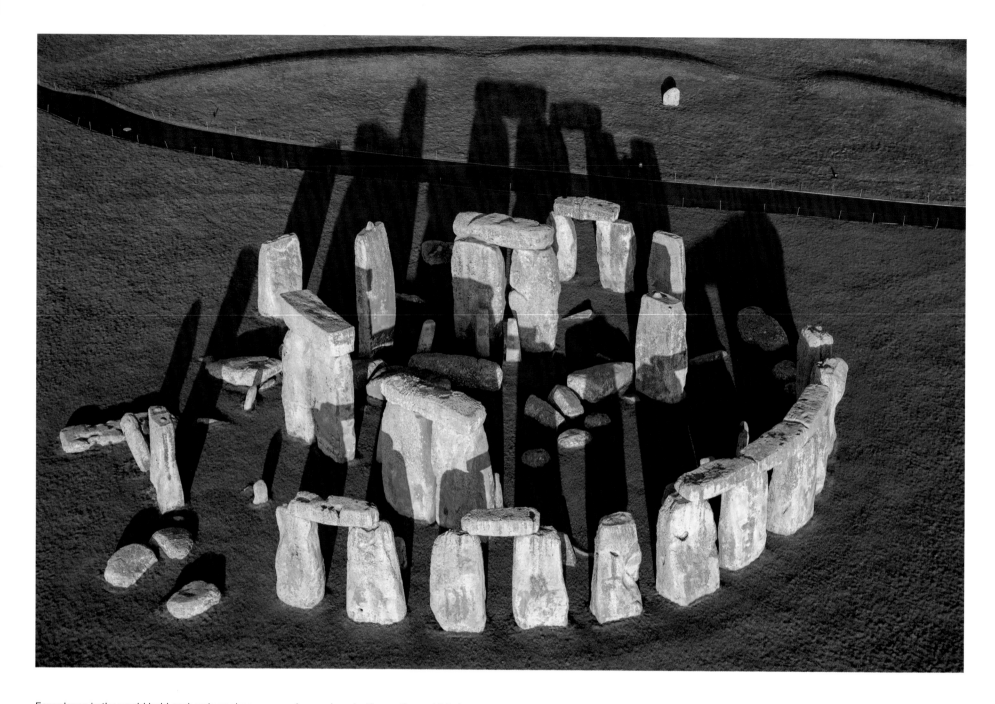

Few places in the world hold such universal power over human imagination as the prehistoric monument of Stonehenge (c. 3000–2000 BC) in southern England. Though weathered by centuries of wind, rain, and erosion, many of the massive stones are still standing. The largest slabs, called sarsens, are sandstone thought to have been transported eighteen miles from the north. The smaller ones are bluestones, and can have come only from Wales, more than one hundred miles to the north. Though the monument and the many Bronze Age burial mounds in the surrounding countryside have been combed over by archaeologists and historians, we still have no precise understanding of what, exactly, Stonehenge was used for. The monument is pictured here on a clear spring morning one day after the vernal equinox. Stonehenge, Wiltshire, United Kingdom.

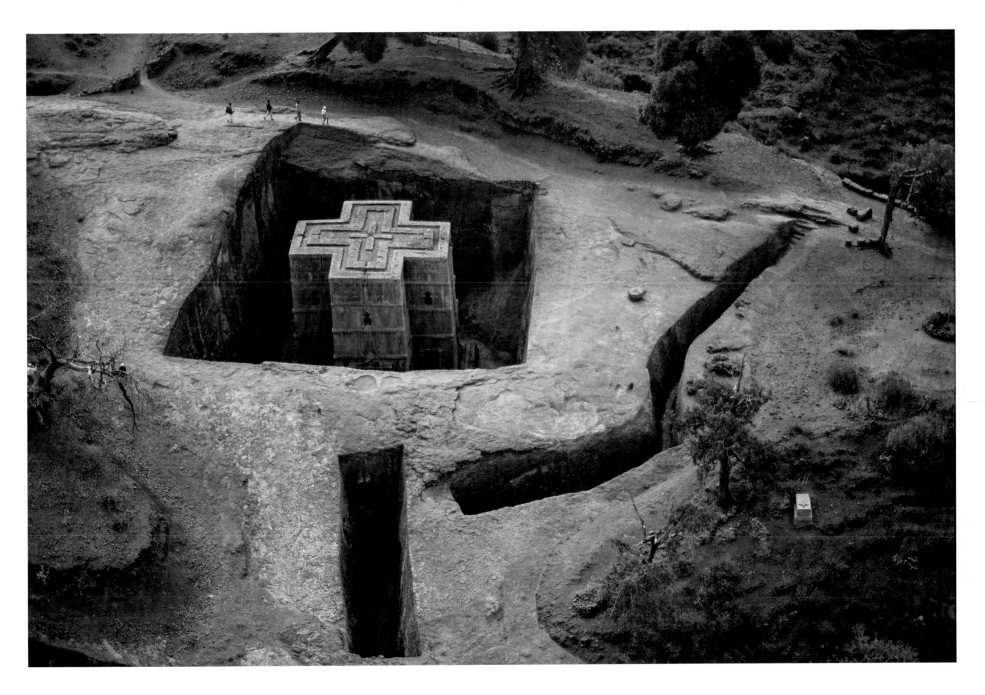

Bet Giyorgis is perhaps the most beautiful of Ethiopia's monolithic churches, which were carved into the ground or hewn from a single (mono) rock (lith). Eight hundred years ago, Ethiopian King Lalibela had a vision that he should construct a new church in the volcanic rock beneath his birth site. His workmen chiseled his vision to life, starting at ground level, where they cut a roof in the shape of a square cross, then carving down forty feet and tunneling windows into the walls. The result of those efforts is a stunning cross-shaped three-level plinth, freestanding in the earth. Today, the building remains in excellent condition, and prayer services continue to be held there daily. Lalibela, Ethiopia.

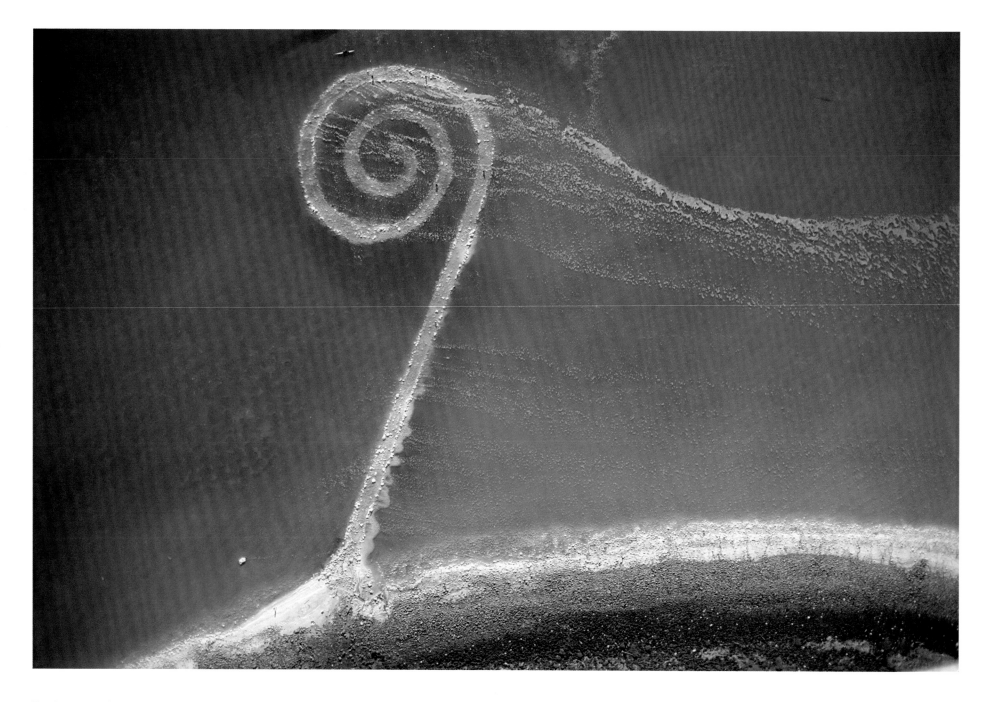

For thousands of years, cultures all over the world have used the earth as a canvas to create large designs on the soil known as geoglyphs. Some appear to be functionally oriented, while others, like the Nazca Lines in Peru that form animals such as hummingbirds, monkeys, and orcas, seem to be decorative or celebratory. Pictured here is a geoglyph created in 1970 by American artist Robert Smithson on the northeastern shore of Utah's Great Salt Lake. He used black basalt rocks to create this fifteen-thousand-foot-long coil, which he called *Spiral Jetty*, that extends into the water. In the mid-1970s, the lake level rose and submerged the geoglyph. When water levels fell again decades later, the jetty reemerged with a new look, its rocks blanched by the salt water. Rozel Point, Utah, United States.

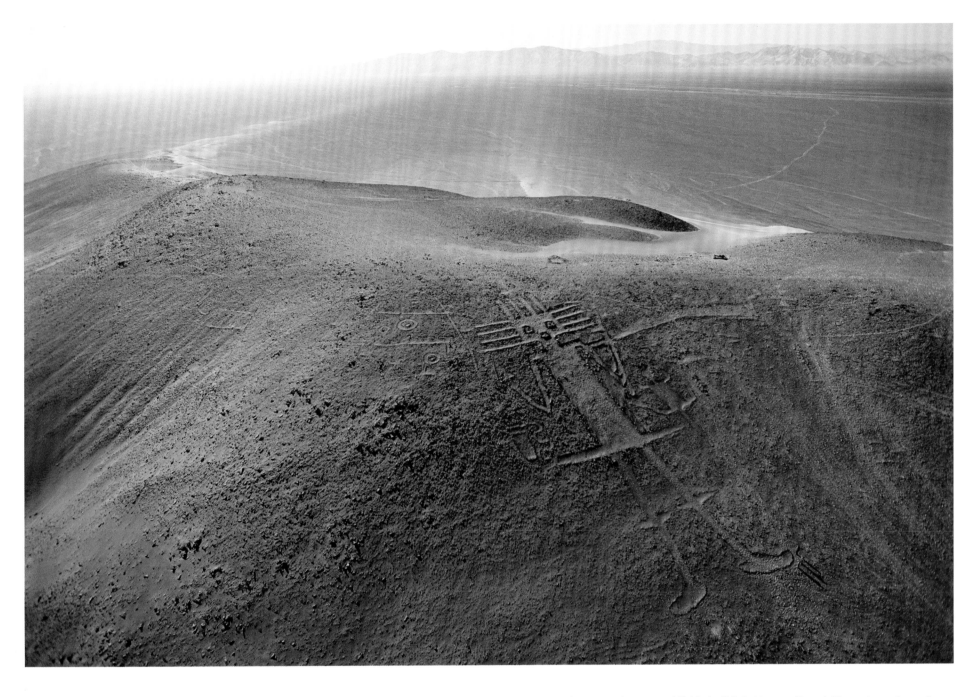

The Atacama Giant sprawls across a hillside in Chile's Atacama Desert. Measuring a staggering 390 feet long, it is the largest anthropomorphic geoglyph in the world (an arrow in Peru's Nazca Lines is 1,600 feet in length). It is believed that several indigenous cultures contributed to creating the figure between 1000 and 1400 CE, but its meaning and origins remain unknown. Illuga, Región de Tarapacá, Chile.

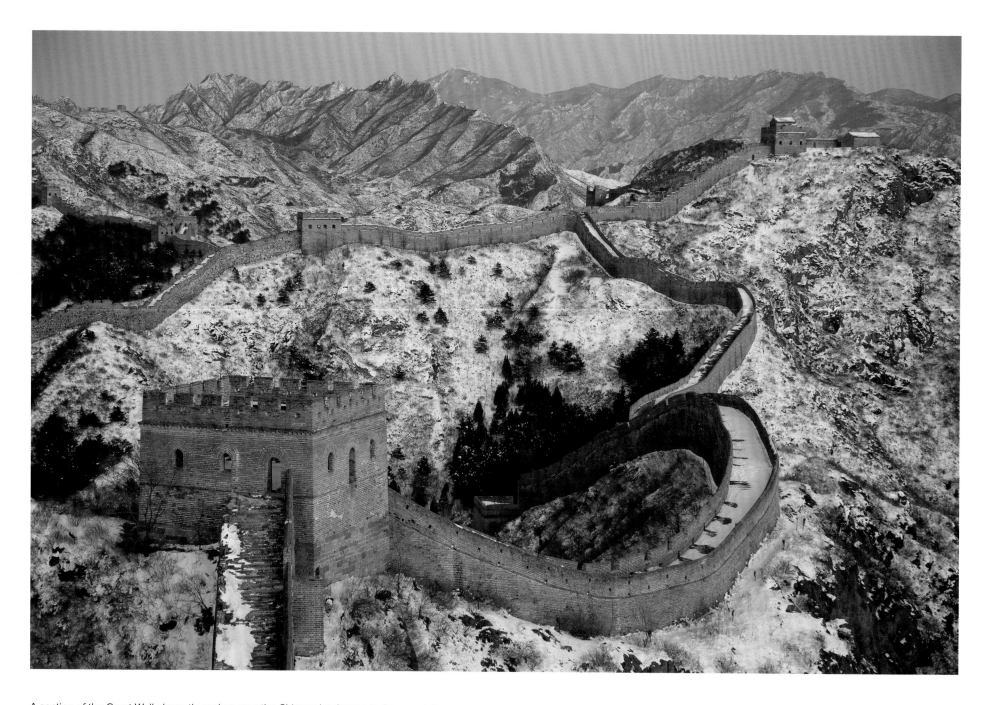

A section of the Great Wall elegantly snakes over the Chinese landscape in the mountainous Jinshanling region. This is one of the best-preserved sections of the wall and retains many of its original features. Today tourists come to hike these ramparts, which afford sweeping views of the Greater and Lesser Jinshan Ranges (gold mountains). The Great Wall of China is actually a series of connected fortifications with distinct features, built in various periods by rulers with differing needs. The entirety of the wall measures some thirteen thousand miles. Jinshanling, Hebei Province, China.

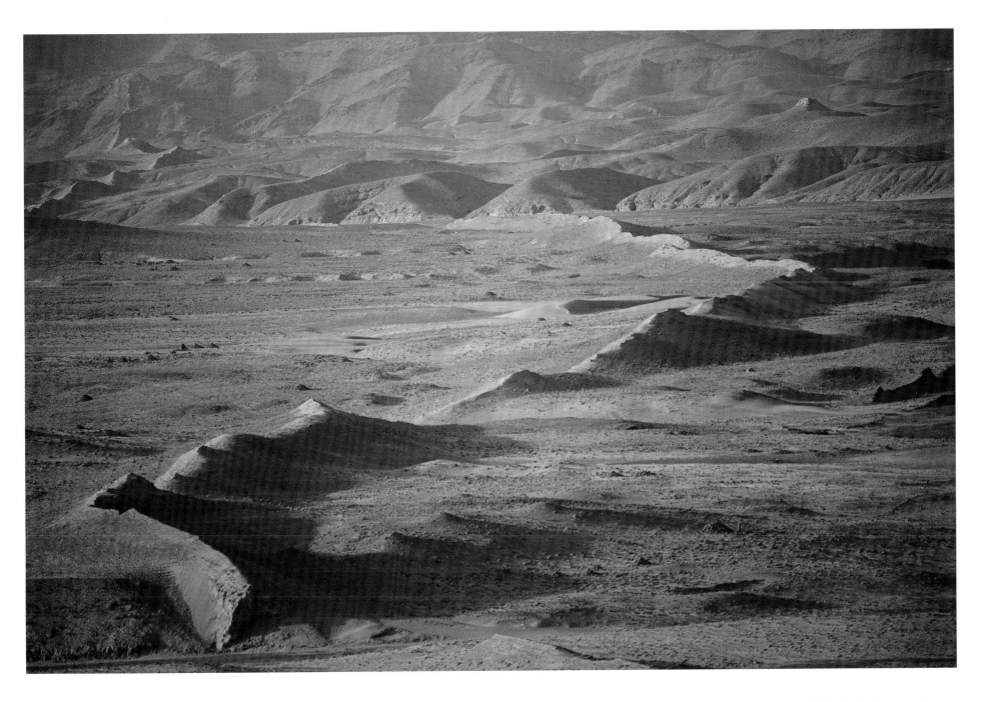

This section of the Great Wall in Zhongwei is a study in contrasts with its Jinshanling counterpart. In Zhongwei, precipitation is sparse, and the terrain of grasslands and desert cannot hold much moisture. The wall here was originally constructed with mud during the Ming dynasty, which began in 1368. Over the course of many generations of wind and sporadic rain, the structure has eroded, and it appears that the land is slowly reclaiming it. Almost one-third of the original Great Wall is now in ruins. Zhongwei, Gansu Province, China.

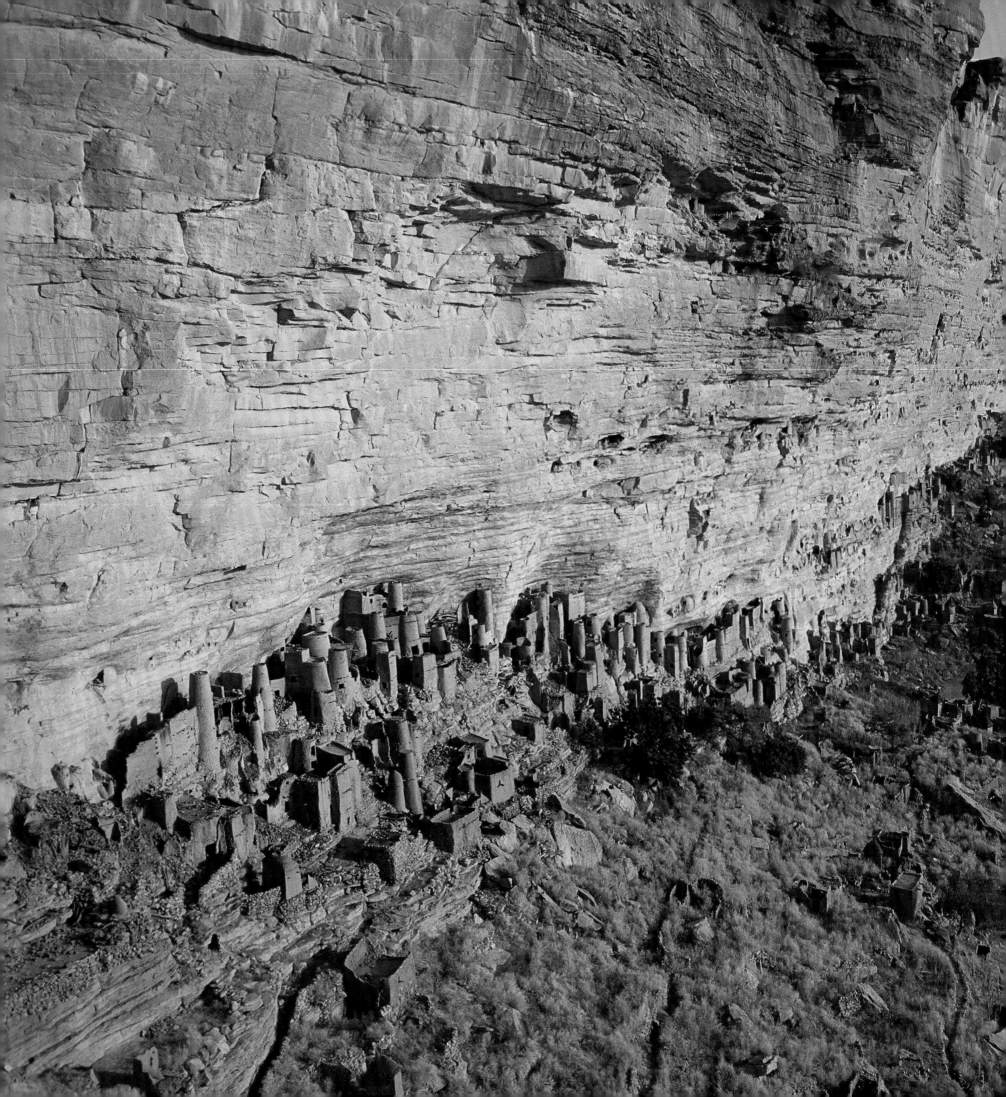

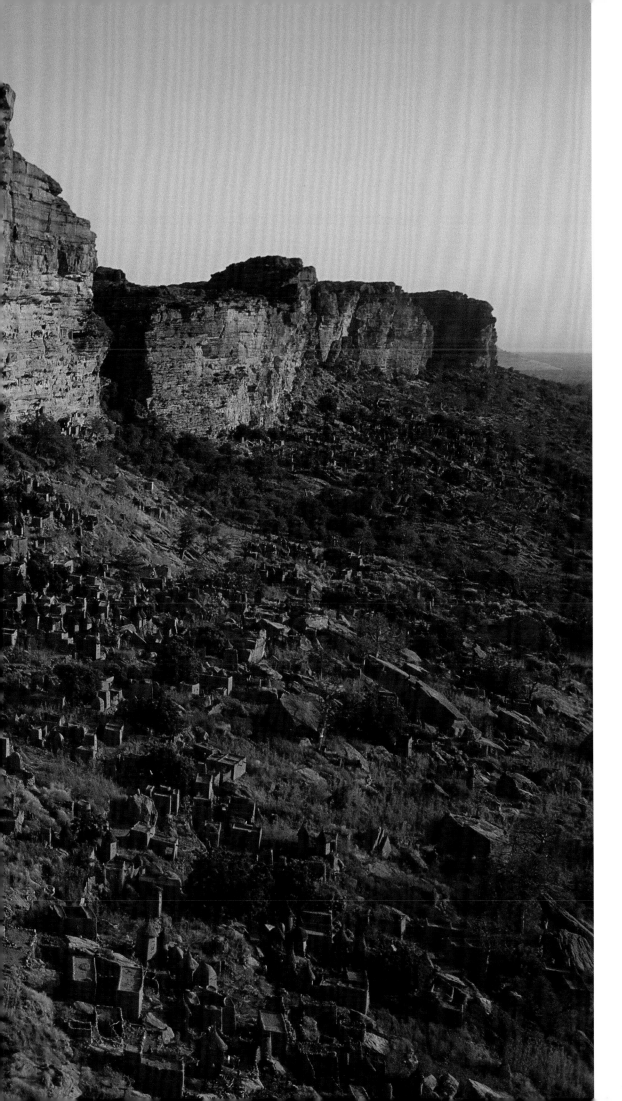

The Cliff of Bandiagara towers over the sandstone plateau and plains known as the Land of the Dogons. Thousand-year-old earthen dwellings cluster at the base of the escarpment, clinging to the rock face like children to their mothers. Once home to the Tellem people, these curved, wind-smoothed structures are now used as a mausoleum by the Dogon people, who have built their own village among the shrubs and rocks of a nearby descending slope. Cliff of Bandiagara, Mali.

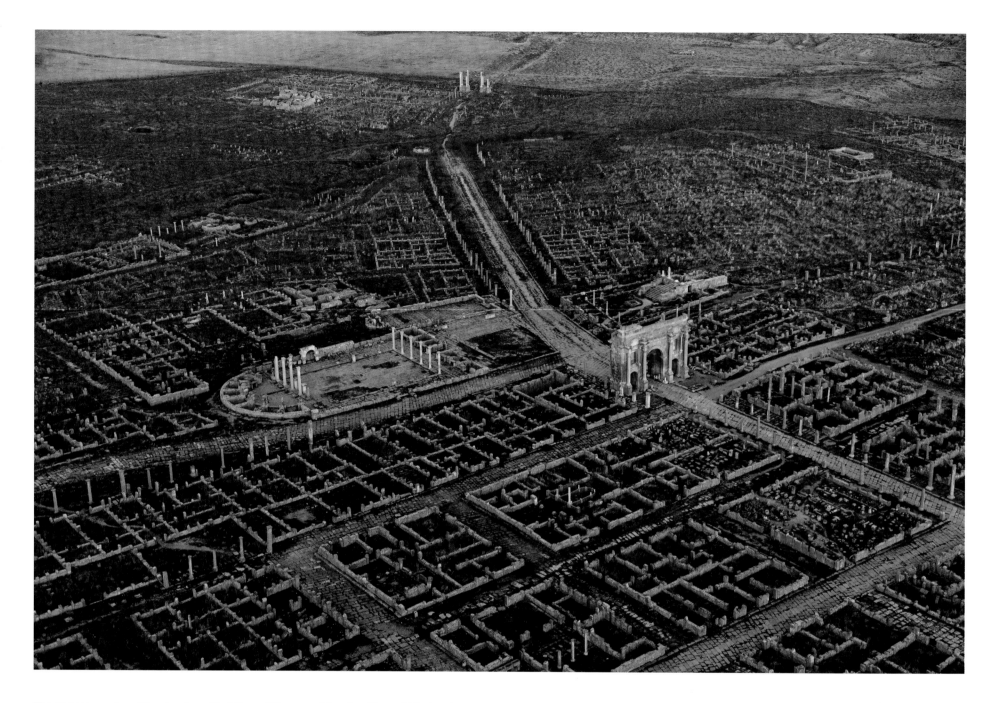

The ancient remains of the streets and buildings of Thamugadi (modern Timgad) blanket the Algerian landscape with an elegantly geometric precision. The Roman city, built by Emperor Trajan as a military colony for veterans, was generously appointed with an amphitheater, a forum (market), a library, and an elaborate baths complex. It is an excellent example of the grid-style urban planning favored by the Romans. The streets were paved with large rectangular limestone slabs, with the two main roads running perpendicular to each other. In the center of this picture is the twelve-meter-high triumphal monument known as the Arch of Trajan. After an Arab invasion, the city was abandoned in the eighth century, and it ultimately disappeared from view, swallowed up by the protective sands of the Sahara. There it lay for a thousand years, until it was discovered and excavated in 1881. Timgad, Batna, Algeria.

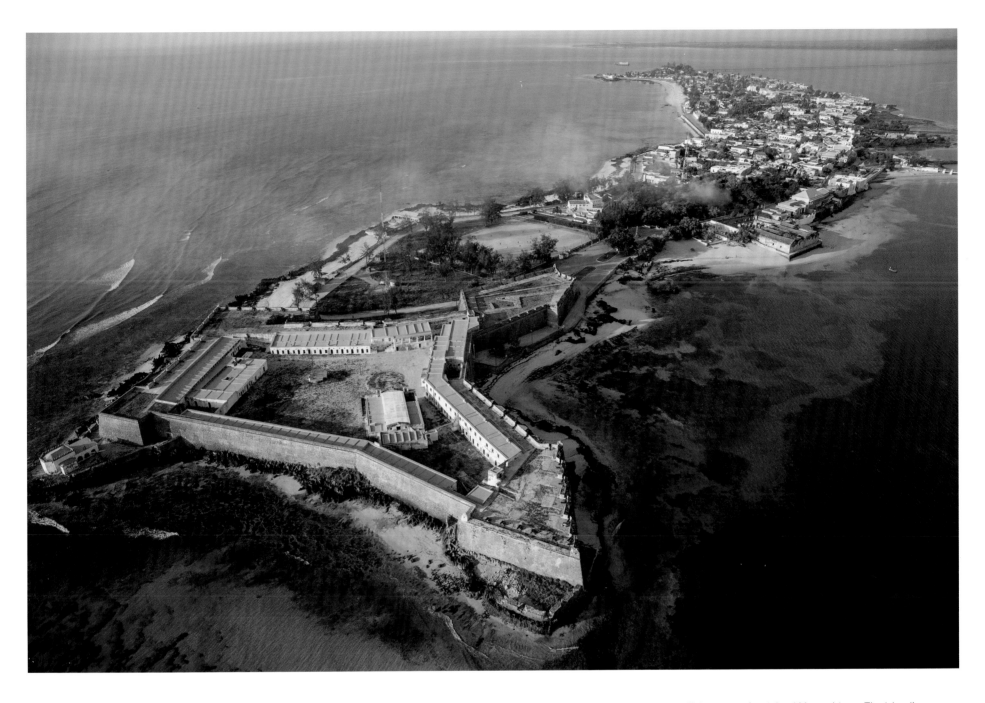

Mozambique Island lies several miles off the coast of mainland Mozambique. The island's fortress of São Sebastião commands immediate attention, its walled fortifications converging in an arrow-shaped bastion pointing toward the north. The island is a calcareous coral reef, and it was first settled by the Portuguese in 1507, after which it became a center of the African slave trade. In 2018, an archaeology center was opened on the island that will focus on researching slave ship routes and locating and preserving the remains of slave ships that sank off the coast. Mozambique Island, Nampula Province, Mozambique.

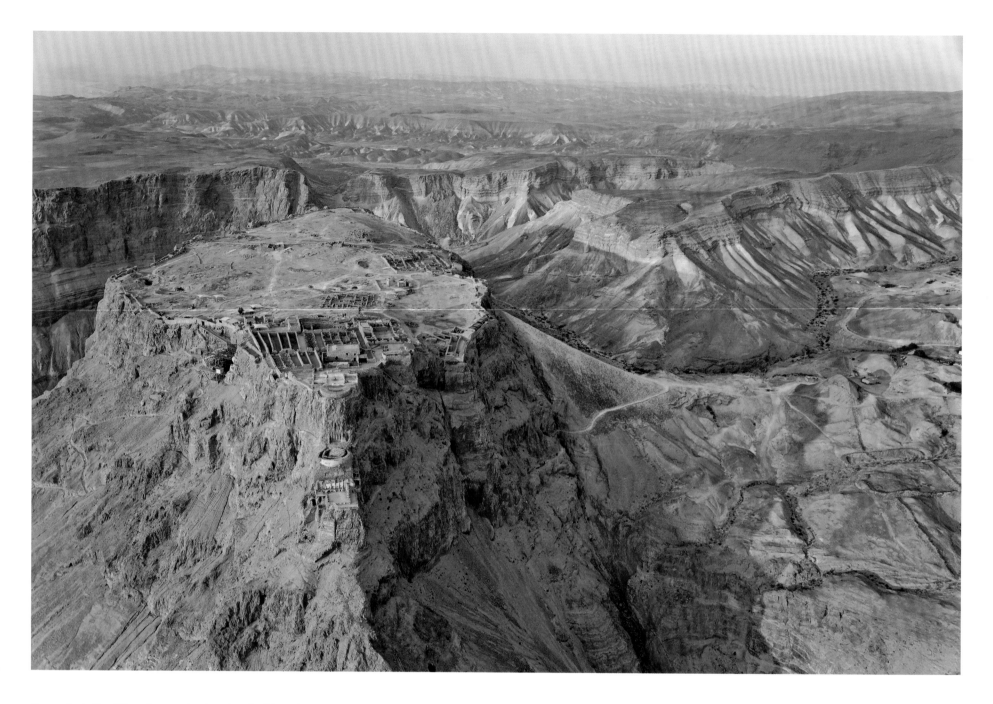

The ancient city of Masada soars fourteen hundred feet above the ground, its walls clustered at the rock's apex as if the town is riding the prow of a great stone ship. King Herod of Judea fortified and added cisterns to the existing desert fortress for the Jewish people. Roman troops sacked Jerusalem in 70 CE, and several years later laid siege to Masada, where hundreds of Jewish men, women, and children had taken sanctuary. After unsuccessfully trying to starve them out, the Romans built a massive earthen siege ramp, seen in the center of this photograph. When they finally breached Masada's casement walls with a battering ram and entered the fortress, they found that the hundreds of refugees inside had committed suicide. Masada, Israel.

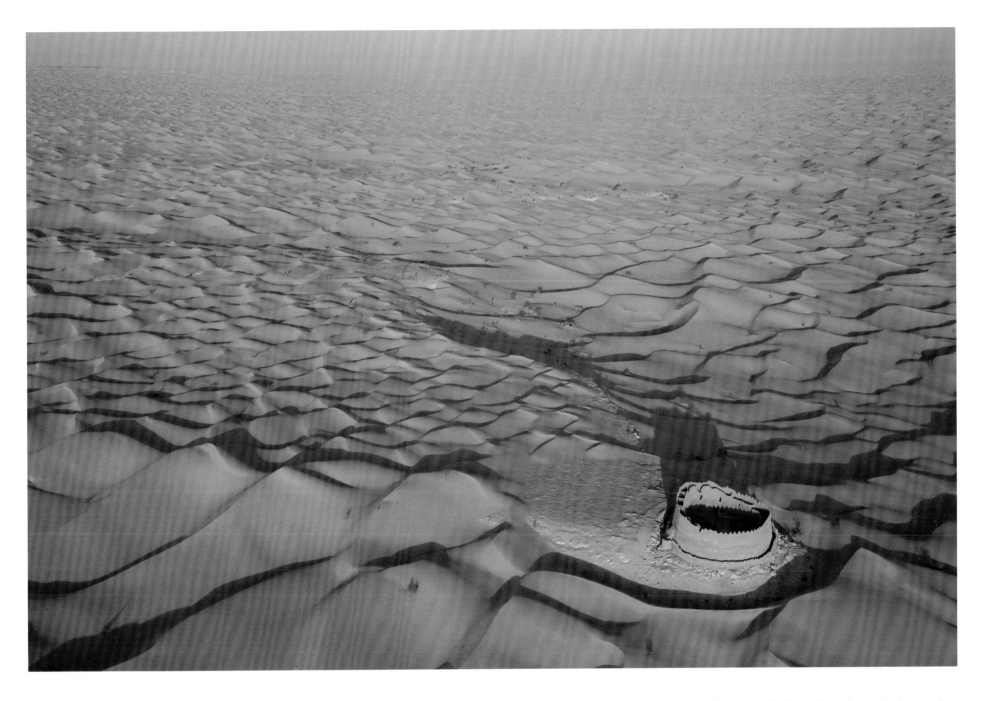

An abandoned *ksar*, or fortified village, stands lonely vigil in the endlessly barren landscape of the Grand Erg Occidental. An erg is an area of desert that has been consumed by wind-driven sand and becomes predominantly made up of dunes, with no vegetation coverage. Every old village in the area has its fortifications, but most have been ground into ruins by the force of the constant sandblasts. This *ksar* is unusual in that it is virtually intact, and in that it is made with stones rather than mud brick; it is all that remains of terrain that must once have been sufficiently verdant, and forgiving enough, to support human life. It is said locally that the name of this place is Ksar Dra'a, and that it was once occupied by a Jewish sect in a time when much of the territory of modern Algeria was Jewish. Timimoun, Adrar, Algeria.

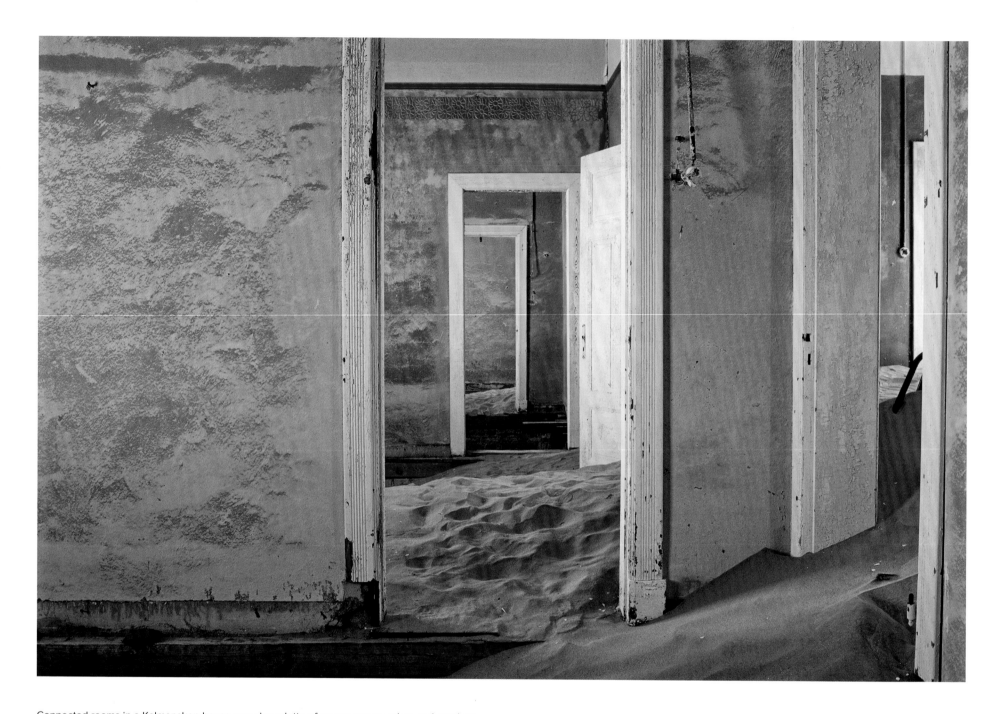

Connected rooms in a Kolmanskop house reveal a palette of grassy green, ocher, and cerulean blue that belies the utter absence of life here. In the early twentieth century, a railroad worker spotted a scattering of diamonds on the dried surface of a riverbed. The desolate region was soon descended upon by crowds of fortune hunters, and a diamond rush ensued, with a mine producing a staggering million carats a year. Within just two decades, the diamonds were depleted. The fortune seekers moved on, but the houses and shops remain, standing upright even as the unyielding sands of the Namib push their way inside. Kolmanskop, Namibia.

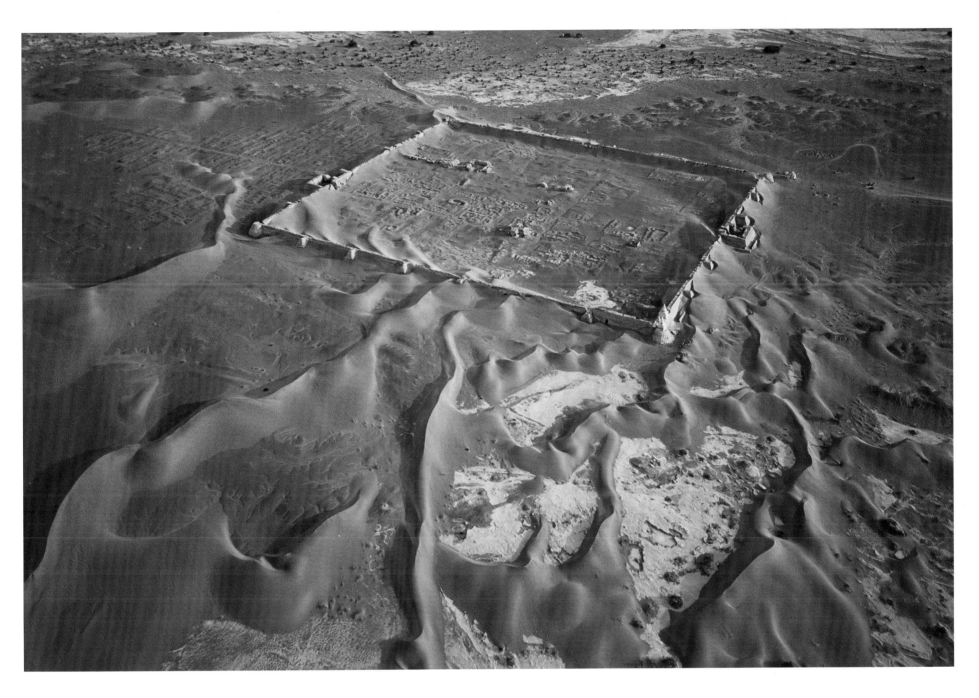

The skeleton of a fortified town is shrouded by a rippling fabric of desert sand. The Gobi is the northernmost desert on Earth, and is one of China's least populated regions. This town was given the name Khara Khoto, meaning "black city," and local lore has it that the site is teeming with demons and spirits. In 1226, the sound of hoofbeats erupted across the horizon as Genghis Khan's Mongol armies descended on and seized the fortress. Marco Polo visited this site later in the century, and cautioned future visitors to provision fully before departing, as the desert beyond the black city required a full forty days' journey to pass. Ejin Qi, Inner Mongolia, China.

The venerable homes of the old walled city of Ghadames honeycomb a pre-Saharan oasis on the desert's edge. The thick albescent walls reflect the sunlight and keep the interiors of these buildings cool in all but the hottest summer months. The flat roofs are designed as warm-weather sleeping areas, and are connected to one another by pathways, just as a network of ground-level alleys provides covered walkways protected from the sun. The city, which has no electricity or plumbing, was abandoned in the early 1980s when the government built new housing for the residents. Many continue to maintain their ancestral homes, however, and the city has become a popular tourist destination, a paradigm of sustainable architecture from which the world has much to learn. Ghadames, Libya.

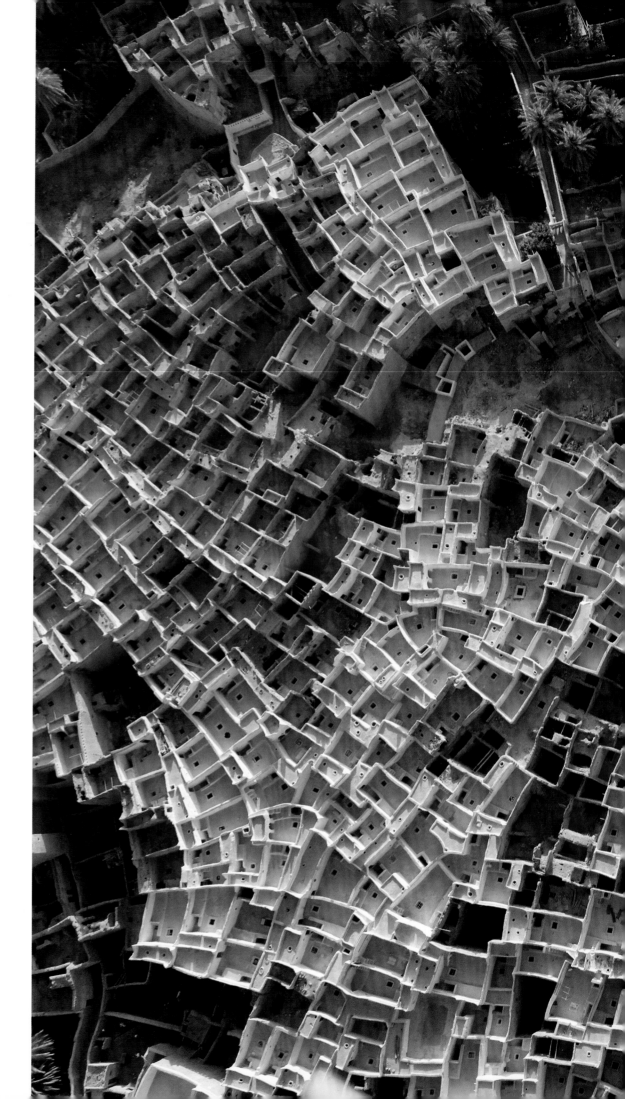

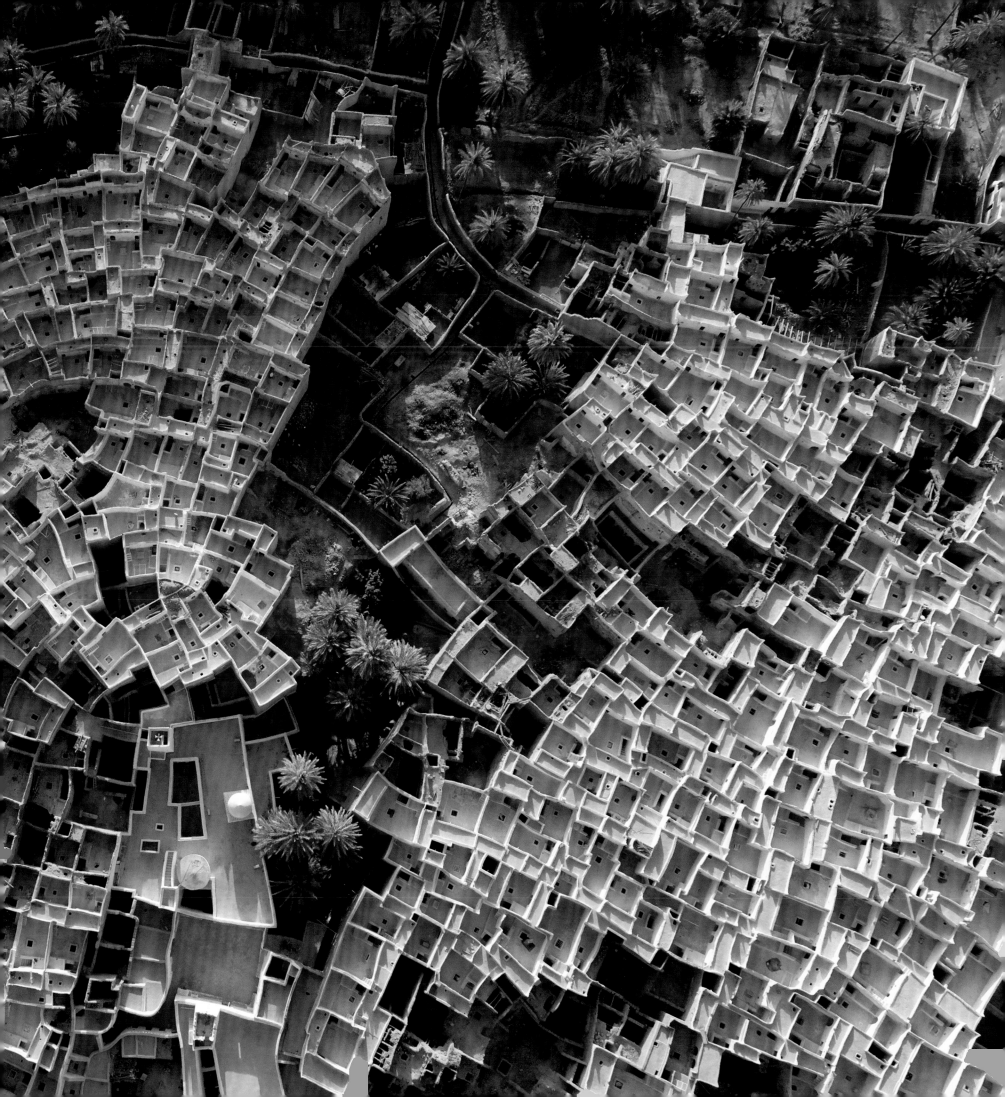

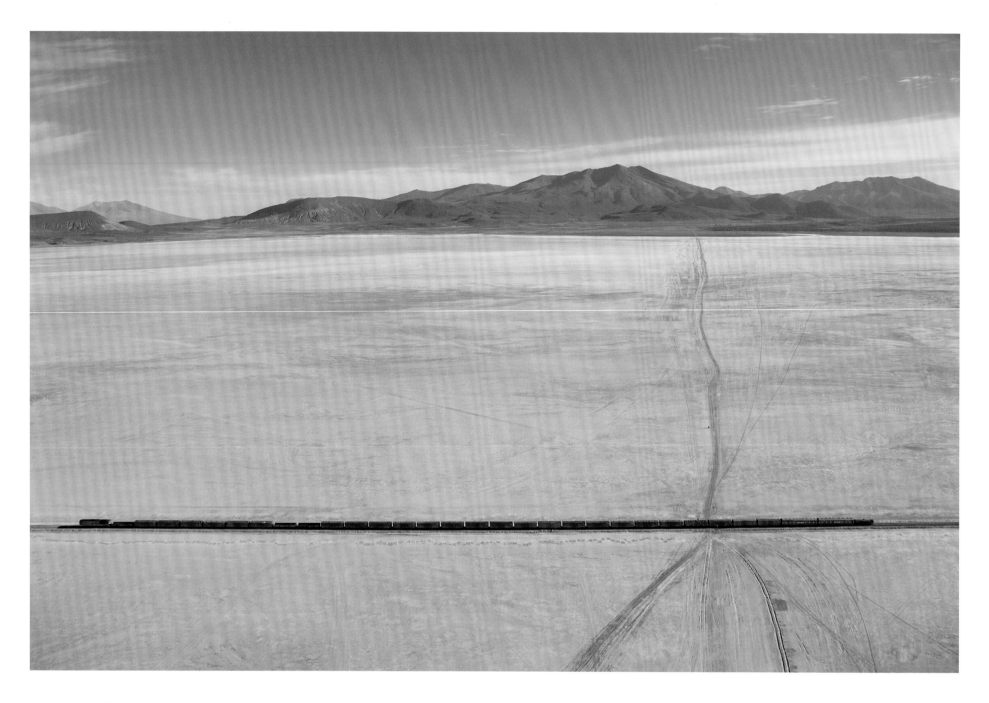

A train crosses the Salar de Chiguana from Uyuni in southwest Bolivia. Its final destination will be the frontier village of Avaroa on the Chilean border. The Salar is a flat salt plain that extends for about 250 miles, encircled by volcanoes. For someone wishing to cross the Salar, methods are few and far between. The train carries passengers only on Mondays and Thursdays. The rails here are crisscrossed by the tire tracks of jeeps, a more popular and convenient way to traverse the Salar. Avaroa, Potosí, Bolivia.

The tracks of the Trans-Mongolian Railway follow the path of an old tea caravan route through the Gobi Desert. This line between Wuhai and Jilanti was one of the last sections of track in the Gobi to still use steam locomotives. The problem of sand burying sections of track was a serious one until the 1950s, when a method was devised to weave grids out of straw to flank the tracks in heavy dune areas. The mats (seen here) have stabilized the dune and encouraged growth of groundcover, as evidenced by the patches of green visible on the right. Jartai, Inner Mongolia, China.

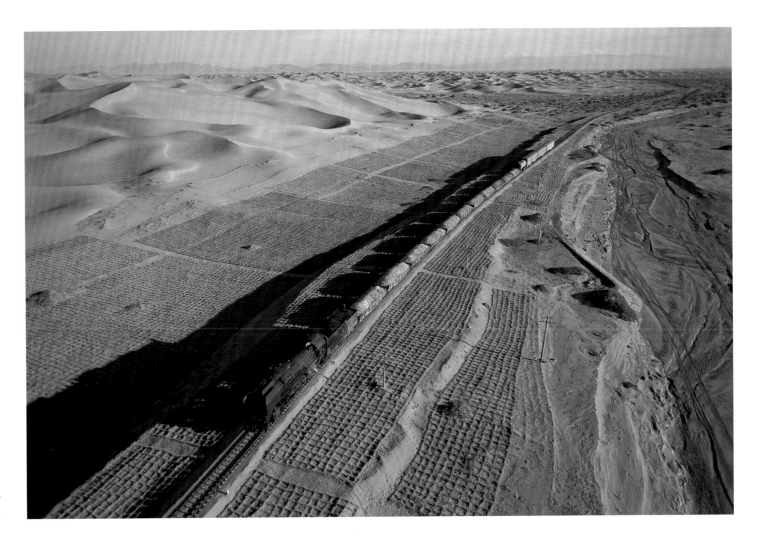

The dunes of Sharurah stretch for hundreds of miles across the southern margins of the desolate erg known as the Rub' al-Khali, or Empty Quarter. This region was excessively difficult to reach until modern times, when a two-lane asphalt road was built. A remote border town, Sharurah lies 209 miles from Najran, the provincial capital. The Saudi government maintains a military post there in an effort to secure a disputed border with Yemen. Saudi Arabia.

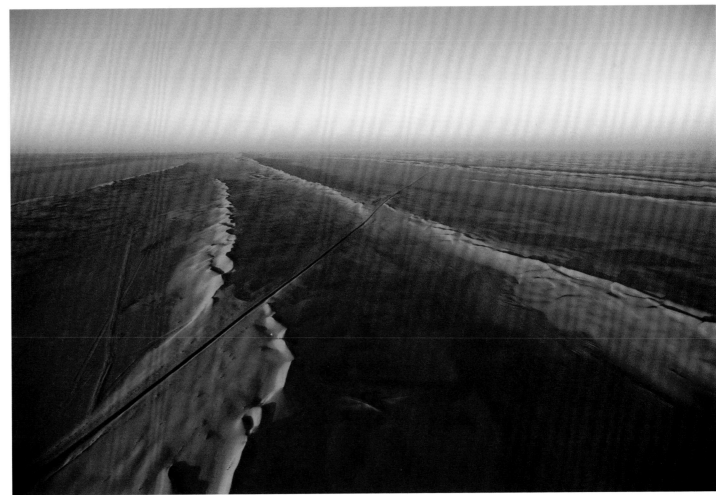

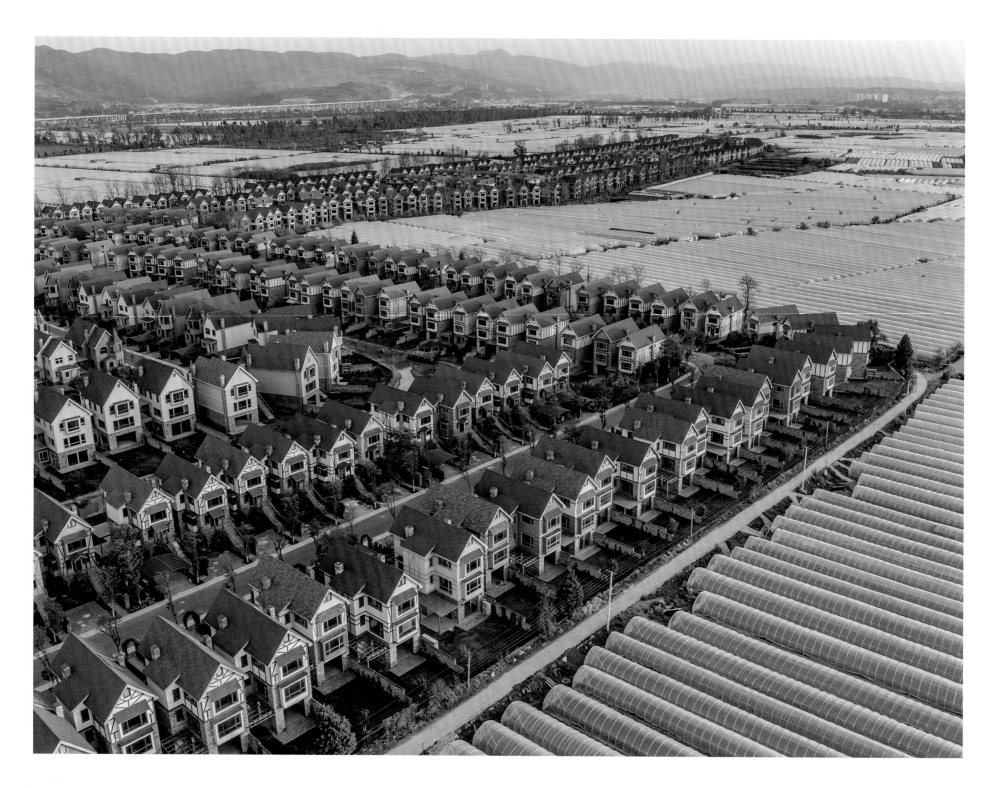

Staggered rows of houses fill a new suburban development just north of Kunming, and face lines of tube-shaped plastic greenhouses. Rising incomes in China have led to a predilection for Western taste in both lifestyle and diet. Inside the greenhouses, fruits and vegetables are cultivated year-round in the mild climate, under the watchful eyes of the adjacent homeowners. Songming County, Yunnan Province, China.

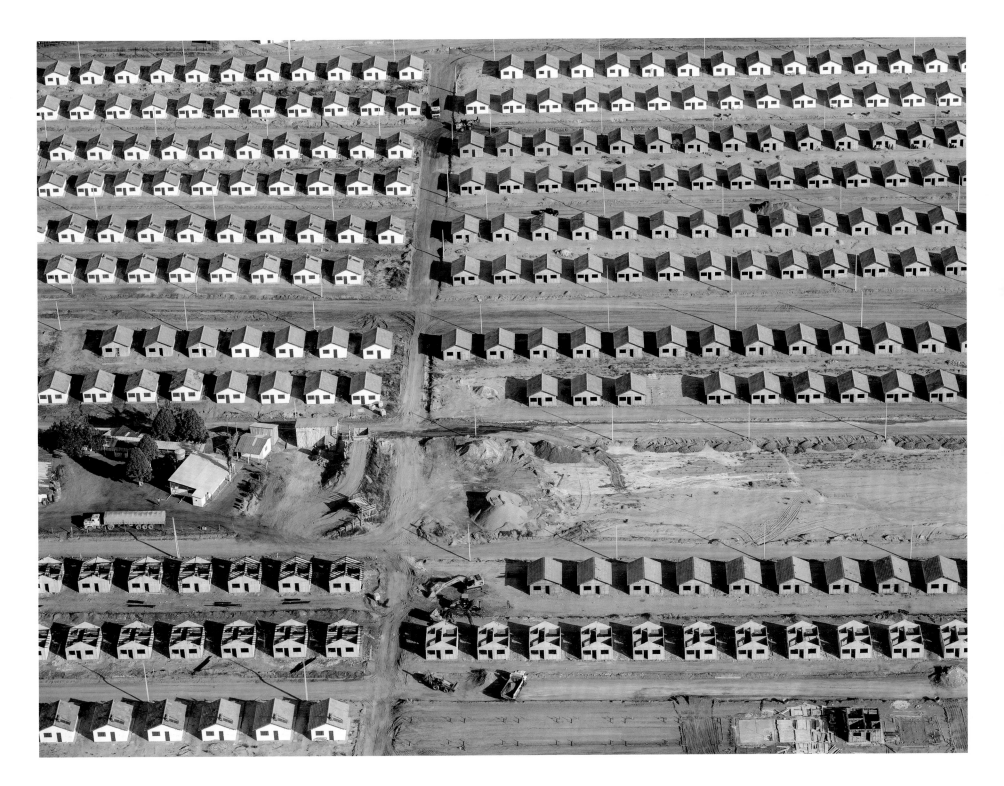

Rows of identical houses are being built in the Amazon by the Brazilian government. Itaituba has been significantly impacted by the soy boom in the Amazon. Much of Brazil's exported soy is shipped to China, and large barges are now frequenting the small rivers of the Pará region, as using this northern water route reduces shipping time to the Far East. New jobs arise, creating an influx of workers, which has in turn created a demand for affordable housing. Itaituba, Pará State, Brazil.

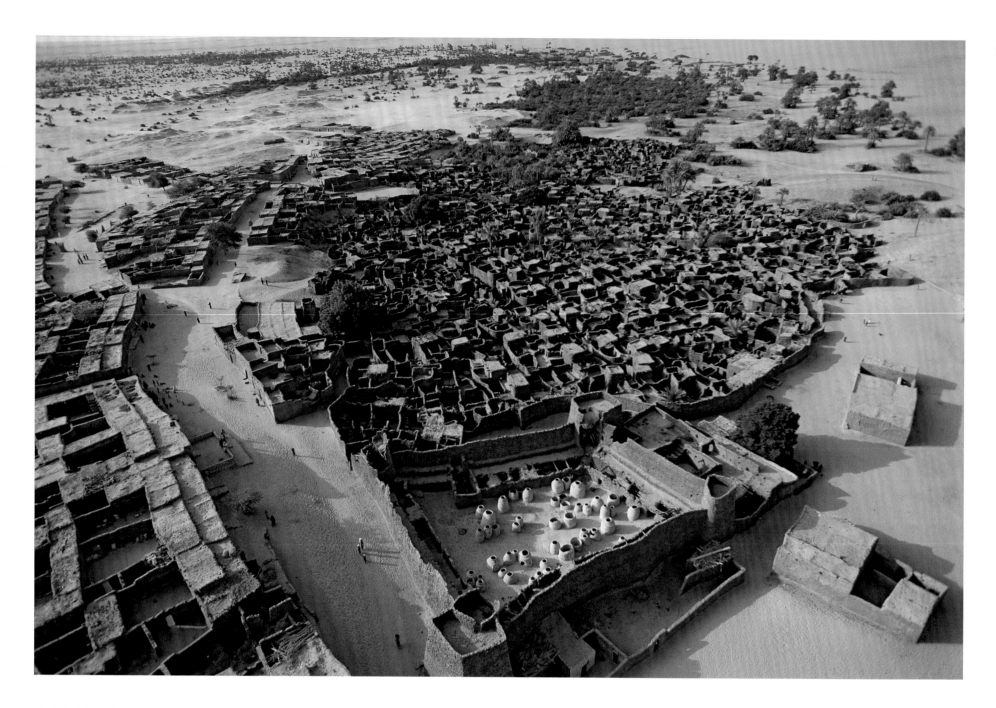

The labyrinthine fortified desert city of Fachi was designed to repel the raids of Tuaregs and other rivals. Behind the mud walls of its citadel are granaries and wells to enable the population to withstand a long siege. Once an important stop on the slave-trading routes, Fachi is now a sleepy town with few public services. Locals have long mined the salt pans in the vast Ténéré desert region by digging down to the water table and allowing the water to evaporate; the residual salt is formed into cones and dried for trading. On the far left of the photograph is "suburban Fachi," the newer and larger houses that were built after Niger became an official French colony in 1922. Fachi, Niger.

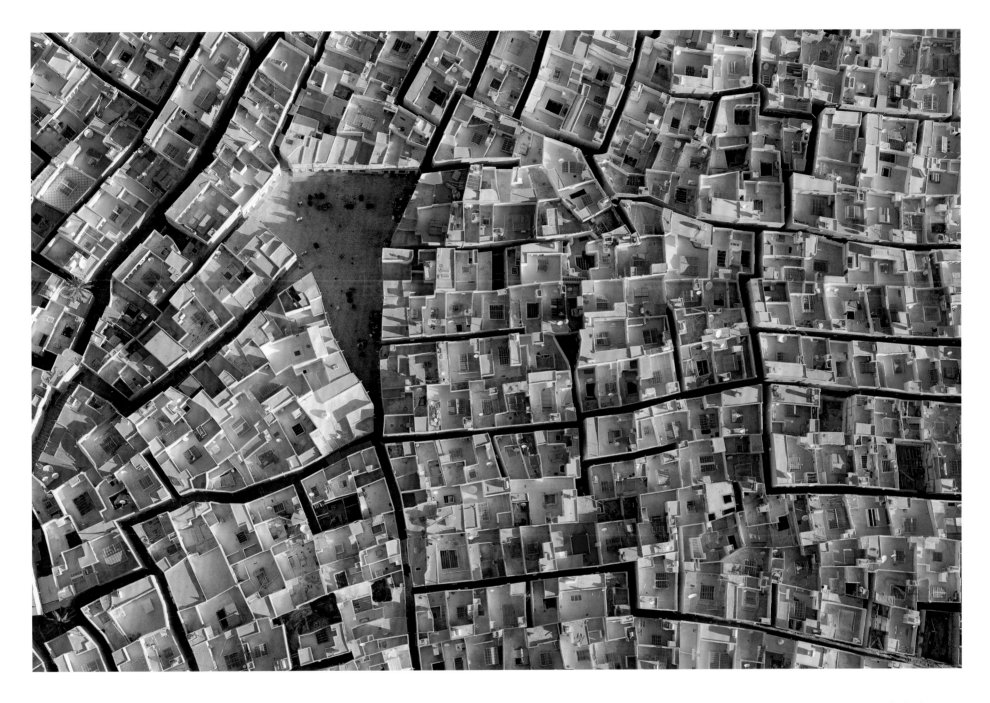

A conservative Muslim community where the women walk about covered in white haiks that reveal only one eye, the town of Beni Isguen is normally closed to foreigners. One of five Algerian hill towns that form a pentapolis in the M'zab valley, Beni Isguen is virtually untouched by the modern world, and the way of life of its people has been largely unchanged since the eleventh century. The sixty-eight hundred residents carefully maintain their antique homes, which often feature a walled roof serving as an open-air sleeping area on hot Saharan nights. Ghardaïa, Algeria.

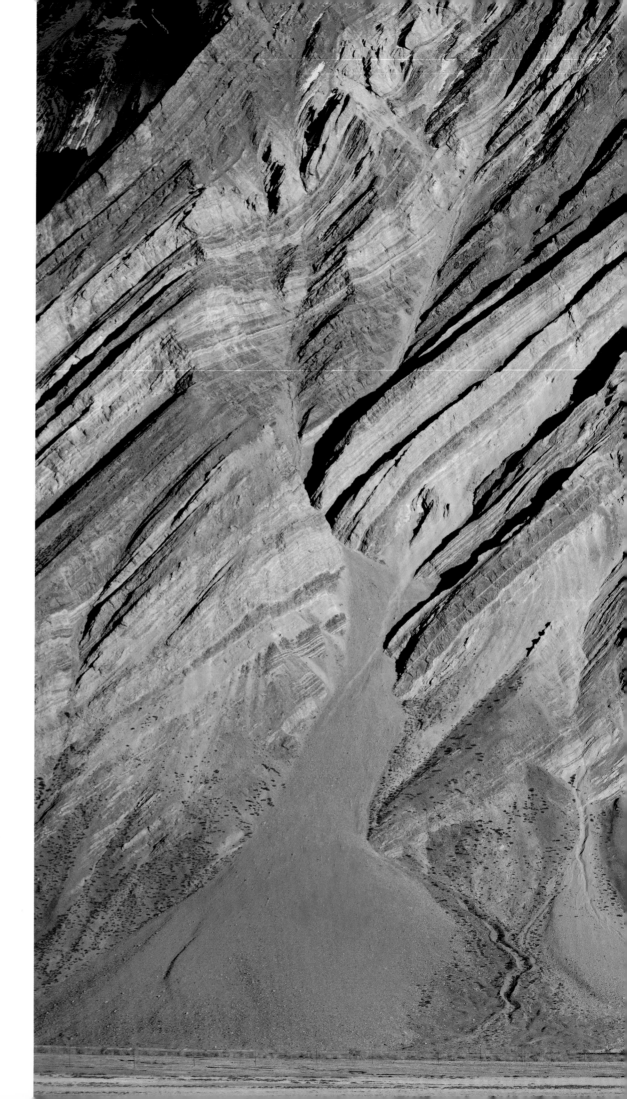

The Rangdum Monastery falls into shadow while the sun's rays continue to warm the face of the mountain behind it. The two-hundred-year-old monastery sits on a hillock midway between Kargil and Zanskar, in the most remote reaches of Ladakh's Suru valley. The isolated nature of the terrain is well suited to the needs of the forty devout and reclusive monks who live and practice here. The Rangdum Monastery follows the Gelugpa sect of Tibetan Buddhism, the same school of Buddhism practiced by the Dalai Lama. Rangdum village, Jammu and Kashmir, India.

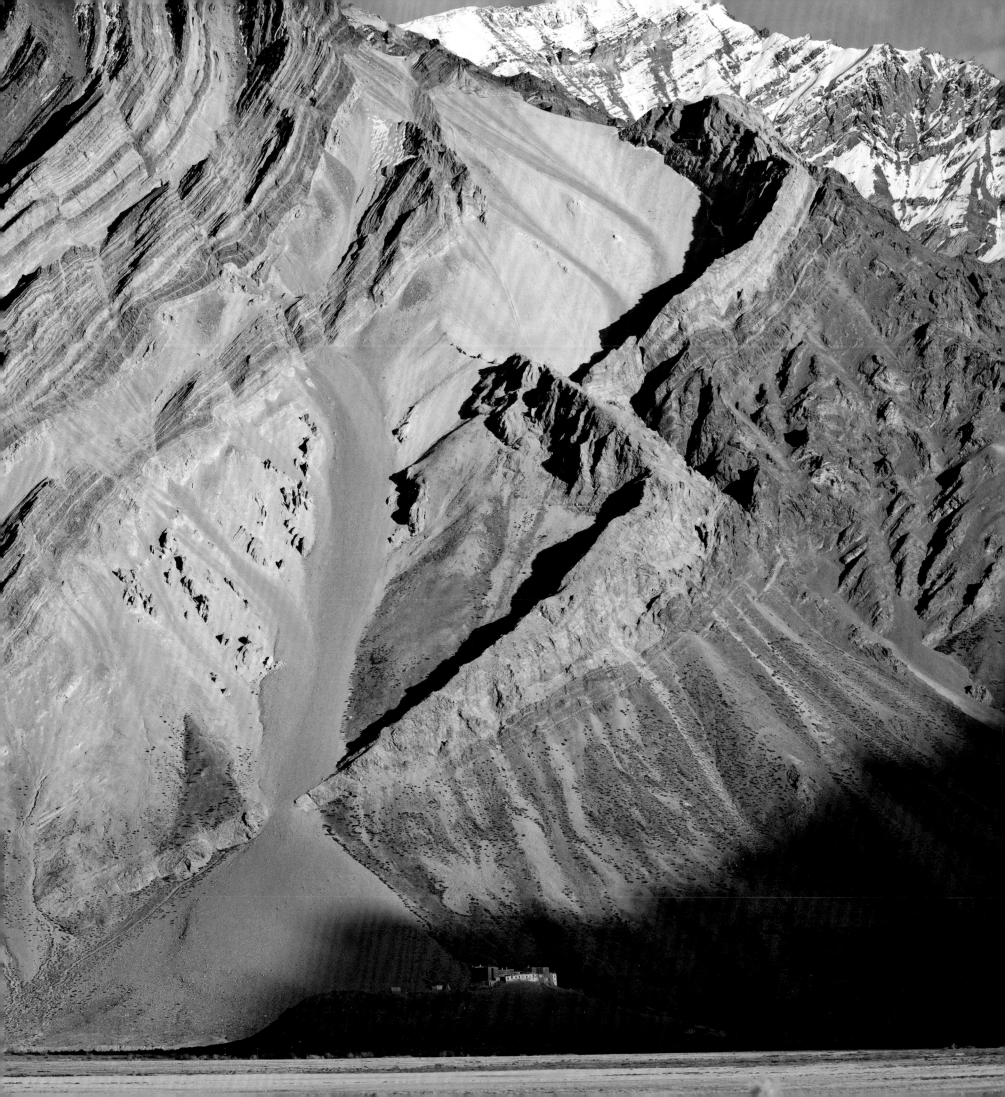

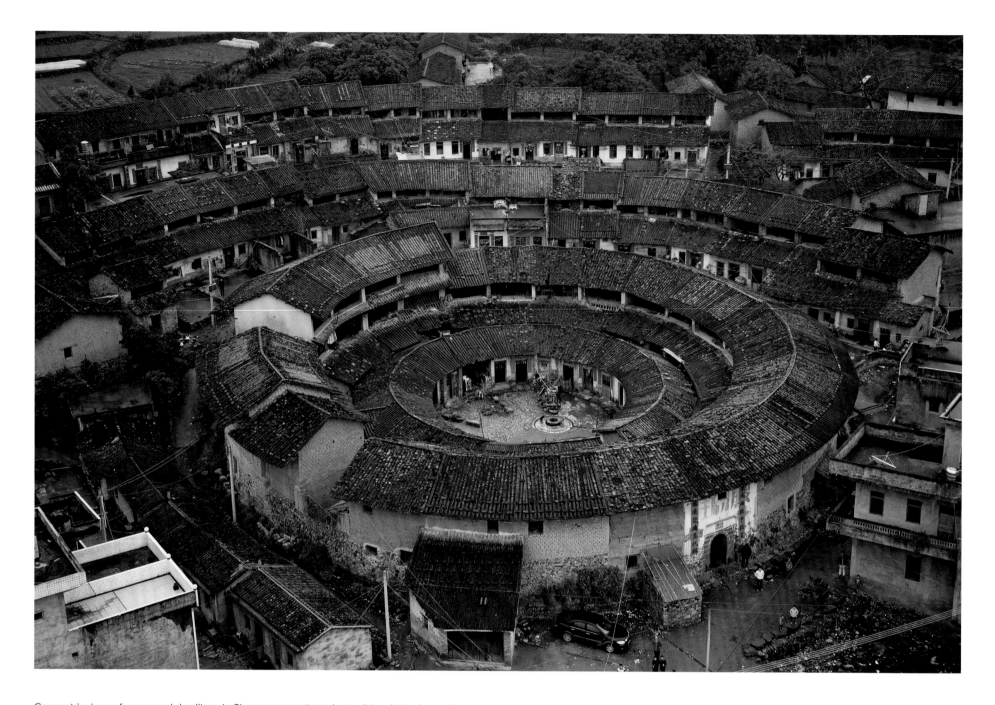

Concentric rings of communal dwellings in Shangrao constitute the traditional circular mud villages favored by the Hakka people. Called *tolou*, these buildings of rammed earth and wood are said to be resistant to damage from fire or earthquake. The thick walls provide a natural insulation that retains heat in the cold months and cool air in the summer, and most of the houses have heavy doors and small outer windows on the upper stories, which made them easy to defend in earlier days when conflict was endemic to the region. Their design proved to be adaptable as village populations grew, with additional rings being constructed around the original settlement. After damage wrought by a particularly destructive typhoon in 2006, however, the *tolou* of Shangrao are being abandoned in favor of more modern, individual homes that are designed to accommodate electricity and plumbing. Makeng village, Shangrao town, Jiangxi Province, China.

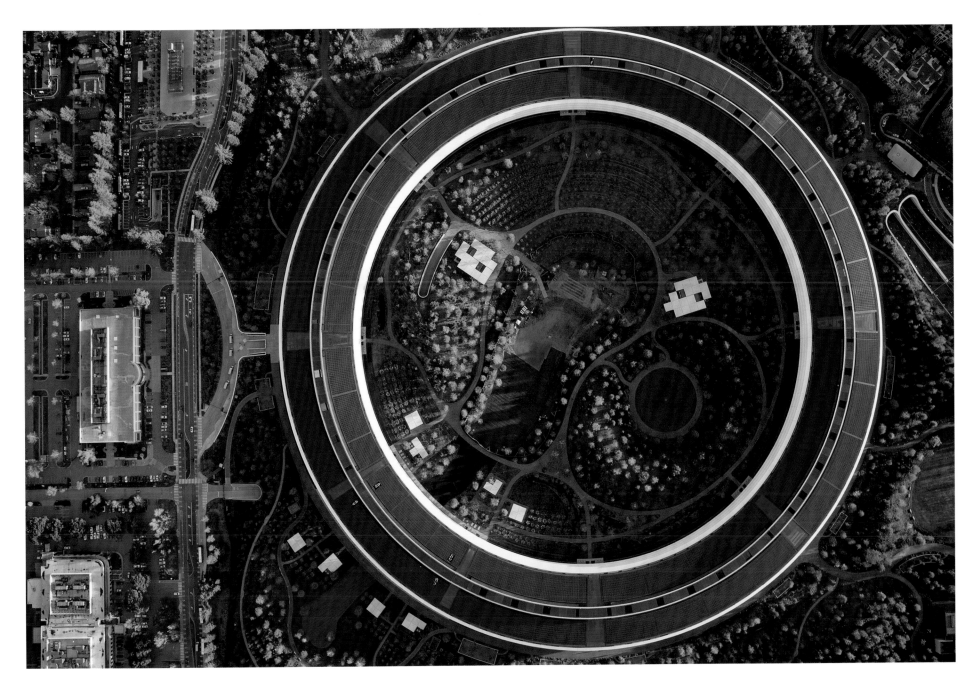

The starship-shaped Apple Park is the neo-futurist headquarters of the world's most valuable corporation. Four stories high, the building occupies 2.8 million square feet on the 175-acre campus. Encircling a park, the ring's interior and exterior windows avail employees of plentiful natural light and views of the outdoors. An open-plan layout is used in much of the interior. To accommodate the open design, contractors acquired and installed the largest panes of curved glass in the world. Eighty percent of the property consists of green space landscaped with local plants and drought-resistant trees. In addition to garden walkways, the inner courtyard features an artificial pond. The entire circumference of the roof is topped by massive solar panels, and the complex is powered entirely by renewable energy sources. It cost $5 billion to build. Cupertino, California, United States.

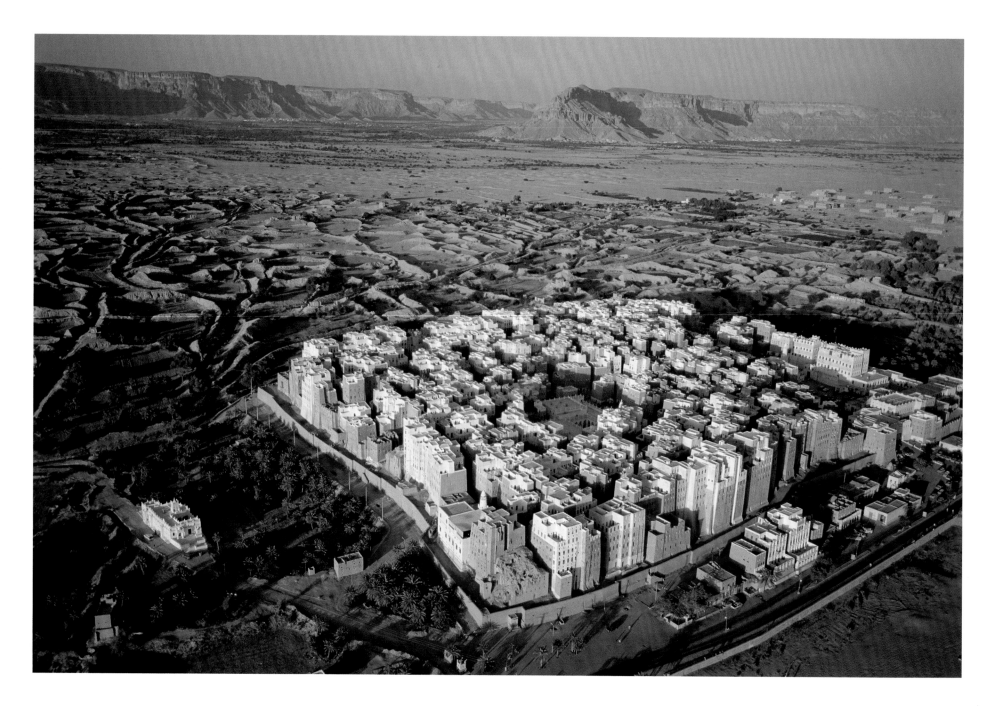

The sixteenth-century walled city of Shibam provides a remarkable skyline amid the flat arid backdrop of the Arabian Peninsula's Empty Quarter. About five hundred multistoried mud buildings are clustered together, some interlinked by midair passageways. The towers are constructed with sun-baked bricks of soil, hay, water, and palm wood, making this weathered metropolis a living monument to medieval ingenuity. The city endures as one of the earliest and grandest urban models to utilize vertical architecture. Shibam, Yemen.

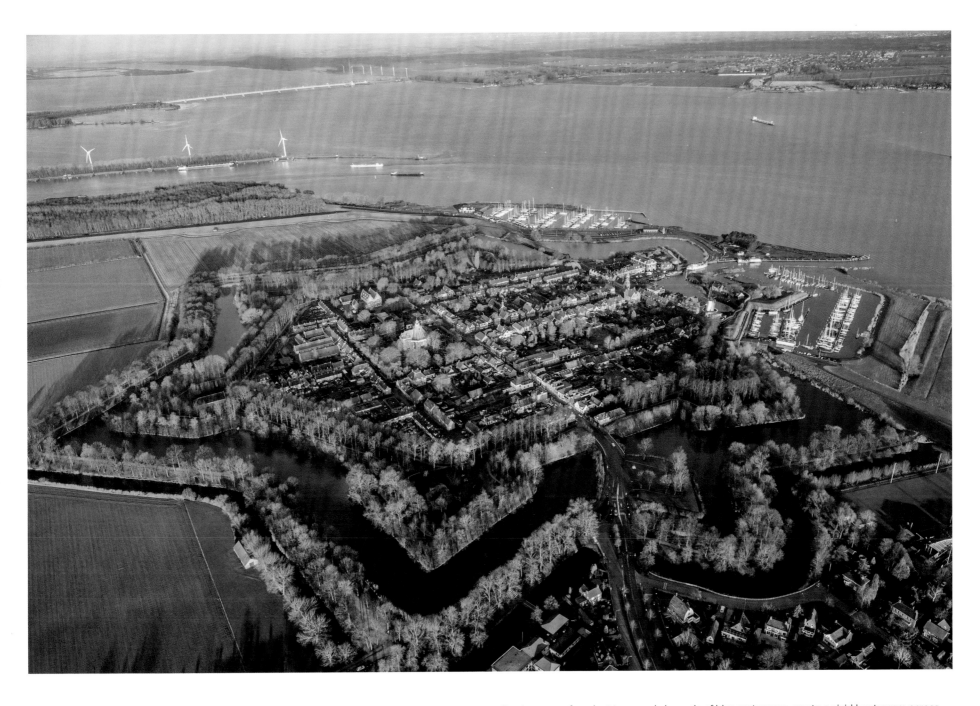

Precise rows of verdant trees and channels of blue waterways create a vivid heptagram across the Dutch landscape of Willemstad, named for William of Orange, who led the Dutch in their successful revolution against Spain. The bastions at the points of this star-shaped fortress town, one of five in the Netherlands, were named after each of the seven provinces that united in that struggle. Their design was intended to facilitate strategic protection of canals, bastions, and ravelins that might be vulnerable to invasion. The Netherlands is more at risk from the effects of rising sea levels than any other nation in Europe. The country has been consistently proactive in planning for the inevitable flooding and in cultivating strategies to mitigate the long-term effects of climate change. Willemstad, Noord-Brabant, Netherlands.

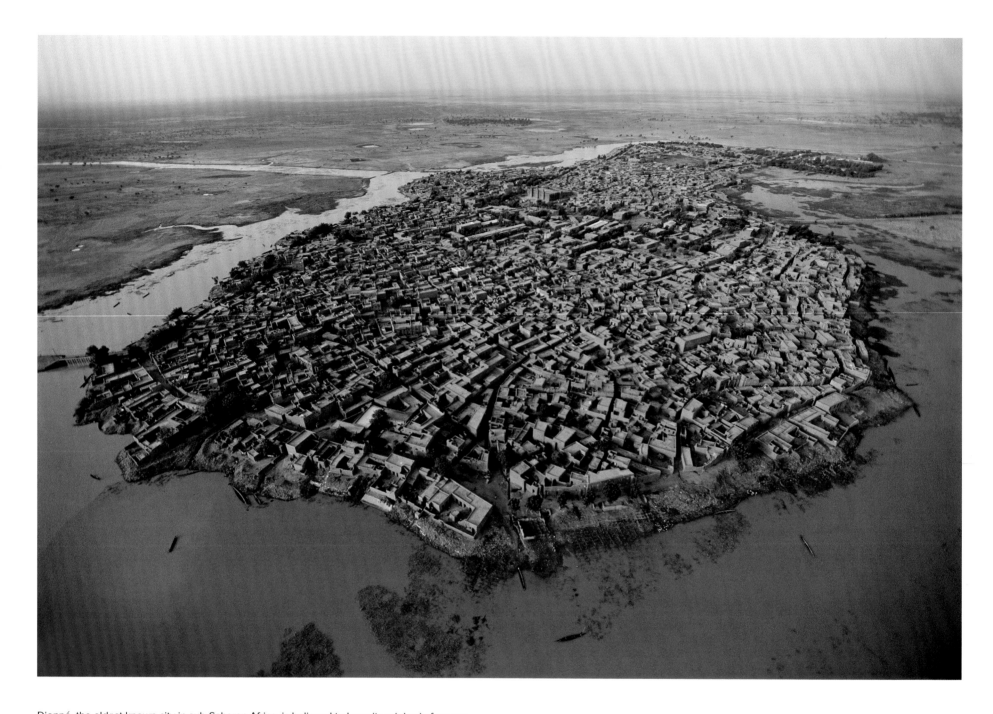

Djenné, the oldest known city in sub-Saharan Africa, is believed to have its origins in four pre-Islamic communities in the immediate vicinity, the oldest of which was founded by the Bozo people circa 250 BCE. The alluvial soil of the floodplains of the Bani River is rich in calcites, making it especially well suited for use in the city's distinctive adobe architecture. Clay from the surrounding plains is mixed with river water to form the mud, which is still used in construction today. For as far back as archaeologists can examine, residents of Djenné have demonstrated a profound connection to the earth in their art and architecture. Djenné, Mali.

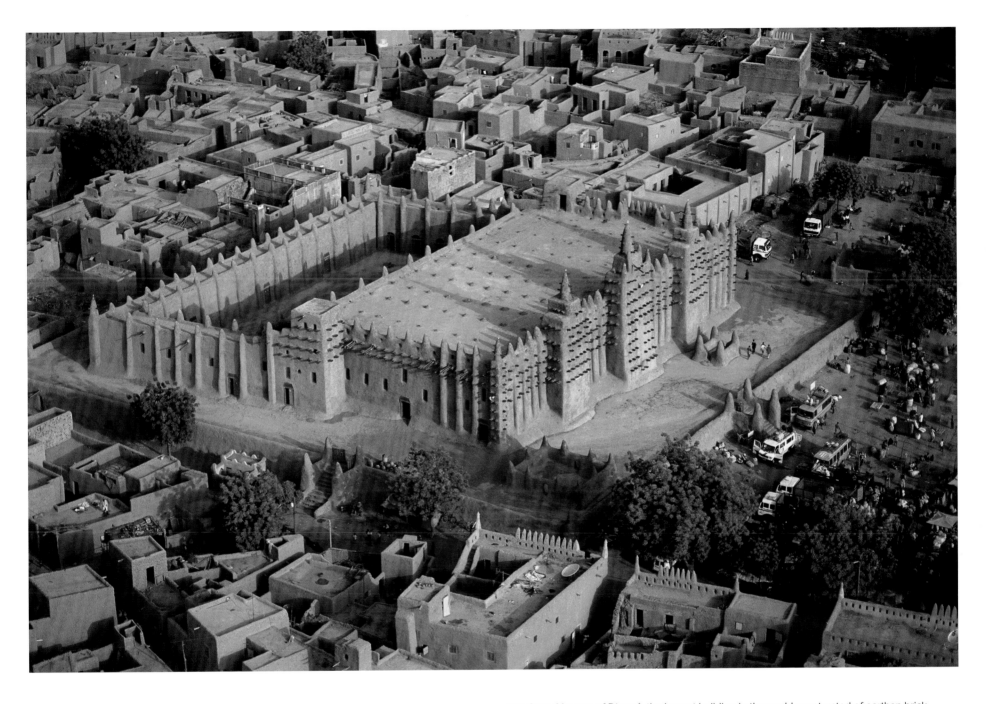

The Great Mosque of Djenné, the largest building in the world constructed of earthen brick, is considered a paradigm of Sudano-Sahelian architecture, as much for its innate biomorphic simplicity as for its sustainably grand scale. The existing mosque was erected in 1906 on the footprint of an earlier structure that was destroyed by fire. Its prayer hall, enclosed courtyard, qibla (prayer) wall, and many interior earthen columns are typical of hypostyle mosques. Timber beams provide a decorative scaffolding that ensures access for the continuous replastering and restoration that an adobe building requires. The mud masons who oversee this work pass the knowledge and technique specific to maintaining this structure down from one generation to the next, and from surface to bones the Great Mosque bears the imprint of the very people who gather within its hall to worship. Djenné, Mali.

Goumina village is built atop a small island in the inner delta of the Niger River, which is the second-largest inland wetland in all of Africa. The region is greatly biodiverse but has suffered from environmental stress. This village relies on the annual flooding of the Niger to irrigate its rice crop, but climate variability has created unpredictable water regime variations that disrupt harvests. Goumina, Mali.

The Venetian Islands, a chain of man-made islands in Biscayne Bay covered with multimillion-dollar homes, sit just one to two feet above sea level and are especially vulnerable to storm surges. The islands were spared the widespread devastation that Hurricane Irma visited on the Florida Keys in 2017, but polluted storm water from the mainland that poured into the bay during the hurricane fueled a worsening of the algae blooms that have been choking sea grass and wreaking havoc on the ecosystem. Miami, Florida, United States.

Gated communities of the Las Vegas suburb called "the Lakes." Part of the appeal of this housing development is the luxury of living lakeside in a desert region, and yet every house is supplied with air conditioning, a two-car garage, and a heated swimming pool. Some environmentalists believe Las Vegas is heading toward an acute water and energy crisis in the future. Ninety percent of Las Vegas's water and power come from Lake Mead, whose water levels have been falling steadily for more than a decade. Las Vegas, Nevada, United States.

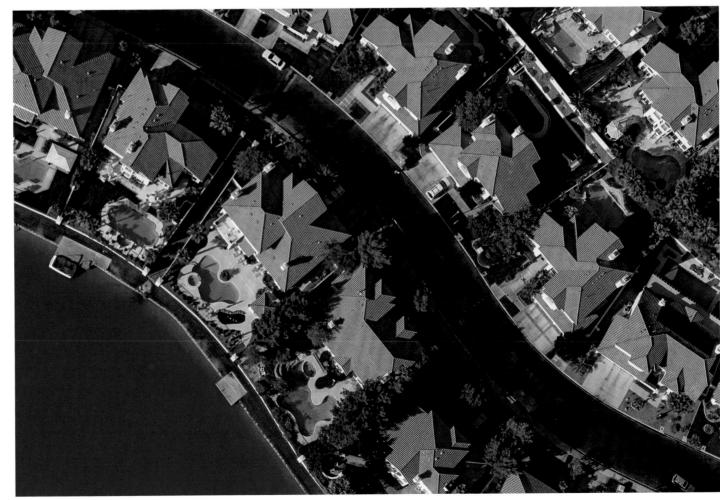

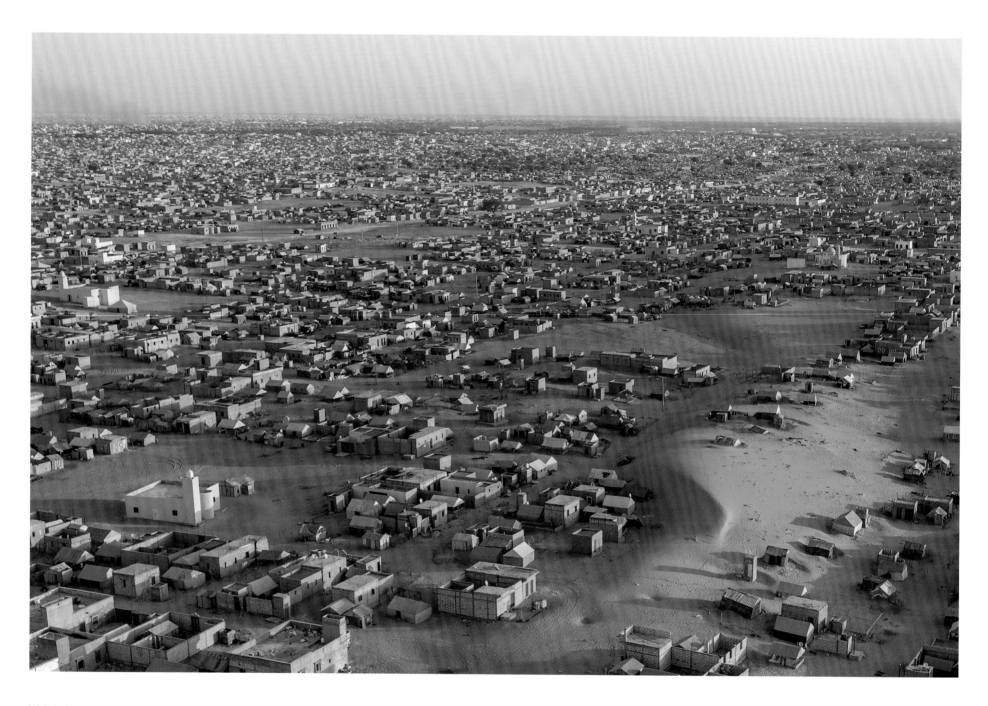

With its homes and roads partially buried in sand, the community of Tarhir Dubai no. 9 on Nouakchott's outskirts relies on weekly trucked-in deliveries that provide a supply of between 200 and 300 liters of drinking water to each household. Nouakchott, Mauritania's capital city, has long suffered from shortages of drinking water. Leaks in the city's old distribution system exacerbate the problem. Drought and climate change have caused many Mauritanians to relocate to Nouakchott, although it's unclear whether the desert is overtaking the city or the city is overtaking the desert. Nouakchott, Mauritania.

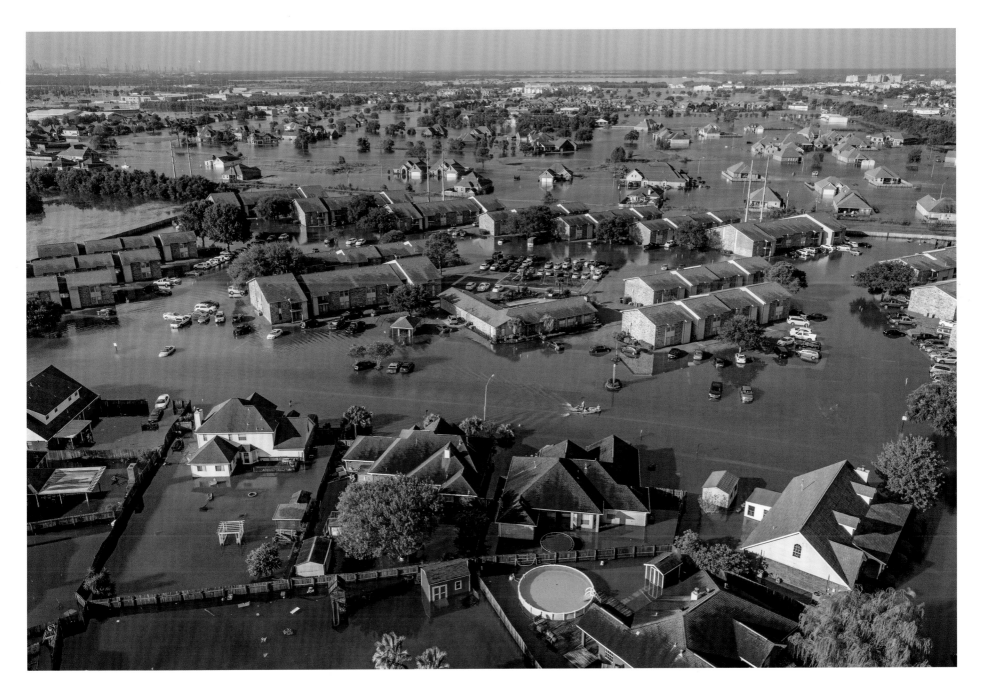

Homes in Beaumont, Texas, sit marooned amid floodwater. Much of southeast Texas was besieged by trillions of gallons of rainwater and flooding when Hurricane Harvey stalled over the region in 2017, becoming one of the costliest natural disasters in the state's history. In Beaumont, home to 120,000 people, the crisis worsened when the municipal water system failed, leaving locals without running water and forcing at least one hospital to evacuate patients by helicopter. Beaumont, Texas, United States.

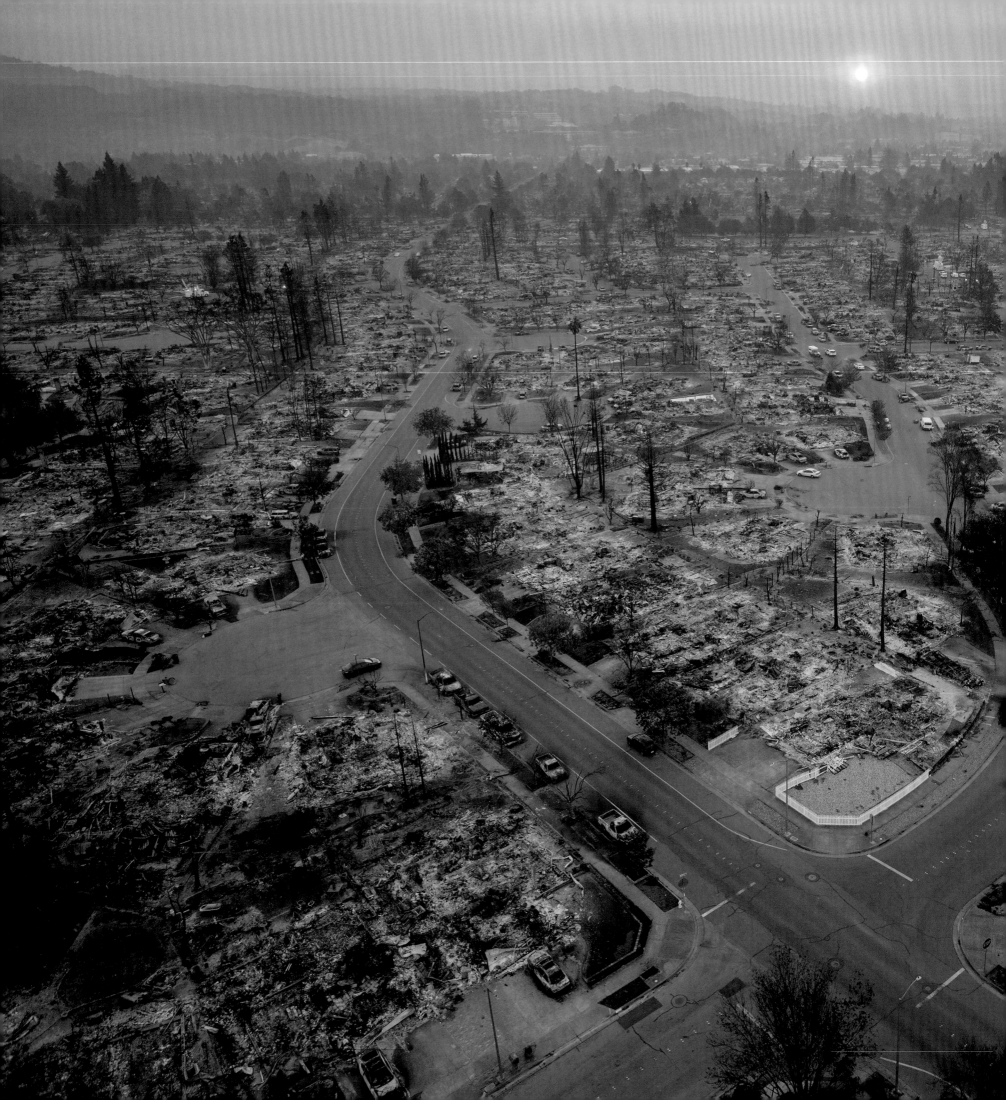

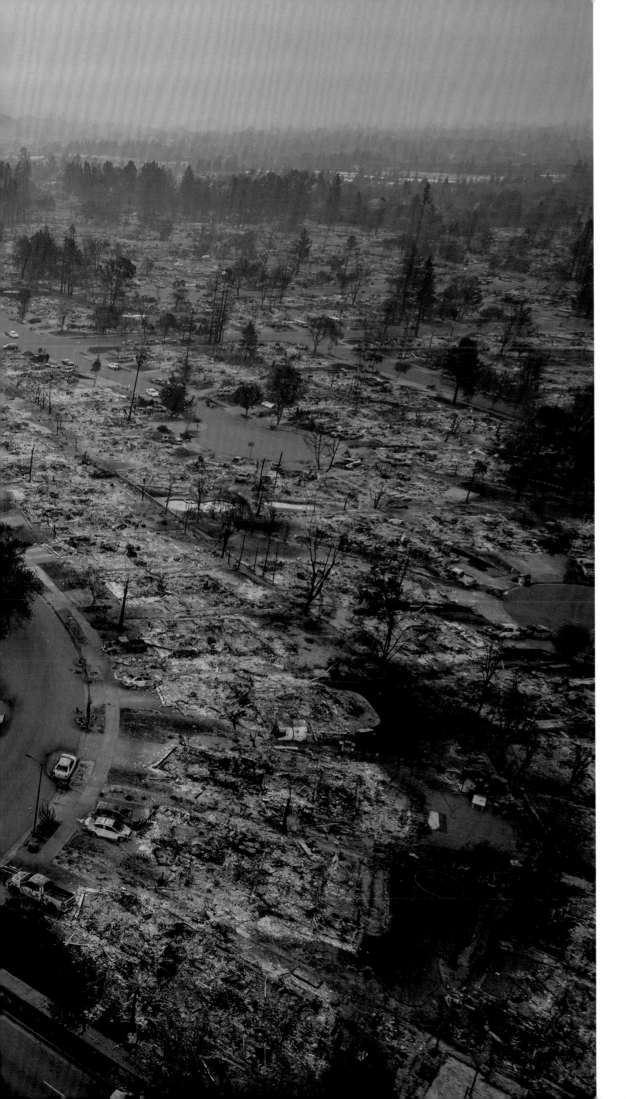

The suburban neighborhood of Coffey Park in Santa Rosa was virtually annihilated in October 2017 by swiftly moving fires that made a wind-propelled jump over a six-lane highway that had been expected to act as a fire block. In this single community, more than fourteen hundred homes were destroyed, one-quarter of the total houses lost in the Tubbs Fire that spread across Sonoma and Napa Counties. While sagging power lines owned by the Pacific Gas and Electric Company were deemed to be the cause of twelve of Northern California's wildfires in 2017, a 2019 report by California fire investigators determined that the Tubbs Fire was caused by an electrical problem on a privately owned property. In 2018, the United Nations released a report indicating that rising temperatures from climate change are creating conditions that will bring an increase in the frequency and size of US wildfires. Santa Rosa, California, United States.

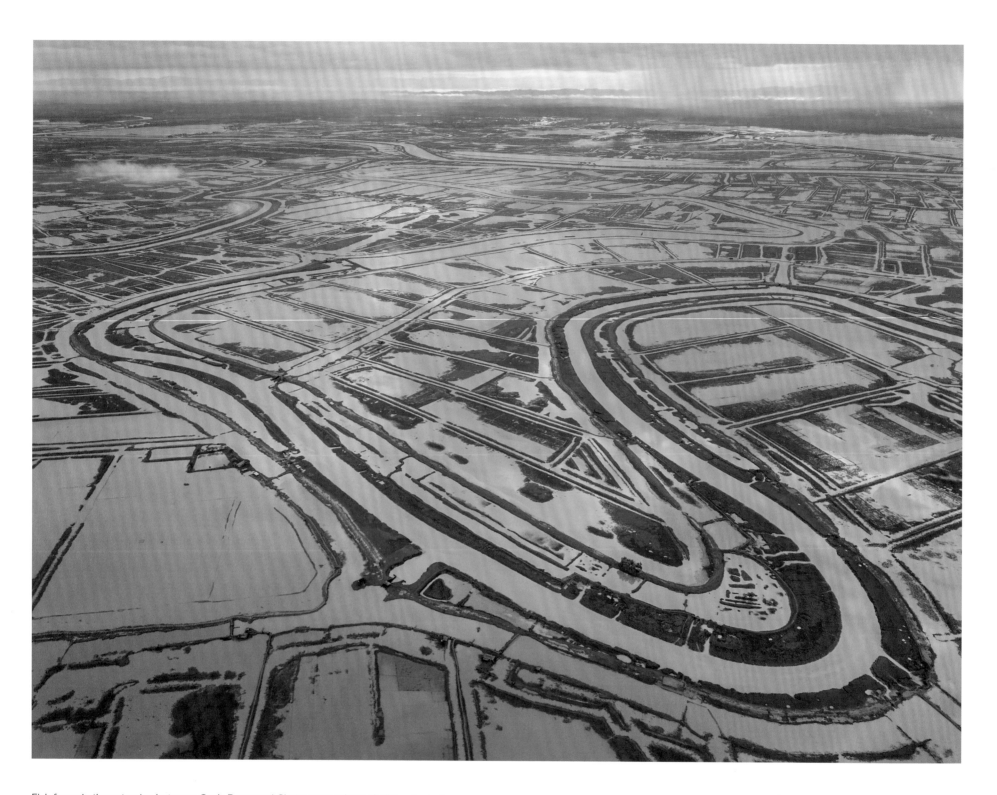

Fish farms in the estuaries between Cox's Bazar and Chattogram, where shallow channels magnify wind-driven storm surges, are often flooded during the summer monsoon. Each one of these ponds has a caretaker charged with caring for the fish, and each farm is equipped with a concrete shelter to provide refuge from the rising waters. Bangladesh is largely composed of flat terrain that sits barely above sea level and is one of the monsoon regions in Asia that customarily experiences a heavy rainy season. Its topography coupled with its population density put Bangladesh among the nations most vulnerable to the effects of climate change. Local reports estimated that a 2017 flash flood in the Chakaria area submerged hundreds of homes and marooned hundreds of thousands of people, and as the flood devastation widened, one-third of the country was submerged. Cox's Bazar, Chattogram, Bangladesh.

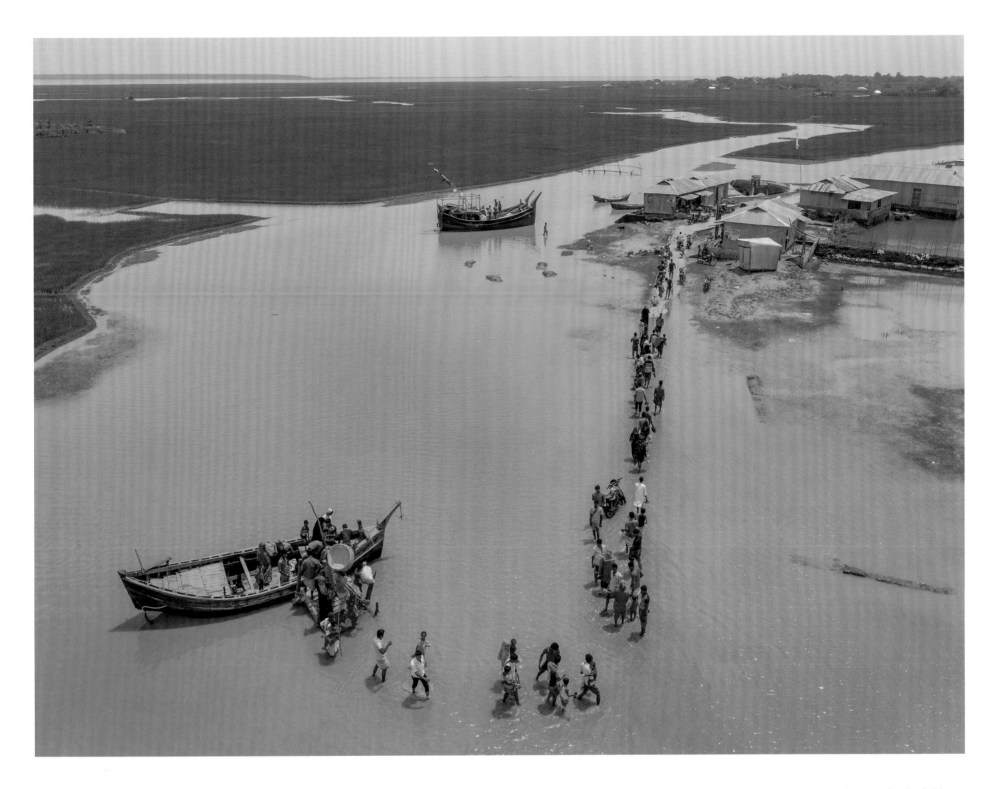

Inhabitants of southern Bangladesh travel between the delta islands by boat, as the rice fields are planted just inches above the high tide line. This area is flooded on an almost regular basis by tropical storms. While the rising strength and frequency of storms have negatively affected fishing prospects, the flooding spreads clay and silt, which enhances soil fertility to the farmers' advantage. But with a five-foot rise in sea level predicted by 2100, this balancing act will soon be over. Nijhum Dwip, Chattogram, Bangladesh.

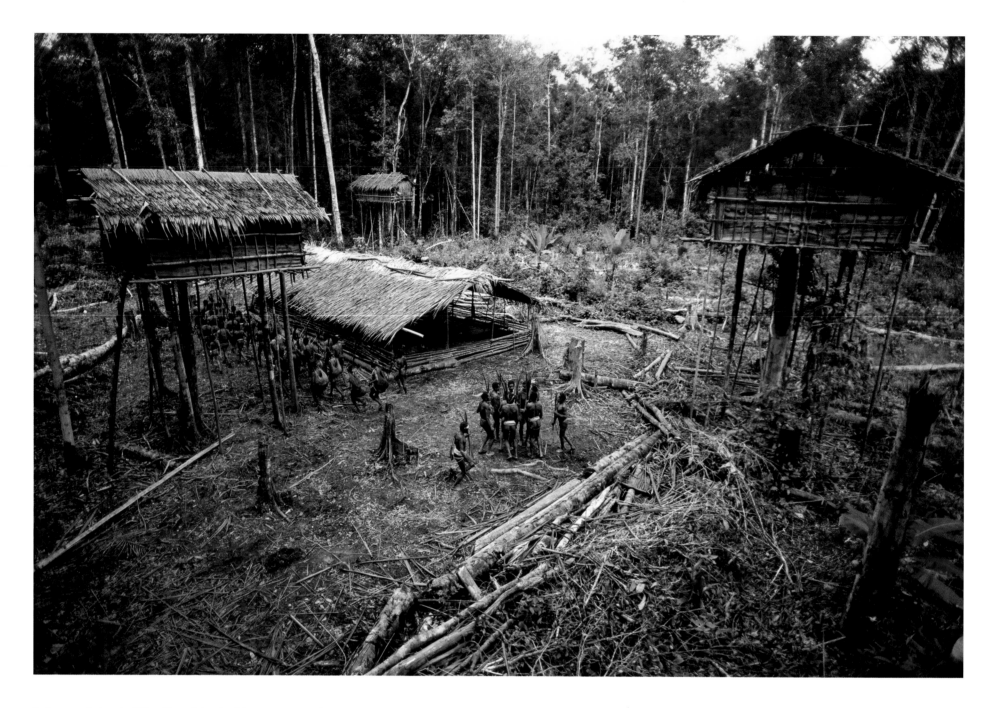

In the remote heart of West Papua's lowland forest, a group of Korowai clansmen have arranged a sago grub feast for a group of French tourists, who are at the edge of the clearing just out of range of this photograph. The Korowai people lived in complete isolation from the outside world until the 1970s, when they were contacted by Dutch missionaries. They are hunter-gatherers, living off meat and fish as well as vegetables that they cultivate in gardens, and off plants that grow locally such as the sago palm. Group tourism in this region began in the 1990s and has been increasing. A typical weeklong program immerses the visitor in Korowai traditions such as tree house building and hunting, and culminates with a sago feast. West Papua, Indonesia.

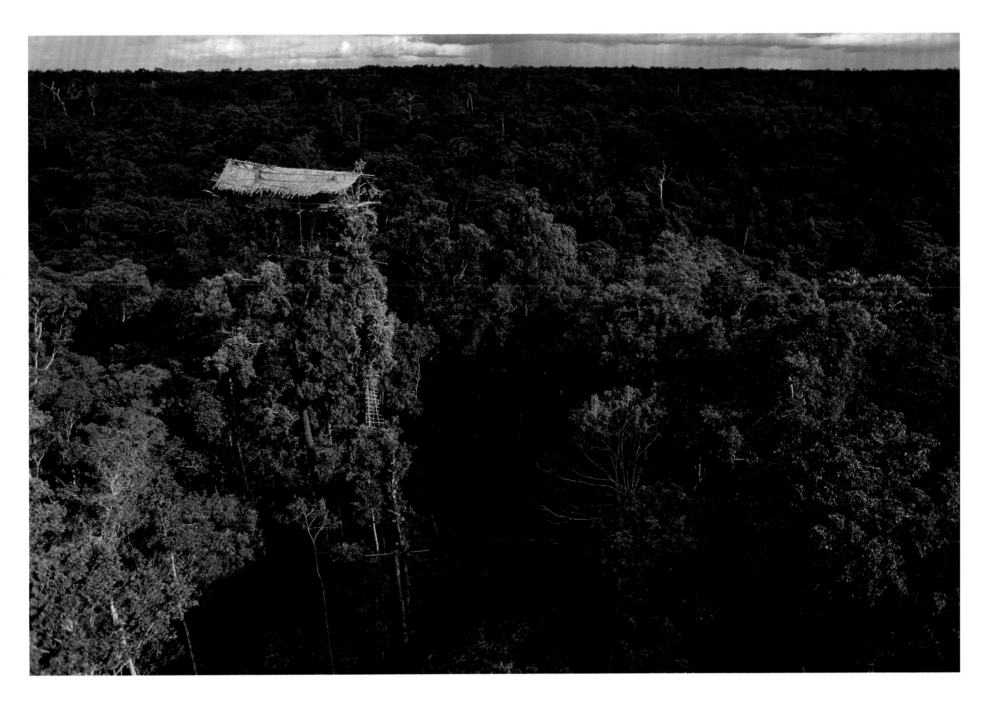

A recently abandoned Korowai tree house. Many Korowai construct and live in tree houses, which provide protection from mosquitoes and from historical enemies such as the Citak tribe. In five weeks of hiking and eight hours of surveying Korowai country by air, this is the tallest treehouse Steinmetz observed, measuring some 160 feet in height. Its owner, Landi Gifanop, says he built a tall tree house to see airplanes and mountains "but mainly to keep sorcerers from climbing my stairs." Local beliefs center around both good and evil spirits; ritual cannibalism is said to have been limited to those considered *kahkhua*, or witches, and the practice is dying out and outlawed by the Indonesian government. Papua, Indonesia.

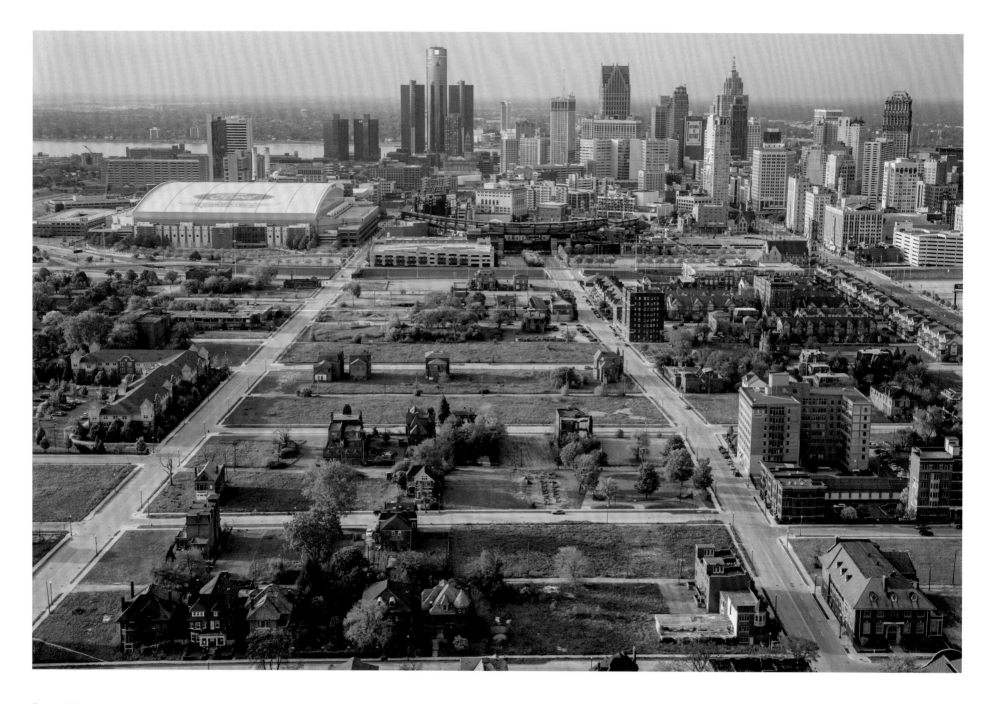

Detroit's Brush Park neighborhood was known as Little Paris in its late nineteenth-century heyday, when the streets were lined with elegant Victorian mansions. Following the vicissitudes of the Great Depression and Detroit's race riots of the 1940s, the neighborhood succumbed to poverty and crime, and many buildings were razed. Those that remained continued to fall into disrepair, and by the 1960s the neighborhood was all but abandoned. This picture was taken in 2013, when only a handful of the mansions were still standing. Since then new developments have started to fill in areas of Brush Park. In the background of the photograph is downtown Detroit, and across the water on the horizon is Windsor, Ontario. Detroit, Michigan, United States.

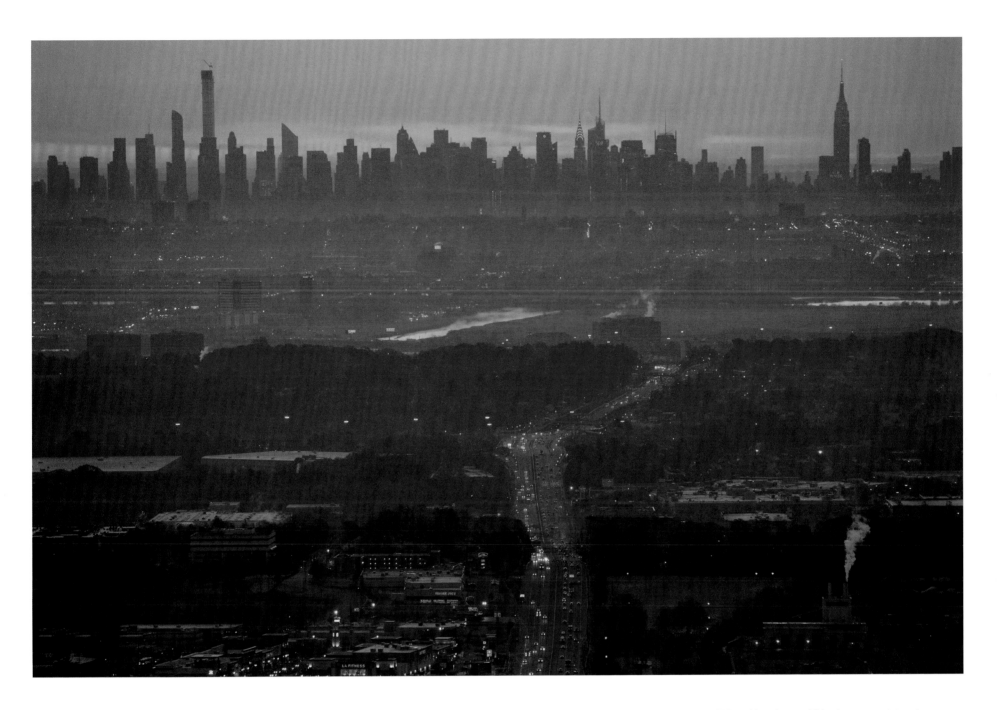

Looking toward the Manhattan skyline from Clifton, New Jersey. This picture was taken in November 2014, a few weeks after 432 Park Avenue topped out and replaced the Empire State Building as New York City's tallest building. In 2019, the Empire State Building has dropped to fourth on the list, bested by 30 Hudson Yards, 432 Park, and One World Trade Center (currently in the number one spot). Manhattan is getting taller at a rapid rate, with all but two of its ten tallest buildings constructed after 2007. The iconic skyline is expected to continuously transform over the next few years, with a record number of one-thousand-foot-plus buildings in the planning stages. New York City, United States.

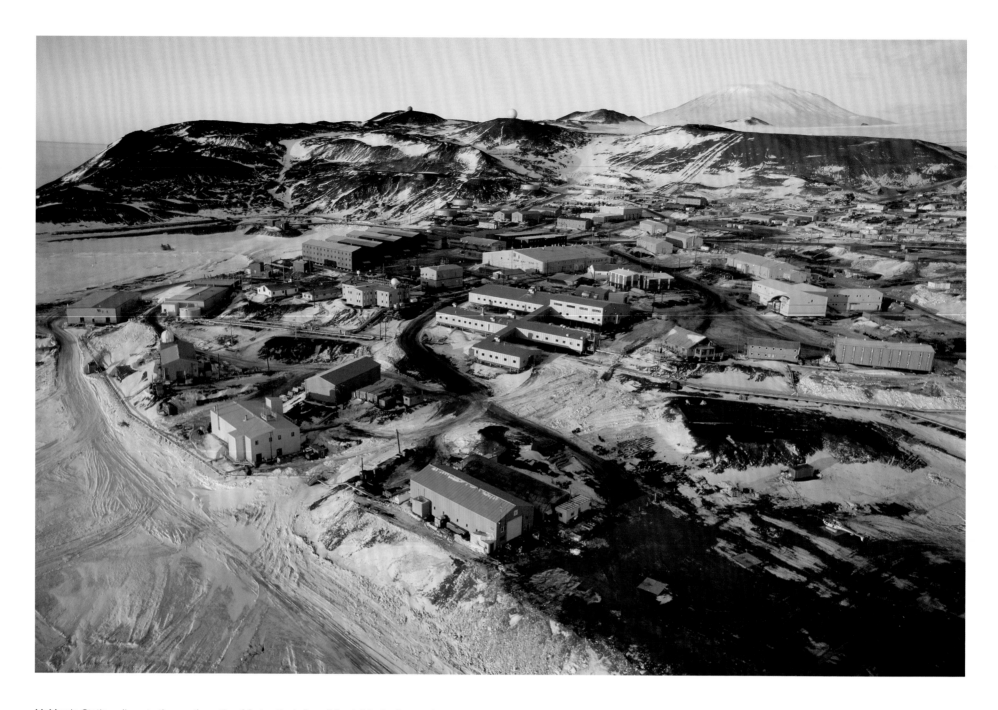

McMurdo Station clings to the southern tip of Antarctica's Ross Island. It is the largest human settlement on the continent and the main base for US scientific and logistic efforts in Antarctica. The population swells to some seventeen hundred people between October and January, and the station is supplied annually by a cargo vessel and fuel tanker, which often need an ice breaker to reach the port. Established in 1956, it has grown into a complex of many buildings that occupy some 160 acres and has long been acknowledged as requiring a serious makeover. In February 2019, the National Science Foundation got the go-ahead to begin construction on an infrastructure overhaul that will consolidate the complex into just six primary energy-efficient structures. Antarctica.

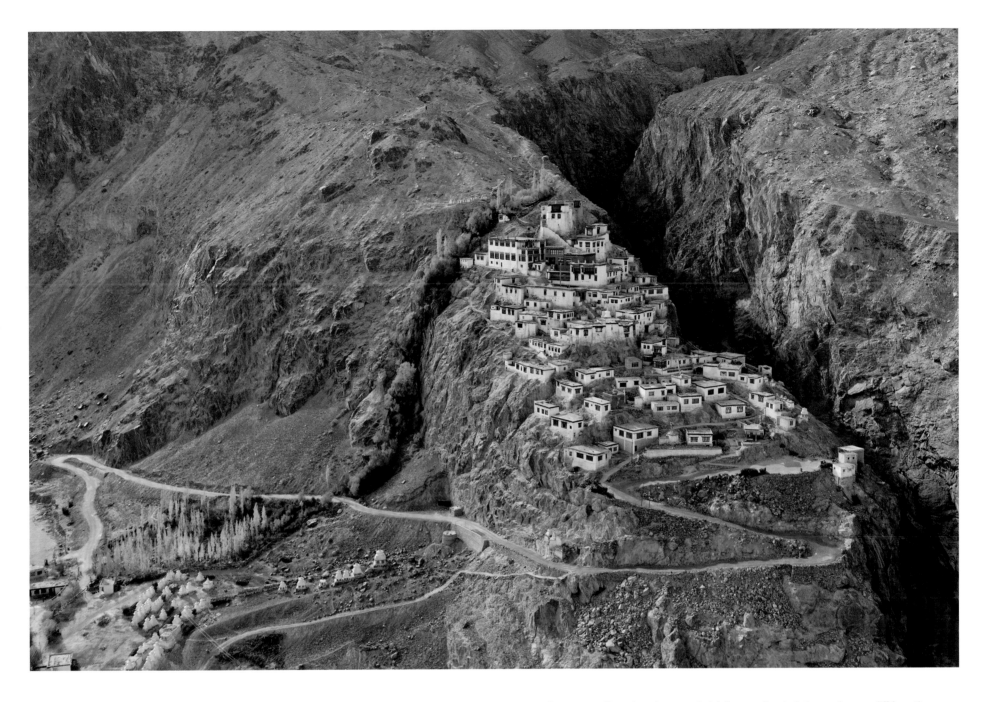

Sunrise illuminates a line of poplar trees that follows a diverted stream down a cliff from the ancient Diskit Monastery. The steep canyon to the right of the monastery leads down from the crests of the Ladakh Range, whose peaks reach more than 19,000 feet in height. The Diskit Monastery was founded in the fourteenth century by Changzem Tserab Zangpo, a disciple of Tsongkhapa, who founded the Gelugpa school of Tibetan Buddhism. The monastery is dominated by a 104-foot statue of the Maitreya Buddha, traditionally considered to be the Buddha of the future, who will be born to bring enlightenment to the next age of humankind. Diskit, Jammu and Kashmir, India.

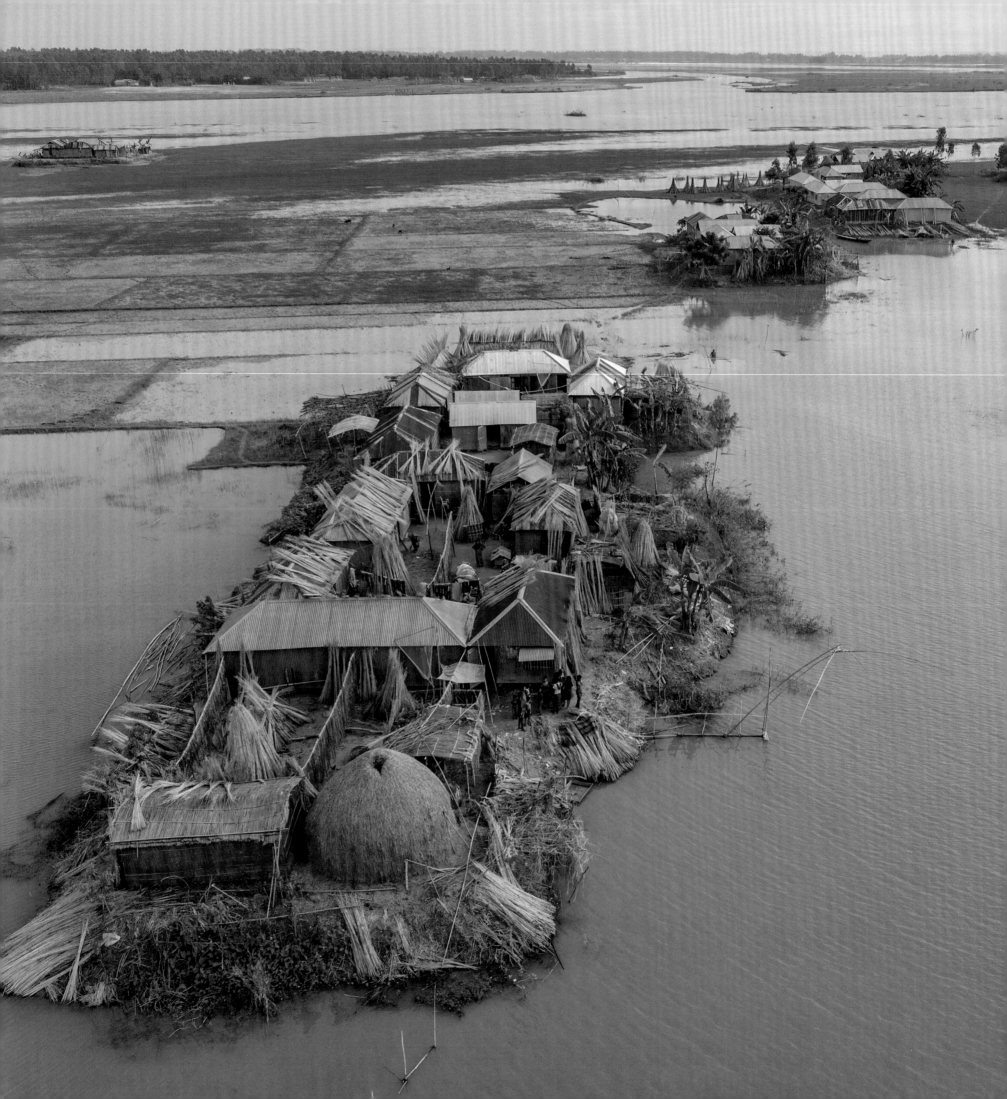

Around the world, people are attracted to zones of plenty that, all too often, are also zones of periodic peril. Volcanoes and river deltas both regularly renew agricultural fertility by dispersing minerals and nutrients vital for plants. But the resulting eruptions and floods can destroy the lives of those who settle to reap the bounty. Around the delta of the Brahmaputra (or Jamuna) River, villages have sprouted on countless silty islets that, Steinmetz was told, are flooded in six out of ten monsoon seasons. People flee to high ground, then return, drawn by the soil, fish, and free land. Tangail District, Dhaka, Bangladesh.

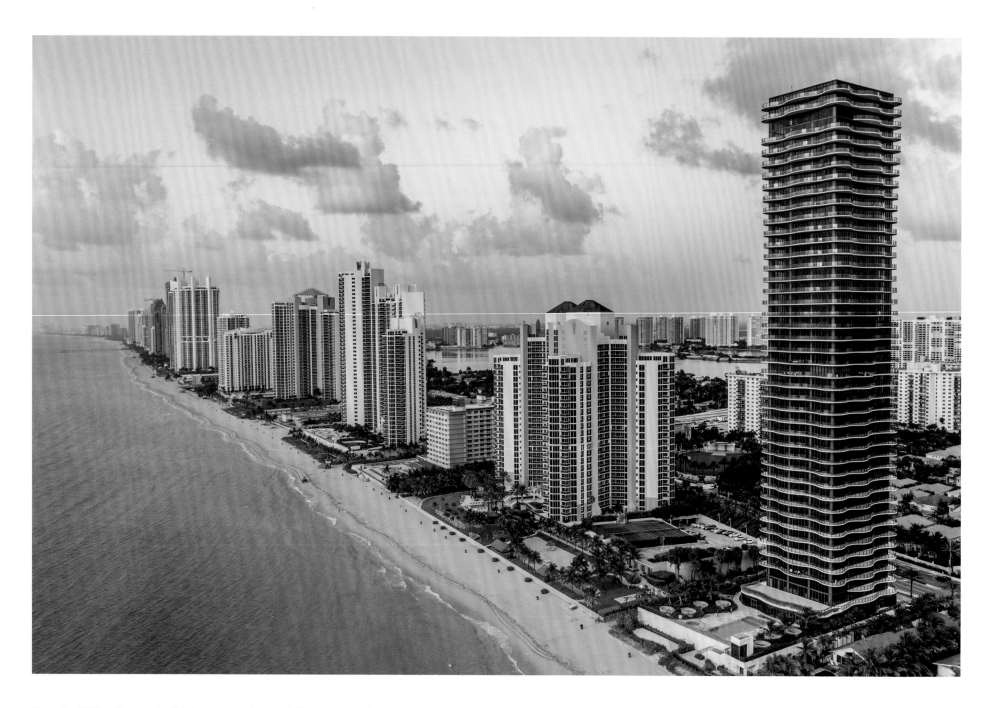

Since the 1980s, climate scientists have warned of South Florida's special vulnerability to the unrelenting rise in sea level projected for generations to come, even if global heat-trapping emissions somehow begin to slow. That vulnerability has hardly blunted coastal development. The ground floors of these towers north of Miami Beach are designed to flood, while one, the Porsche Design Tower, even has an elevator for residents' cars, saving apartment owners a walk to a parking garage. As in so many other cities, the vulnerability to flooding lies in the poorer neighborhoods, where "sunny day" flooding is already commonplace. Sunny Isles Beach, Florida, United States.

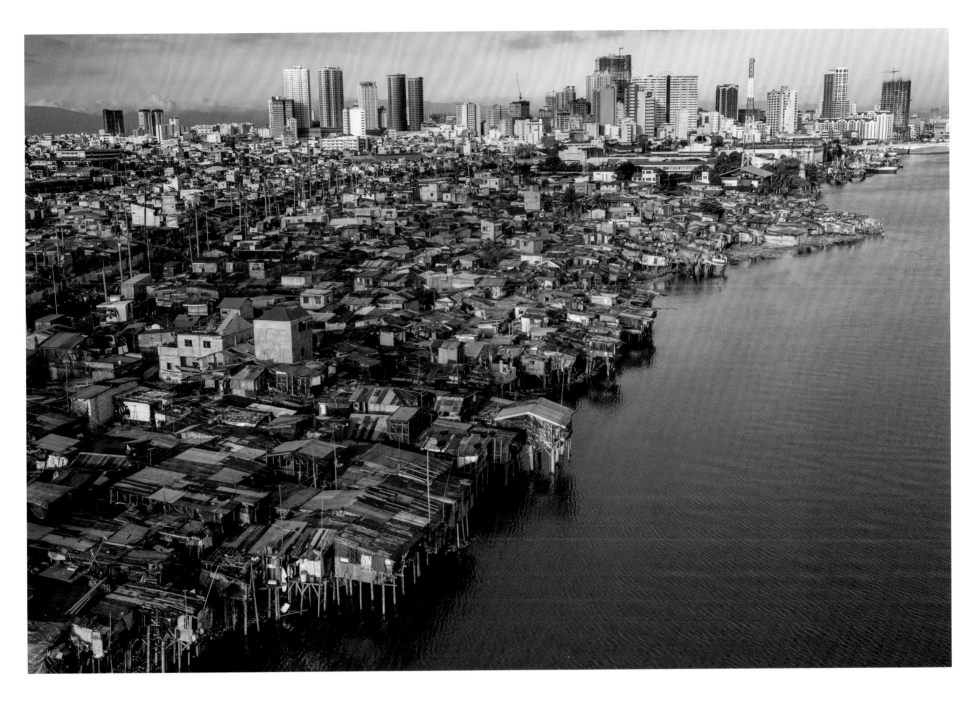

Around the world, millions of poor residents of coastal cities live not on the shoreline but instead in slums built on stilts, as here along the Parola Binondo side of Manila's harbor, or on floating aggregations of hundreds of rafts and boats, as is the case for some three hundred thousand people in Lagos's Makoko slum. Such improvised developments provide cheap accommodations close to work in a city without a functioning mass transit system, but these coastal slums are increasingly exposed to disaster as sea levels rise and tropical storms intensify. Manila, Philippines.

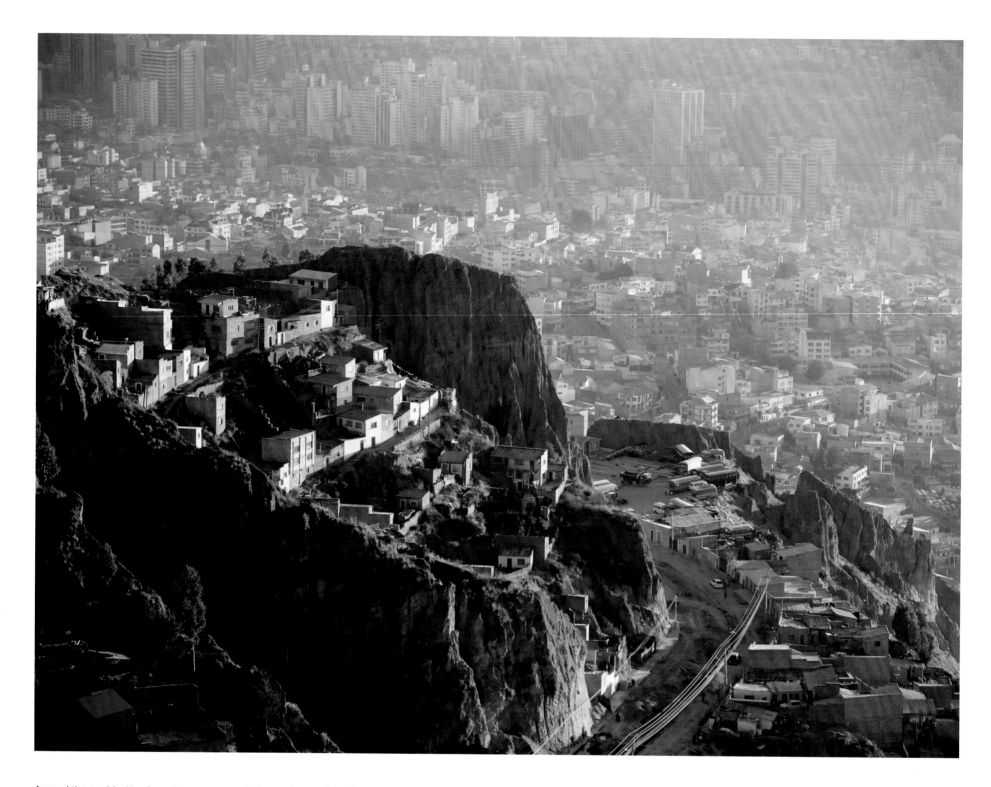

Around the world, cities have become magnets for workers and families seeking better lives as economies and climate conditions shift and rural opportunity wanes. The urban surge has resulted in sprawling danger zones of dense development on impossibly steep slopes or flood-prone lowlands. In La Paz, two miles high in the Andes, landslides are a chronic and deadly hazard, as a quick look at the terrain would imply. La Paz, Bolivia.

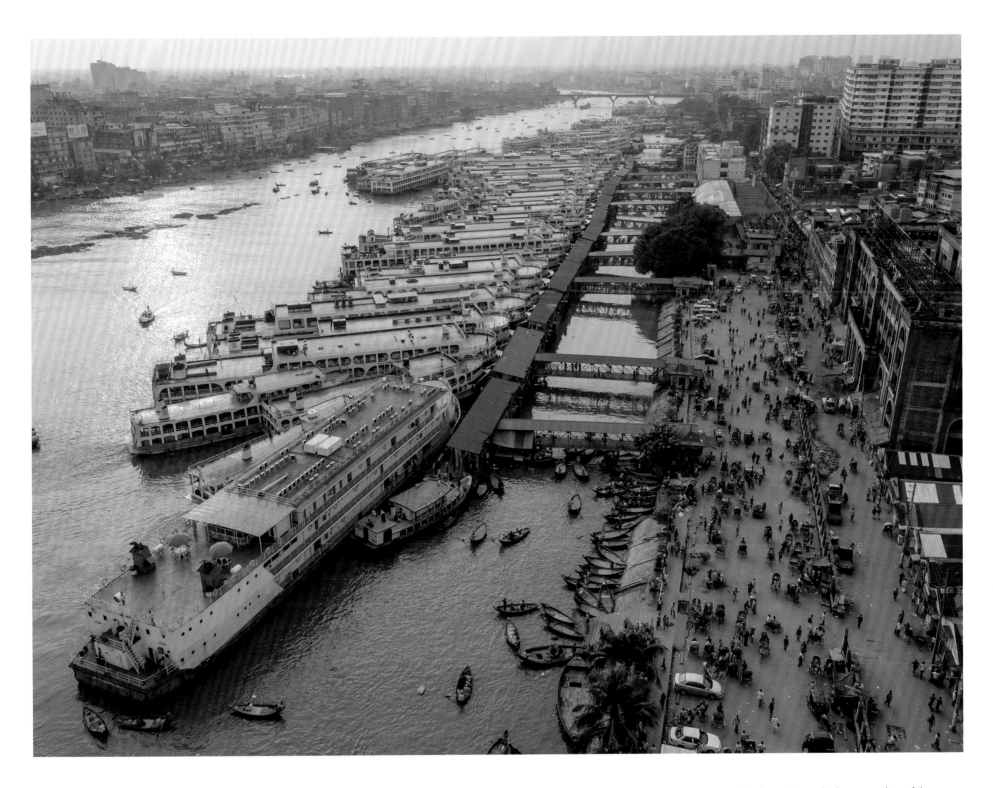

The main ferry terminal on the Buriganga River in Dhaka, a city on the lower reaches of the Ganges-Brahmaputra delta surrounded, and frequently inundated, by water, in a region where the river is a densely traveled highway for people and goods. As the population of metropolitan Dhaka has risen past eighteen million, many of the channels that once drained city streets have been filled in and built upon, which makes it more difficult for floodwaters to drain during heavy monsoon rains. World Bank studies foresee worsening conditions in a warming climate, with the impact greatest in the poorest margins. Dhaka, Bangladesh.

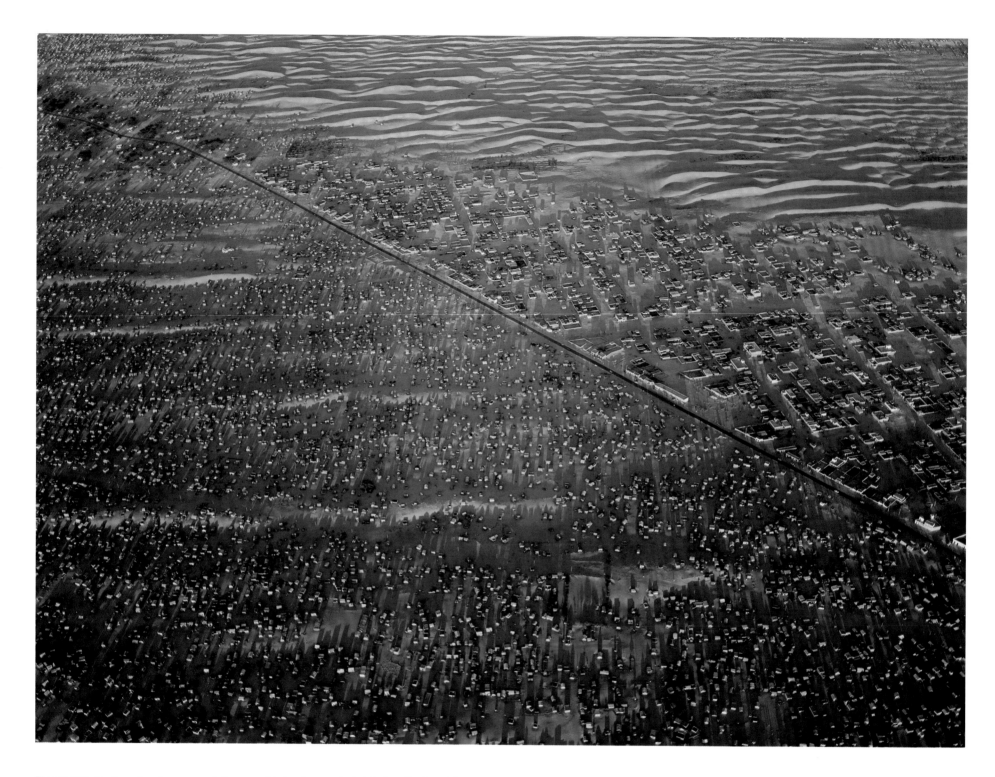

The world's developed and poor populations used to be demarcated globally—North and South, First World and Third World. Increasingly, those divisions now exist within all nations, often side by side. Here, a small strip of road separates relative prosperity and deep poverty on the outskirts of Nouakchott, which was an oasis village of fifteen families before Mauritania gained independence from France in 1960. It is now the capital and home to seven hundred thousand people. Nouakchott, Mauritania.

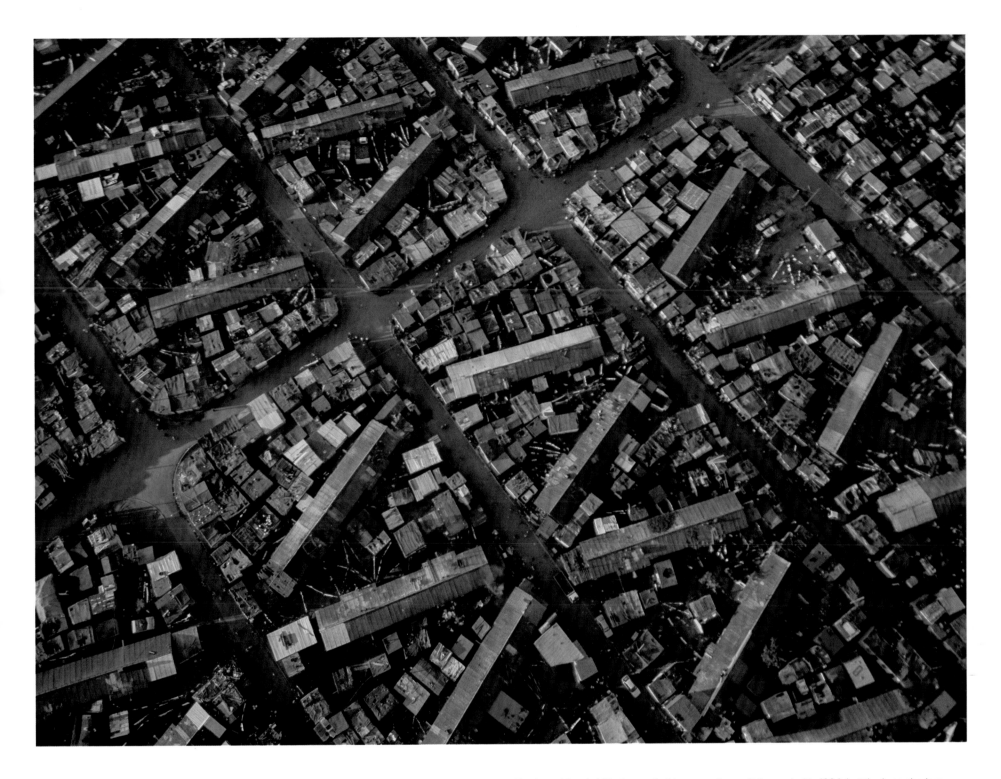

The last of South Africa's apartheid segregation policies ended in 1994, but the long shadow of oppression persists, particularly in housing. The elongated housing units in the Cape Flats section of Cape Town were built decades ago for "colored" families and workers. The rapid urban influx of job-seeking black and mixed-race citizens has filled in the gaps with improvised shanties of squatters. Cape Town, South Africa.

New York City has one million buildings, with the majority sprawling across the low-rise outer boroughs. While parts of Brooklyn and Queens, in particular, have become pricey residential and business districts, Manhattan, which gave the world its first experience with vertical housing, remains the high-rise epicenter. Residents cool off around a rooftop pool in Greenwich Village in the summer of 2014. New York City, United States.

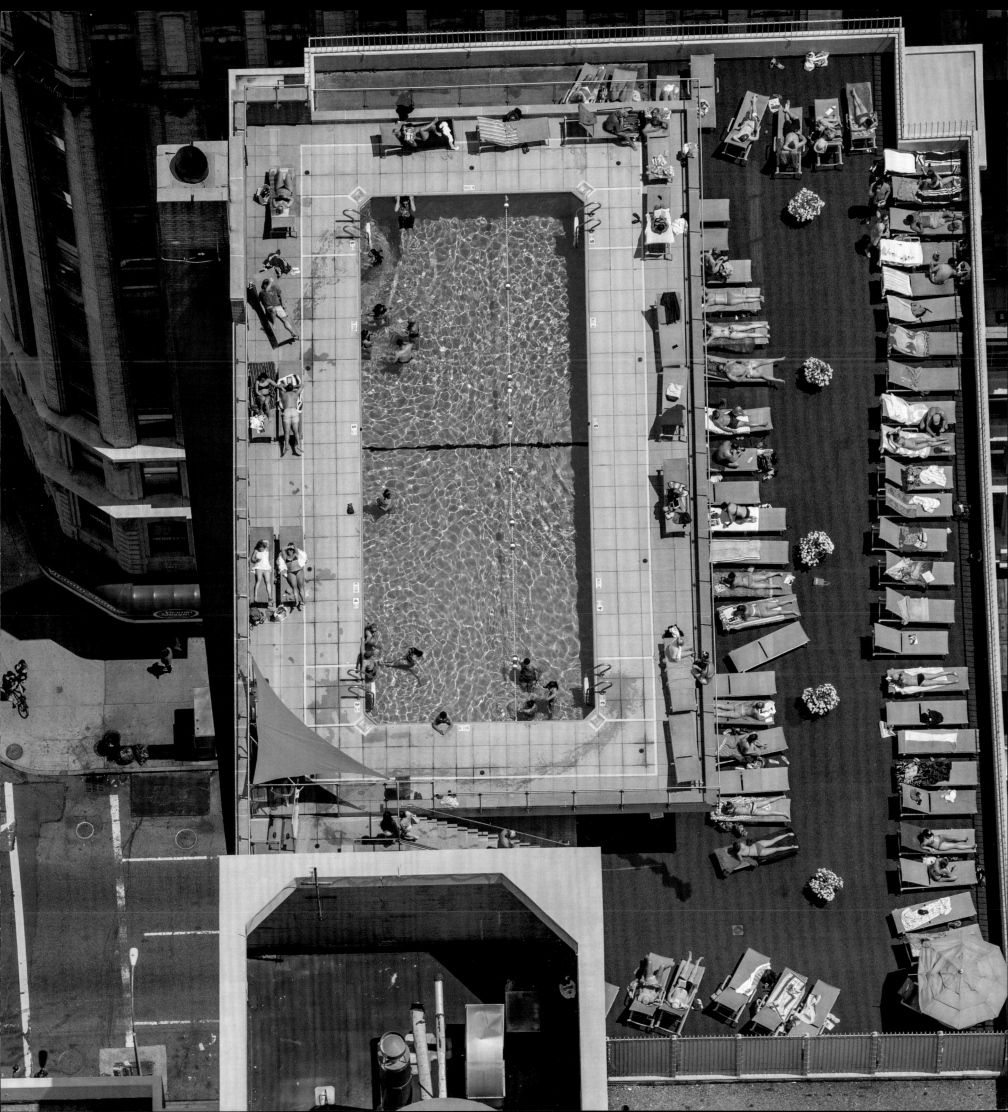

Standing 992 feet high, the Kingdom Centre was the tallest skyscraper in Saudi Arabia when completed in 2002—and is considered only the second to have been built in the country—but is now fifth on the list. The oil kingdom's Jeddah Tower, slated for completion in 2020, will be taller than three Kingdom Centres stacked atop one another. Riyadh, Saudi Arabia.

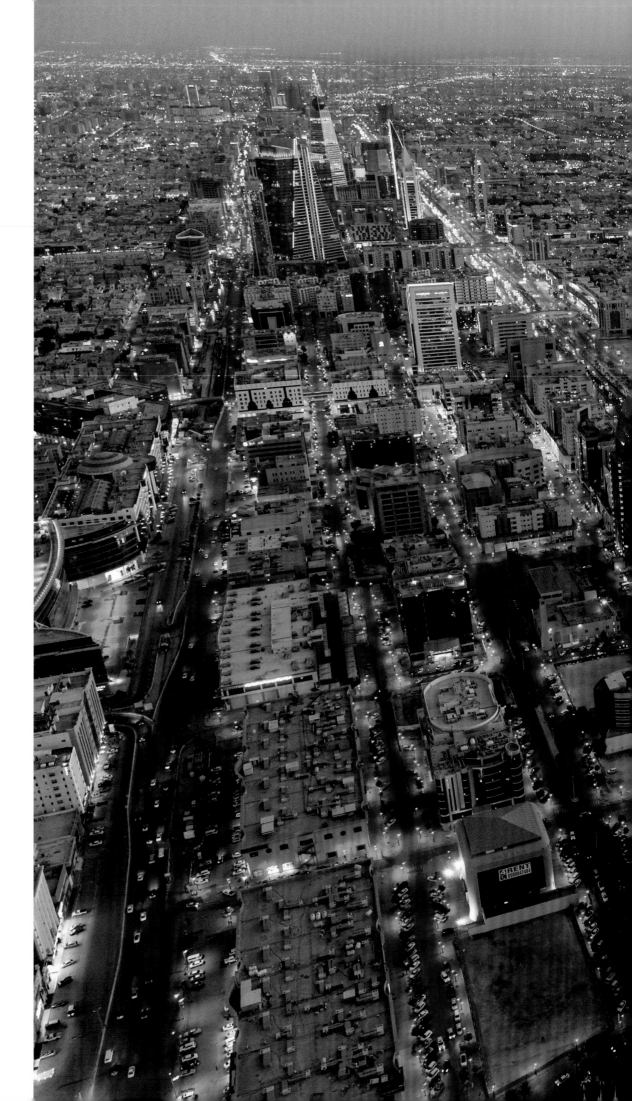

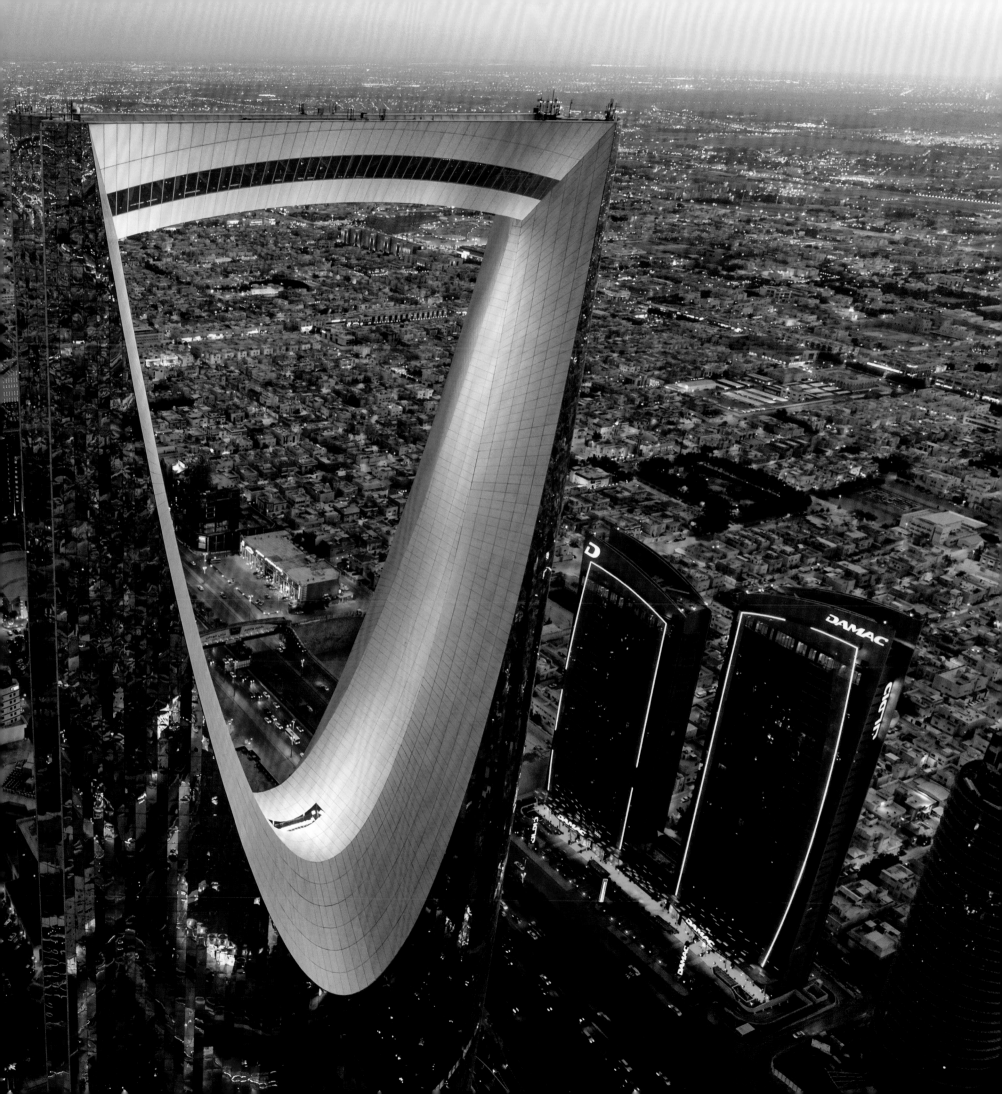

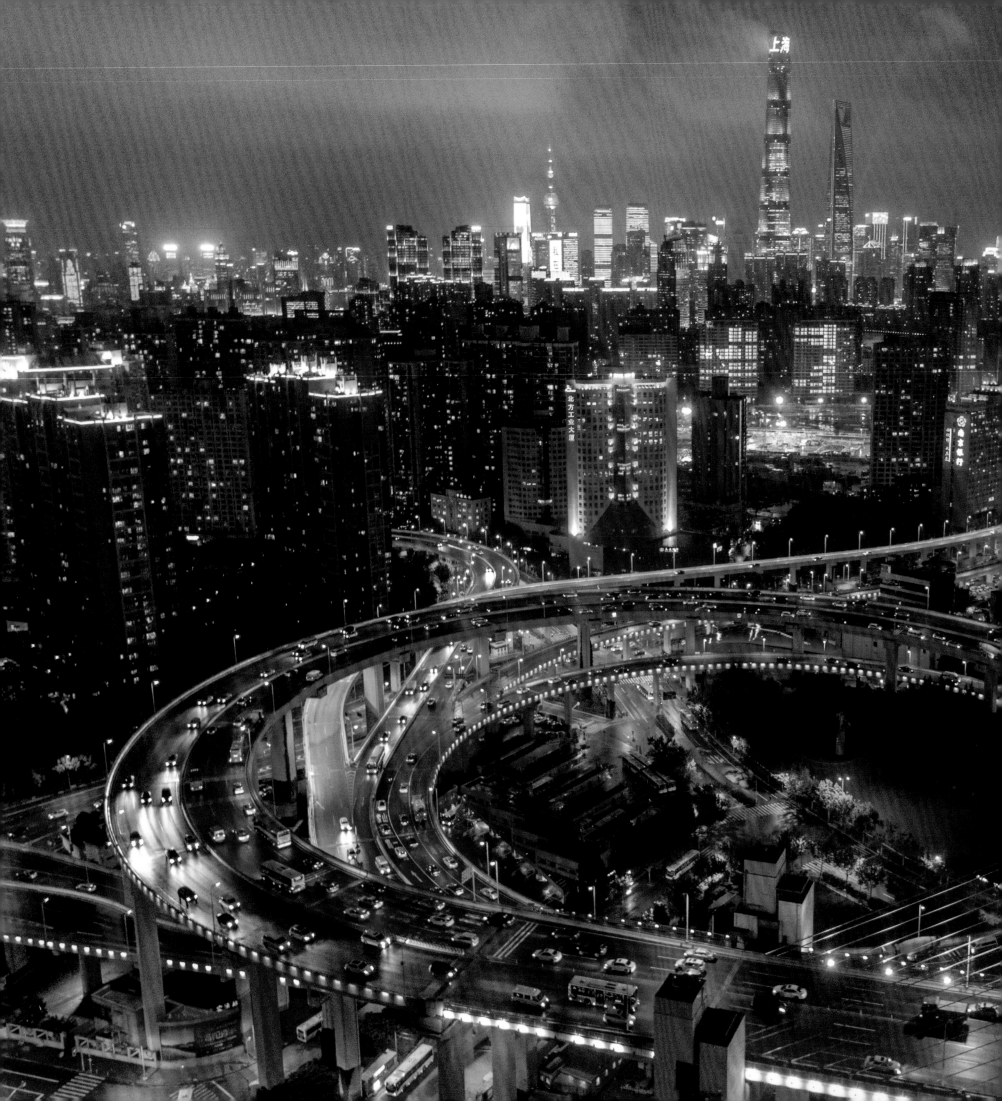

A rare relatively quiet evening commute on the Nanpu Bridge and spiral interchange in Shanghai. As China's middle class has exploded, so have car ownership and vehicle traffic. In 2009, the country had sixty-two million registered vehicles. By 2017, the tally topped an unimaginable three-hundred million. Unrelenting expansion of demand for personal transport has lured American manufacturers, including Ford, which in 2017 began selling its Ford F-150 pickup truck there. To cut congestion, smog, and climate-warming emissions, China is pursuing a host of policies, with a big push to mass transit, as well as electric, autonomous, and shared vehicles. But the challenge of getting to and from hundreds of cities will remain enormous. Shanghai, China.

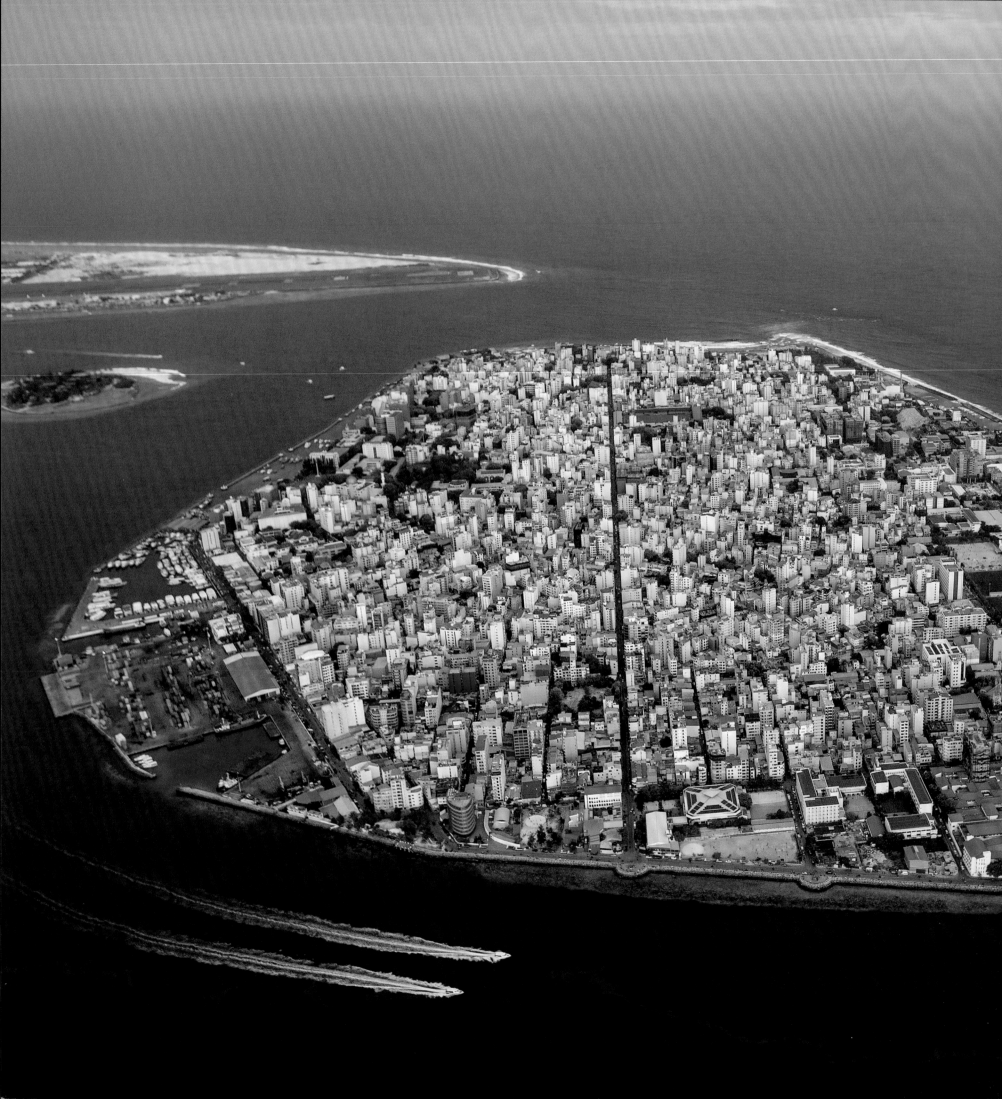

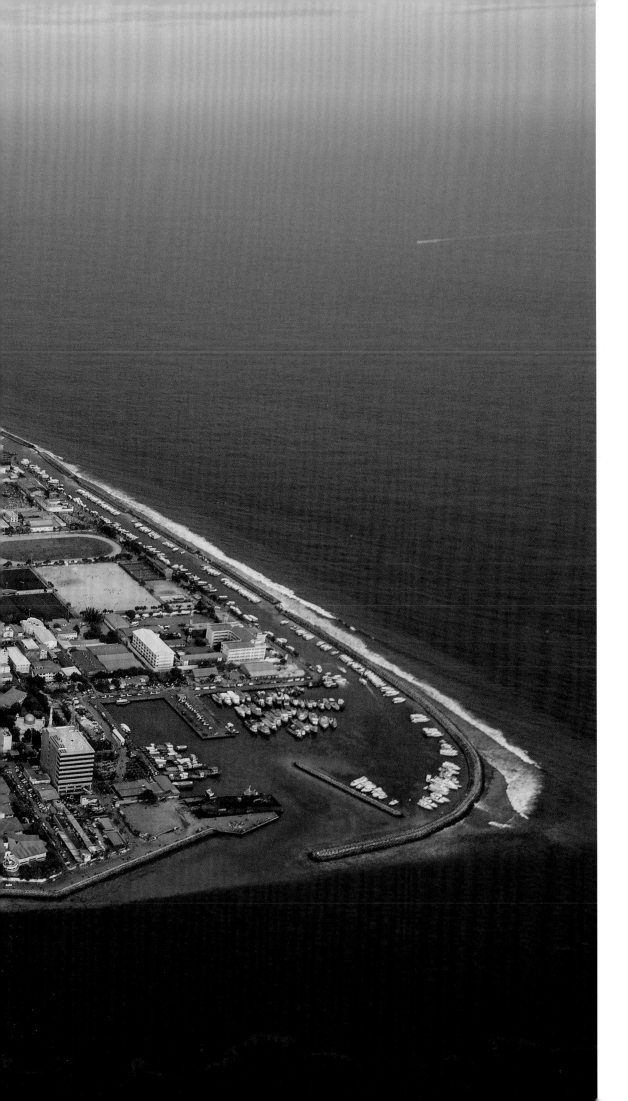

The Republic of Maldives, a chain of 1,192 low coral-fringed islets in the Indian Ocean, has long been considered one of the world's most vulnerable countries as seas rise on this human-heated planet. Studies of many small outer islets there and elsewhere show coral and wave-shifted sands can actually keep up with the rise, with some islands even growing over time. But that capacity has been lost on the tiny island underpinning the crowding capital, Malé, which has been developed and armored right to the shoreline. The population of Maldives, 436,000, has more than doubled since 1990, and Malé is far more densely populated than New York City's Manhattan. Malé, Republic of Maldives.

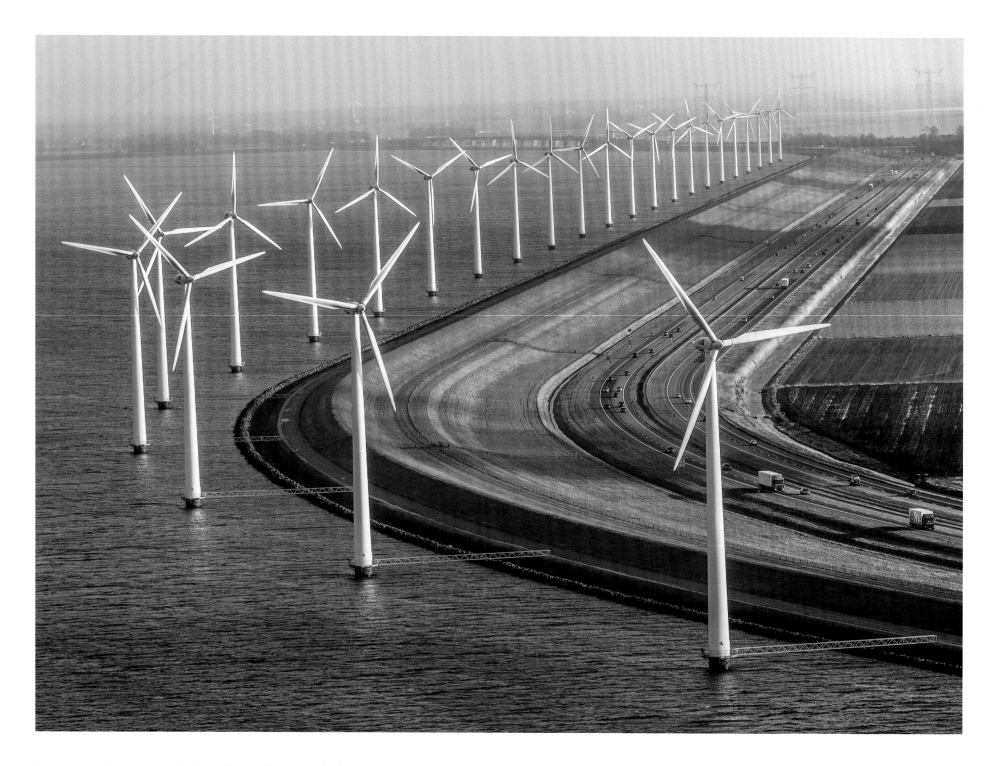

Even as renewable energy technologies like wind turbines and solar panels get cheaper and more efficient, demand for energy continues to mount in a world heading toward a population of nine billion people seeking energy-enabled lives. This means that long after strip mines and smokestacks are a memory, sources of energy will be a significant, if far cleaner, feature of Anthropocene landscapes. Here, dozens of wind turbines sprout along a Dutch dike that long ago turned one five-hundred-square-mile stretch of tidal flats into farmland. Flevoland, Netherlands.

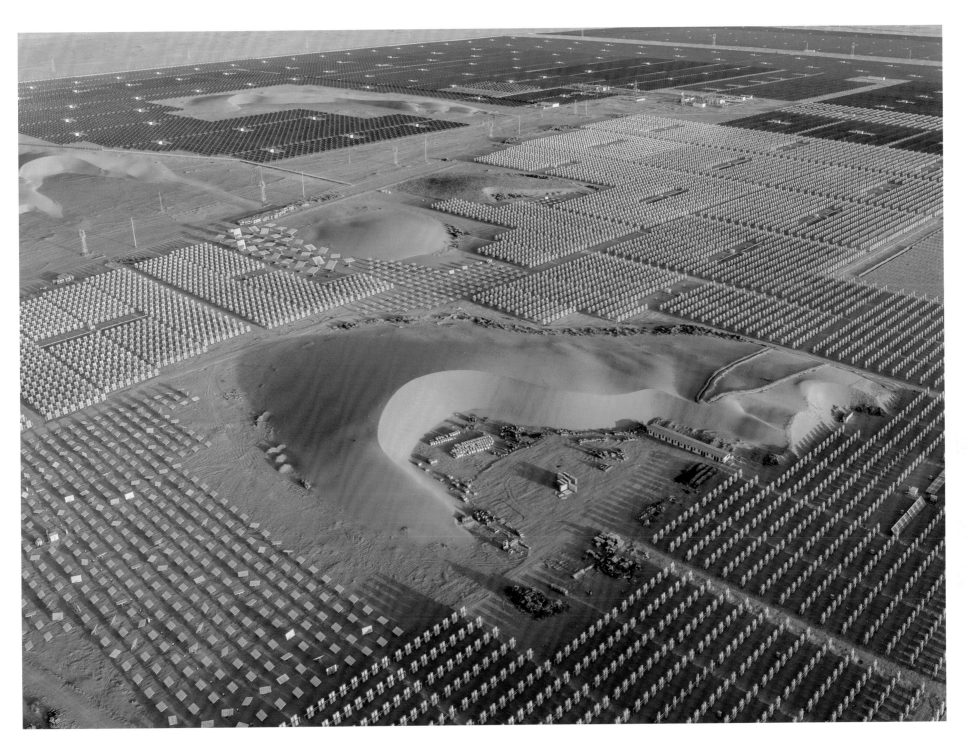

On the high dry plains of Qinghai Province in northwestern China, one of the country's fastest-growing solar-power facilities spreads amid desert sands. The hundreds of photovoltaic panels in the Golmud Solar Park track the sun's location through the day to glean the most energy. An enormous expansion of panel arrays is under way in the region, with some estimates suggesting that, by 2030, the combined generation capacity when the sun is shining could be akin to that from five large coal or nuclear plants. At present, there is no way to store the energy for nighttime use. Golmud, Qinghai Province, China.

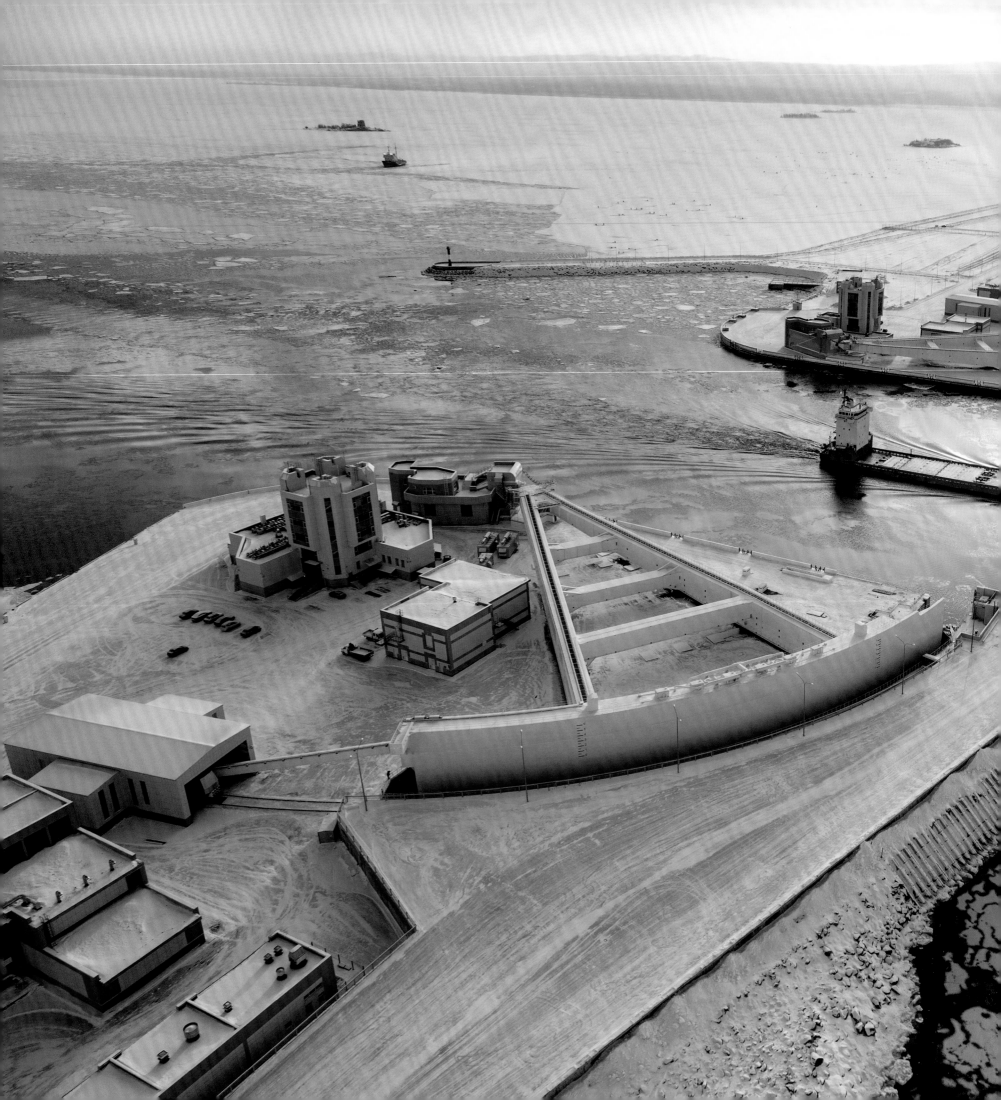

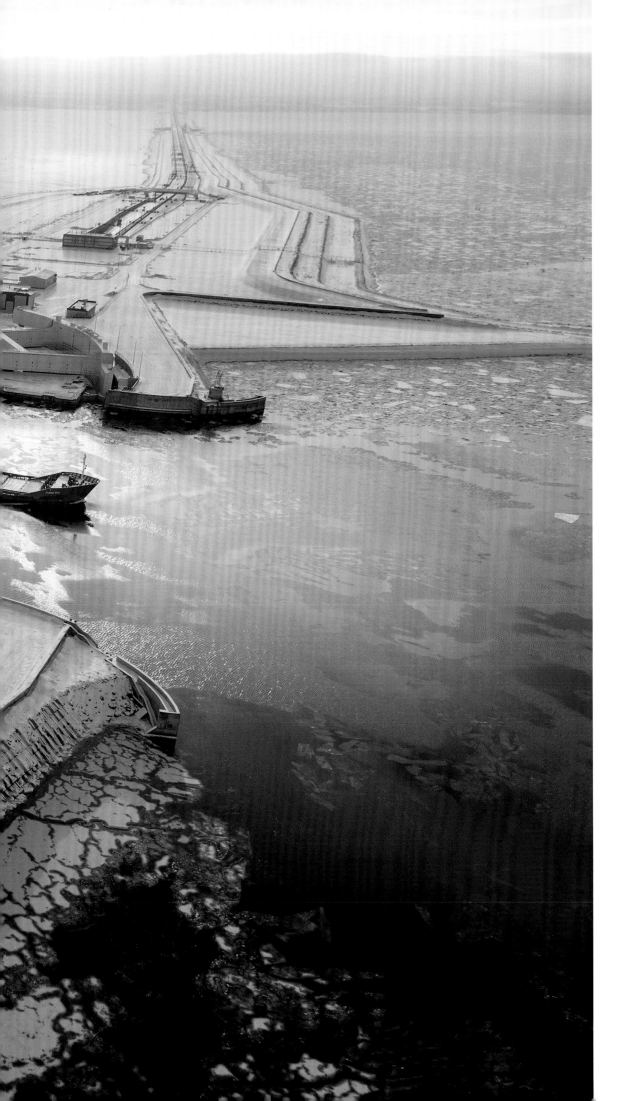

Given that seas will be rising for generations to come, worsening the flood risk from severe storms, ever more coastal cities are building or considering storm-surge protections like the sixteen-mile array of barriers, movable gates, and other defenses shielding St. Petersburg, Russia, from the full force of great storms that occasionally explode across the Baltic Sea. Cities great and small, from London, England, to Providence, Rhode Island, have pursued such projects, with an enormous barrier in the works for Venice—and already thought by some to be obsolete in the face of projections for sea-level rise through this century and beyond. St. Petersburg, Russia.

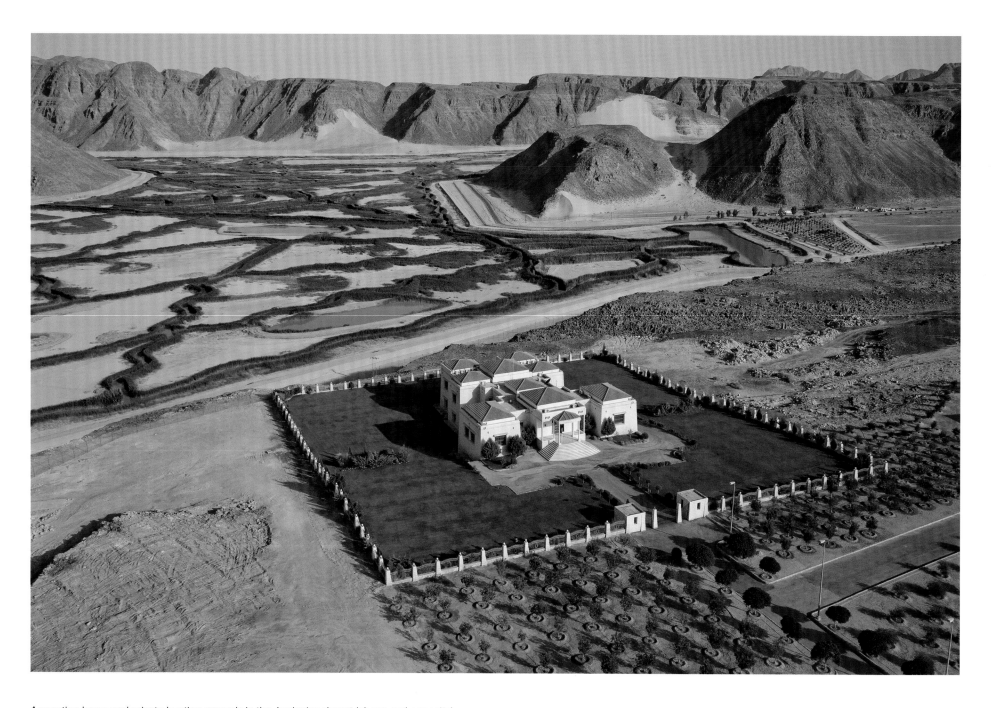

A vacation home and private hunting grounds in the Jordanian desert (above and opposite) created by Abu Dhabi's crown prince is sustained by fossil groundwater pumped from a deep aquifer. After Steinmetz made an emergency landing on the property, staff working on the estate told him that the owner rarely visits. Near Wadi Rum, Jordan.

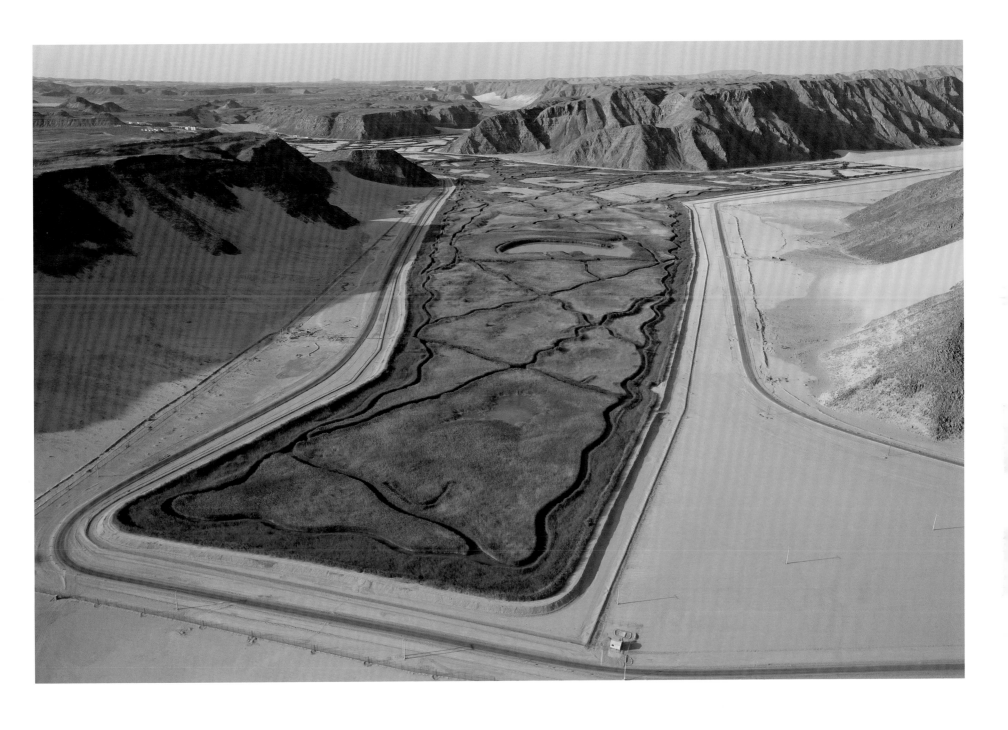

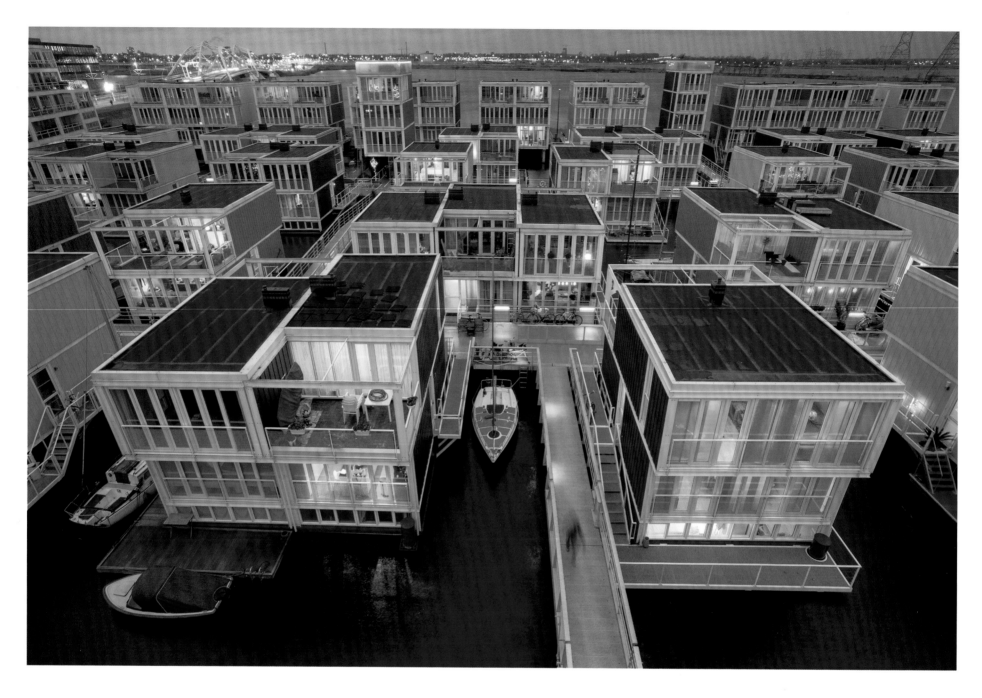

One of the most basic, and inconvenient, realities on a heating planet is that seas will be rising
for centuries to come even if emissions of greenhouse gases somehow decline right away—an
outcome that is highly unlikely. Only the rate of coastal change is in doubt, and it is a certainty
that shorefront communities worldwide have to retreat or reinvent themselves. One option is
floating cities—actually, in most cases so far, floating communities. Some are already under
way, including about one hundred floating houses in the IJburg section of Amsterdam's harbor.
Amsterdam, Netherlands.

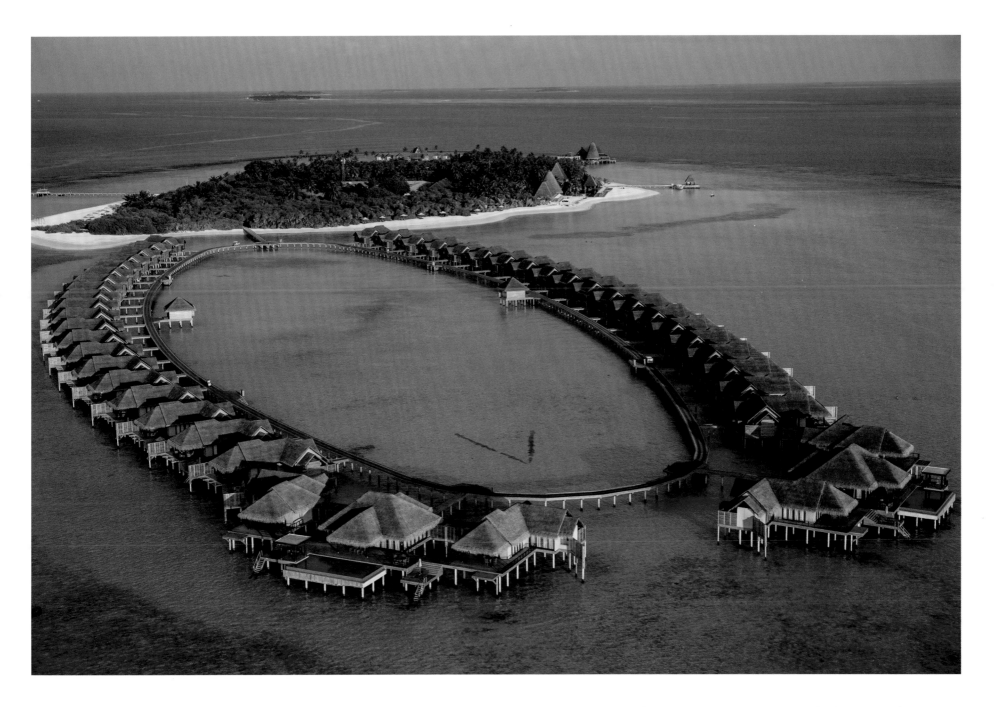

With low sandy atolls vulnerable to storm surge even now, some island nations are shaping their tourism industries around sea levels to come. In the Indian Ocean island nation Maldives, villas costing $1,350 a night perch on stilts about six feet above sea level at the Anantara Kihavah resort. At a special United Nations workshop on cities and rising seas in April 2019, Deputy Secretary-General Amina J. Mohammed pressed the case for more ambitious efforts. "Our approaches to development and environmental sustainability in cities need a serious retooling," she said. "Floating cities can be part of our new arsenal of tools." Baa Atoll, Republic of Maldives.

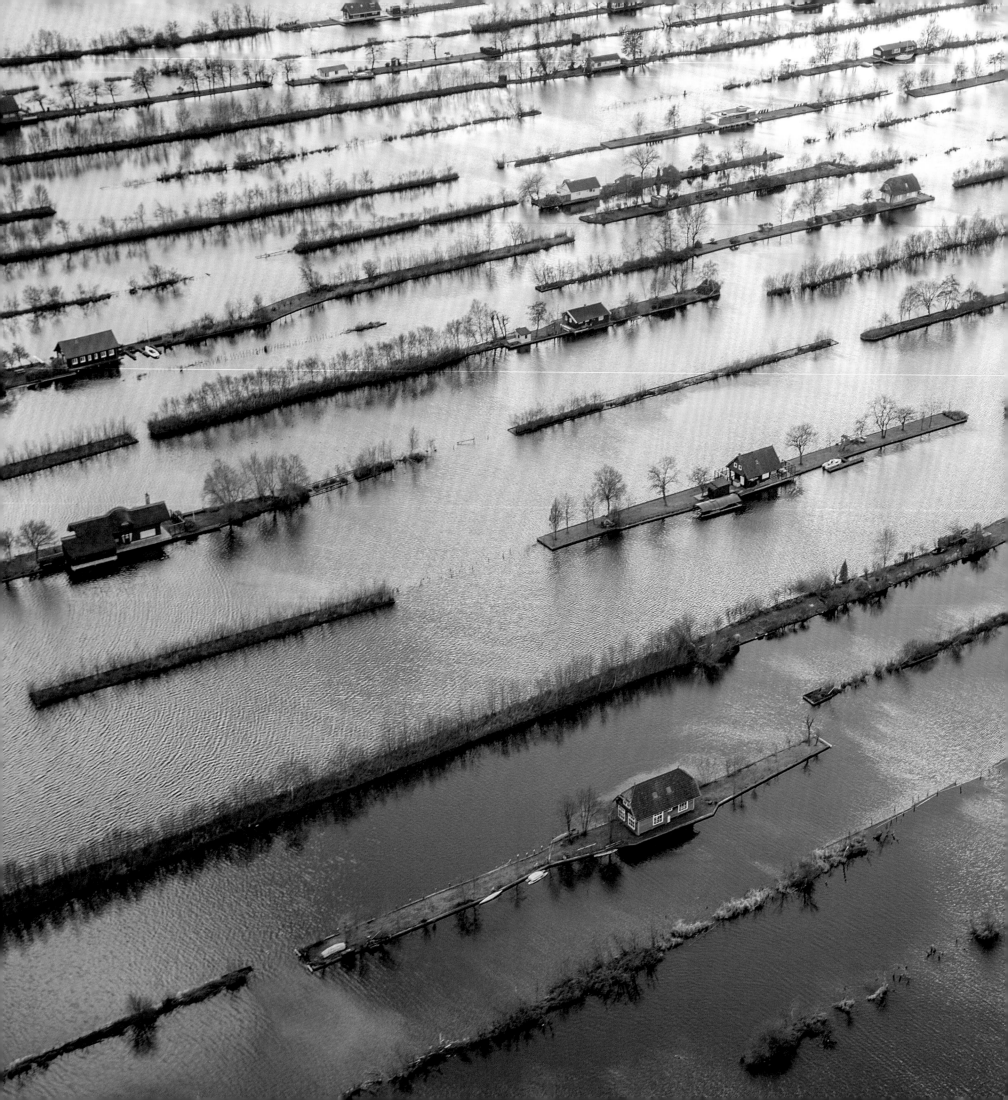

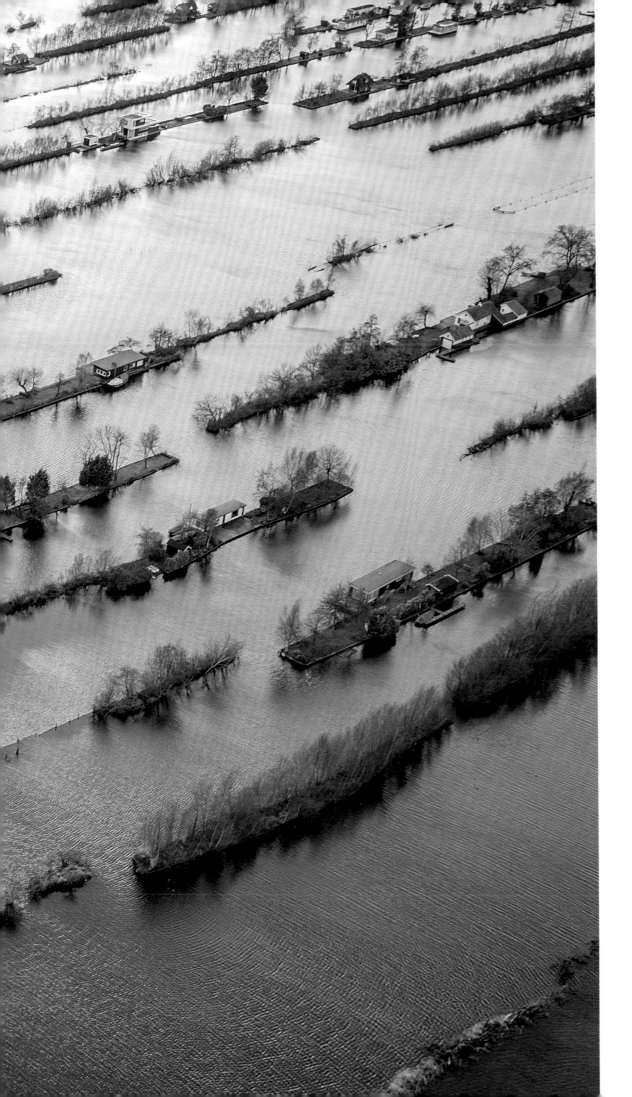

In many parts of the sparsely forested Netherlands, thick layers of peat were harvested for hundreds of years and burned as fuel both in homes and by industry. Because peat takes thousands of years to form, the result is widespread sunken, water-filled areas crossed by strips of land. In this northern region, many slender islets have been turned into pricey vacation properties for urbanites. Wijdemeren, Noord-Holland, Netherlands.

Urban centers from Sydney to Singapore to, here, Milan, are sprouting green-fringed skyscrapers that amount to what their architects call "vertical forests"—with hundreds of trees and thousands of plants on roofs, patios, and balconies filtering air pollution for residents and absorbing some climate-warming carbon dioxide. This two-tower complex, designed by Stefano Boeri and completed in 2014, was the first such effort. Other builders are taking less visible approaches to cutting urban environmental impacts, including a planned one-thousand-foot-tall skyscraper in Tokyo to be built, by 2041, almost entirely of wood instead of concrete or steel. Milan, Italy.

THE ACCIDENTAL ENVIRONMENTALIST

George Steinmetz

I NEVER SAW MYSELF AS AN ENVIRONMENTALIST. I'm a restless person, perpetually curious to see what's over the horizon. I've always disliked what I thought was the arrogance of missionaries who knocked on my family's door in New Jersey and tried to change my religion, which is to be skeptical and open-minded. In 1979, when I left college to explore the world with my camera, it was a journey of discovery, not proselytization. I approached the world as a journalist wanting to capture what I saw and share those findings with others.

But after forty years of crisscrossing all seven continents and photographing in almost one hundred countries, I've started to see things differently. I've witnessed how quickly our population is growing and our wild places are disappearing, and the accelerating rates at which we are consuming the world's resources. It's not the job of journalists to solve the world's problems, but journalists can identify significant problems, which is the first step to finding solutions. It's become clear to me that we are entering an era of limits, because we can't keep consuming resources at today's pace if we wish to leave a habitable planet to the next generations. The classic narrative of man *versus* nature might need to be rethought, as a narrative of man *with* nature.

CURIOUS GEORGE

When I was twenty-one years old, I dropped out of Stanford University, where I had been studying geophysics, to spend a year hitchhiking across Africa. I didn't really know what I would find, except something different from the life I had known growing up in California. I brought a camera with me, as I thought I might find beautiful and exotic things like those I had seen in the pages of *National Geographic*. I didn't have much money, so most of my rides were on top of open cargo trucks that swayed down dusty and muddy tracks. From that rolling perch I often wondered what it would be like to fly over new places, like a bird, exploring what I could see from above the trees and over the horizon.

I fell in love with photography on that trip, and eventually I became a professional photographer and started traveling the world working for various publications, including *National Geographic*. I always loved seeing things from above, whether it was by climbing trees in my backyard when I was a kid or going up to the top of a minaret in the Middle East. With assignment money I was able to take real aerial pictures from planes, helicopters, and whatever else was handy, and the more remote the location, the better.

That hitchhiker's dream of flying like a bird stayed with me, but there weren't many aircraft to hire or airstrips with fuel in the places I wanted to photograph. So for a *National Geographic* story on the central Sahara in 1997, I bought a new kind of ultralight aircraft called a motorized paraglider, which consists of a backpack motor suspended from a parachute-style wing. I'd run to take off and land, and reach an airspeed of about thirty miles per hour. With two and one-half gallons of fuel, I could stay up in my flying lawn chair for almost two hours. It was tricky piloting and taking pictures at the same time, but I had a fantastic, unrestricted view in all directions.

I set off to explore Earth from above—first deserts, then forests, oceans, cities, and agriculture. As I branched out into various environments, I found that an aerial perspective is ideal for revealing patterns of land use, like suburban sprawl or deforestation. Whether it's rice paddies in China or glass canyons in New York City or Inca ruins in Peru, the elevated perspective always reveals something new. While a motorized paraglider is an ideal platform for exploring some environments, airplanes or helicopters are better choices for others. Over the past few years, I've been using drones designed for photographers to get my camera into positions I could only have dreamed of before.

During the last decade or so, what I've been seeing from above has become increasingly disturbing. I might be doing research with Google Earth on an area that I know well, and I'll be surprised to see new road networks penetrating an area that I remembered as virgin forest. On a recent trip to Nairobi, I found the city almost unrecognizable, with a population five times what it was when I first visited forty years ago. As a location photographer dedicated to fieldwork, I consider ground truth paramount, and I need to experience things for myself.

CAVE PAINTINGS OF THE SAHARA

I spent some fifteen years exploring the world's extreme deserts. They are Earth's most sterile environments, which makes them great preservers of history. The Sahara and Arabian Deserts have become more arid over the past few thousand years and are home to numerous ancient cities that

George Steinmetz photographing an ancient abandoned village in the Grand Erg Occidental of Algeria. Timimoun, Adrar, Algeria. Photograph by François Lagarde

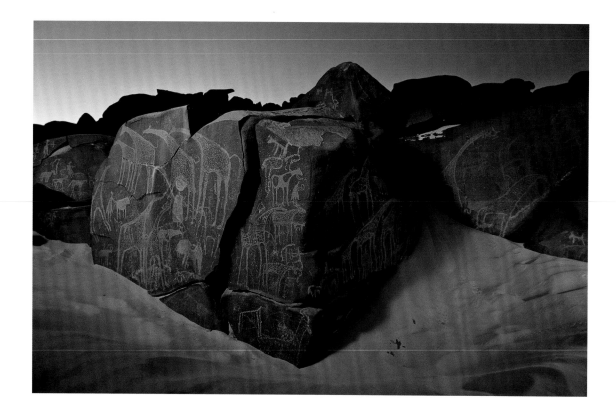

Drawings on rocks beside
long-empty riverbeds depict
wildlife and people mingling
in a far wetter environment
than today's, when they were
created around three thousand
years ago. Aïr Mountains,
northern Niger.

are now half-buried in sand. Deserts are beautifully desolate places, with hardly any people, let alone weather stations with well-kept records, but you can follow climatic changes by reading the writing on the deserts' walls. On the inside of desert caves that were once used as campsites by herders and hunters, there are depictions of cattle and the spearing of gazelles, and out in the sun are rock faces carved with drawings of hippos, rhinos, and giraffes—in environments that are so dry that there is no way they could support such forms of savanna wildlife today. In the Sahara, the desiccation has accelerated since the Little Ice Age (1300–1850 CE), but now it seems that things are starting to change. In the field, I have experienced strange new phenomena, like a freak snowstorm that hit an oasis of palm trees on the desert side of the Atlas Mountains in Morocco and rainbows of ephemeral rains during the dry season on the Skeleton Coast of Namibia. It wasn't supposed to snow or rain in these areas. When I spoke with scientists, they confirmed that they, too, were seeing evidence of climatic shifts that were without recent precedent: sub-Saharan lakes starting to grow again, old people reporting rain in places where it had never rained in their lifetimes. While precipitation in the desert may seem like a good thing, to an experienced desert traveler it's a warning that something big is going on, and that the weather on our planet is moving toward a new equilibrium.

DISAPPEARING ICE OF THE ANDES

In 1997, I was given a magazine assignment to go to the summit of Nevado Sajama, the highest point in Bolivia, to follow the work of Lonnie Thompson, a climatologist from Ohio State University who was taking samples of high-altitude ice caps in tropical and subtropical regions. These ice caps are disappearing at an alarming rate, and Lonnie wanted to recover the records of pollen, ash, and paleo-atmosphere that were trapped in the ancient ice before it melted and the information was lost forever. The summit of Sajama is at 21,463 feet, and my first morning up there I woke before sunrise and photographed the shadow of the mountain as it was projected out across the continental divide and into the atmosphere over the Pacific, with Volcán Parinacota, a volcano about fifteen miles to the west, off to one side. It was an impressive vista, but I wanted to see the view to be had from

the divide that is formed by Volcán Parinacota and the nearby Volcán Pomerape. So ten years later, at the same time of year, I climbed up the ridge of Pomerape to 19,000 feet. I was surprised to see the wisdom of Lonnie's science in my own photographs. If you compare the the ice cap on Parinacota in the earlier and later images (pages 40–41), you can see that the snow line has gone up hundreds of feet. The strange spiky ice on the flanks of Pomerape is typical of areas where high-altitude ice is evaporating without ever melting. For millennia the ice on the peaks of the Andes has acted like a reservoir, collecting moisture in the wet season and releasing it in the dry season when the people and ecosystems below most need water. It seems that life in the Andes is about to get a lot more difficult.

THE VANISHING AMAZON

In 2018, I had another wake-up call from our changing planet in the Brazilian part of the Amazon basin. I went out on helicopter patrol with agents from IBAMA, Brazil's federal environmental agency, who travel in bulletproof vests, as saving the forest is like trying to stop drug trafficking in a very tough neighborhood. The southern part of the forest is known as the Cerrado; it lies in an agricultural sweet spot where farmers can get two crops (soybeans and corn) per year out of the same fields without any irrigation. Over the past fifty years, about half of the Cerrado's native forests and grasslands have been converted to human use, for the most part illegally. If you look at satellite imagery from the last twenty years, it resembles a time-lapse view of a termite farm, with narrow roads penetrating the forest and sending out branches that quickly spread in all directions. The scale of the deforestation we flew over was staggering. But I wanted to see it up close, on the ground, on my own terms, with my drone. So I drove out to one of the newly cleared areas at dawn, just as the first rays of sunlight were hitting the forest and the dew still clung to the upturned roots of felled trees. Away from the clatter of the helicopter I could hear a chorus of birdsong and animal life coming from the wall of green on one side. There was absolute silence on the other. The difference between life and death was haunting. It was apparent that the cleared land had huge economic value, but the value of the forest and birdsong wasn't bankable.

A WAY FORWARD?

Farmers and loggers I met in Brazil questioned the moral authority of people in Europe and North America to tell them what to do with their own country. Their attitudes reminded me of my own annoyance at the missionaries who have come to my home, to convert me. The Brazilian settlers would point out that American pioneers had plowed the prairies of the midwestern United States, and I realized that even my own ancestors in Germany had probably cleared the trees of the Black Forest. Was the Amazon the "lungs of the planet," or was it the Brazilian settlers' own natural resource to be exploited as completely and profitably as possible? It was a difficult question to answer.

When I set out across Africa as a young man, I wanted only to explore the world. But after seeing the changes we have made to it during my forty years of fieldwork, I feel a responsibility that my photographs carry a message. I've come to realize that we are pressing against the limit of what Earth can provide. We can't keep fighting against nature, we have to make peace with it, and that will require some concessions from all of us. Finding that balance is not my job, but I hope you don't mind that I pointed out the problem.

INDEX

ACKNOWLEDGMENTS

This book would not exist without the deft and patient judgment of Eric Himmel, the editor in chief at Abrams, who championed this project from the beginning and spent many weeks editing my lifetime of work into this visually coherent form. I'm also indebted to Andrew Revkin, who has followed a path of discovery parallel to my own and beautifully articulates the issues that we are facing today.

My father once told me that the key to making your way in this world is OPM (aka other people's money), and traveling the world like I have for more than thirty years is not cheap. I am greatly appreciative of the editors who have supported my fieldwork through the years, especially those at *National Geographic Magazine*, German *GEO*, and the *New York Times Magazine*. At *NGM* I was supported by Bill Allen, Rich Clarkson, Dennis Dimick, Bill Douthitt, Susan Goldberg, David Griffin, Todd James, Chris Johns, Whitney Johnson, Tom Kennedy, Kent Kobersteen, Elizabeth Krist, Sarah Leen, Kathy Moran, Kurt Mutchler, and Susan Welchman. At German *GEO*, I'm indebted to Christane Breustedt, Ruth Eichhorn, and Peter-Matthias Gaede; and at the *NYTM*, Kathy Ryan, Jake Silverstein, and Christine Walsh. They are the kind of people who expect the extraordinary, and their guidance and editorial judgment were critical to my success.

My photography went through a major evolution in 1998 when I learned how to fly a motorized paraglider, the world's lightest and slowest motorized aircraft. I would probably not be alive today without the guidance of my French brothers in flight, François Lagarde and Alain Arnoux. The trips, which we shared over both carburetors and campfires, were so much better with their company.

And most importantly, I have to thank my infinitely patient and loving wife, Lisa Bannon, who has let me run freely all over the world, following my passion for taking pictures. Lisa, and our kids Nell, Nick, and John, has given me the greatest gift of all: a foundation of family and home life that make everything else possible. For what would an adventure be without a campfire to return to?

—George Steinmetz

PAGES 2–3:
In Lençóis Maranhenses National Park (page 19), conditions and colors vary from region to region, with these sinuous dunes surrounded by ephemeral blue and green lakes. Maranhão State, Brazil.

PAGES 4–5:
A fishing village on Africa's west coast outside Nouakchott is packed with boats. Mauritania's population is just about 4.5 million and growing rapidly, and the country is one of the world's poorest, but it has a wealth of natural resources, including oil, gold, and iron. Although arable land accounts for less than 0.5 percent of Mauritania's 390,000 square miles, half its workforce is employed in the sectors of farming, forestry, and fishing, and worsening droughts have forced many desert nomads to turn to the sea for survival. Mauritania's coastal waters have been called some of the richest fishing grounds in the world, but they are increasing in temperature at a rate that exceeds any other section of the tropical convergence zone. Fisheries are dependent on migratory fish such as the sardinella. A recent study indicates that as a result of warming waters, sardinella have been pushed north by perhaps two hundred miles since 1995. Nouakchott, Mauritania.

Designer: Darilyn Lowe Carnes
Production Manager: Anet Sirna-Bruder

Library of Congress Control Number: 2019936964

ISBN: 978-1-4197-4277-4
eISBN: 978-1-68335-880-0

Copyright © 2020 George Steinmetz
Text by Andrew Revkin © 2020 Andrew Revkin

Jacket © 2020 Abrams

Printed and bound in China
10 9 8 7 6 5 4 3 2 1

Abrams books are available at special discounts when purchased in quantity for premiums and promotions as well as fundraising or educational use. Special editions can also be created to specification. For details, contact specialsales@abramsbooks.com or the address below.

Abrams® is a registered trademark of Harry N. Abrams, Inc.

ABRAMS The Art of Books
195 Broadway, New York, NY 10007
abramsbooks.com